THE HANDBAG BOOK

400 Designer Bags That Changed Fashion

SOPHIE GACHET
Foreword by **INES DE LA FRESSANGE**

THE HANDBAG BOOK

400 Designer Bags That Changed Fashion

Abrams, New York

CONTENTS

FOREWORD

BY INES DE LA FRESSANGE

The handbag is both a woman's fantasy and a reflection of her reality.

By choosing it, she endows it with a magical power, as if the accessory could not only transform her figure but also change her into the woman she desires to be.

The desire to be this augmented woman, and therefore make what sometimes feels like an unreasonable purchase to obtain a little girl's dream, will compel her to justify owning a desired handbag for practical reasons, often perturbing and perplexing her partner, who contemplates a closet full of bags that rarely see the light of day.

Once obtained, this object of luxury (indeed, it is not a necessity) quickly becomes an everyday accessory and, with each passing day, an extension of who we are.

You only have to look at a handbag to know a little something about its owner's personality. But, of course, it is the contents that make up the fingerprint that definitively identifies the person: A pocketknife, a folded pamphlet, a pair of headphones, a few munchies—inside can be found all kinds of objects and, sometimes, though rarer and quite puzzling, almost nothing.

Whatever its contents or ultimate purpose, a new handbag can become a neurosis and, in less than a week, take on the identity of our previous bag. Changing how we fill it, organize it, or treat it seems as impossible as changing our voices or tastes in food.

As splendid, rare, desirable, expensive, and beautiful as they are, our handbags often end up mistreated and eventually abandoned, except for a few that we take care of, mend, put away, take out on different occasions, and hold on to all our lives. What was at first our lover eventually becomes our friend.

MAKING THE CASE FOR HANDBAGS

The handbag is the ultimate object of desire. Coveting a handbag to the point of going to great lengths to possess it shows the unconditional love we apply to a detail that becomes part of our look. Although its primary function is to carry what we need, a handbag symbolizes who we are. Its contents say a great deal about our personal lives. A handbag also depicts how we want to present ourselves to the world. According to Sigmund Freud, the father of psychoanalysis, our handbag reveals our most profound nature. Tell me what handbag you carry, and I'll tell you who you are. Are you someone who prefers a formal or casual style? Do you like a structured or soft tote? Kate Middleton's discreet clutches reveal something about her that is quite different from what Kim Kardashian's eye-catching totes reveal about her. A psychoanalyst could quickly conclude much about a patient by studying her handbag.

In *The Handbag Book: 400 Designer Bags That Changed Fashion*, we are mainly interested in the handbag as an essential accessory. Within the pages of this book, you can admire the different bags that have left their mark on the history of fashion: the 2.55 by Chanel, the Kelly by Hermès, the Speedy by Louis Vuitton, the Baguette by Fendi, the Jackie by Gucci, and many others. This book contains all the must-know bags plus the bestsellers that have crossed generations without losing a single ounce of their luster as objects of desire. You'll also discover many other designer bags that represent beauty and creativity.

The purpose of this book is not only to list the different models that have become or will become important as fashion accessories, but also to reveal a little more about the history of the fashion house that made them and the story of their creation. Whether you are a handbag addict, admirer, designer, or just searching for your ideal style, this book is the ultimate guide to this star accessory. And regardless of our choice, one thing is sure: Style is in the bag!

ACNE STUDIOS
SCANDINAVIAN COOL

"Perfection is boring." **Jonny Johansson**

Founded: 1996

The story: Acne Studios is a Stockholm-based company. Its creative director, Jonny Johansson, has many passions beyond fashion, including photography, art, architecture, and contemporary culture. In addition to ready-to-wear, the company creates magazines, books, furniture, and exhibitions. The fashion line began in 1996 when Jonny gifted his friends one hundred pairs of raw denim jeans with red stitching. The jeans were an immediate success, and Jonny soon launched a more complete collection, followed in 2015 by the first handbags and accessories.

The style: Acne Studios has often been referred to as minimalist, but the studio's style is rather maximalist considering the many references to art, design, literature, and music. Jonny says his primary inspiration came from the Warhol Factory. All the designs reflect great attention to detail, and the fabrics used are often tailor-made.

Heard on the street: *"Did you know that Acne was originally an acronym for Associated Computer Nerd Enterprises? Today, these letters are said to stand for Ambition to Create Novel Expression."*

FASHION HOUSE FACT
Acne Studios' largest European boutique opened in Paris in 2022 at 219 rue Saint-Honoré. It is almost 4,150 square feet (385 square meters).

WHO WEARS ACNE STUDIOS?
Kendall and Kylie Jenner fell in love with the brand's handbags. Rihanna, Dua Lipa, and Selena Gomez are also fans.

MUSUBI

2017

The Musubi was inspired by the large, twisted knot of the obi, the traditional Japanese belt.
The bag gives an impression of softness while being structured. The handcrafted Italian calfskin
has been bonded to the lining, which eliminates any visible seams and keeps the surface perfectly
smooth. The brand's logo is embossed, and the closure is magnetic. The models with handles have
a removable strap.

Since its launch, the Musubi has gone through many variations, both in color and style. Each season, the bag takes on new forms. In 2022, the Musubi Micro Tote and the Musubi Shoulder Bag were launched. In 2023, the Musubi Midi bag made its appearance. (This tote, perfectly suited for everyday, is available in a new material reminiscent of vintage tie-dyed T-shirts.)

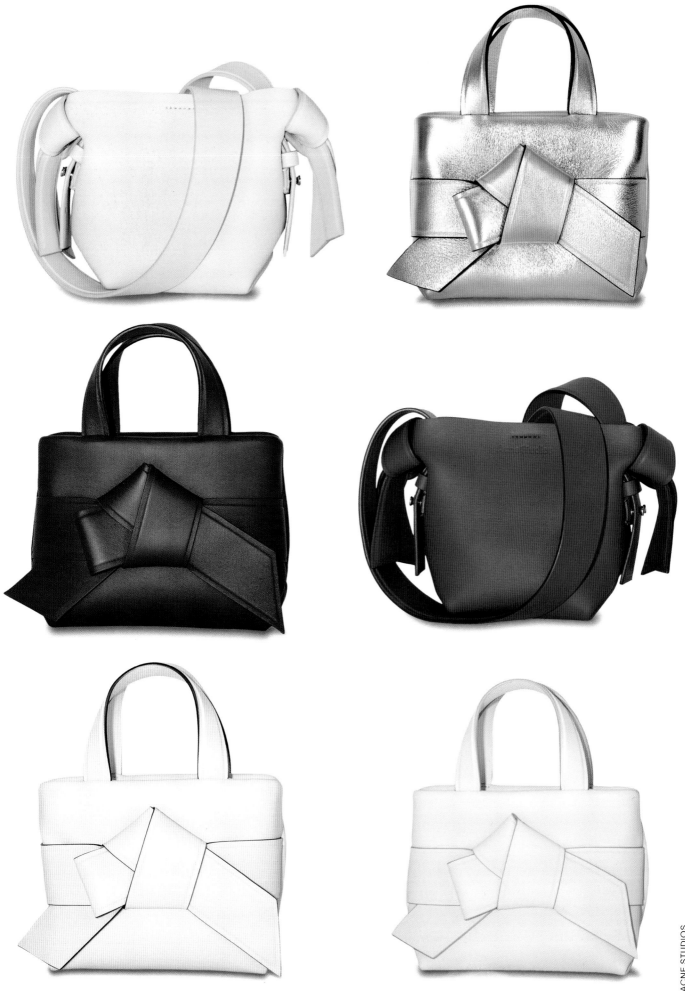

PLATT

2023

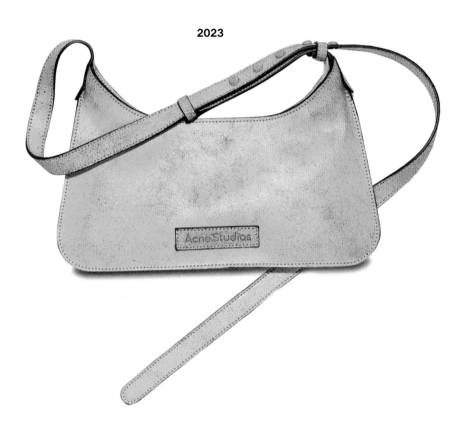

This shoulder bag has a very simple, almost plain shape. The shoulder strap is longer on one side and hangs below the bag, a signature detail of the brand. The bag contains a mirror with the inscription "You are beautiful." Released in 2023, the Platt Crackle is a variation of this bag. Made of cowhide leather with a crackling effect, it is available in three sizes and three colors: grayish black, acid lime, and dark beige. The Platt Crossbody Crackle, with a squarer shape and a flap, is another variation of the Platt. Some display pointed studs on the shoulder strap. Although it looks worn at first glance, the bag has a lustrous surface—a small paradox, and very representative of the Acne Studios style.

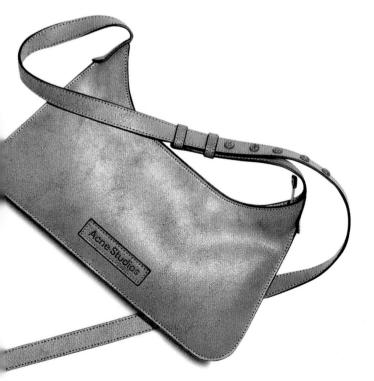

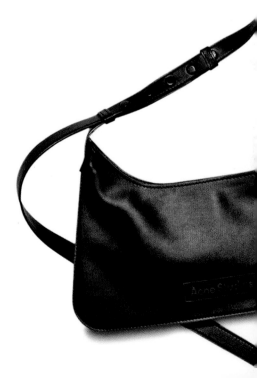

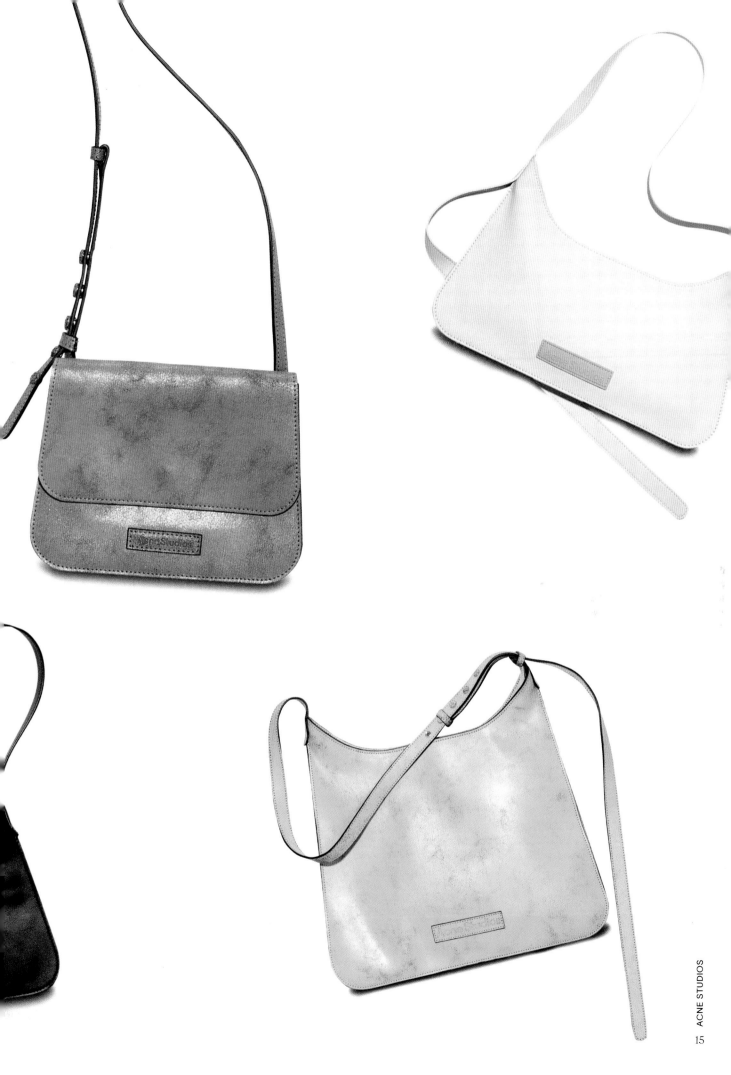

ALAÏA
FASHION
SCULPTOR

*"I like black because, for me,
it's a very joyful color."* **Azzedine Alaïa**

Founded: 1980

The story: Born in Tunisia, Azzedine Alaïa entered the School of Fine Arts in Tunis at fifteen. He quickly developed a passion for sewing and decided to leave for Paris in 1956. There, he made dresses for women of French and Tunisian high society. Between 1956 and 1958, Azzedine worked briefly for Dior and Guy Laroche. In 1964, he opened his couture workshop on rue de Bellechasse, which was frequented by Greta Garbo, Arletty, and the wives of Pablo Picasso, Joan Miró, and Alexander Calder, among other high-profile clients. In 1980, he launched his first ready-to-wear collection and soon began dressing stars such as Grace Jones and Tina Turner. His fame exploded, and the top models of the time—Naomi Campbell, Stephanie Seymour, and Farida Khelfa—walked the runways for him and became his friends. When he passed away in 2017, he left a considerable stylistic legacy, now in the hands of the Belgian Pieter Mulier, who has overseen artistic direction since 2021 and continues the quest for perfection and modernity with the same technical prowess as Azzedine.

The style: Tight, sculptural dresses, made of materials that maintain the silhouette while leaving the body free to move. The skater skirts, tightened at the waist by a corset belt, and the short crinoline dresses are no less sexy.

Heard on the street: "*Azzedine had acquired more than 15,000 articles of clothing that were part of fashion history. Exhibitions are held regularly at his foundation.*"

FASHION HOUSE FACT
The Azzedine Alaïa Foundation, responsible for continuing the couturier's work, organizes exhibitions that the public can visit at 18 rue de la Verrerie, Paris.

WHO WEARS ALAÏA?
Jennie Kim, Jennifer Lawrence, Rita Ora, Rihanna, Irina Shayk, Tilda Swinton, and, still, all his favorite top models, including Naomi Campbell and Stephanie Seymour.

THE MINA

The Mina is the brand's iconic tote bag, recognizable by its laser-perforated leather reminiscent of moucharaby, the carved wooden-latticed windows found in Middle Eastern countries. The bag's perforations are made up of metal eyelets. Its pinched and pleated shape along its spacious sides can be adjusted as needed. It can be carried by hand or on the shoulder thanks to its removable shoulder strap.

LE CŒUR

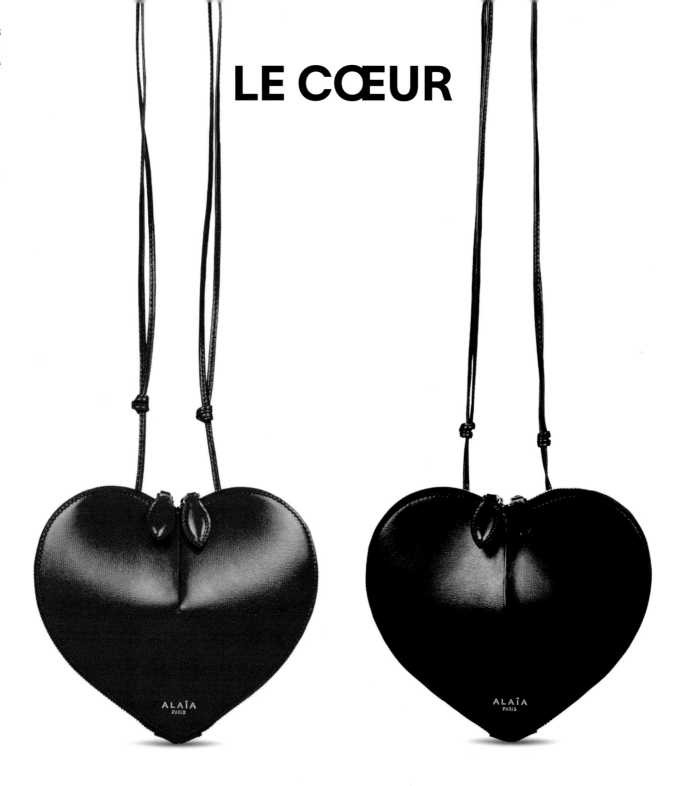

"*My heart belongs to papa.*" In the 1990s, Azzedine had his favorite supermodels walk the runway with this statement on their dresses. This inspired Pieter Mulier to create this heart-shaped leather bag. The minaudière version is made of brass.

LE PAPA

2022

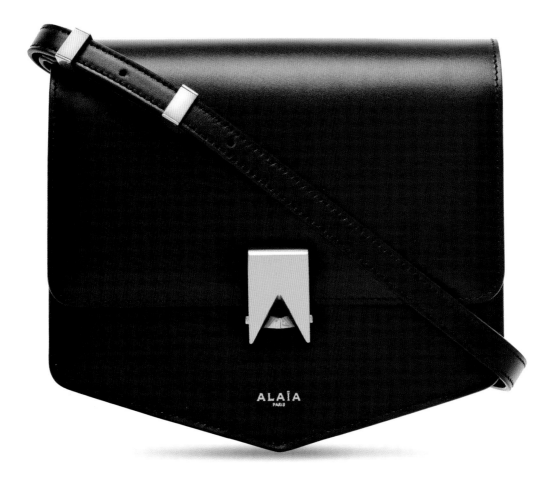

Just like Le Cœur, the name of this handbag is a reference to Azzedine Alaïa, who was called Papa by all his favorite runway models. The architectural lines of the clasp form the *A* of Alaïa. The bag is made of leather and is worn on the shoulder. Le Papa comes in three sizes, one of which can be carried by hand with a handle and has a chain shoulder strap.

ALEXANDER MCQUEEN
SUBTLY EXTRAVAGANT

"Fashion should be a form of escapism, and not a form of imprisonment." **Alexander McQueen**

Founded: 1992

The story: Alexander McQueen created his brand after completing his master's degree in fashion design at Central Saint Martins College of Art and Design in London. In 1996, he became artistic director of Givenchy but continued to design collections for his own label. In 2001, he left Givenchy, and his label became part of the Gucci group (now Kering). McQueen released a line of handbags and shoes in 2005. When he passed away in 2010, Sarah Burton, his first assistant and, at the time, director of women's ready-to-wear since 2000, took over the brand's artistic direction. Sarah left the Alexander McQueen fashion house in 2023. Its current creative director is Seán McGirr.

The style: Futuristic silhouettes and bold lines. All of Alexander McQueen's collections have something poetic yet somber about them at the same time.

Heard on the street: *"Having your rings as part of your bag is super practical!"*

FASHION HOUSE FACT
Sarah Burton set up an educational program for and donates unused fabrics to students studying fashion in the United Kingdom.

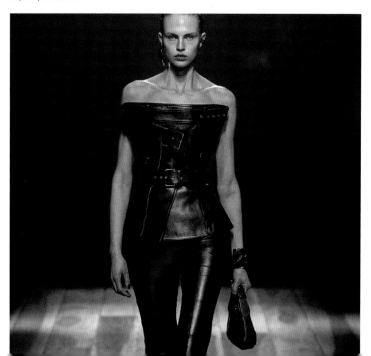

WHO WEARS ALEXANDER MCQUEEN?
Beyoncé, Cate Blanchett, Lily-Rose Depp, Kaia Gerber, Sydney Sweeney, and of course Kate Middleton, whose wedding dress was designed by Sarah Burton for Alexander McQueen.

JEWELED HOBO

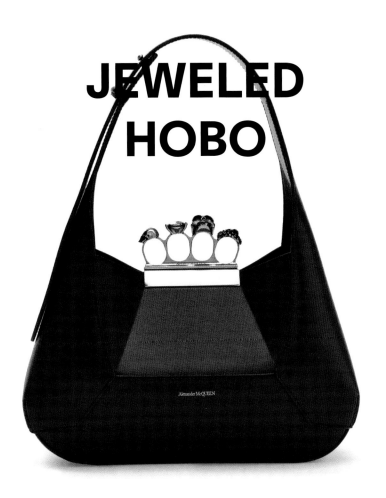

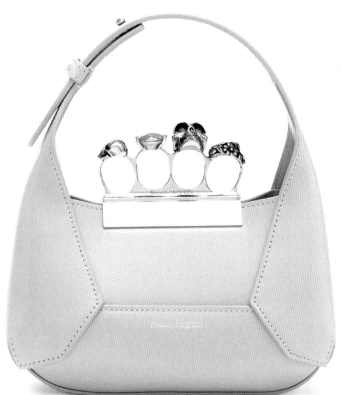

The silhouette of this bag is inspired by the faceted stone on the clasp, between the skulls. Several panels of leather are cut and reassembled to create a new shape with a 3D effect that recalls the sharp silhouettes typical of the fashion house. It's available in many colors, in leather or studded with crystals, and in two sizes.

JEWELED SATCHEL

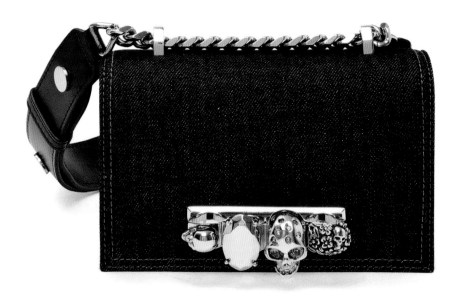

This line is very emblematic of the brand. The knuckle clasp is adorned with skulls, one of Alexander McQueen's signatures. The Jeweled Satchel is handmade and infinitely varied: offered in leather, embossed crocodile leather, leather with graffiti, tweed, and studded with crystals. The clasp also changes color, and the chain shoulder strap is adapted to the style of the bag. It comes in three sizes.

KNUCKLE CLUTCH

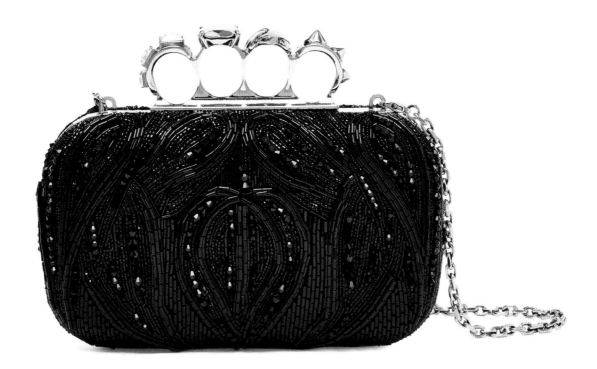

The minaudière version of the famous skull clasp. Its small detachable chain is available in many styles, ranging from the simplest, in transparent resin, to the most refined, encrusted with Swarovski stones.

AMI
PARISIAN FOR
"LOVE"

Founded: 2011

The story: This is the story of a designer who understood how to build a successful brand without skipping steps. Born in 1980, Alexandre Mattiussi studied at the École Duperré in Paris. He worked for various brands (Dior, Givenchy, Marc Jacobs) for ten years as a specialist in men's fashion before launching his label in 2011. His idea was to create an ideal wardrobe for men. In 2013, he received the ANDAM prize. Four years later, his line, with the famous little red heart called Ami de Cœur, made him part of the world of recognizable logos—and one highly desired. Women rushed to purchase his men's sweaters. In January 2018, Alexandre had the idea to unveil his "Menswear for Women" collection. The following year, for Spring/Summer 2019, he carried this concept through by creating his first women's collection. AMI released its first handbag in 2021, the Déjà-vu. Catherine Deneuve was its muse.

The style: French with a Parisian accent. It is chic yet relaxed, nonchalant yet friendly, masculine yet easily accommodating the feminine. It's a true brand without fuss and with a lot of heart.

Heard on the street: *"The three letters of AMI are found in the French word* aimer *(to love).... It must be a sign!"*

FASHION HOUSE FACT
At amiparis.com , if you click on the "AMI For Ever" link, you can sell or buy second-hand AMI clothes.

MORE TO KNOW
During fashion shows, throngs of people crowd into the front row, and even onto the stage.

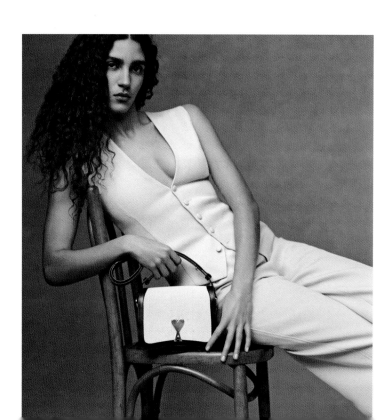

WHO WEARS AMI?
Isabelle Adjani, Carla Bruni, Naomi Campbell, Laetitia Casta, Cara Delevingne, Catherine Deneuve, and Emily Ratajkowski.

PARIS PARIS

2023

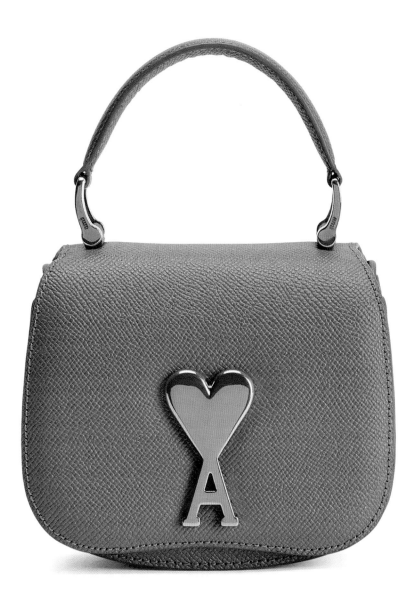

Although Alexandre Mattiussi has proven he can create more sophisticated bags—L'Accordéon and Déjà-vu—the one that makes waves and is already considered *the* iconic bag of the brand is the Paris Paris. Its Ami de Cœur clasp makes it the undisputed emblem of the fashion house with its masculine-feminine and ultra-Parisian style. Made of leather, or cotton canvas and leather, it is available in several sizes and different versions, with a shoulder strap or with a handle for carrying by hand. This bag has all the makings of a classic!

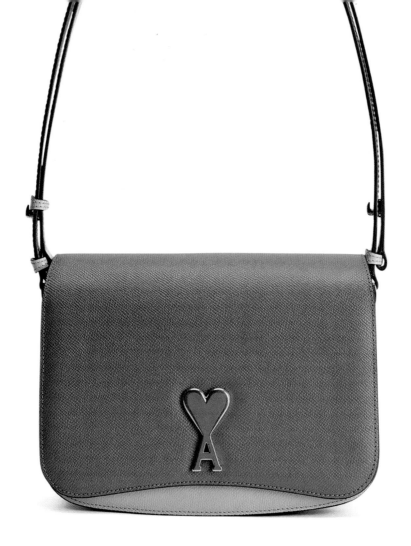

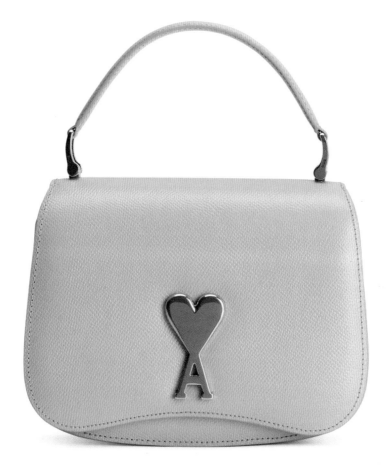

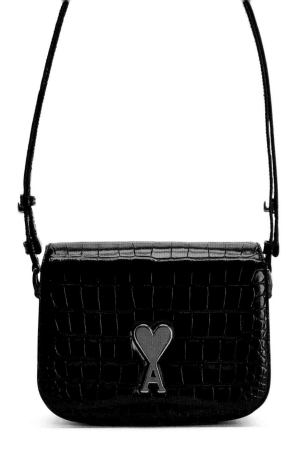
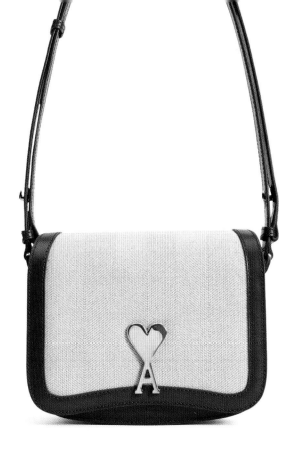
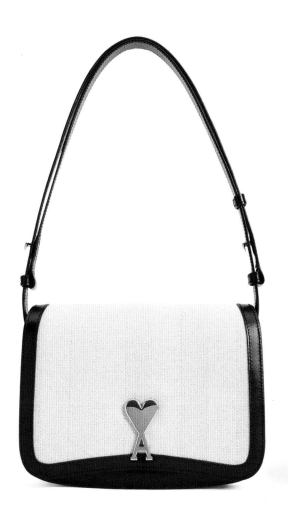
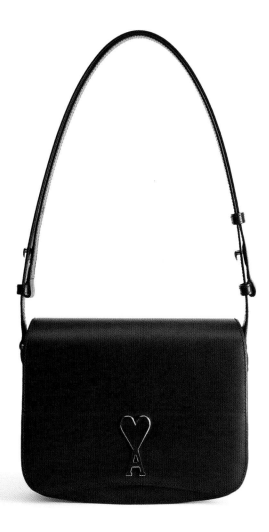

ANYA HINDMARCH
SUSTAINABLE CHIC

"We need to go back to our fundamentals and be very clear about what we stand for." **Anya Hindmarch**

Founded: 1987

The story: At age nineteen, Anya Hindmarch opened a small handbag shop in London. It was a success, and her handbags, accented with a small bow, spread worldwide. With her love of craftsmanship, attention to detail, and customization, she has made a name for herself with her beautiful creations and the importance she attaches to sustainable development. In 2021, Anya opened the Village on Pont Street in the Chelsea district of London. This new retail concept brought together all her passions (personalization of style and recycling) within six different boutiques on the same street. You can even enjoy Anya Hindmarch's cakes in the café, open from eight AM to six PM.

The style: Anya moves between handbags made of natural materials with a timeless look and pop, and colorful models intended to bring a smile. But even when she injects humor into her collections, she always seeks to draw attention to serious social issues, as in 2007 when she created the "I Am Not a Plastic Bag" tote collection. In 2020, she evolved the concept with "I Am a Plastic Bag," bags produced from recycled plastic bottles. Anya is always in step with the times.

Heard on the street: *"Since I've been walking around with my Coca-Cola can minaudière, I've been drinking a lot more water."*

FASHION HOUSE FACT
In 2021, Anya wrote a book: *If in Doubt, Wash Your Hair: A Manual for Life*, published by Bloomsbury. In it, she talks about her experience as an entrepreneur, mother, and stepmother.

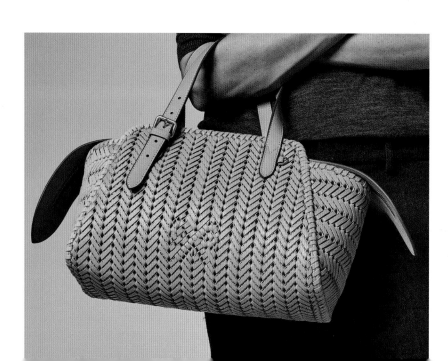

WHO WEARS ANYA HINDMARCH?
Adele, Jessica Alba, Princess Beatrice, Dakota Johnson, Angelina Jolie, Kate Middleton, Emma Roberts, and Emma Watson.

ANYA
BRANDS

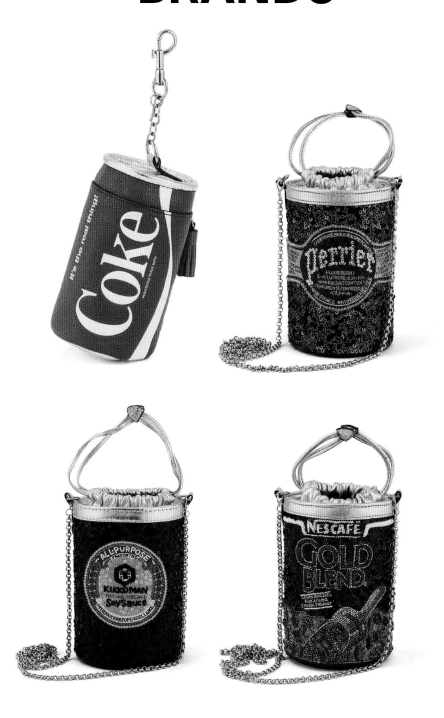

The bags that made Anya famous. By transforming a soda can, a bottle of soy sauce, or a cereal box into a small evening bag made of leather and sequins, the designer has changed what is ordinary into something extraordinary. Some of these bags are iconic objects that are part of the permanent collection of the Victoria and Albert Museum in London.

NEESON

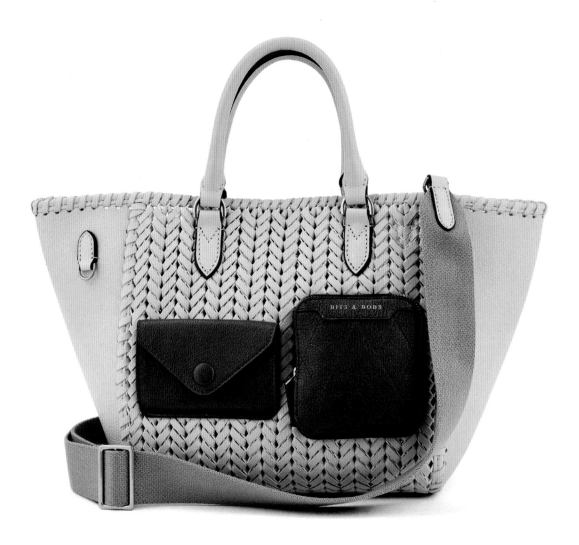

The new version of one of the label's most iconic bags. Made of handwoven leather, the Neeson is rather lightweight. It takes several days to make one. The fashion house's emblematic knot is woven into the outside center of the bag, which comes in many styles, including the one you see here with pockets. The woven leather is the collection's signature.

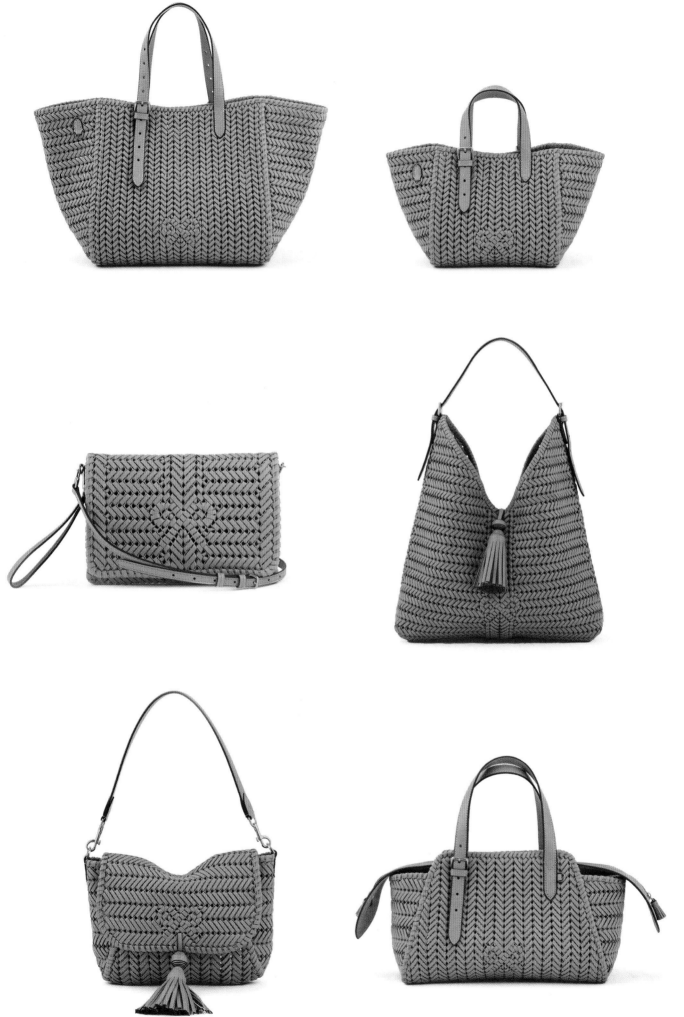

RETURN TO NATURE

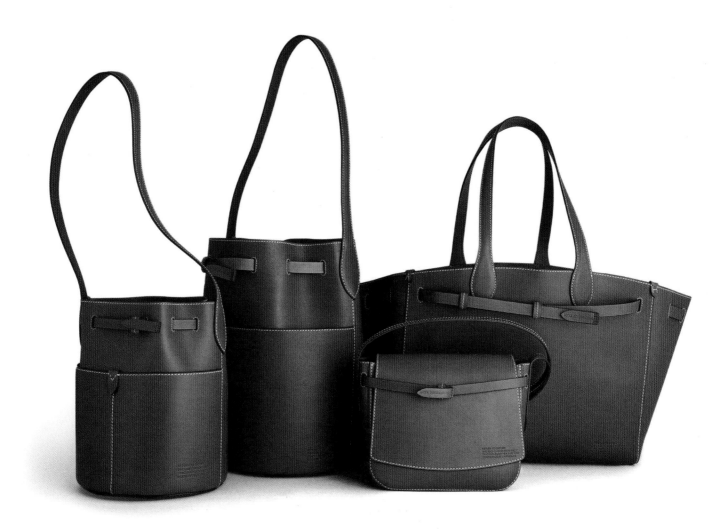

This is the ultimate sustainable handbag. The Return to Nature is designed to break down naturally when recycled. To create this line of biodegradable bags, the company had to find tanneries capable of offering full traceability of the hides as well as artisans with innovative tanning methods. During compost testing, the company discovered that the leather nourishes the soil and that plant growth was 20 percent stronger than that of the control compost. Thus, not only will this bag never reach the landfill, it will also return to nature at the end of its life. Anya collaborates with the charity Dirt, founded by Arizona Muse, which is very involved in sustainable development. For every Return to Nature bag sold, thirteen dollars (about twelve euros) is donated to the charity. The collection includes seven designs in six shades.

VERE

The ultimate everyday bag. Its satchel shape is ultrapractical, and its zipped flap adorned with tassels gives it personality. Inside, there are small pockets for credit cards and a phone, a sign of Anya's passion for organization. It is made of supple, smooth leather, or leather and raffia, and it comes in two sizes.

A.P.C.
EFFORTLESS MINIMALISM

"Minimalism requires maximum effort." **Jean Touitou**

Founded: 1987

The story: During the boom of the disco years, Jean Touitou created A.P.C. (meaning Atelier de Production et de Création in French, or the Production and Creation Workshop) in a style that was the total opposite of the flashy and shiny looks of the time. After working for Kenzo, agnès b., and Irié, Touitou became known for his raw Japanese-denim jeans, which became softer with each wear. Soon after its launch, A.P.C. offered a complete collection of clothing and accessories for women and men who love simplicity in a look.

The style: This is quintessential minimalist style, with clothes and accessories at their simplest, yet with sleekness pushed to the max and with, of course, always a cool vibe—and above all, a lot of chic.

Heard on the street: *"A.P.C. bags don't follow fashion, that's why they're always fashionable!"*

FASHION HOUSE FACT
A.P.C. encourages us to be green! With its recycling program, the brand offers its customers the opportunity to return their old A.P.C. clothes to the store for recycling in exchange for a store credit valid for six months, according to a set price list. The collected clothes are donated to charity. The program is permanent and available in all A.P.C. stores.

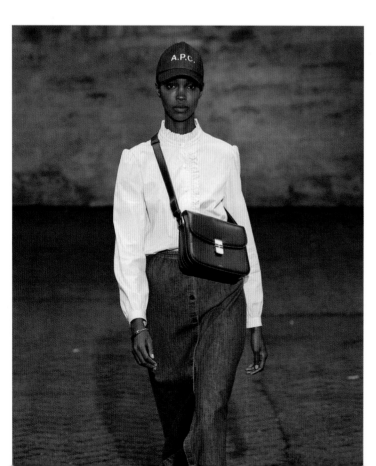

WHO WEARS A.P.C.?
Alexa Chung, Katie Holmes, Dakota Johnson, Diane Kruger, Jennifer Lawrence, Rita Ora, and Suki Waterhouse.

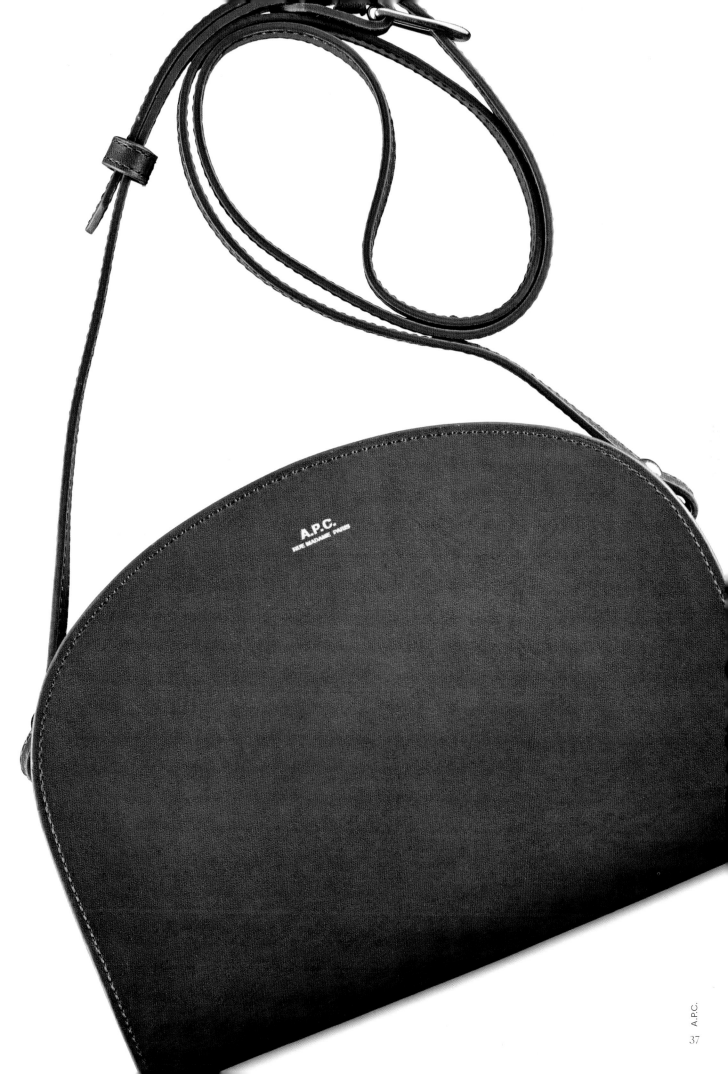

DEMI-LUNE

2013

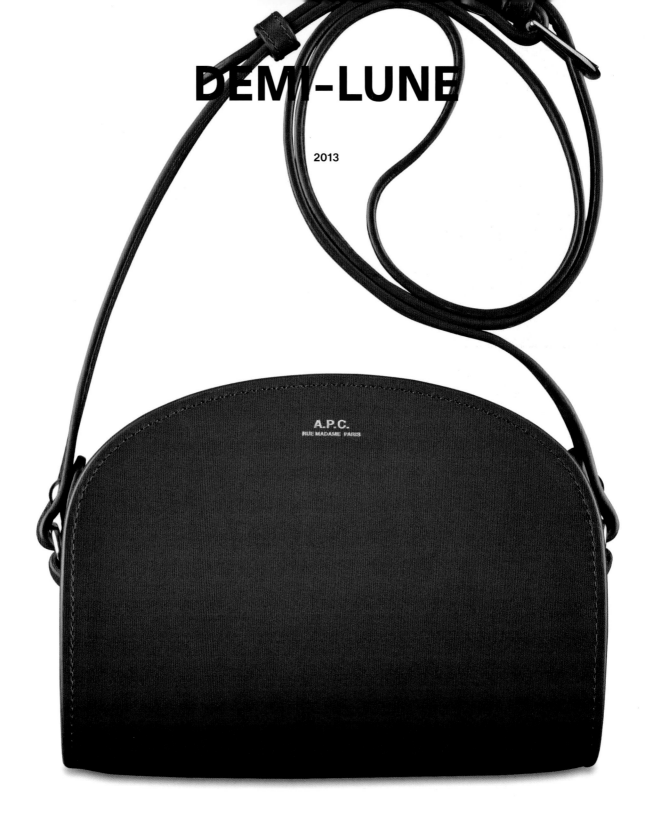

The brand's bestselling bag since its launch in 2013. As its name suggests, this bag is shaped like a half-moon. Originally, it was offered only in smooth vegetable-tanned leather, which developed a patina over time. Today, it is also available in canvas and leather, grained leather, or embossed crocodile leather. Fashioned with a two-way zipper on the top, it can be worn as a crossbody and is also available as a mini, clutch, or with a drawstring pouch. The golden A.P.C. Rue Madame Paris logo, embossed on the front, brings a discreet and timeless signature to the bag.

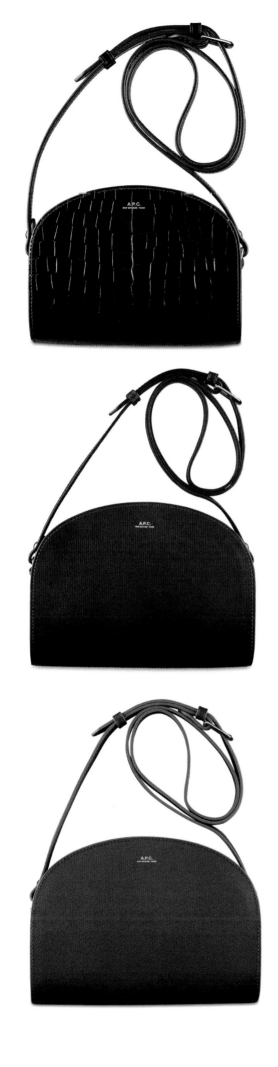
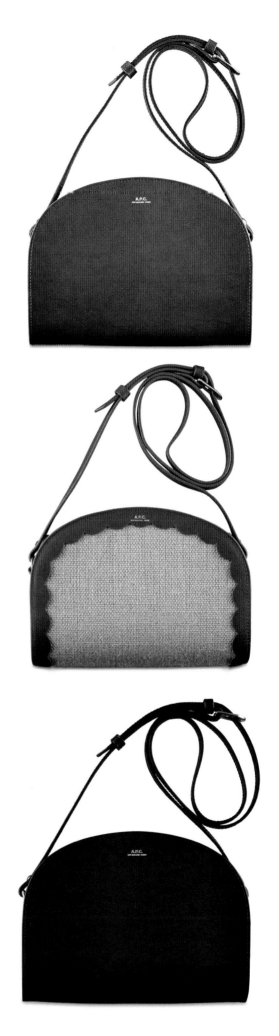

GRACE

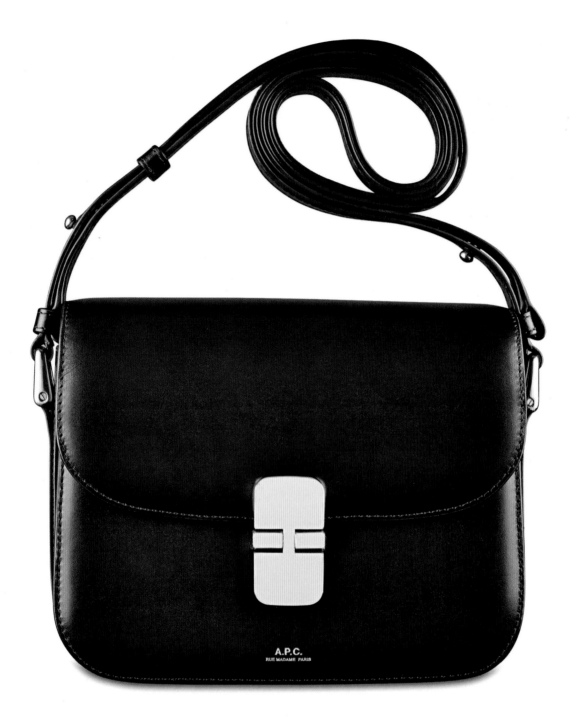

So timeless! With its slightly trapezoid, almost square shape and its flap with a very simple gold clasp, this rigid bag in smooth leather is a true classic. It has a large compartment and two smaller ones attached to the large one. It has a cotton-blend lining. Like all the other bags of the brand, the golden logo A.P.C. Rue Madame Paris is embossed on the front. Whether you choose it in small, mini, baguette (rectangle), or clutch format, it's impossible to make a fashion faux pas carrying this sleek bag!

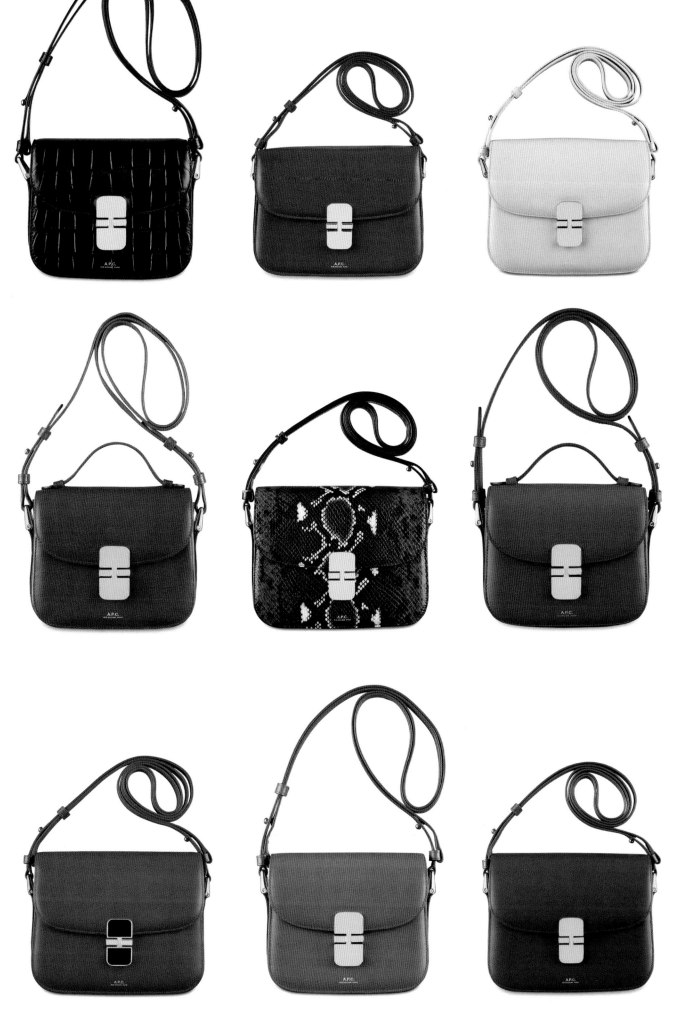

VIRGINIE
SMALL

A small trapezoidal bag in smooth leather, which can be carried by hand or across the body. Some styles have a small inner pocket attached to the bottom, while others have a small pouch attached with a thin leather strap. The height of simplicity, the gold embossed A.P.C. logo is found inside the bag on the small inner pocket. These handbags are the pinnacle of low profile.

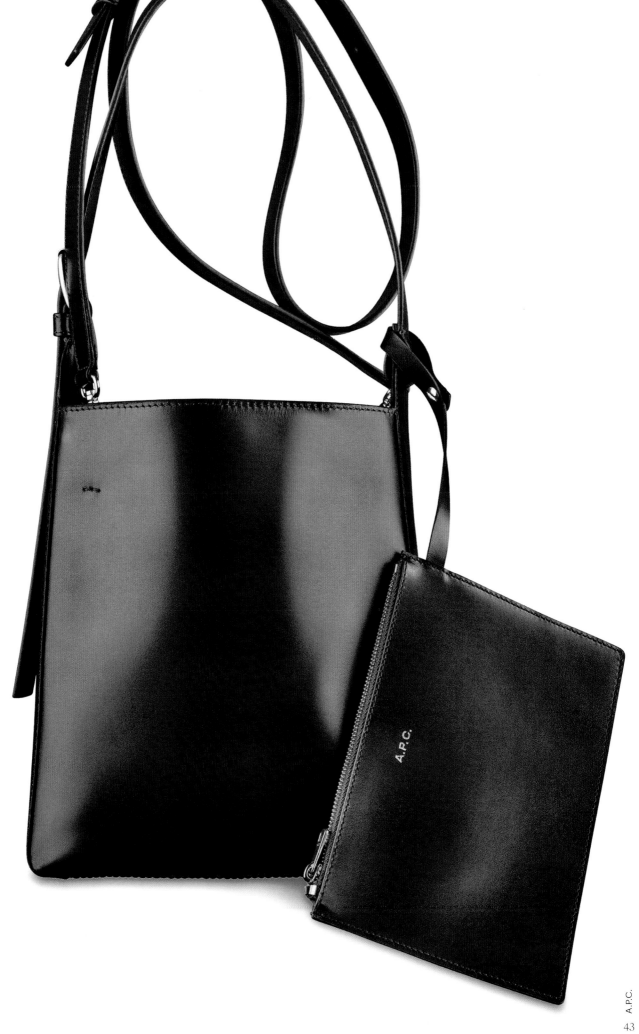

BALENCIAGA
FUTURISTIC INNOVATION

"Elegance is elimination."

Cristóbal Balenciaga

Founded: 1917

The story: Cristóbal Balenciaga, from Spain, set up his fashion house in San Sebastián in 1917. Chic women and Spain's royal family were his clients. Fleeing the Spanish Civil War, the couturier sought refuge in Paris and presented his first haute couture collection in 1937. A true fashion architect, he invented legendary shapes, such as the tonneau line, the sack dress, and the cowl back. In 1968, Cristóbal closed all his fashion houses; he passed away four years later. The brand remained dormant until 1991, when Josephus Thimister, the new artistic director, launched the ready-to-wear line "Le Dix." Nicolas Ghesquière was appointed to succeed Thimister in 1997. Ghesquière propelled the brand forward for fifteen years, making it futuristic and modern with a timeless chic. In 2012, Alexander Wang took over and worked on the brand's fundamentals. Demna Gvasalia replaced him in 2015. A native of Georgia, Demna studied at Maison Margiela and Louis Vuitton before launching the Vetements complex, focusing on the Spanish master's most daring creations. He invented sculptural silhouettes with new volumes. In 2021, Demna relaunched couture in the historic salons of 10 avenue George V in Paris.

The style: Structure, volume, and innovation are the three words that best characterize Balenciaga's creations.

Heard on the street: *"In fashion today, you have to take risks to survive, says Demna!"*

WHO WEARS BALENCIAGA?
In Cristóbal's time, all the big stars, including Ingrid Bergman, Marlene Dietrich, and Ava Gardner. Today, the label is worn by Hailey Bieber, Amal Clooney, Miley Cyrus, Céline Dion, Julia Fox, Bella Hadid, Anne Hathaway, Kim Kardashian (who has been the face of the brand), Dua Lipa, and Rihanna.

FASHION HOUSE FACT
In 2011, the Balenciaga Museum was opened in Getaria, sixteen miles (twenty-five kilometers) from San Sebastián.

CLASSIC

2000

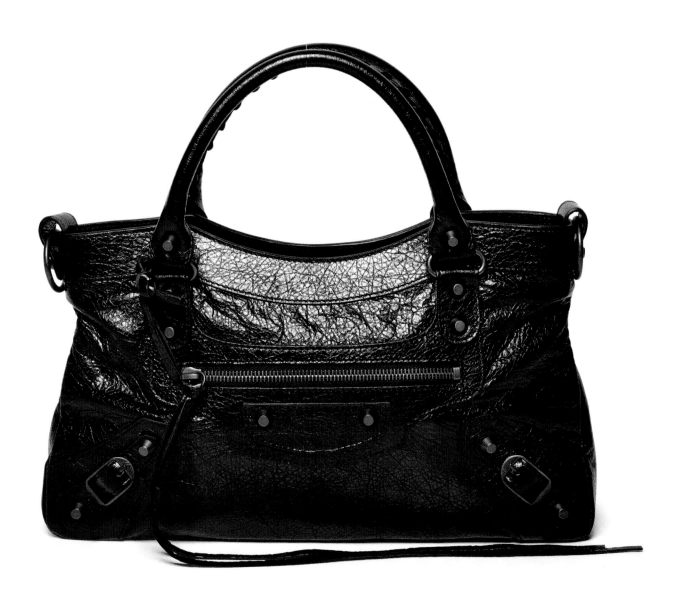

Created by Nicolas Ghesquière, this handbag has gone through several name changes throughout its lifetime before finally settling on Classic. Its original name was Le Dix Motorcycle Lariat. The handbag almost never made it to the shops because it didn't fit the beauty standards of the It bags of the time. Although the house didn't intend to produce it, the prototype was put on display. Consequently, fashion models snapped it up, and once Kate Moss wore it, that's all it took for it to gain popularity. Its vintage feel was appealing, as well as its suppleness at a time when bag designs were generally rigid. As the seasons passed, new versions appeared under as many different names, but the cool vibe remained. Although it is no longer produced, the Classic has been revisited by Demna Gvasalia, who has given it a facelift—the Neo Cagole City—which could be considered a worthy successor.

HOURGLASS

2019

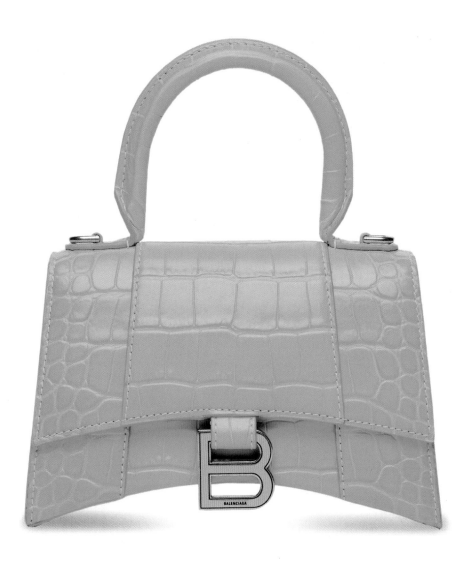

Refined and original, it's the bag we expect from a brand created by a couturier such as Cristóbal Balenciaga. Its shape, designed by Demna, is unmistakable: A curvilinear base distinguishes it from the usual styles. It has a handle and a detachable shoulder strap. On its magnetic clasp, the *B* logo is prominently displayed. Many materials are available, from a mirror effect in calfskin to a 3D effect in satin bows, as well as metallic embossed crocodile calfskin, crushed-effect lambskin, or embroidered lambskin.

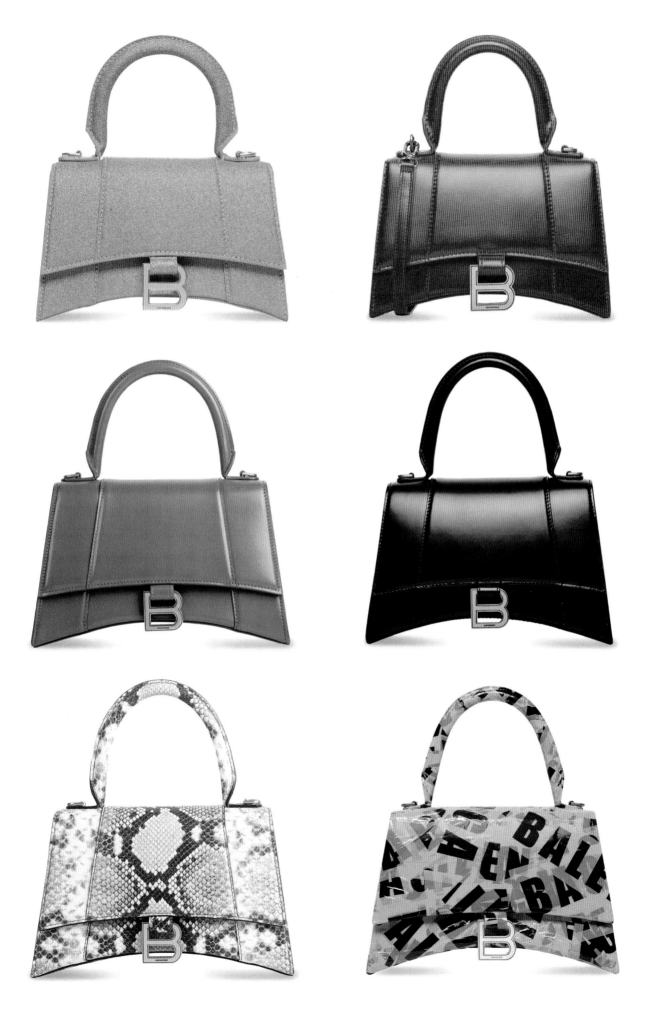

LE CAGOLE

2021

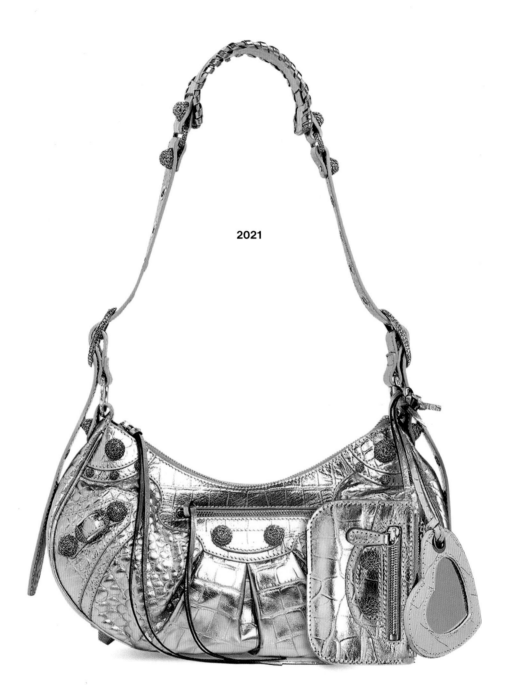

Inspired by the Classic, Le Cagole has a crescent shape. Its somewhat provocative name comes from a Marseille slang term that describes a flirtatious girl. Fashion addicts scrambled for the handbag, which comes in all leathers, colors, and sizes (including the Neo Cagole City, which looks like the Classic). Made of supple leather, it has two matching accessories hanging from its shoulder strap: a mini coin purse and a small heart-shaped mirror.

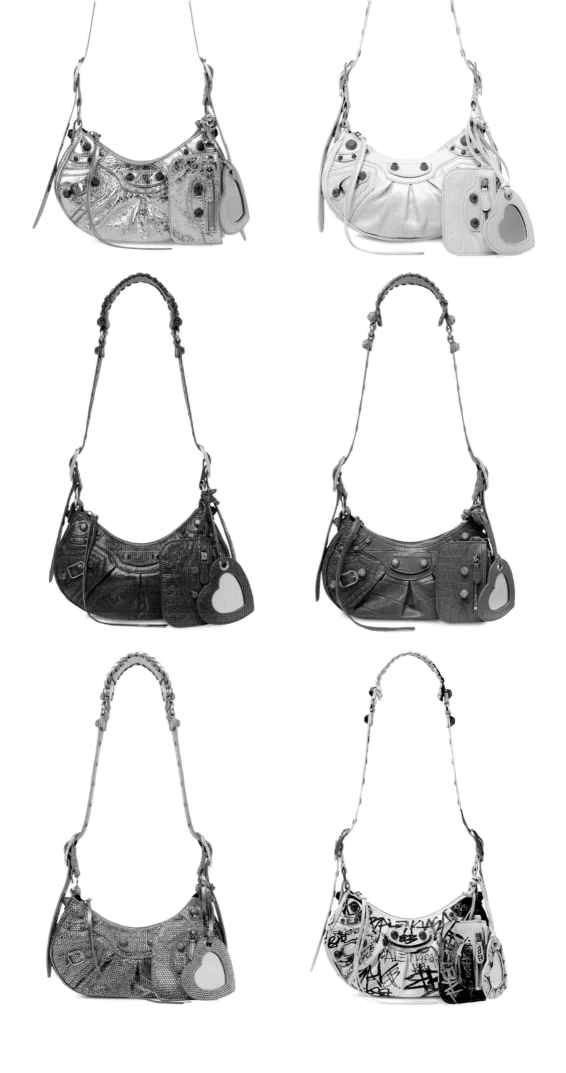

CRUSH

2022

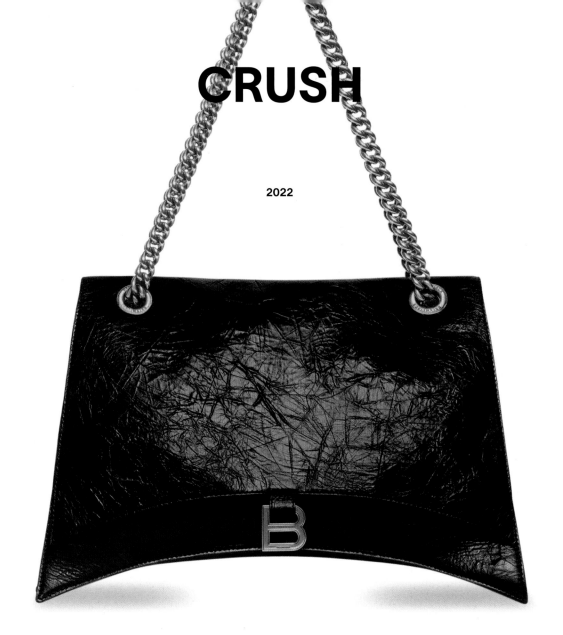

Inspired by the Hourglass line, the Crush does not have a handle but instead sports a strap for over-the-shoulder wear. Some models have a chain instead of a leather strap. Like the Hourglass, it comes in several sizes and materials. It gives the impression of being a much more supple version of that bag, especially in the quilted satin trompe l'oeil calfskin version.

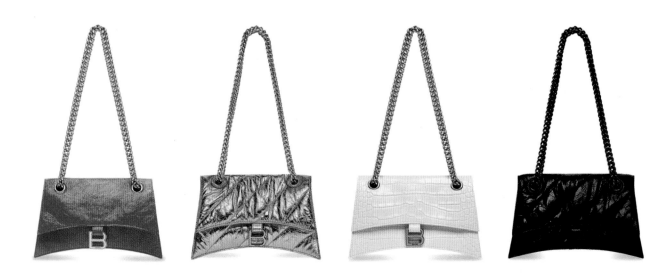

BISTRO

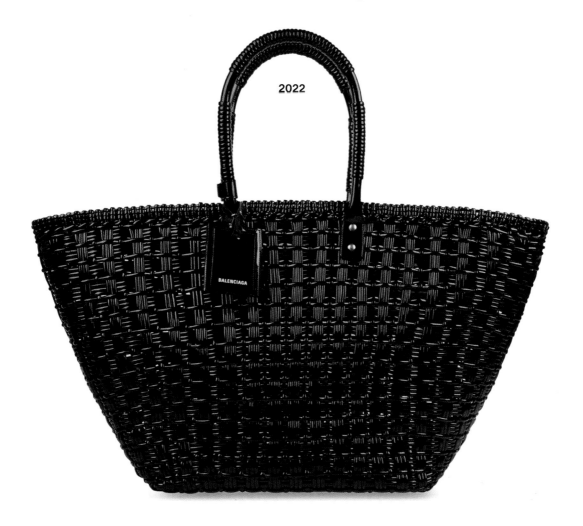

2022

This basket bag with a detachable shoulder strap is the perfect travel companion and even has a luggage tag hanging from the handle. But as the name suggests, you can simply take it out for a night on the town when hanging out in an intimate bistro. It is available in many materials, including faux calfskin, terry cloth, faded and frayed denim, or mirror-effect fabric. It is available in several sizes, from the maxi to the micro.

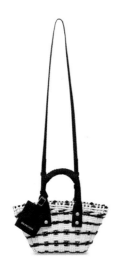
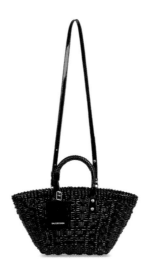
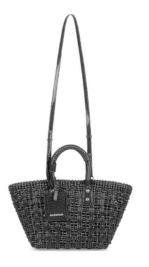

BALMAIN
DARING CHIC

"The synonym for luxury is timelessness."

Olivier Rousteing, creative director of Balmain

The couturier Pierre Balmain helped make Paris the fashion capital of the world in the 1950s. His fresh and feminine haute couture collections immediately made a name for themselves in the postwar period. Olivier Rousteing has led the brand's artistic direction for more than ten years. He succeeded in reinventing the famous "new French style" that was attributed to Pierre Balmain when he created his brand in 1945. The young designer keeps up the couture vibe of the fashion house by infusing it with a new femininity—more modern, sexier, still very Parisian, but with a true notion of inclusivity and democratization. He knows how to draw on the heritage of the brand while remaining honest with his vision of today's fashion. To get his message across, he created the Balmain Army, which brings together bold and inspiring women from diverse backgrounds. This is a rather more assertive evolution of Pierre Balmain's Jolie Madame. Optimism, boldness, and audaciousness are the values at the origin of the brand, which Olivier Rousteing has magnified.

7 KEY DATES

1945
After an apprenticeship with Edward Molyneux and Lucien Lelong, Pierre Balmain founds the house that bears his name at 44 rue François 1er in Paris. In this postwar period of simplicity, he infuses a great deal of femininity into his creations. Embroidery, cinched waistlines, and corolla skirts make up what is Jolie Madame, the Parisian woman look he created.

1950
In the 1950s, the biggest stars dress in Balmain, from Marlene Dietrich to Katharine Hepburn to Brigitte Bardot to Sophia Loren.

1982
After the couturier's death, Erik Mortensen, Pierre Balmain's right-hand man, oversees the collections.

1992
Oscar de la Renta is appointed creative director and maintains the brand's elegance.

2007
Christophe Decarnin takes over from Oscar de la Renta and adds a touch of rock.

2011
At just twenty-five years old, Olivier Rousteing takes over as creative director. Blending the feminine heritage of the house with its ultramodern and inclusive vision of fashion, it attracts young women looking for a style that makes sense.

2021
Olivier celebrates his tenth year as the head of the brand with a fashion show music festival.

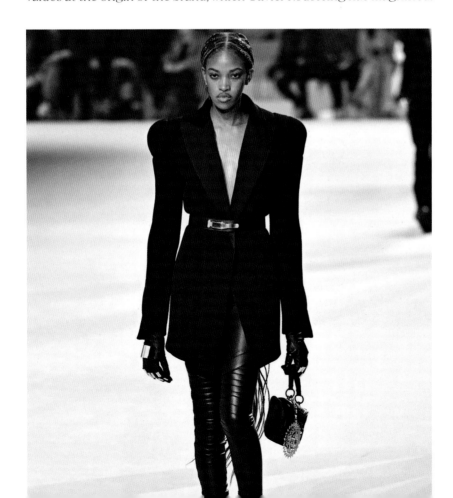

THE 5 HOUSE CODES OF BALMAIN

01.
Gold accents

02.
The revisited sailor shirt

03.
Black-and-white

04.
The labyrinth pattern

05.
The architectural silhouette

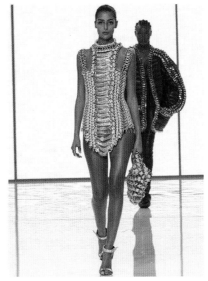

01

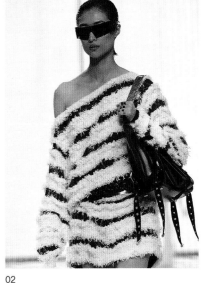

02

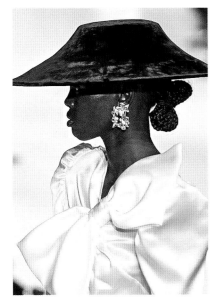

03

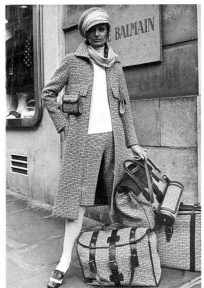

04

FASHION HOUSE FACT
Olivier Rousteing learned the craft of design at the École Supérieure des Arts et Techniques de la Mode (ESMOD) in Paris. At the age of eighteen, he left for Italy for an internship with Roberto Cavalli. He stayed in Italy for five years and became a designer for men's and women's ready-to-wear before joining Balmain.

05

MORE TO KNOW
Balmain has always been closely linked to musical talents such as Rihanna, Jennifer Lopez, Björk, and Beyoncé, whom Olivier also dresses for her tours. *"Beyoncé is a true icon, an inspiration, and, above all, a very good friend. She taught me so many things,"* the designer said.

B-BUZZ

2019

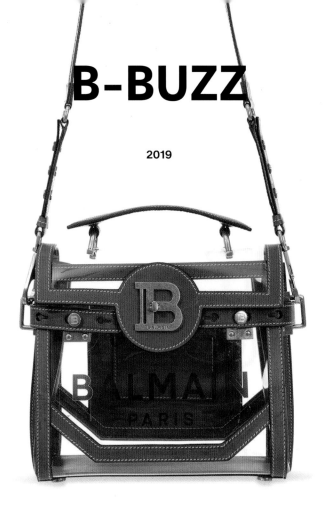

This bag's shape immediately recalls the Balmain brand. Present are the *B* clasp and a very couture shape with details that showcase the house's craftsmanship. The B-Buzz features some of Olivier Rousteing's signatures, such as the wide edges, quilted leathers, gold-plated metal pieces, animal-inspired materials, crystal inlays, and black-and-white graphic patterns; the bag plays chameleon according to the collections. As soon as it was launched, the B-Buzz created a real buzz.

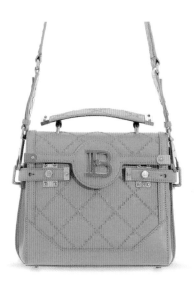

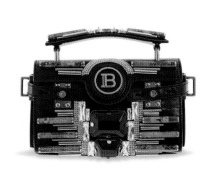

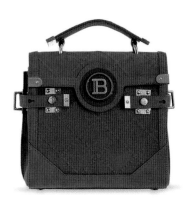

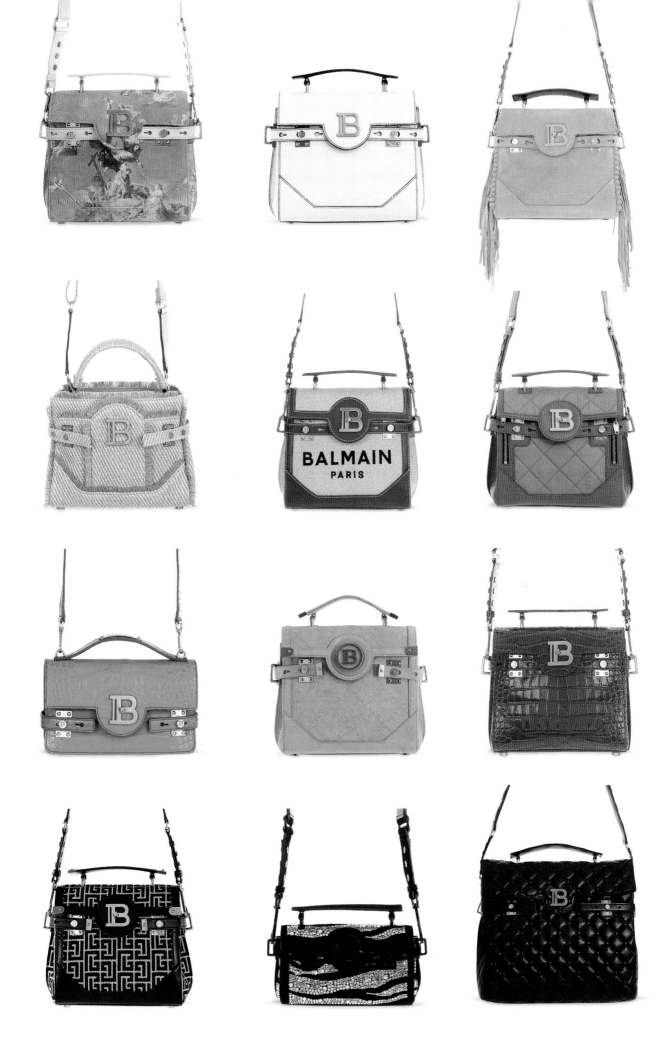

1945 HERITAGE

2020

This line was inspired by Pierre Balmain's creations from the 1970s. The repeating, labyrinth-like pattern (these patterns fascinated Pierre Balmain, who was passionate about French Renaissance gardens designed in these patterns) features a *B* in reference to the founder's name and an interlocking *P* that evokes both the names Pierre and Paris, the city closely linked to the house's history.

In addition to this line, soft ivory-and-black leather bags illustrate Olivier and Pierre's love of contrasts and graphic lines. Medallions, buttons, and chains, all gilded and galvanized for an aged look, embellish the bags.

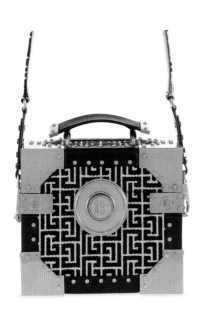

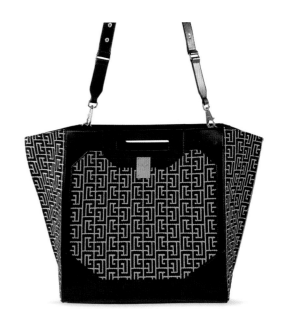

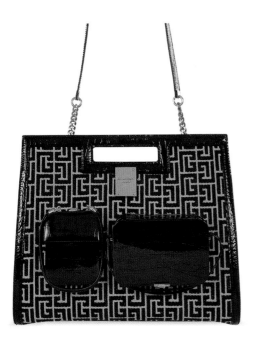

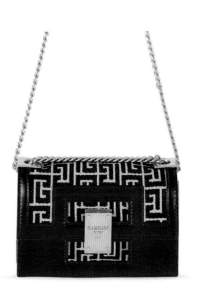

ELY

2021

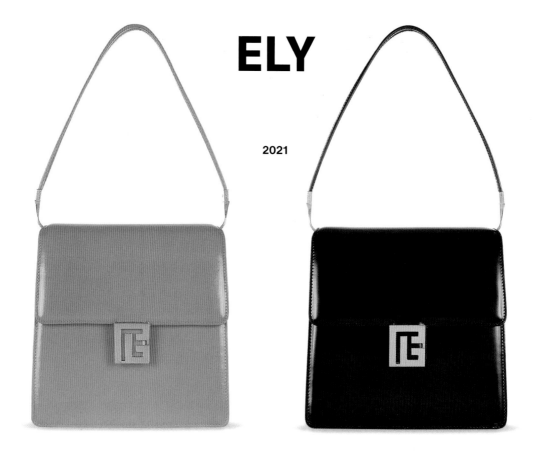

Pierre Balmain traveled extensively (to America, England, and Australia) to give lectures on French culture and artisanal know-how. Travel inspired the Fall/ Winter 2021–2022 collection and the Ely bag, a diminutive for Élysées 64-83 (the Balmain house's original phone number). This shoulder bag is reminiscent of a bag created by Pierre Balmain in the 1970s.

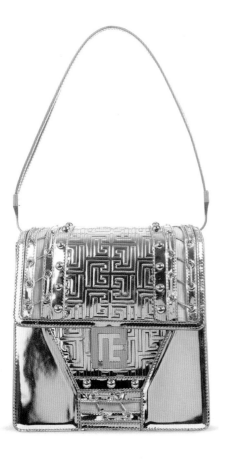

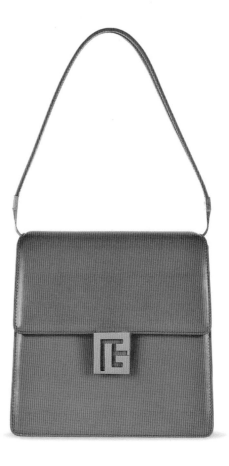

CHOCOLAT

2019

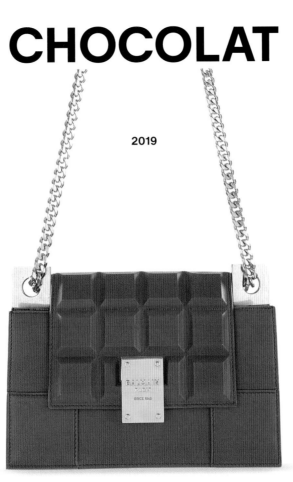

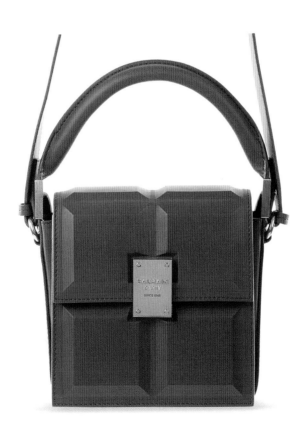

Because of Olivier's daring, he launched this bag that recalls a chocolate bar.
Unfortunately for chocolate lovers, it is no longer available.

PILLOW

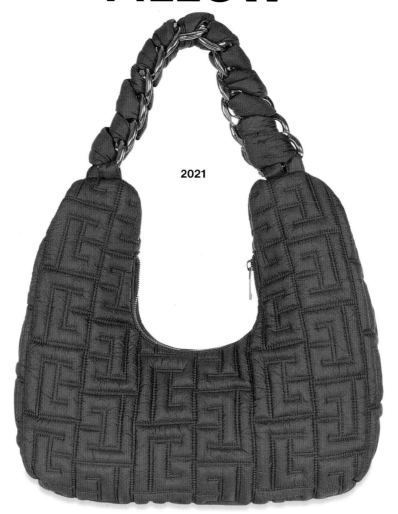

2021

Inspired by travel pillows, the Pillow, carried on the shoulder, has a chain handle that intertwines with the bag's leather or fabric material.

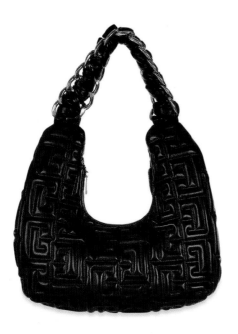

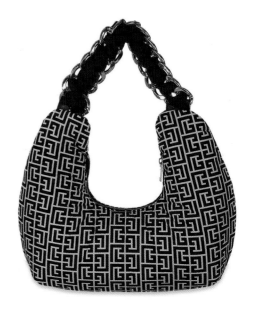

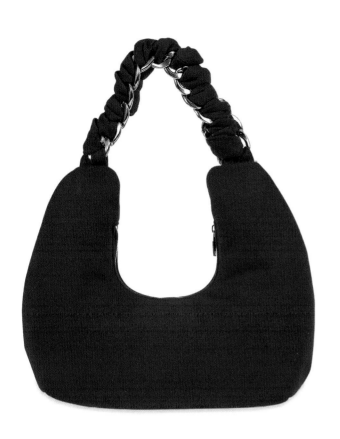

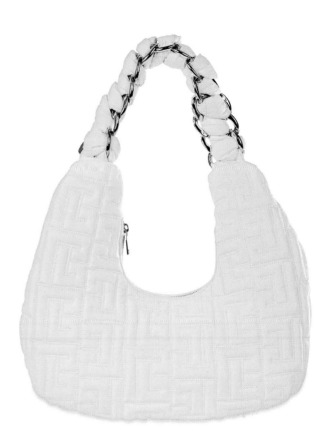

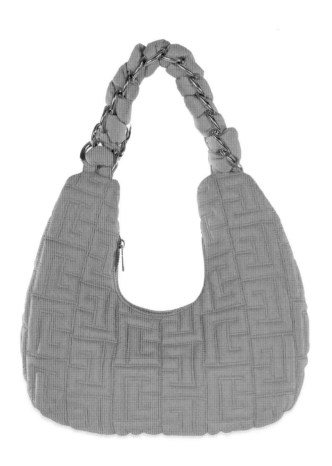

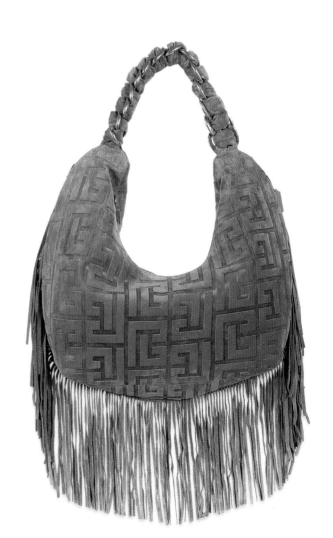

BLAZE

2022

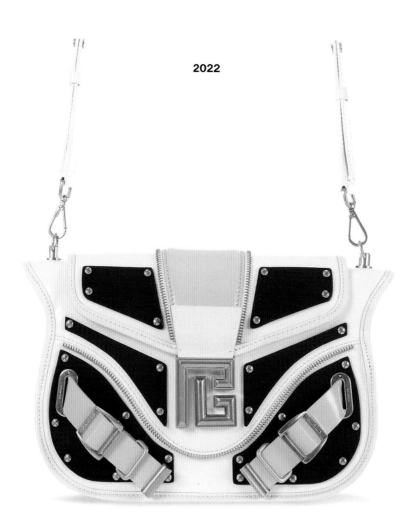

With a shape that does not go unnoticed, this bag integrates the complete Balmain vibe with its impressive metalwork and a baroque and modern look. The name Blaze could refer to the house's blazers, with their well-defined shoulders and cinched waists. *"Above all, I wanted the Blaze to be a bag that would stand out,"* says Olivier. *"I told my design team that I envisioned these bags as making the boldest impression possible. To me, these designs evoke the bulletproof shields worn by the fearless superheroes of my youth, and I really like the idea that our Balmain Blaze bag brings a sense of invincibility and is the perfect finishing touch to each ensemble."* The bag changes shape a bit depending on the sizes. In terms of material, there is a glamorous element to them. The hand-carried versions have a detachable shoulder strap.

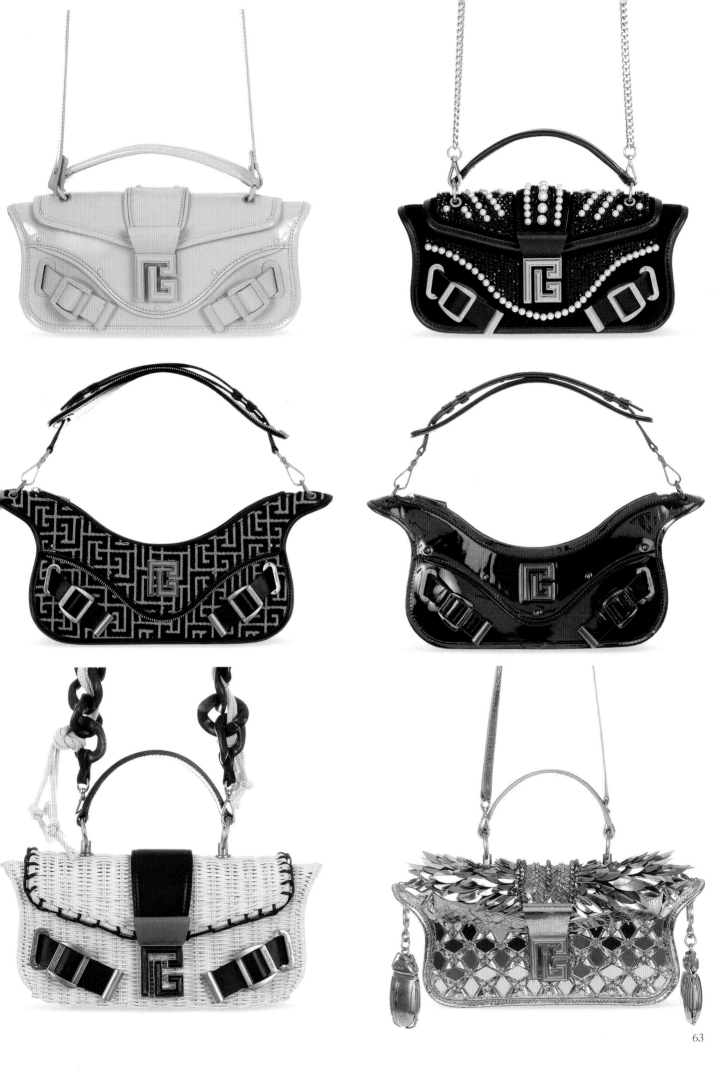

B-BUZZ DYNASTY

2023

A newcomer to the B-Buzz line, the B-Buzz Dynasty was inspired by Pierre Balmain's fascination with the art of travel and his passion for travel trunks and suitcases. Olivier Rousteing translated the highly structured lines of a travel vanity case into this bag. With finishing studs around the edges, a lambskin lining, an identification plate, a vanity mirror, and a unique *B* clasp, it has the standards of a luxury handbag. *"The collection of trunks and suitcases in the Balmain archives evoked the idea of a strong-willed woman and her global travels: Women who move forward with determination, with an aura of glamour and sensuality,"* says the designer. From the house monogram to the crocodile print, and from different leathers to constellations of crystals, this bag is a playground of creativity. It can be worn in several ways with its detachable shoulder strap.

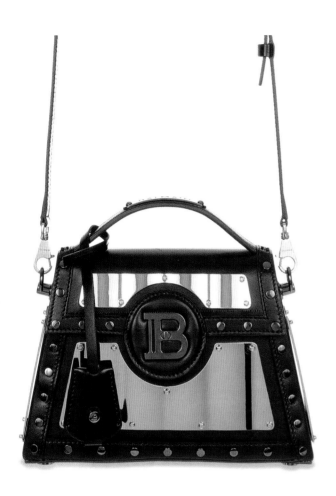

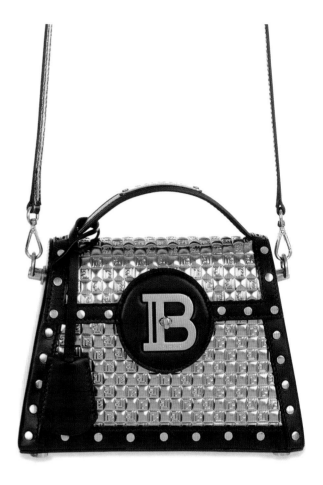

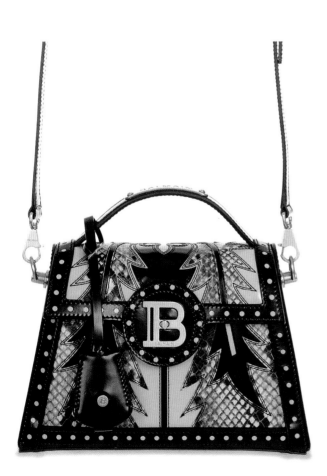

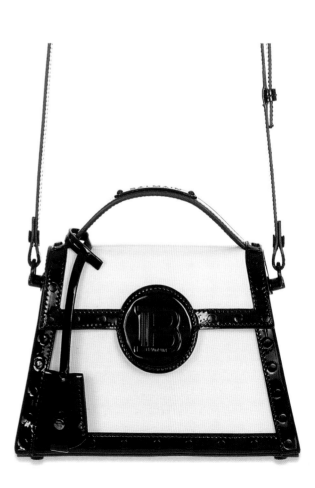

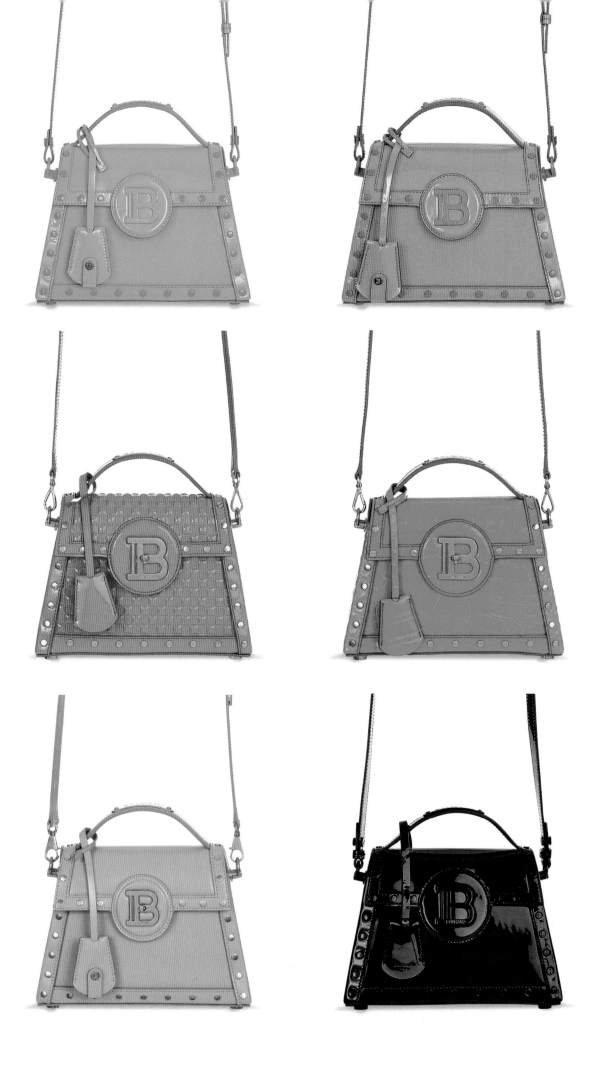

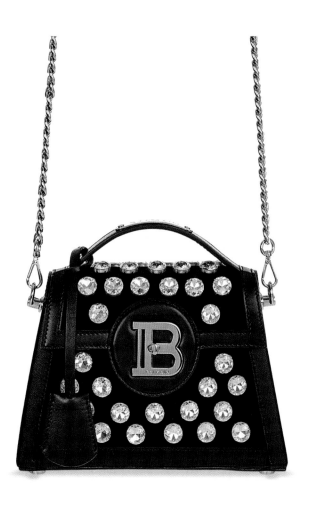

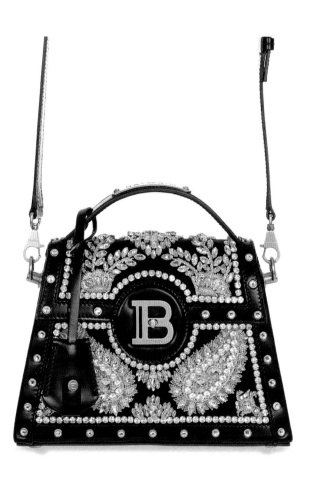

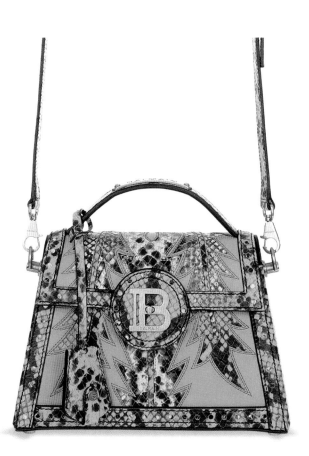

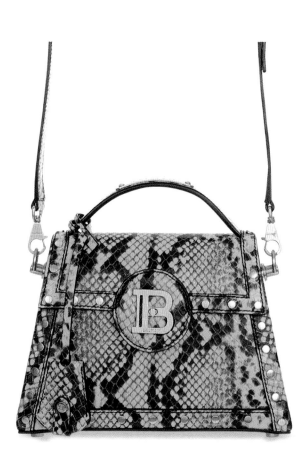

MINAUDIÈRES
AND OTHER WHIMSICAL CASES

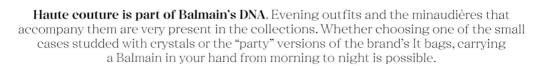

Haute couture is part of Balmain's DNA. Evening outfits and the minaudières that accompany them are very present in the collections. Whether choosing one of the small cases studded with crystals or the "party" versions of the brand's It bags, carrying a Balmain in your hand from morning to night is possible.

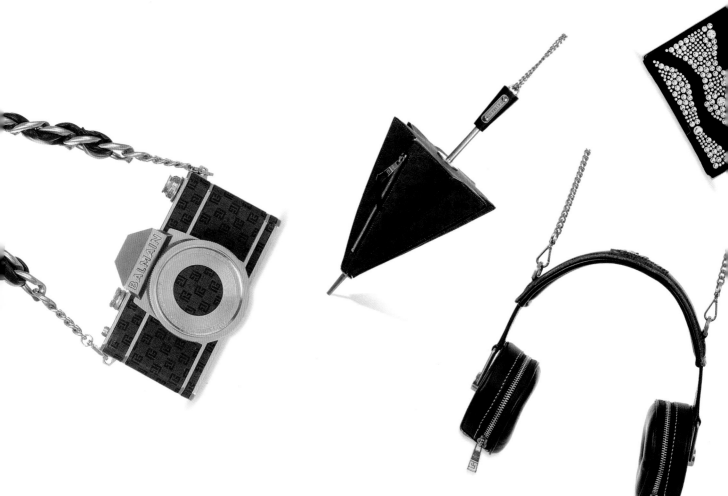

The house regularly showcases its boldness, and Olivier Rousteing has dared to create mini-branded minaudières in rather amusing shapes: a camera, a coffee mug, a micro-umbrella, a picnic basket, headphones, a radio, and a guitar. These well-designed bags, in the shape of ordinary objects, prove that Balmain has maintained a freshness to its look and knows how to please its customers: *"I am determined that my collections always reflect the way the current generation wants to live and dress,"* says Olivier Rousteing.

BOTTEGA VENETA

CABAT

"True luxury takes time. Crafting a Bottega Veneta bag is measured in days not hours." This is the message of the brand, of which the Cabat is one of the most emblematic bags. This soft tote bag, created in 2001 by Tomas Maier, then artistic director of the house, is in the *intrecciato* style (the term used by Bottega to refer to weaving). It made its debut in the Spring/Summer 2002 collection and has continued to be a star every season for more than twenty years. Handwoven from double-sided leather strips, it has no stitching. It's the kind of bag where the inside looks as good as the outside. It's a true gem of craftsmanship.

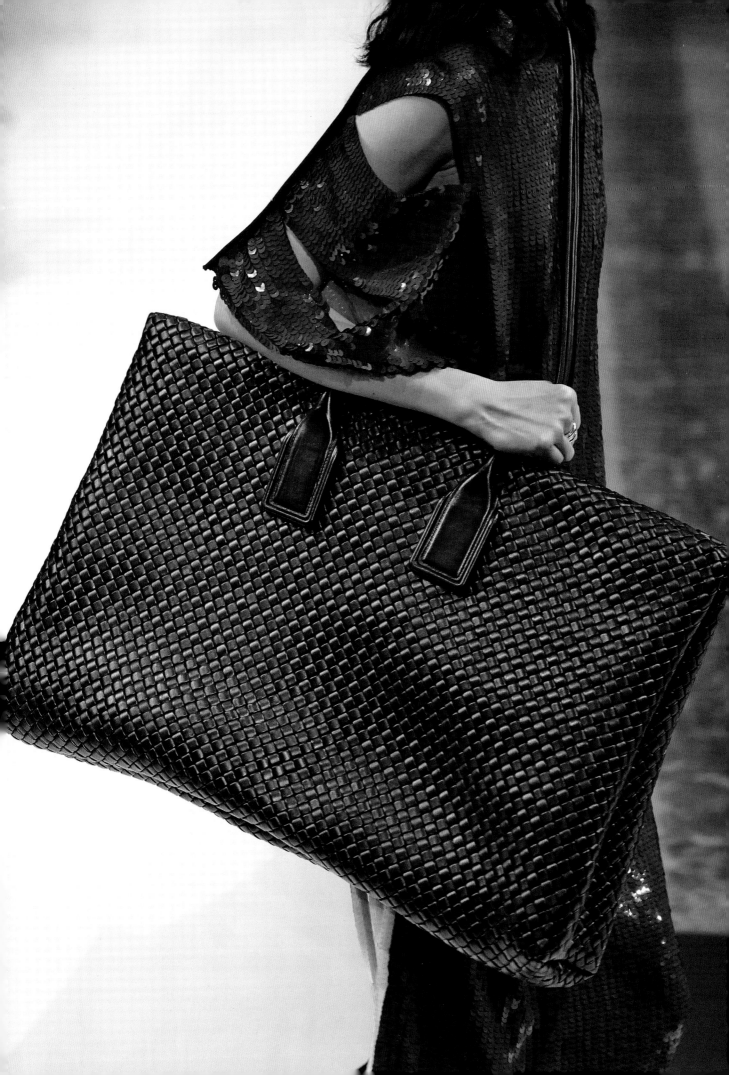

BULGARI
PRECIOUS GEMS

"La dolce vita is Roman. And Rome is Bulgari." **Anita Ekberg**

Founded: 1884

The story: Sotirio Bulgari, a Greek silversmith, moved to Rome to set up his jewelry house. He made a name for himself with his original combinations of colors and refined volumes. In the 1920s, his first pieces of high jewelry blended diamonds and platinum with geometric Art Deco motifs. In the 1940s, Bulgari began to infuse its creations with a certain Italian flair using shiny yellow gold. The shop in Via Condotti experienced *la dolce vita* in the 1950s and 1960s, with all the movie stars of the time stopping by. In the 1970s, the Bulgari brothers, the third generation of the family, innovated by looking beyond Italy to Asia and pop art. With its jewelry, high jewelry, watches, and accessories (the bags were launched in 2011), the house is now a symbol of a complete lifestyle. It also creates perfumes and has opened hotels all over the world.

The style: The sensuality of the volumes, the rigor of the lines, the brilliance of the colored stones: Bulgari's style is above all one that is quite precious.

Heard on the street: *"With this bag, I don't need to wear jewelry."*

FASHION HOUSE FACT
The serpent's head on each bag's clasp also appears on a braided leather bracelet.

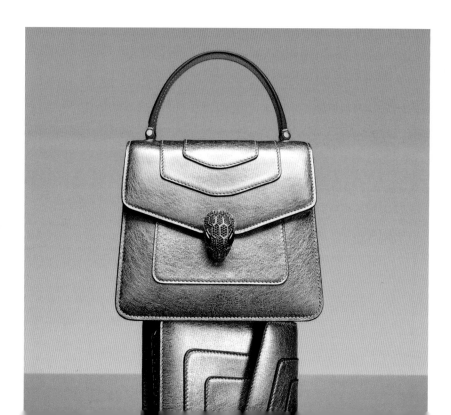

WHO WEARS BULGARI?
When it comes to jewelry, Bulgari has adorned all the stars of Hollywood's Golden Age, from Elizabeth Taylor to Audrey Hepburn to Ingrid Bergman. Today, Lady Gaga, Dua Lipa, and Charlize Theron wear Bulgari jewelry. As for the bags, the most fashionable women, including Hailey Bieber, Olivia Palermo, and Taylor Swift, can be seen carrying them.

SERPENTI FOREVER

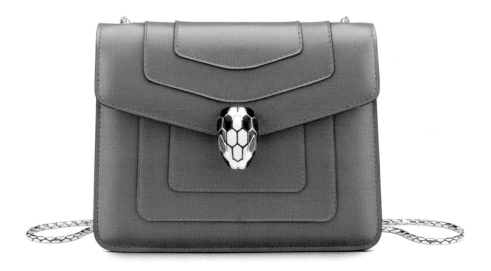

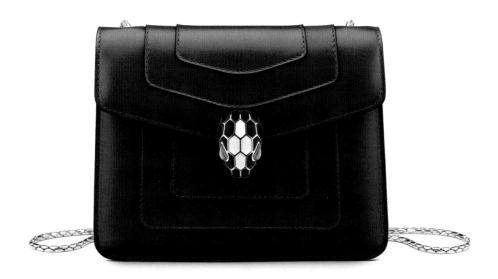

The serpent is the emblem of Bulgari. It could even serve as the brand's logo. It first appeared on a watch. The serpent-head clasp that adorns the bags today is made of gilded brass accented with black and white enamel scales. The eyes are made of malachite. Depending on the model, other stones, such as rose quartz and onyx, can be found on the serpent's head.

The bag is made of leather, of which some versions are very precious and represented in jewel-like tones. With its chain strap, the Serpenti Forever immediately lends a touch of luxury and timelessness.

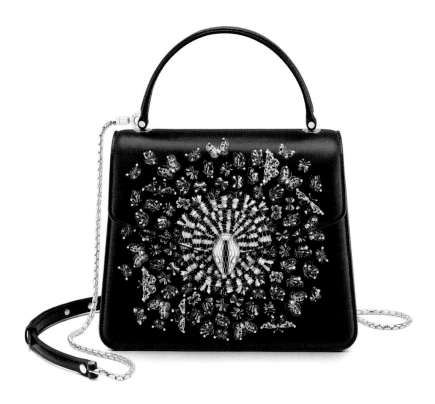

Bulgari sometimes teams up with artists to transform the bag. Fashion designer Mary Katrantzou designed her version of the black bag with embroidery depicting a coiled snake that transforms into a mix of butterflies. This is luxury leather goods at their finest.

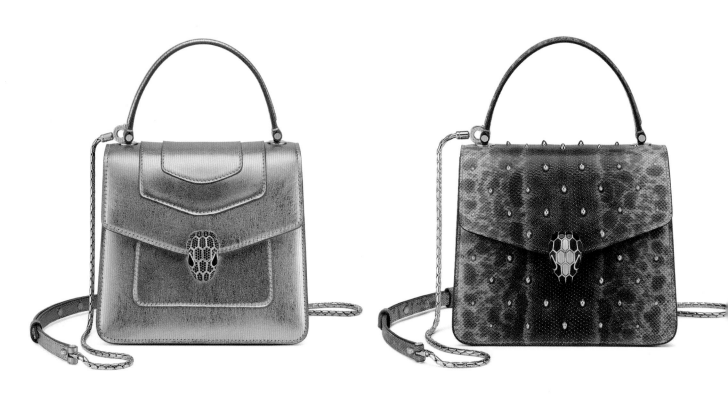

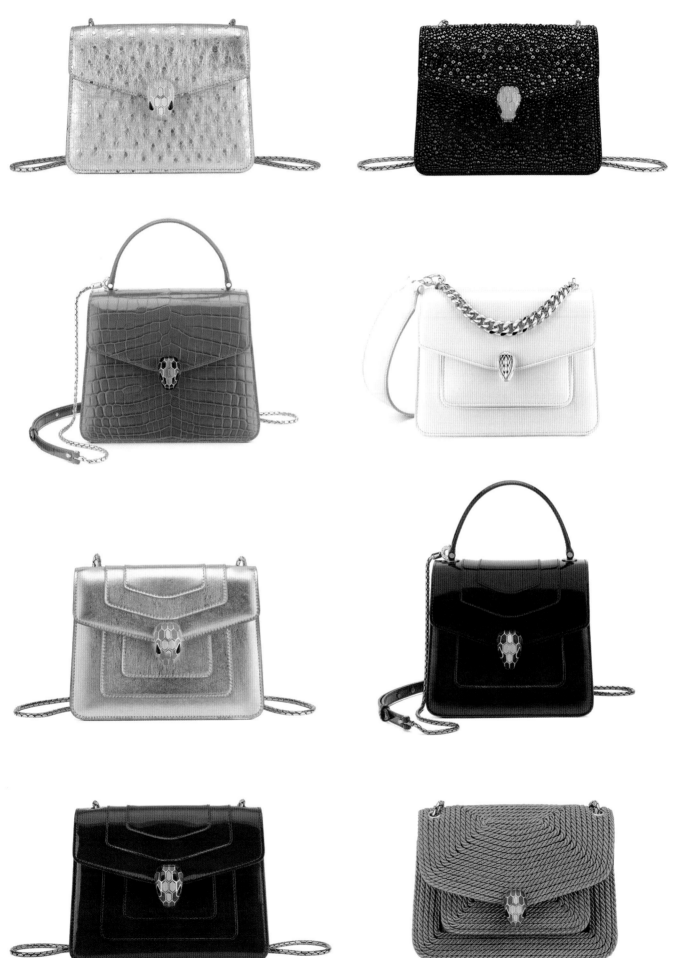

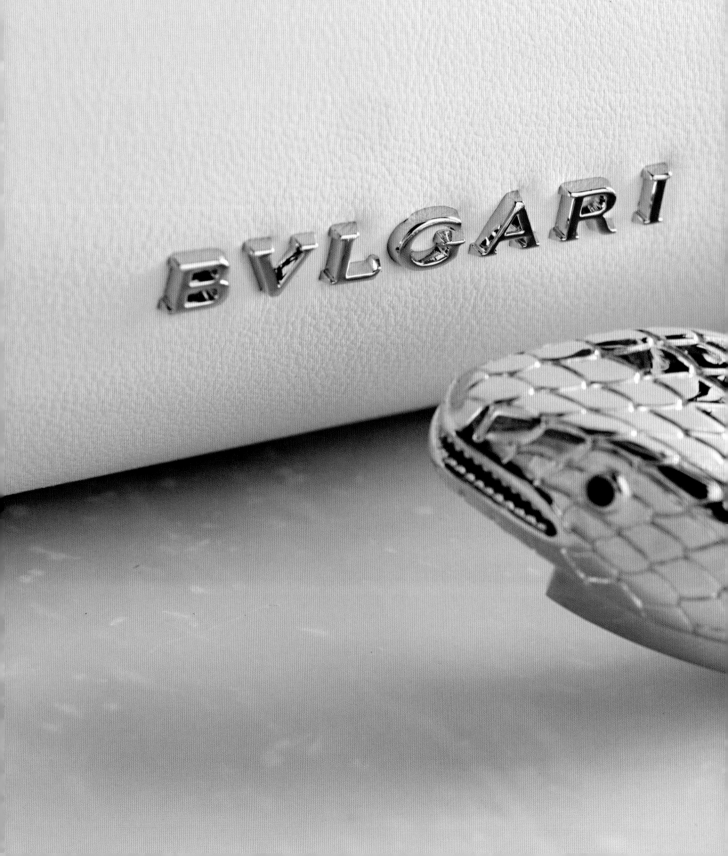

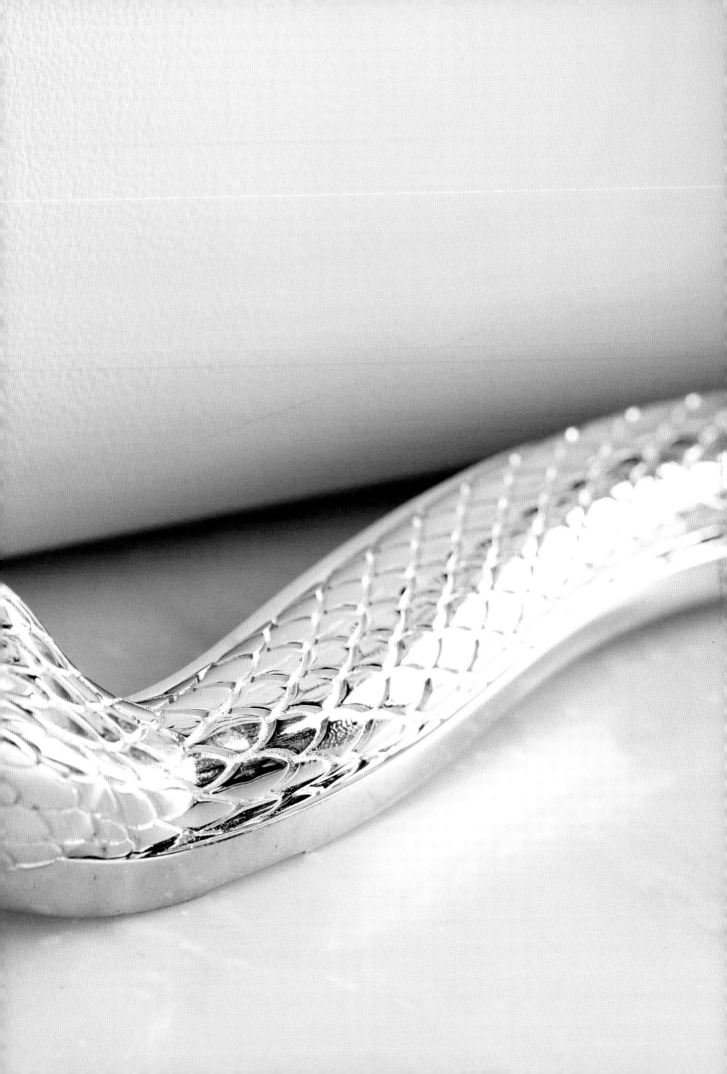

CAREL
PARISIAN POP

"It's very important to have freshness and renewal while at the same time tradition and craftsmanship."

Frédérique Picard, president of Carel

Founded: 1952

The story: This is the story of a small, 1.5-inch (4 centimeter) heel that became something big. Founded by Georges and Rosa Carel, the aim was to "prevent women from walking unhappily" by offering comfortable shoes to Parisian women accustomed to the tall, pointed heel promoted by haute couture. The short heel (1.1 to 1.9 inches/3 to 5 centimeters), called the "trotter," contributed to women's emancipation from the tall heel, including Air France flight attendants, who wore Carel shoes. Sales took off. In 1970, more than a million pairs had been sold. The bags were also a success. In the 1980s, Carel created shoes to accompany designers' collections, such as Thierry Mugler, Jean-Paul Gaultier, Jean-Charles de Castelbajac, and Chantal Thomass. In 2010, Frédérique Picard took over the house. After revitalizing the brand, she reinvigorated the clientele and widely employed alternative eco-friendly materials such as Piñatex (made from pineapple fibers). What style!

The style: Parisian, modern, very feminine, with a touch of sixties spirit.

Heard on the street: *"In the Netflix series* Emily in Paris, *Emily (Lily Collins) carries a Carel bag. There's no doubt about it, she's a true Parisian!"*

FASHION HOUSE FACT
Carel's It shoes are the three-strap Mary Jane pumps called Kina, launched in 2010.

WHO WEARS CAREL?
Angèle, Carla Bruni, Alexa Chung, Lily-Rose Depp, Isabelle Huppert, Clara Luciani, and even Brigitte Macron.

SORBONNE

In 1952, the first Carel boutique opened at 29 boulevard Saint-Michel in Paris's fifth arrondissement, near the Sorbonne. With the boutique located on the same street as the school, students naturally gravitated to the brand's bags and shoes, offered in colored leathers. The Sorbonne bag looks like a mini school bag worn across the body. It displays a *C*, the emblem of the brand, on its clasp. It also has a little sister, the Mini Sorbonne. Both are made of leather or patent leather.

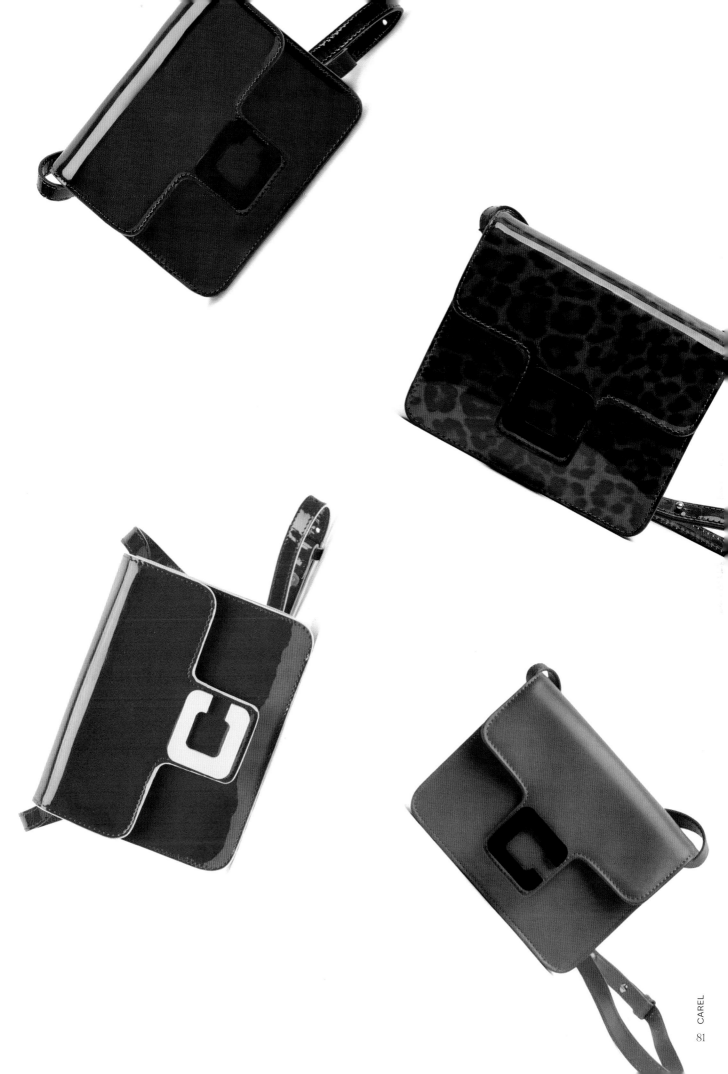

BUBBLE

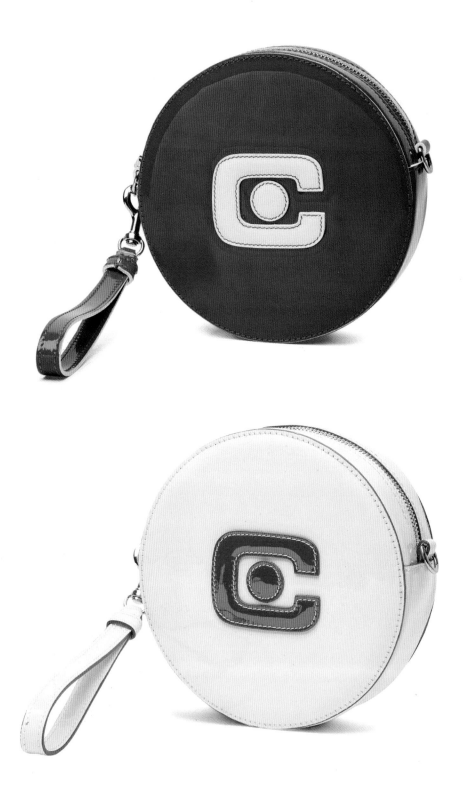

This little round bag was directly inspired by the company's archives from the sixties. At the time, it was carried by its handle. Times have changed, however, and today the shoulder strap is essential for capturing the attention of young women who love a crossbody, or of those who want to wear it on the belt thanks to the loop added to the back. It's chic and practical.

BIBI

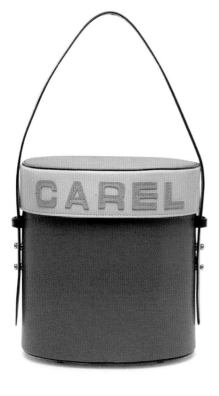
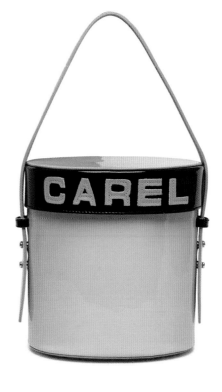
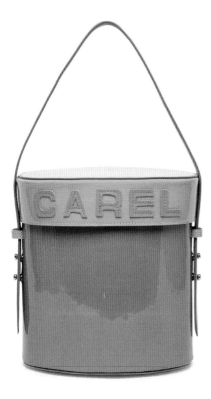
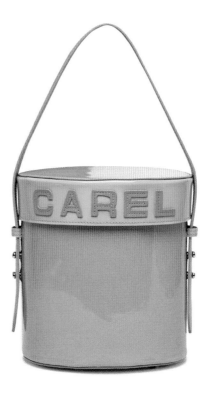

It's a kind of bucket bag that evokes a hatbox. It can be carried by hand or at the elbow. Whether in leather or patent leather, it lends a certain allure to the wearer.

CELINE

ICONIC HIT–ICONIC HIT–ICONIC HIT–ICONIC

TRIOMPHE

Hedi Slimane has mastered the art of the handbag. He created a collection called "Haute Maroquinerie," in which you can order a unique piece adorned with 18-carat gold jewelry and made by a single craftsperson. But this artistic director also knows how to approach ready-to-wear with the Triomphe bag, which he created in 2018 and which immediately triumphed in the pantheon of It bags. The clasp, inspired by the Celine logo from the 1970s, is a sign of recognition for women who want a timeless bag linked to the history of the brand, and with a name that inspires.

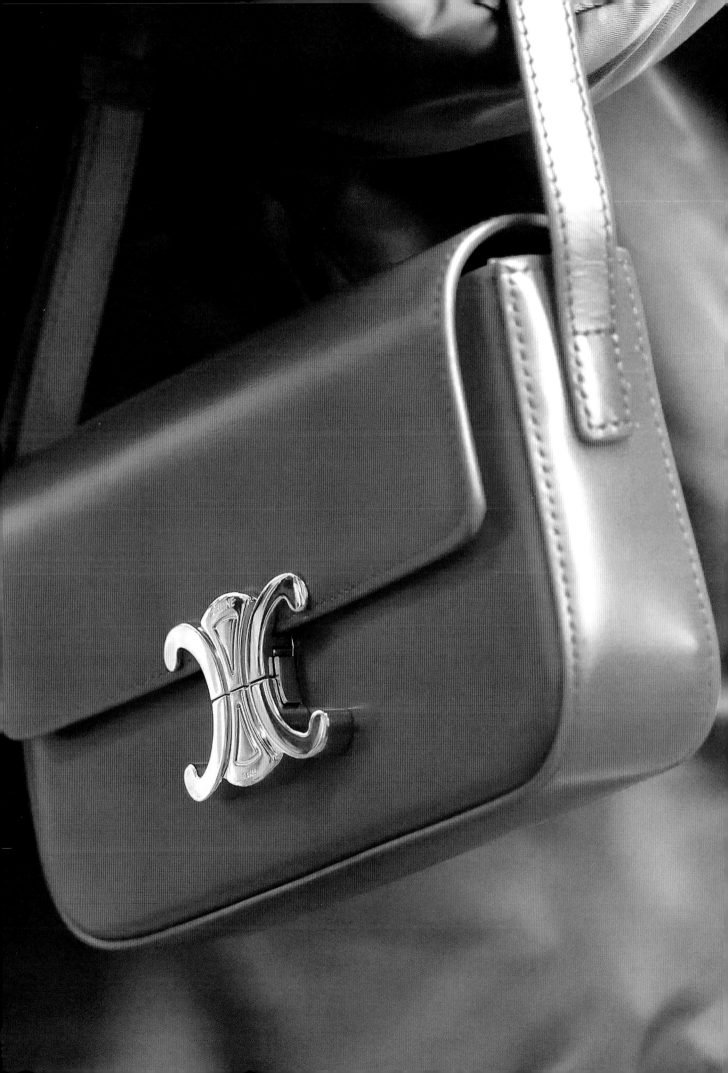

CHANEL
TIMELESS

"Fashion fades, only style remains the same."

Gabrielle Chanel in *Le Temps Chanel*, Edmonde Charles-Roux, Éditions Grasset, 1980, p. 244

Can simplicity be the height of luxury? Gabrielle "Coco" Chanel answered this question with her little black dress, tweed jacket, and 2.55 handbag that has survived the years without the quilting taking on a single metaphorical wrinkle. Inspired by the masculinity of men's wardrobes, the designer invented casual chic and dared to revolutionize fashion while remaining classic—a true *triomphe*! By adding a shoulder strap to women's bags, she gave women freedom of movement. Since the death of the couturier in 1971, Karl Lagerfeld and, now, Virginie Viard, the creative directors of fashion, have propelled the brand's vision forward with a style that has all the elements of eternal appeal. *"May my legend prosper and thrive. I wish it a long and happy life!"* said Coco Chanel (*L'Allure de Chanel*, Paul Morand, Éditions Hermann, 1996). Her wish seems to have been granted.

7 KEY DATES

1910
Gabrielle Chanel opens a hat boutique called Chanel Modes at 21 rue Cambon in Paris.

1912
The seamstress uses jersey, usually reserved for men's underwear, to make women's clothing. She opens a boutique in Deauville. Six years later, she acquires the building at 31 rue Cambon and sets up her fashion house there.

1939
The fashion house closes at the beginning of the Second World War. Only the shop at 31 rue Cambon remains open, selling perfumes and accessories.

1954
At the age of seventy-one, Gabrielle relaunches her fashion house. She organizes a fashion show on February 5, the designer's favorite number.

1971
On January 10, Mademoiselle dies at the Ritz Hotel in Paris. Her posthumous collection was an enormous success.

1983
Karl Lagerfeld is appointed creative director for Chanel's fashion lines and haute couture collections. He reinvigorates the styles through his "Cruise" collections and introduces the *Métiers d'art* and the pre-collections.

2019
After Karl Lagerfeld's death, Virginie Viard, who worked closely with him, is appointed creative director of the fashion collections.

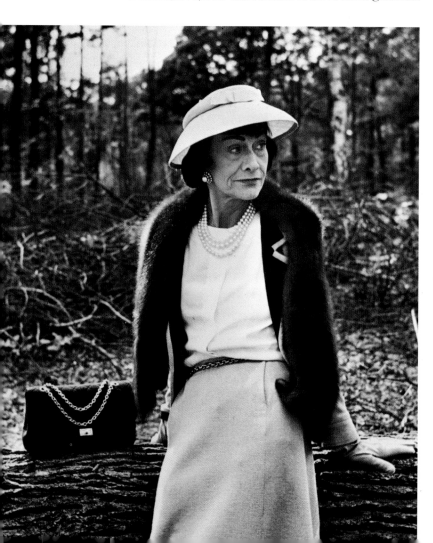

01

03

04

02

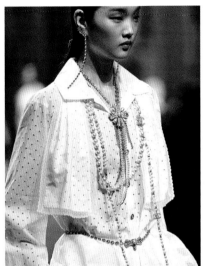

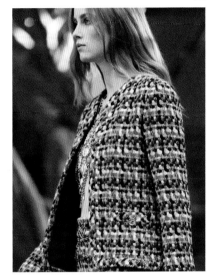

FASHION HOUSE FACT
When she tried to break into
singing, Gabrielle Chanel
had two song titles in her
repertoire that echoed the
nickname her father gave
her–Coco: "Qui qu'a vu
Coco," which was the story
of a little dog named Coco
lost at the Trocadéro, and
"Ko-Ko-Ri-Ko," the sound a
rooster makes.

THE 5 HOUSE CODES OF CHANEL

01.
Quilted
Inspired by horse jockey jackets.

02.
Camellia
Coco's favorite flower.

03.
Pearls
Mademoiselle Chanel wore pearl
necklaces.

04.
The tweed jacket

05.
The two-tone, black-and-white
The fashion house's two emblematic colors.

05

2.55
THE WORLD-FAMOUS

1955

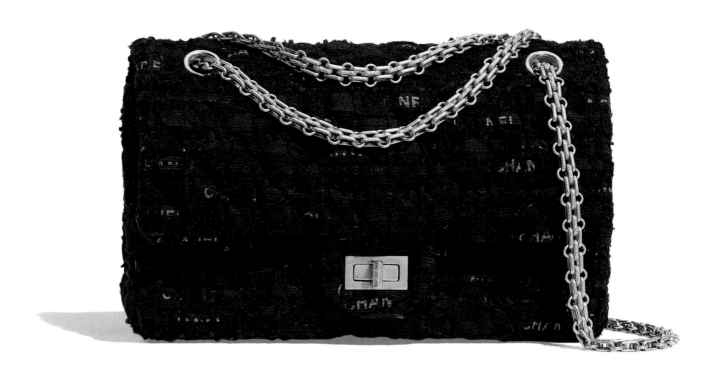

In the early 1920s, Gabrielle Chanel began making handbags. Her goal? To free women from constraints. Inspired by the soldiers' bags of the time, she added a shoulder strap to women's handbags so they no longer had to carry them in their hands. *"Tired of holding my bags in my hand and losing them, I added a strap and wore them over my shoulder,"* said Coco Chanel, quoted by Paul Morand in *L'Allure de Chanel*. During the reopening of her fashion house, she introduced the 2.55 bag, so named because it was released in February 1955. Coco Chanel was seventy-two years old at the time.

In February 2005, to celebrate the fiftieth anniversary of the creation of the 2.55, the brand released an exact reissue of this legendary bag that embodies Coco Chanel's spirit of freedom. The bag symbolizes everything she stood for.

WHAT IS
THE BAG'S CALLING CARD?

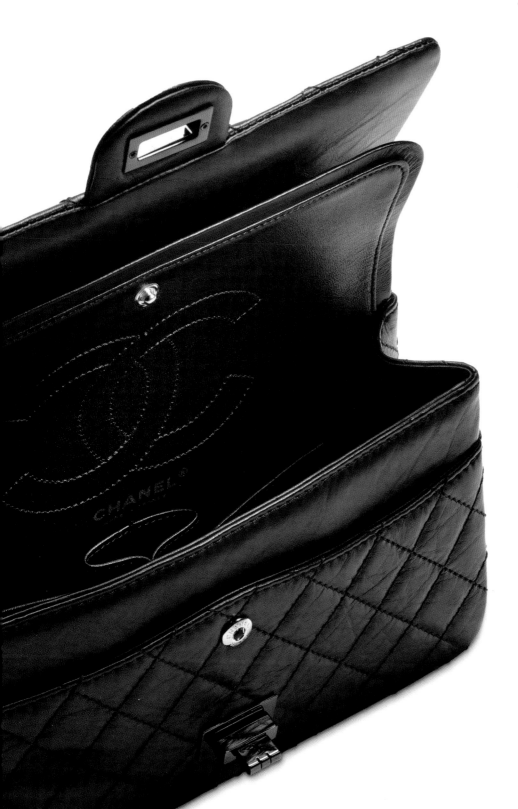

- **The gilded brass chain,** or silver plated, with rows of flat links, which serves as a handle and a shoulder strap. The chain was inspired by the chains nuns wore around their waists to tie their keys.

- Inside the bag, **there are three small, gusseted pockets,** the smallest of which, called Tube, is designed to store a tube of lipstick.

- **The quilted pattern** made of aged calfskin and inspired by jockeys' jackets. Horseback riding was one of Coco's passions.

- **The small, zipped pocket** under the flap, nicknamed The Secret. The legend is that Gabrielle Chanel hid her love letters there.

- **The topstitched interlocking CC,** Chanel's monogram, appears on the inside of the flap.

- **The very simple, rectangular clasp** nicknamed Mademoiselle, one of the nicknames for Gabrielle, who refused to marry.

- **A single back pocket** —nicknamed Mona Lisa's Smile—and a front pocket under the flap.

- **The anti-theft feature** made of two overlapping flaps, the first of which closes with a snap and the second with the clasp.

AVAILABLE IN FOUR SIZES
The Mini: 6 × 7.8 × 2.3 inches
(15.5 × 20 × 6 centimeters)
The Standard: 6.2 × 9.4 × 2.9 inches
(16 × 24 × 7.5 centimeters)
The Large: 7.6 × 10.9 × 2.9 inches
(19.5 × 28 × 7.5 centimeters)
The Maxi: 7.8 × 12.3 × 3.9 inches
(20 × 31.5 × 10 centimeters)

THE MATERIALS
The 2005 version is made of distressed
leather, but the bag comes in many
materials, including tweed, satin, jersey,
and denim.

WHERE AND HOW IT'S MADE
The bags are handmade and, since 1990,
designed exclusively in the house's
ateliers in Verneuil-en-Halatte, France.

ITS CONSTRUCTION
requires 185 hand-performed steps and
fifteen hours of work.

ITS VALUE
keeps rising. The bag's price has been
rising at a rapid pace, making it a good
investment.

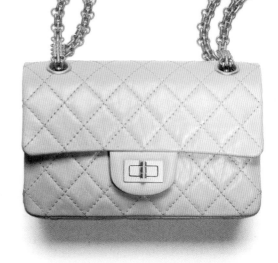

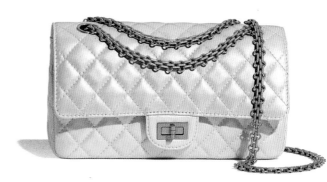

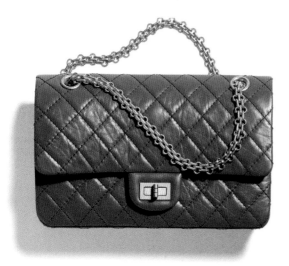

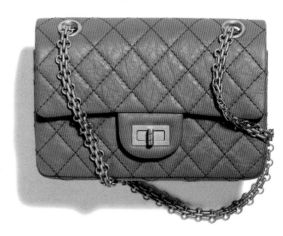

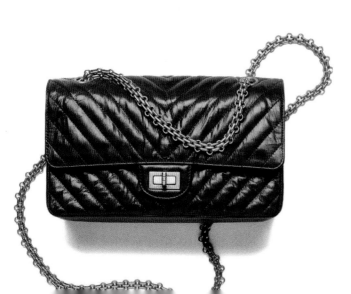

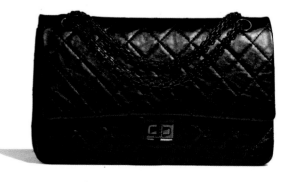

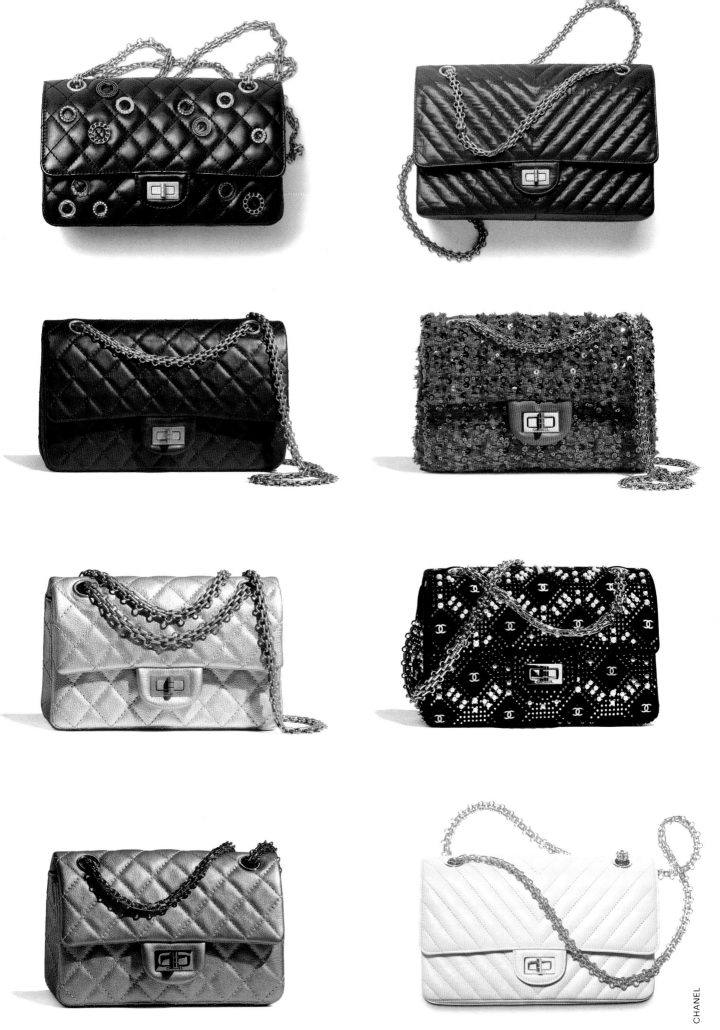

11.12
THE CLASSIC

1973

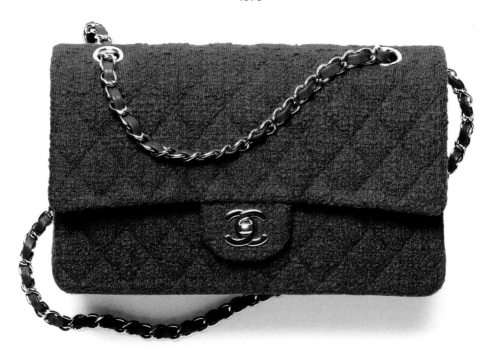

When he arrived at the fashion house in 1983, Karl Lagerfeld reinvented the 11.12 bag created in 1973. With each collection, the couturier applied all his creativity and imagined the bag in different materials and colors: lambskin, patent calfskin, wool tweed, denim, embroidered, pink, yellow, and orange—making the bag a true chameleon adapting to each season. The lining matches the colors of the exterior leather or fabric. Today, Virginie Viard leads the continuing creativity of this timeless and always trendy bag.

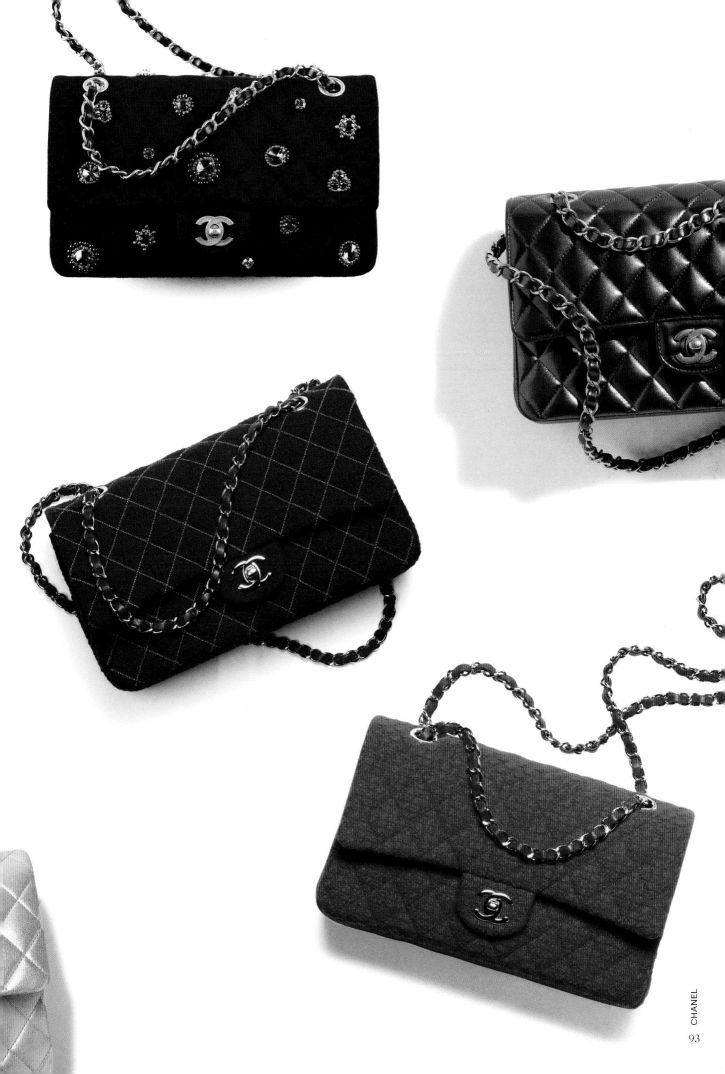

CAMERA

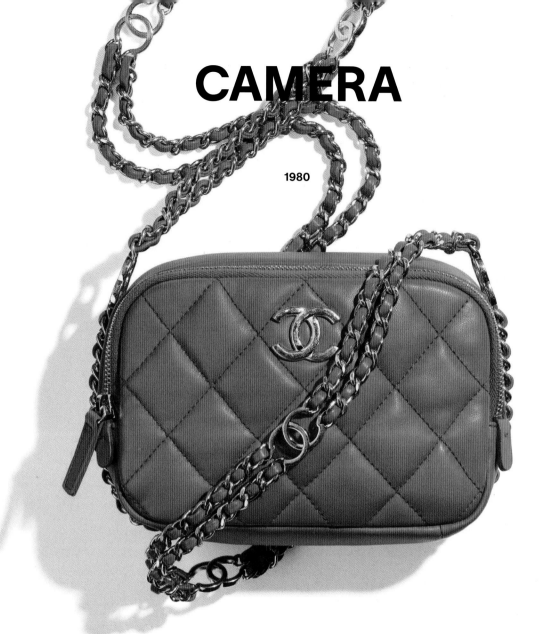

1980

Inspired by the cases carried by photographers and reporters, the Camera bag appeared in the 1980s. It features all the house codes: quilted "diamond" fabric and a chain, which can be either plain or braided with leather. Each season, the handbag's color and chain change, and it has more or fewer pockets. It is even sometimes adorned with the good luck charms that Gabrielle Chanel loved.

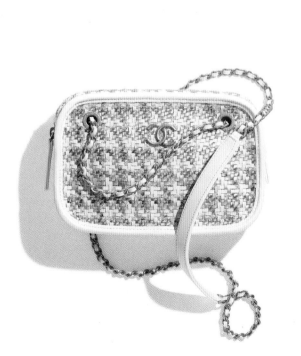

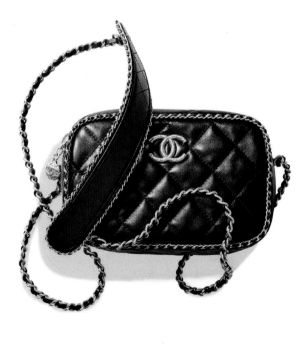

BOY CHANEL

2011

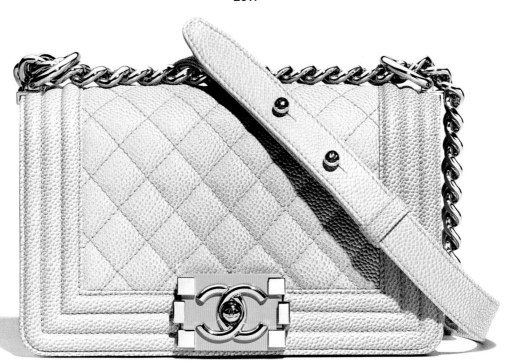

The name is a tribute to Arthur "Boy" Capel, the polo player and childhood sweetheart of Gabrielle Chanel. He helped her open her first boutique in Paris. This rectangular handbag, with its clean lines and locking squeeze clasp (it opens when you press on the sides), also features the monogram, like all the house's bags. The wide-link chain resembles a horse's curb chain. It can be worn on the shoulder with a double or single strap. Its shape is inspired by the cartridge shell belt worn by hunters. Karl Lagerfeld once again blurred the codes of masculine/feminine with it. The Boy Chanel exists in calfskin and lambskin, but since its creation, it has been produced in many materials, including tweed and velvet, and in all colors. Collectors seek out the ones made of exotic skins, which have been rare since 2019 when the brand stopped using these types of leathers for its new creations. The Mermaid, with an iridescent rainbow-style chain, is highly sought after.

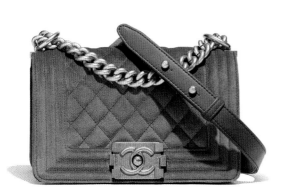

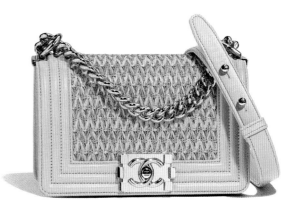

VANITY

1990

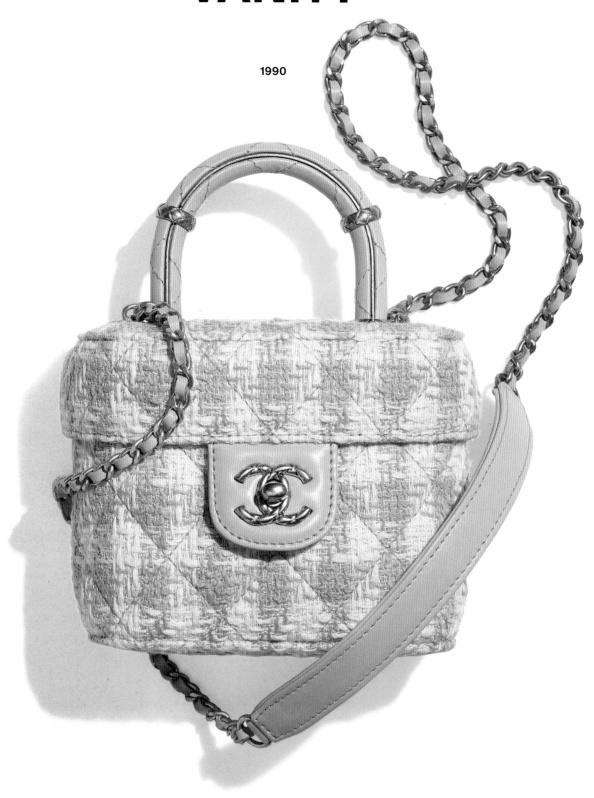

This travel vanity bag was designed by Karl Lagerfeld in the early 1990s. But this vanity bag, which is very faithful to the original one, wasn't really intended as an overnight accessory. In 2015, during the Chanel fashion show in an airport terminal setting, the Vanity bag moved from a travel case to street wear. It resembles a small suitcase and is adorned with a charm and a key. Its small version (the Petit Vanity) is shaped like a small box but can also be round or rectangular. It can be carried over the shoulder by its long chain or in the hand by its handle.

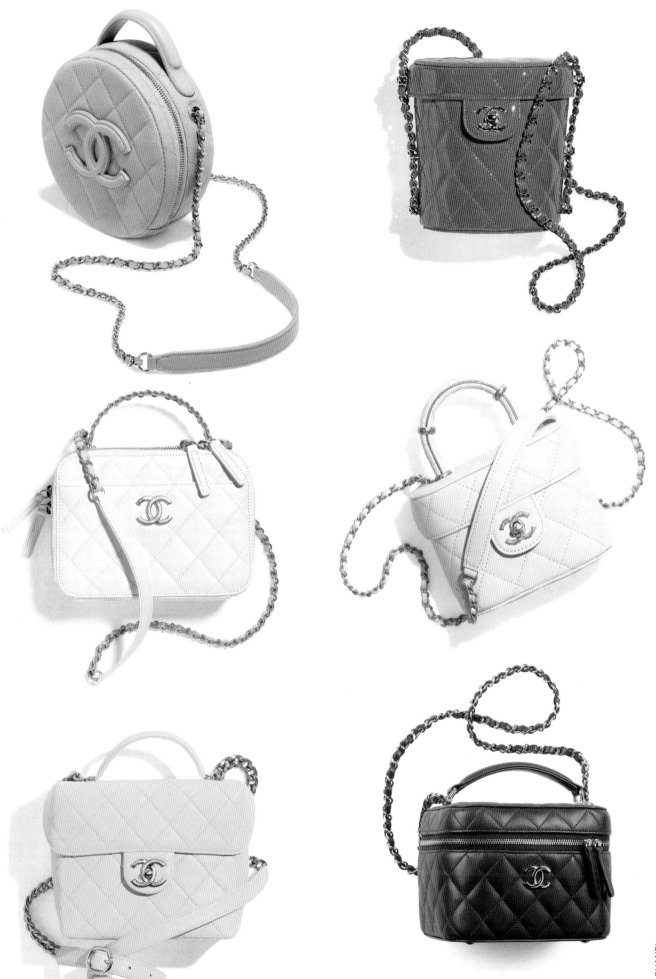

GABRIELLE

2017

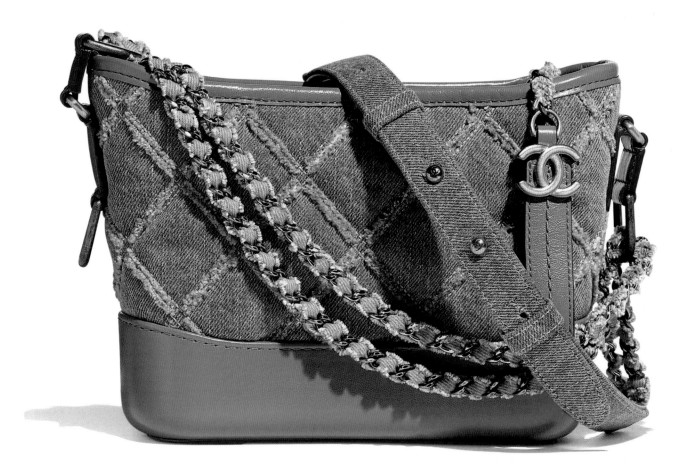

This bag's inspiration was the shape of virtual reality glasses. With its supple body (originally made of aged, quilted calfskin) and its structured, rigid base in smooth leather, the Gabrielle bag is very different from the brand's other bags. It can be worn in several ways thanks to its double chain: long or short, on the shoulder, or across the body. The bag features the quilted pattern, and the interlocking *CC* logo is attached to the zipper.

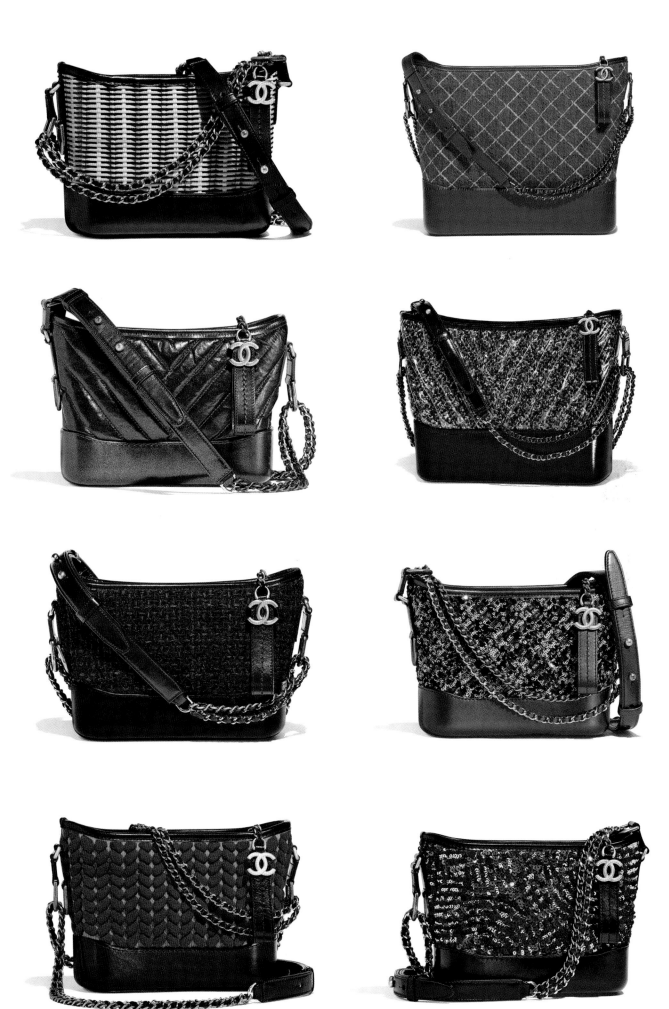

CHANEL 19

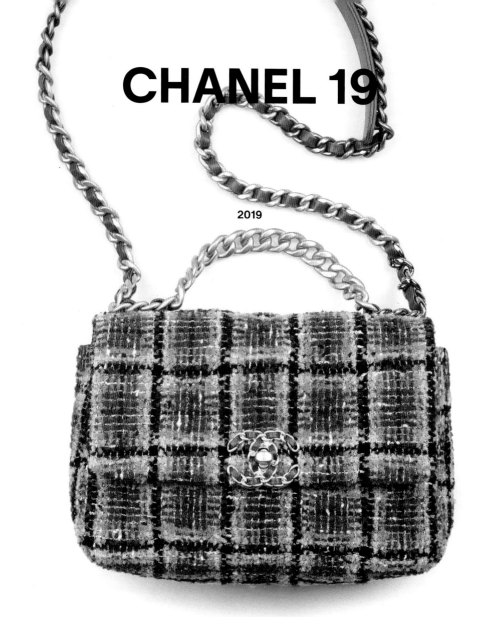

2019

A tribute to the 2.55, the Chanel 19 was created—as its name suggests—in 2019. It is the last bag designed by Karl Lagerfeld, in collaboration with Virginie Viard, now the brand's creative director for fashion collections. The bag is both structured and ultraflexible. Mademoiselle Chanel would have loved it. Her desire to free women in their movements was respected in its design. It can be worn in many ways: on the shoulder, across the body, and in the hand thanks to its short chain handle. Its monogram is larger than that of the Classic, and the interlocking *CC* logo is intertwined with leather, as is its chain, available in either silver, antiqued gold, or ruthenium finish. The quilted diamond pattern, which is also much wider than in the Classic, is available in many materials, ranging from lambskin to denim, jersey, tweed, and silk. Purists of the brand embraced the bag immediately as the epitome of the modernized Classic.

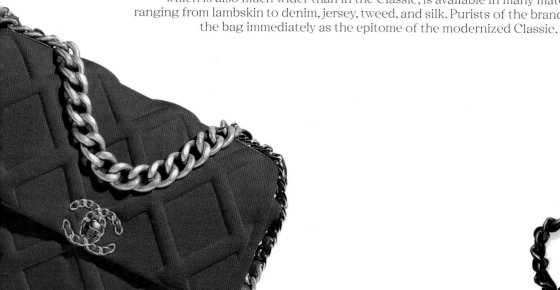

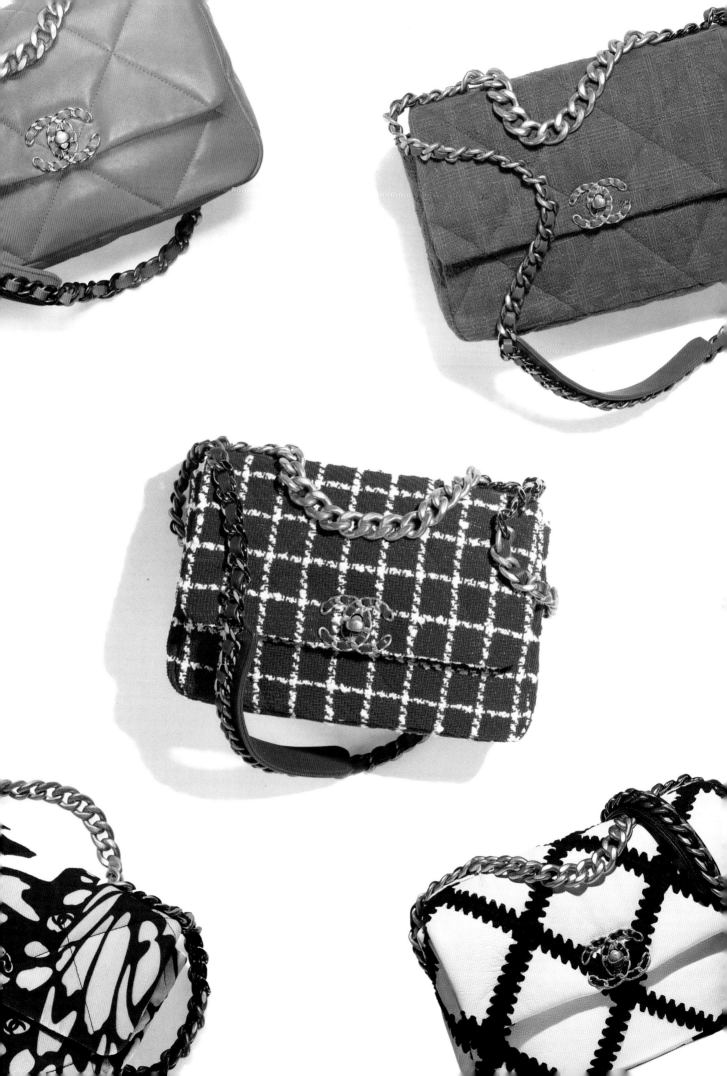

CHANEL 22

2022

Designed by Virginie Viard in 2022, this durable handbag is made of light and supple leather. It is one of the least structured of the Chanel bags. However, it bears all the codes of the brand: quilted leather, the metal chain intertwined with leather, and the name of the brand, which is written in full across the bag. The bag closes with a magnetic button and bears a medallion branded Chanel Paris, with the interlocking *CC* attached to its chain. It is also available in a backpack version.

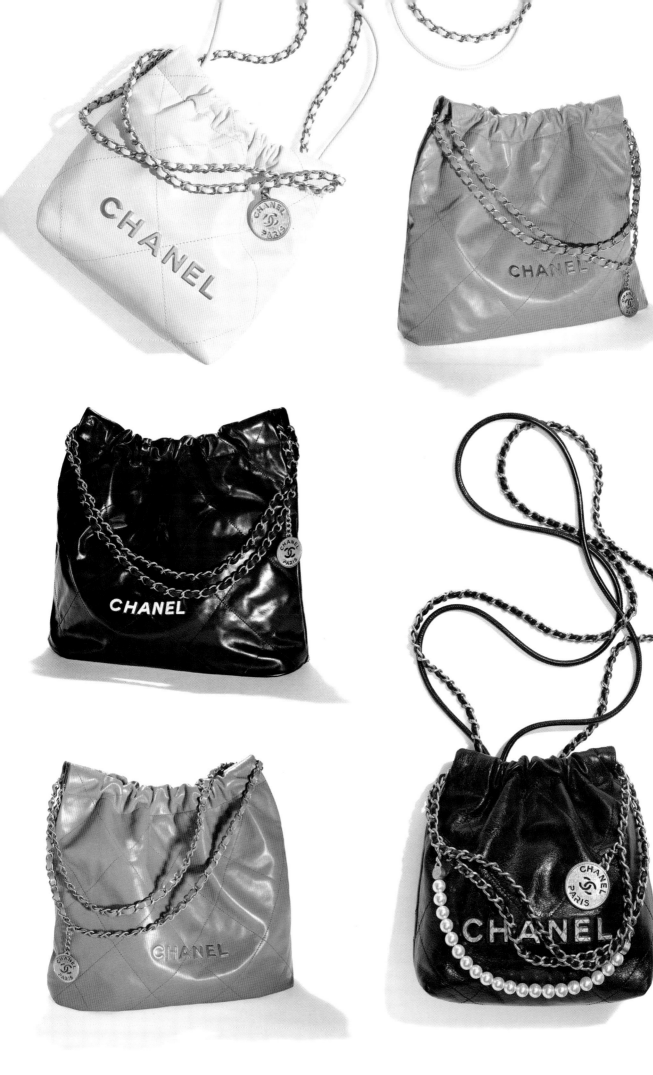

MINAUDIÈRES
AND OTHER WHIMSICAL CASES

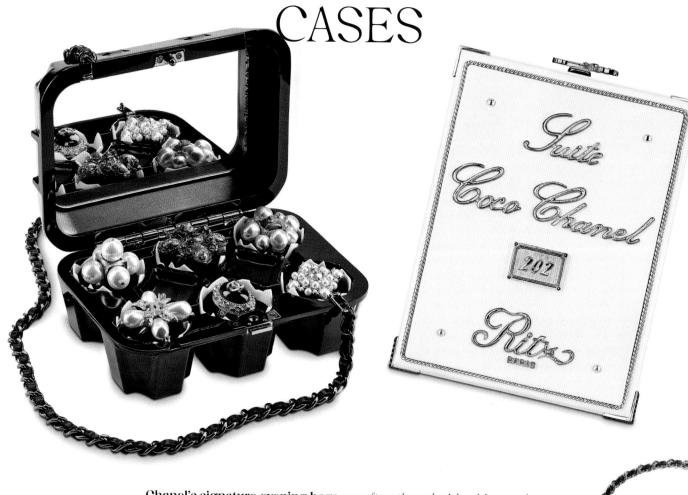

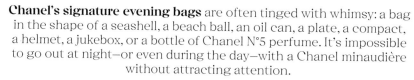

Chanel's signature evening bags are often tinged with whimsy: a bag in the shape of a seashell, a beach ball, an oil can, a plate, a compact, a helmet, a jukebox, or a bottle of Chanel N°5 perfume. It's impossible to go out at night—or even during the day—with a Chanel minaudière without attracting attention.

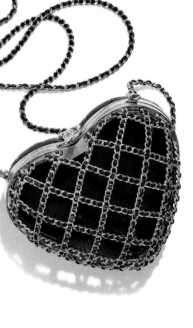

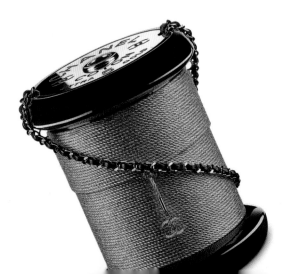

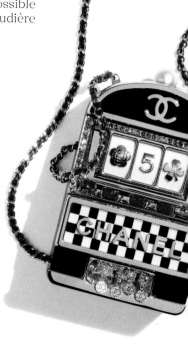

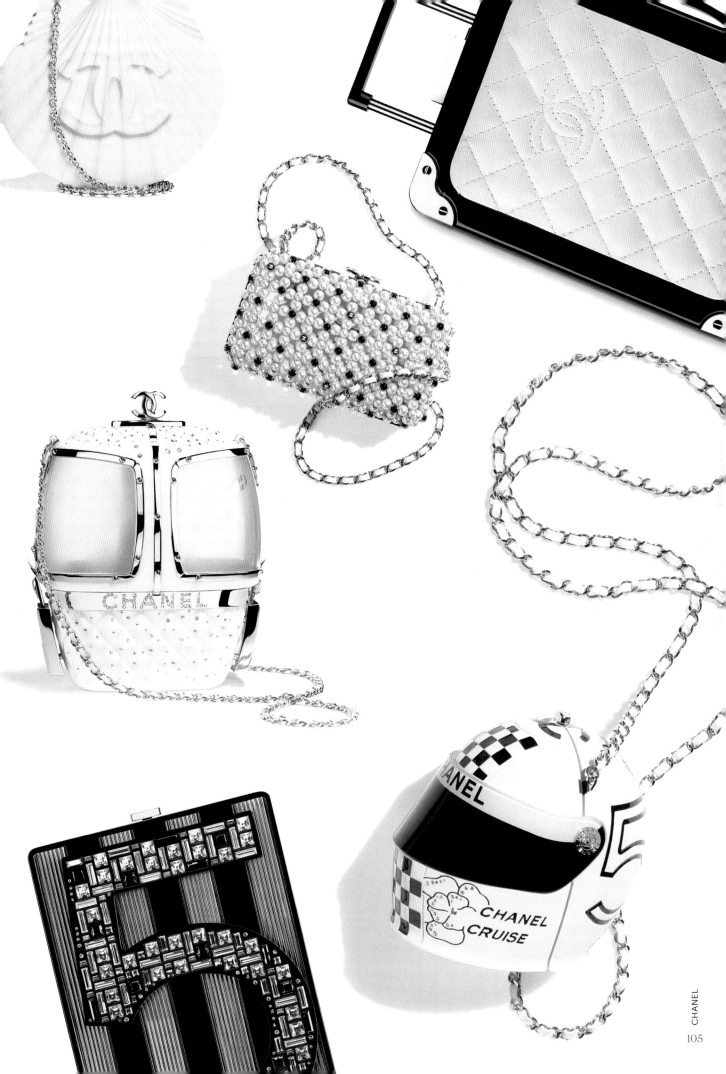

THE BIRTH OF A CLASSIC BAG

Just outside Paris, in the ateliers at Verneuil-en-Halatte, Chanel bags are created. Here are all the steps required to bring the legendary 11.12 bag to life.

01.

Using the patternmaker's plans, the cutters cut the skins. They use their expertise to select the best sections of the leather, free of any defects. They cut the leather using a laser or a die cutter.

02.

The cut-out pieces are worked to obtain the correct thickness for the quilting. A machine sews the seams to create the brand's signature quilted look.

03.

The artisans assemble the different pieces flat, by machine and by hand. The bag is mounted inside out, like a piece of clothing, and then turned right side out with a special gesture that only experts can execute. Once turned right side out, the bag is reinforced with several taps of a hammer.

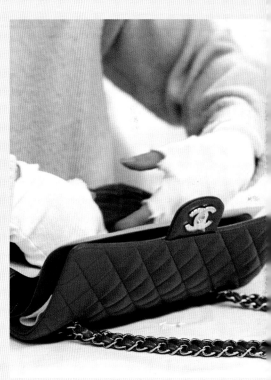

04.

The bag's interior is constructed. A small bag is essentially inserted into a larger one, requiring great expertise.

05.

All the metal components are installed, including the metal and leather chain, eyelets, and clasp.

06.

This is a key step to ensure the bag's highest quality. The slip of a tool, the tiniest scratch in the leather, or the slightest defect will prevent the bag from seeing the light of day.

CHLOÉ
BOHEMIAN LUXURY

*"All I've ever wanted was for Chloé
to have a joyful spirit that makes people happy."*

Gaby Aghion, founder of Chloé

Founded: 1952

The story: Gaby Aghion is one of the pioneers of luxury ready-to-wear. The brand's first fashion show for the Spring/Summer 1958 season took place in Paris at the Café de Flore, a popular venue for artists of the time. In 1958, she recruited the young designer Gérard Pipart to design the collections. Others followed, including Karl Lagerfeld, who arrived in 1964 and became the brand's lead designer two years later. Lagerfeld laid the foundation of the house's style: bohemian, nomadic, and romantic, with true joie de vivre. When he left Chloé in 1983 to join Chanel, several creative directors, including Martine Sitbon, took over at Chloé, but Lagerfeld returned in 1992. In 1997, the sexy rock spirit of Stella McCartney, who succeeded Lagerfeld, blended brilliantly with the romantic bohemian style of the label. In 2001, Phoebe Philo, her right-hand person, replaced her. In 2005, the house launched a line of handbags starting with the Paddington, the first in a long series. Since then, Paulo Melim Andersson, Hannah Mac-Gibbon, Clare Waight Keller, Natacha Ramsay-Levi, and Gabriela Hearst, who left the fashion house in 2023, were entrusted in succession with creative direction. The new creative director is Chemena Kamali.

The style: A very seventies spirit and romantic bohemian with a vagabond flair.

Heard on the street: *"Wearing a Chloé bag shows off your cool attitude."*

WHO WEARS CHLOÉ?
Kate Bosworth, Lucy Boynton, Amber Heard, Katie Holmes, Angelina Jolie, Sienna Miller, Demi Moore, Emma Roberts, and Olivia Wilde.

FASHION HOUSE FACT
Chloé has committed to 90 percent of its collections' raw materials having a reduced impact on the environment by 2025 at the latest.

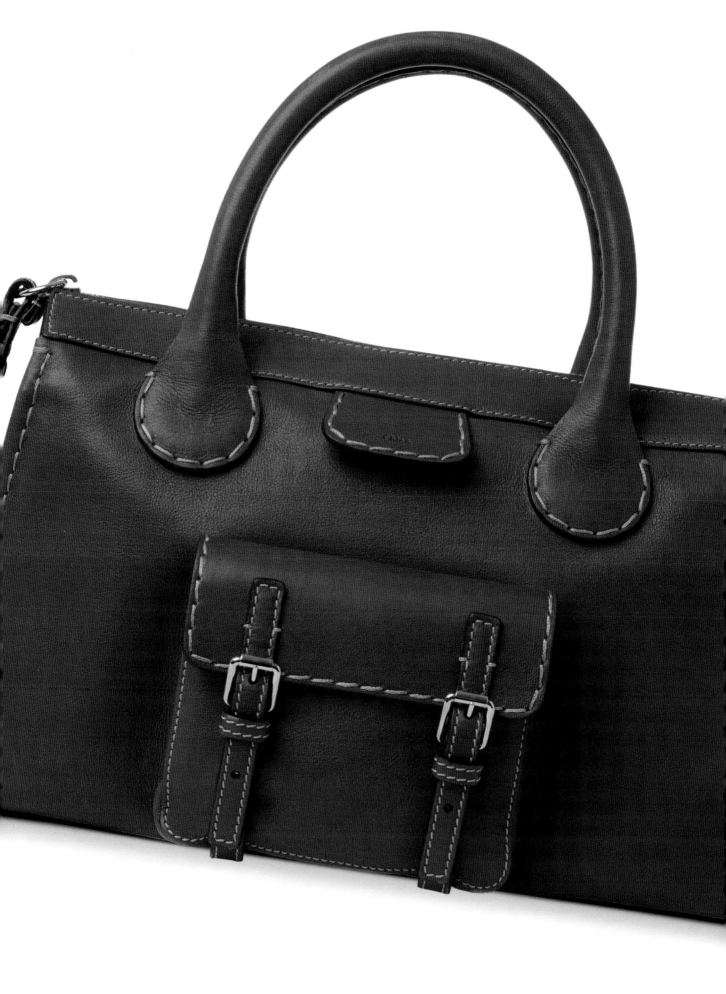

EDITH

2006, 2021

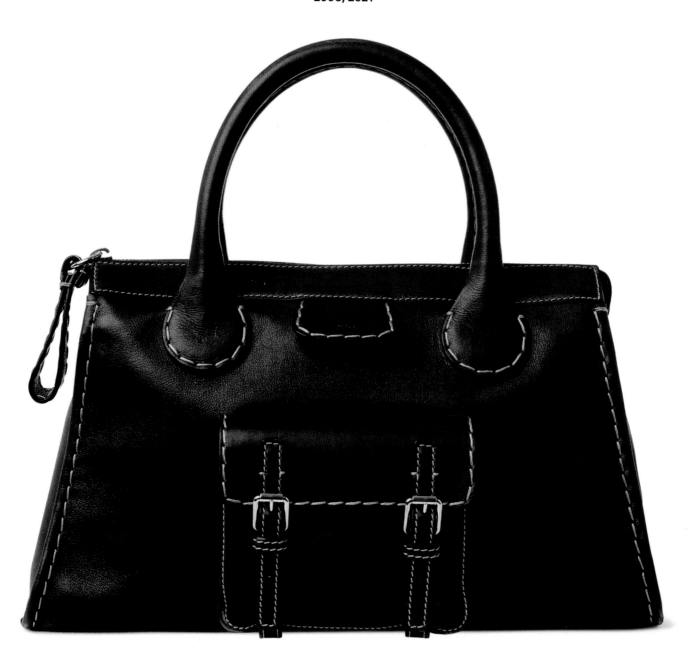

Gabriela Hearst brought this It bag, created in 2006, back to life. The Edith bag was the first luxury bag taken up by the designer. After all, what could be more natural than to revisit and rejuvenate a brand's handbag after taking over as head of design? And this new version still displays the brand's signature seventies look. Made of buffalo leather, the Edith bag is recognizable by its characteristic stitching and its small buckle-strap pocket. It has a detachable shoulder strap.

MARCIE

2010

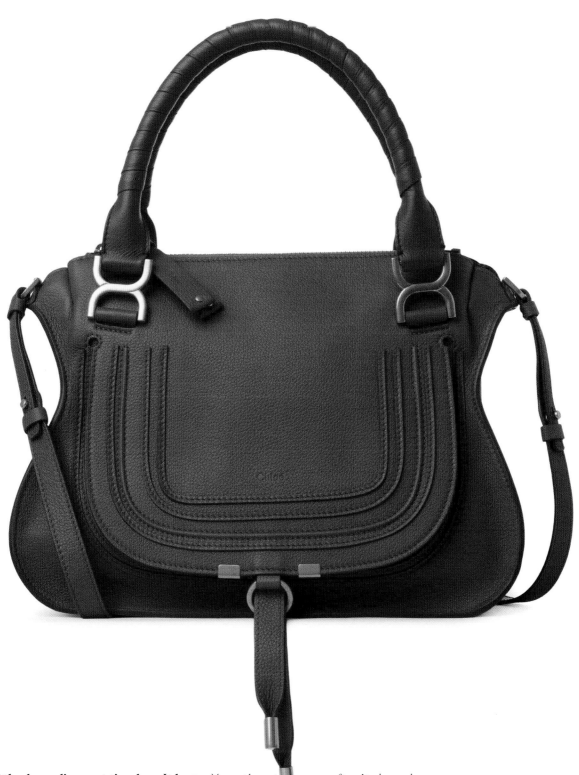

One of the brand's most timeless It bags. More than ten years after its launch, this bag is still as coveted as ever. With its soft silhouette and curved lines, it is made of grained calfskin, highlighted with saddle stitching and dangling leather ties. The little touch that showcases its artisan construction is the hand-twisted handles. It can be carried by hand or over the shoulder.

DREW

2014

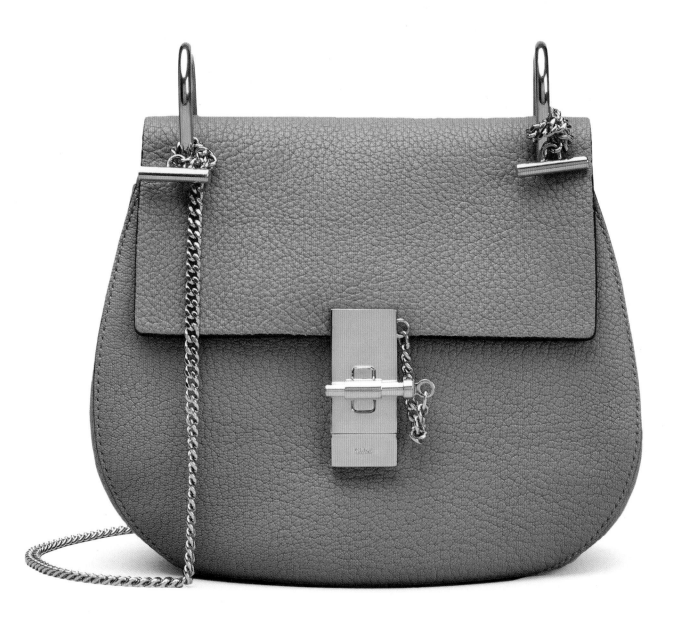

Appearing during the Fall 2014 collection, this shoulder handbag, with its very seventies saddle shape, is made of soft leather. The gold-tone metal details make it chic: oversized metal rings, chain knots, and a jewel-like locking clasp—a look that ranges from glamourous to natural.

FAYE

2015

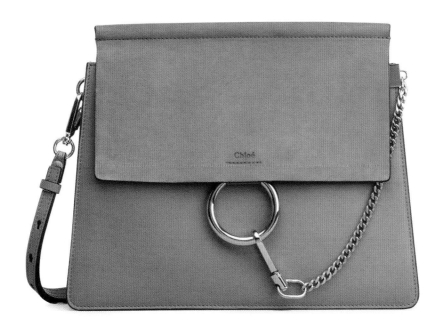

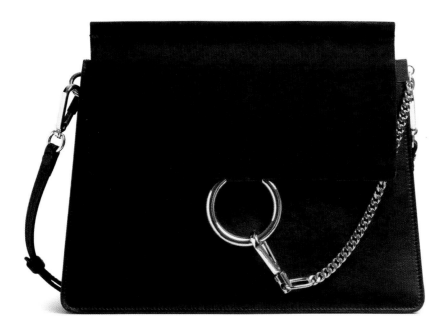

True to the sleek aesthetics of the seventies, the Faye displays its
modernity with its timeless piercing ring clasp, hook, and chain. Proof
that you can be 100 percent feminine, bohemian, and very chic at the
same time.

NILE

2017

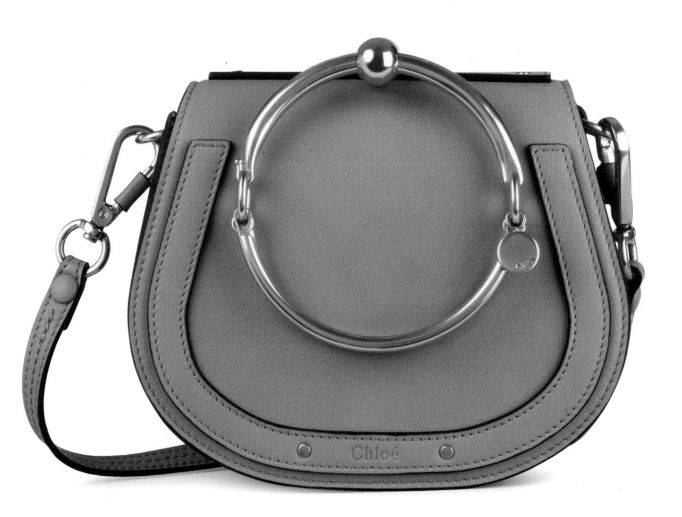

The ring motif is without a doubt part of Chloé's signature. The ring on this bag is much more than decorative, however, since it can also be used as a handle to carry the bag, which is why it is sometimes called the "bracelet bag." The bag can also be worn over the shoulder. Its rounded shape reflects the bohemian side of the brand.

TESS

2018

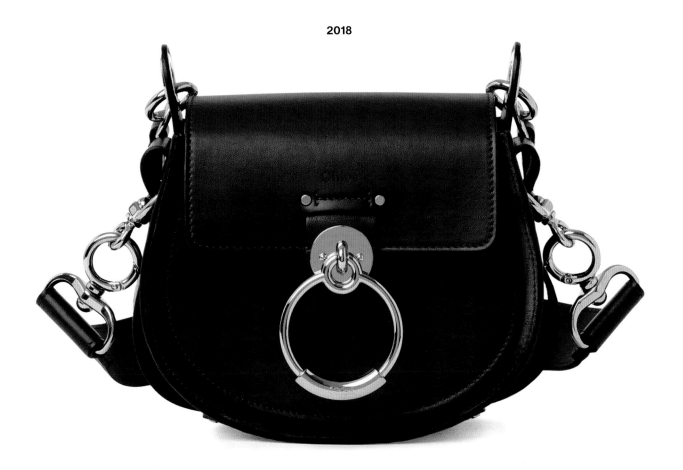

Another representation of the ring! Taking elements from the previous bags, the Tess, in smooth leather and suede calfskin, is shaped like the Drew and the Nile, and its ring is reminiscent of the ring of the Faye. The models in the photos represent the small Tess bag, but there are also the Tess Day and the Tess Day mini, which are square versions with a ring but also a handle and shoulder strap.

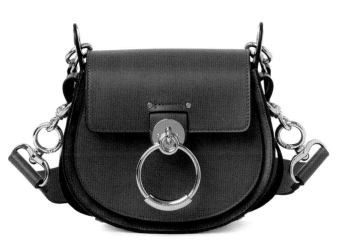

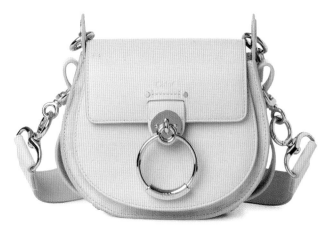

PENELOPE

2023

The Penelope line takes its name from the heroine of Greek mythology who embodies a strong, free, and independent woman. This bag has a soft and bohemian silhouette with a flap highlighted by refined details: braided finishes, coordinating fringe, a gold-tone metal clasp inspired by the brand's archival jewels, and snap hooks on its handle. It is available in many colors, materials, and sizes, including a clutch.

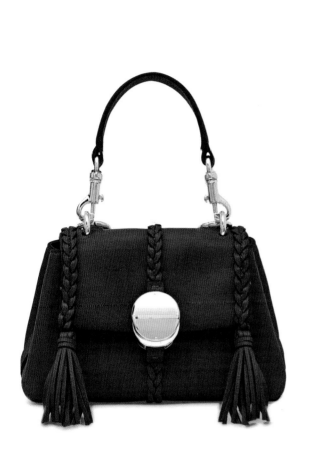

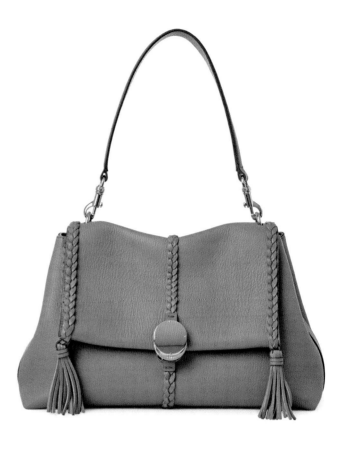

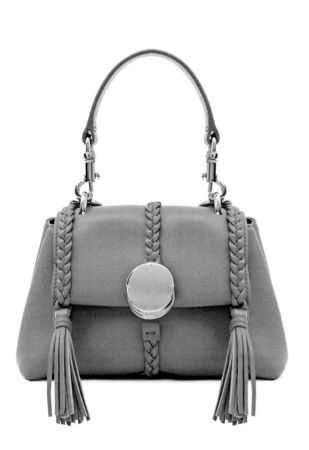

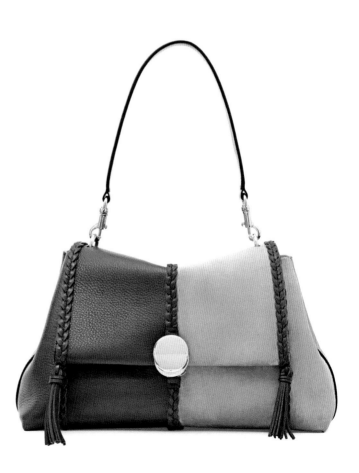

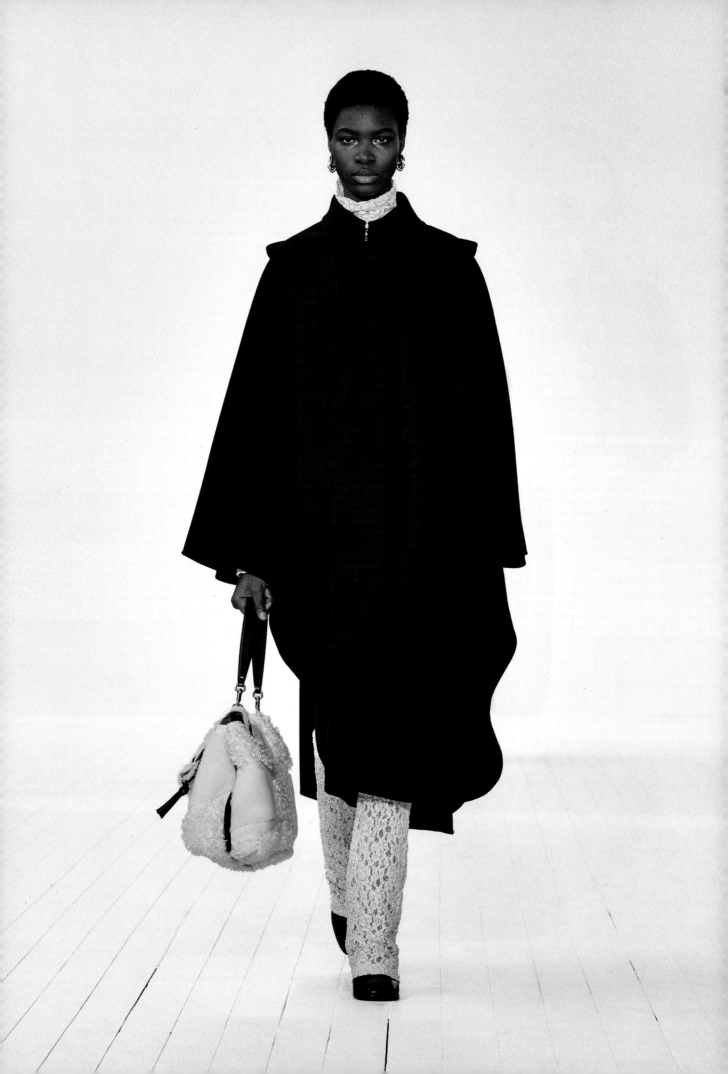

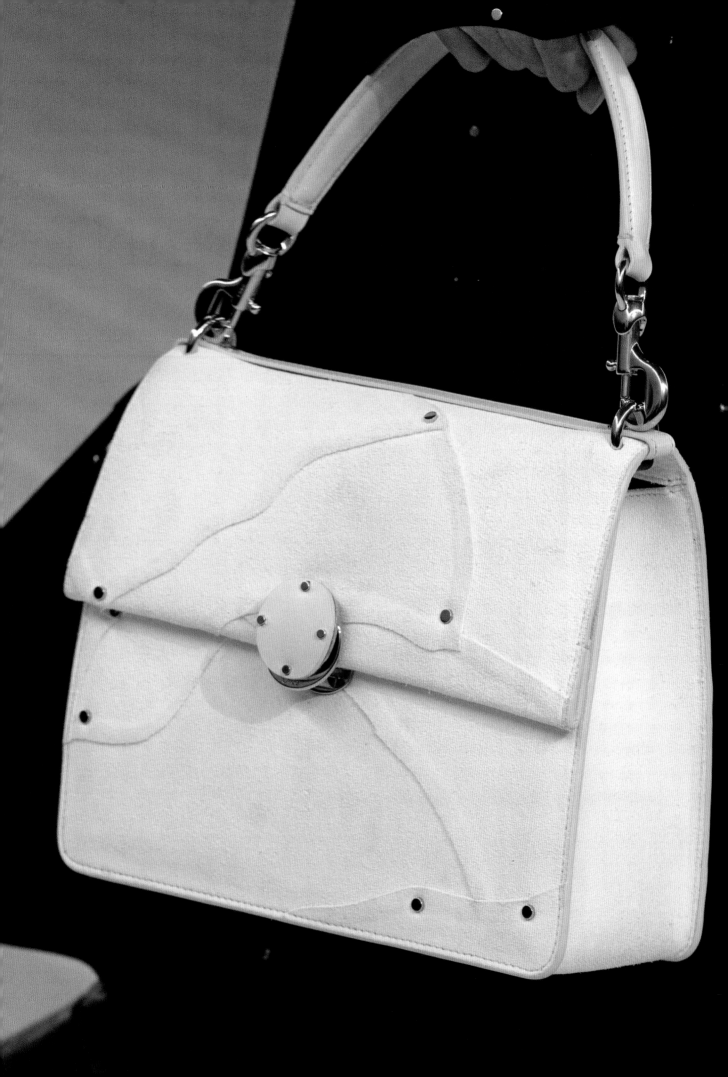

CHRISTIAN LOUBOUTIN
THE FLAMBOYANT

"I'm a designer, and I think when you work in fashion, you have to provide people with fantasy."
Christian Louboutin

Founded: 1991

The story: It all started with a sign illustrating a high-heeled pump that caught the attention of a young Christian at the Museum of African and Oceanic Arts in Paris around age ten. He learned the craft of shoemaking from the inventor of the stiletto heel, Roger Vivier, before creating his own label at the age of twenty-seven. Dressing the dancers' feet at the Folies Bergère sealed his passion for shoes. He shook up everything when he had the idea of coloring the soles of his shoes with red nail polish, a look that became a favorite among shoe lovers, who snatched up these shoes with their sexy twist. Christian's success quickly reached a global scale. He created shoes for many runway shows (Jean-Paul Gaultier, Azzaro, Roland Mouret, Givenchy, Alexandre Vauthier, and Yves Saint Laurent). He started making handbags in the early 2000s and launched his first line of handbags in 2003 with Sweet Charity.

The style: When speaking of the Christian Louboutin label, we mostly think of his super sexy, red-soled shoes. When we think of his handbags, we think, above all, of a very joyful, colorful, and flamboyant style.

Heard on the street: *"I really like Christian Louboutin's tote bags. They are big enough to store my red-soled pumps that I take out as soon as the opportunity arises."*

FASHION HOUSE FACT
The red used on the soles of Christian Louboutin shoes corresponds to Pantone number 18.1663TP. The Court of Justice of the European Union confirmed in 2018 that the company's red outer soles can be a registered trademark.

WHO WEARS LOUBOUTIN?
Rihanna, Blake Lively, Margot Robbie, Taylor Swift. Included among his handbag fans are Emily Blunt, Jennifer Lopez, Olivia Palermo, Yara Shahidi, and Dita Von Teese.

SWEET CHARITY

2003

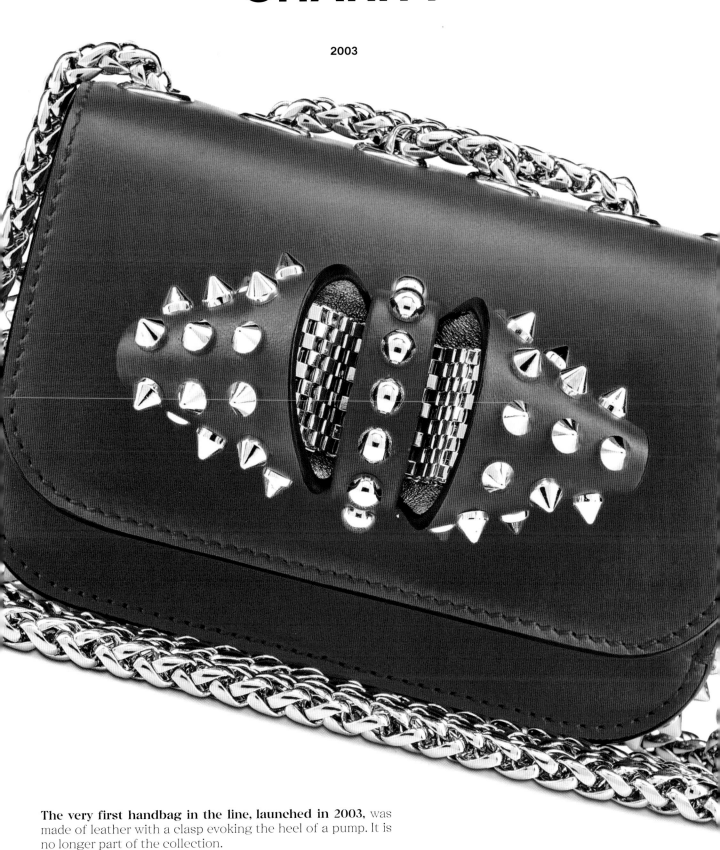

The very first handbag in the line, launched in 2003, was made of leather with a clasp evoking the heel of a pump. It is no longer part of the collection.

CABATA

2016

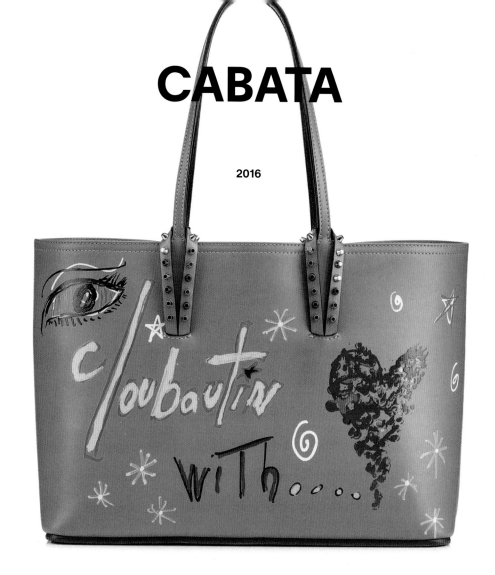

The brand's signature bag. A nod to the shoes, the bag's underside is red, like its interior. The remaining components express complete design freedom: printed, perforated, and grained leather, metal spikes, raffia, cotton, embroidery— anything is fair game. Since 2016, each May, Christian Louboutin has created a tote inspired by his travels in Africa, Mexico, Portugal, Greece, Spain, and other locations. This is his way to spotlight a country and, above all, to showcase artisanal know-how. A percentage of the bag's sales are donated to a different organization each year and always related to the country that inspired the design.

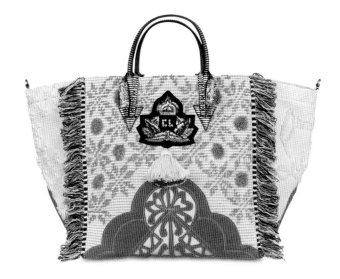

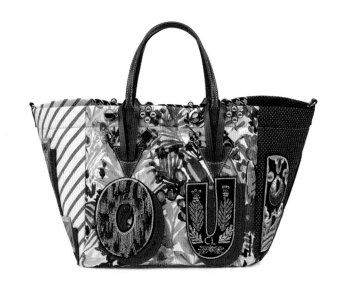

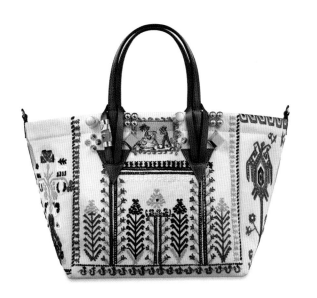

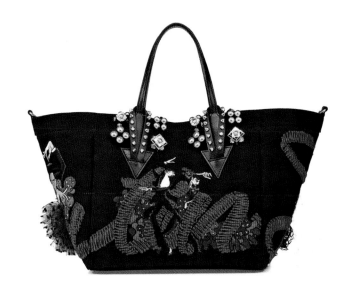

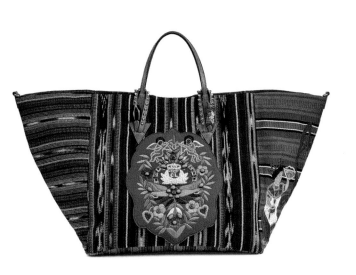

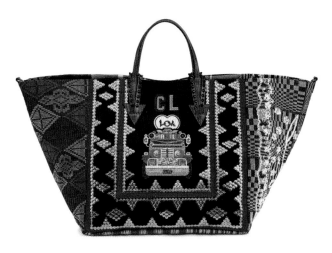

COACH

TABBY

A reinterpretation of a Coach design from the 1970s, the Tabby bag, which can be worn on the shoulder, seems timeless. The handbag went viral on TikTok in just a short time, and its hashtag, #coachtabby, has more than forty million views. Jennifer Lopez was its muse and wears it often. In 1941, Coach was just a small, family-run leather shop on 34th Street in Manhattan that made wallets by hand. It became a true American success story when the Tabby proved its capacity for modernity.

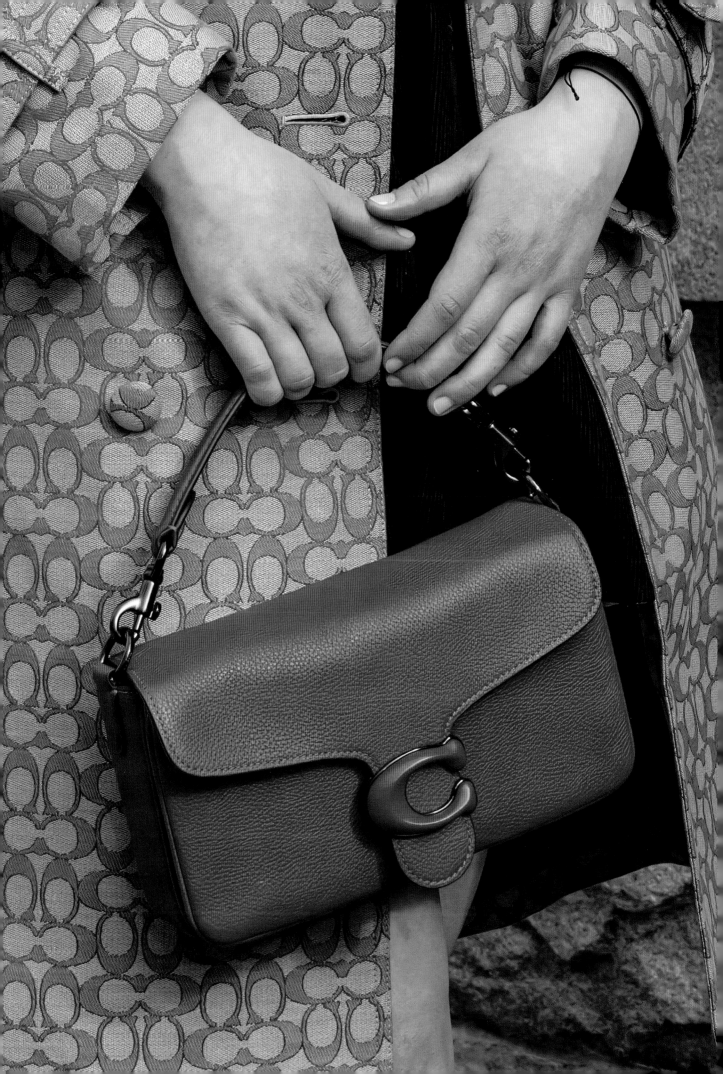

COPERNI
MINIMALIST AND FUTURISTIC

"As young designers, it's our duty to innovate."

Arnaud Vaillant and Sébastien Meyer, founders of Coperni

Founded: 2013

The story: Sébastien Meyer and Arnaud Vaillant met in fashion school in 2009 in Paris. Sébastien had come from a military school, and Arnaud was talented in math. Fashion brought them together, however, and each with complementary skills: Sébastien studied fashion design and sewing, and Arnaud studied business management. When they met, it was a natural pairing. After Arnaud's professional experiences at Balenciaga and Chanel, and Sébastien's involvement in various creative projects, they decided to launch the Coperni label. In 2015, they put their brand on hold to become artistic directors of Courrèges, but they left the fashion house after two years and, in 2018, relaunched their label. Passionate about innovation, they are constantly looking for revolutionary materials, such as the spray-on fabric they used to create a dress on Bella Hadid during the Spring/Summer 2023 fashion show.

The style: Minimal, architectural, futuristic.

Heard on the street: *"I saw that they made earrings in the shape of the Swipe Bag. I'd never thought about it, but matching your earrings to your bag is a great idea!"*

WHO WEARS COPERNI?
Hailey Bieber, Doja Cat, Megan Fox, Kylie Jenner, Dua Lipa, Rita Ora, Rihanna, Olivia Rodrigo, Rosalía, and Maisie Williams.

FASHION HOUSE FACT
The name of the brand refers to Renaissance astronomer Nicolaus Copernicus, known for his theory of the motion of the earth and planets. In his heliocentric system (known as the Copernican system), all the planets revolve around the sun, including the earth—contrary to what other astronomers of the time claimed! The name Coperni says it all about the brand.

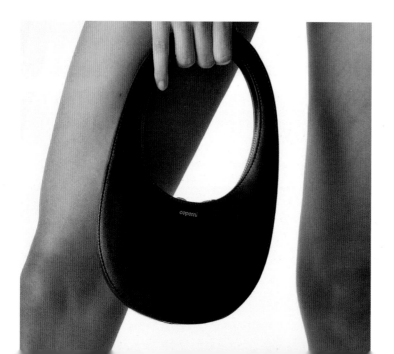

SWIPE BAG

2020

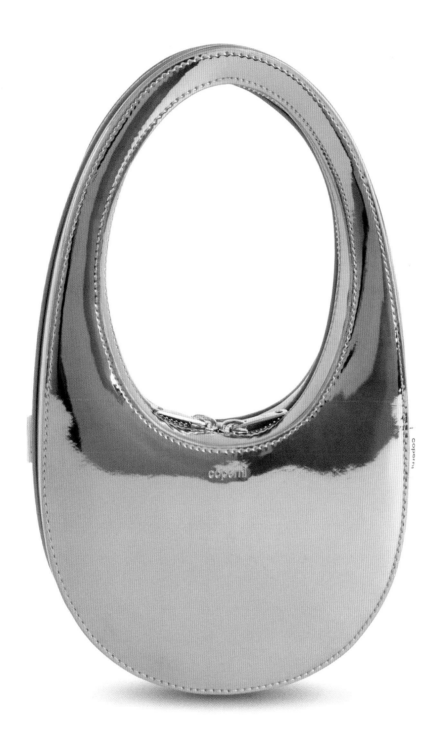

Inspired by tech and science fiction, Coperni launched the Swipe Bag, whose shape derives from the "swipe up to unlock" icon on iPhones. This leather bag can be worn on the shoulder or carried by hand from morning to evening, going easily from the office to the dance floor. Closed with two zippers, it displays the Coperni name on the front. Several versions are available: a mini format (Mini Swipe Bag), a baguette shape (Baguette Swipe Bag), and a metal handle (Ring Swipe Bag).

Every season, the Swipe Bag gets noticed, as in 2022 with its blown glass version (Glass Swipe Bag). The bag went viral, and Coperni's notoriety soared. At the Spring/Summer 2023 fashion show, Arnaud and Sébastien showed it off in a solid gold version, whose production cost was estimated at one hundred fifty thousand euros!

HEART TOTE

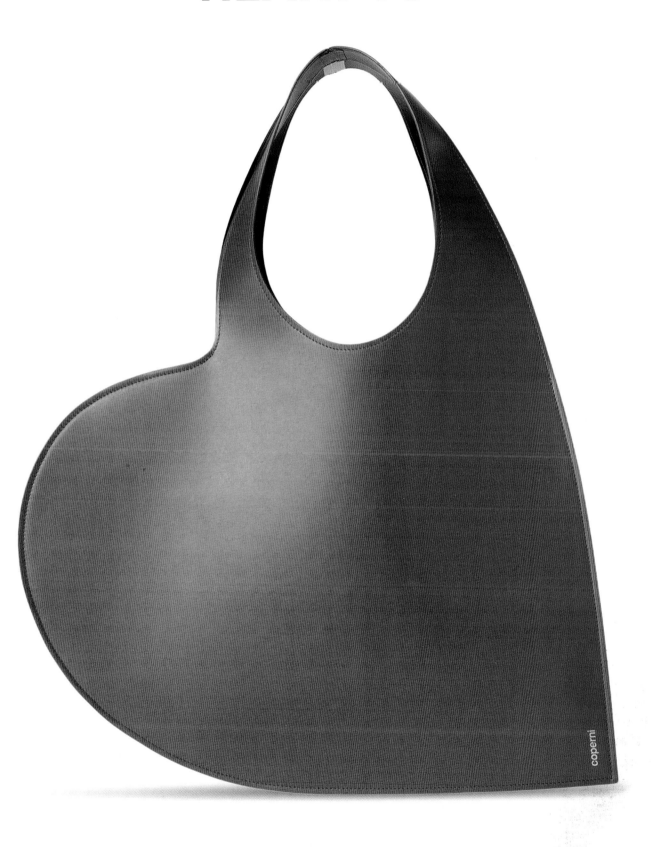

Available in leather or cotton denim, this heart-shaped tote is bound to bring you love when you wear it. It's the perfect bag for a date night.

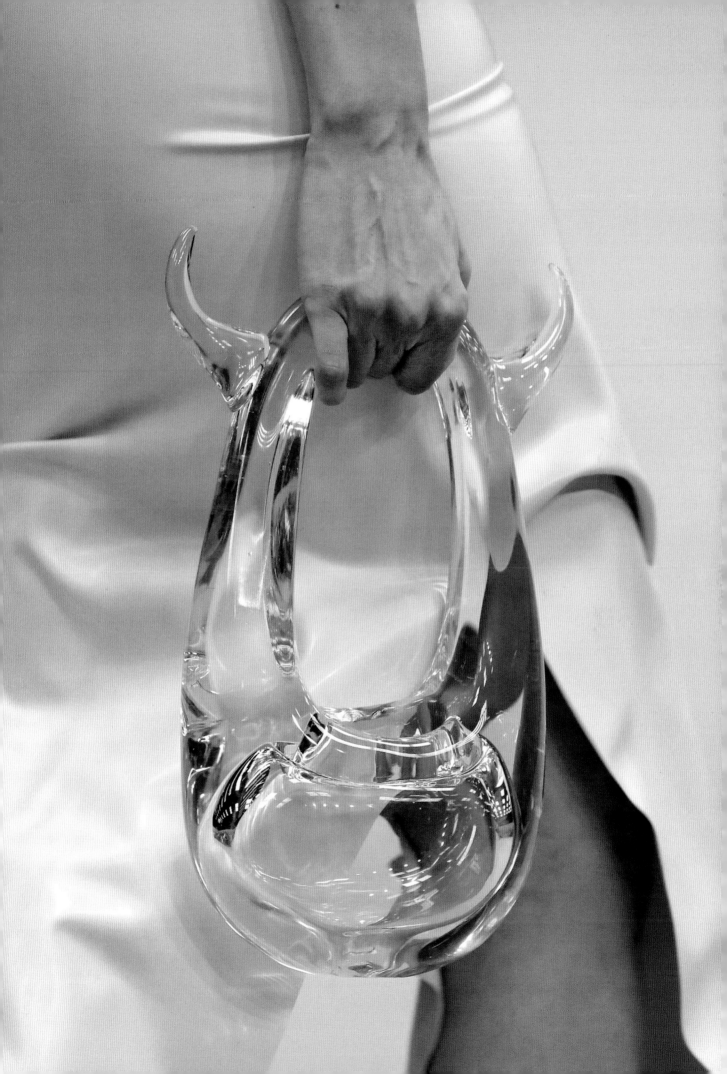

DELVAUX
A LEGACY OF LUXURY

"We're not in fashion, we play with fashion."

Jean-Marc Loubier, CEO of Delvaux

Founded: 1829

The story: In the beginning, Charles Delvaux and his wife, Jeanne Présent, expressed their expert know-how by making travel trunks and other items sold in their Brussels-based shop. In 1883, they were praised for their achievements in quality and excellence when the company was granted the title of purveyor to the Court of Belgium. In 1908, Delvaux was the first brand to file a patent for a leather handbag for its Princess model. Franz Schwennicke took over in 1933. He elevated Delvaux to a brand as exclusive as haute couture and introduced seasonal collections. After he died in 1970, his widow, Solange, set out to modernize the brand's image. Steeped in Belgian surrealism, Delvaux stays on trend and displays enormous cleverness in all its creations.

The style: Luxury and timelessness. It is first and foremost a legacy of artisanal know-how. The lines are pure, but each model has its own detail (buckle, stud, the letter *D*). All Delvaux bags have a timeless aura.

Heard on the street: *"You must be a truly legendary brand to get away with writing 'This is not a Delvaux' on your iconic bag."*

WHO WEARS DELVAUX?
Alexa Chung, Lily Collins in *Emily in Paris*, Céline Dion, Selena Gomez, Angelina Jolie, Lady Gaga, and Olivia Palermo.

FASHION HOUSE FACT
Delvaux has a monumental history of more than three thousand bag styles created since 1829. To ensure nothing is forgotten, everything is recorded in a logbook.

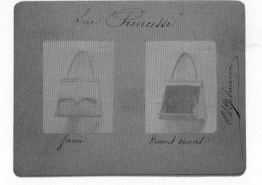

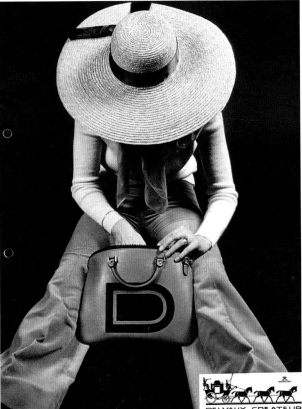

TRUNK LABEL (1885) MUSEUM DELVAUX

DELVAUX

BRILLANT

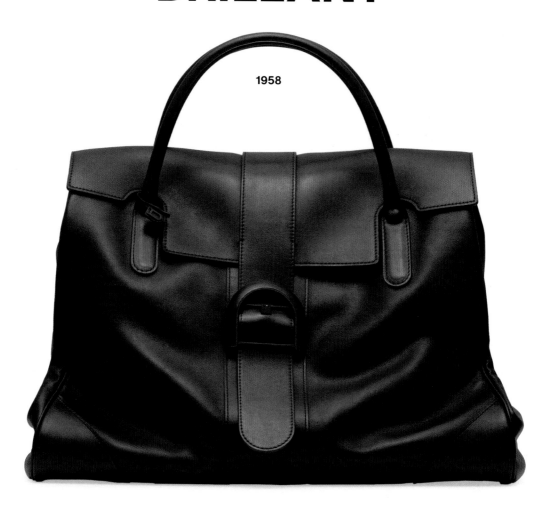

1958

Created by designer Paule Goethals for the 1958 World Expo in Brussels, the Brillant is the brand's iconic bag, recognizable by its large buckle reminiscent of Delvaux's *D*. Trained as an architect, Paule was inspired by the Philips Pavilion (which was designed by Le Corbusier and could be visited during the Expo) to create this bag with architectural forms. The Brillant requires more than eight hours to construct, with its sixty-four pieces of leather and metal. Since its creation, it has remained in collections and has been endlessly redesigned in different versions. For Lady Gaga, a big fan of the brand, the house created a model adorned with the words "Love for Sale," the title of one of her songs with Tony Bennett, released in 2021. The Brillant buckle has also gone through many variations: two-tone, monochrome, metallic, and adorned with pearls and crystals—it changes tirelessly. The bag is available in several sizes and can be carried by hand, on the shoulder, or as a crossbody.

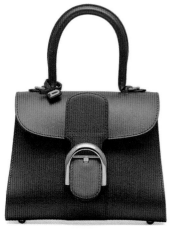
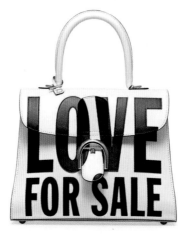
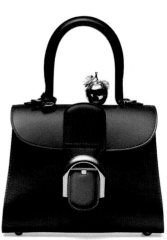

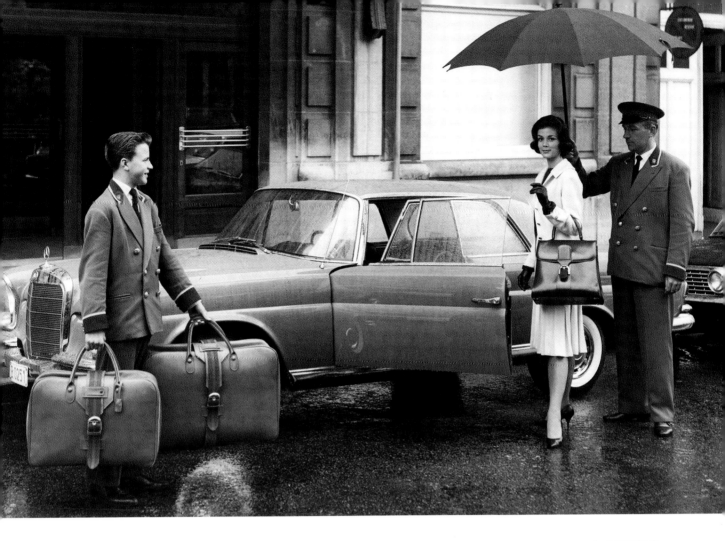

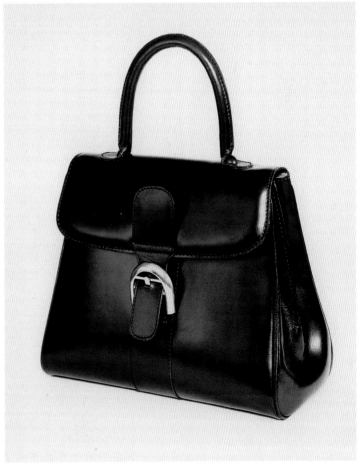

TEMPÊTE

1967

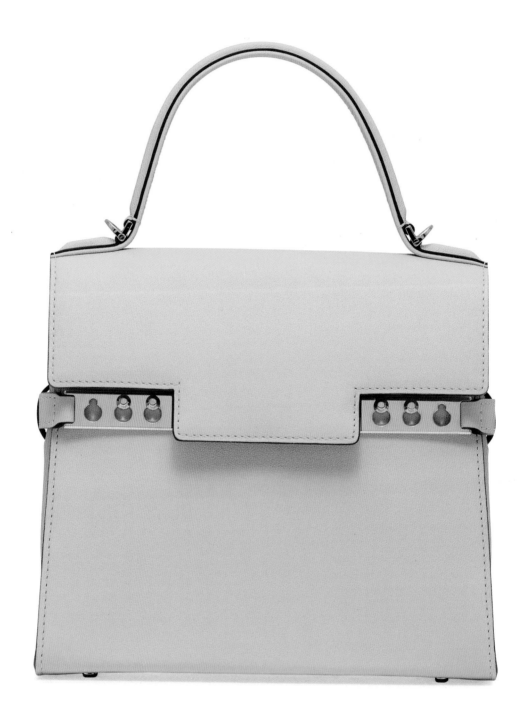

Like the Brillant, this bag was also created by stylist Paule Goethals, as part of the "Yachting" collection. Its trapezoidal shape is reminiscent of the sails on sailboats. On the front, the two leather straps meet at two rows of studs aligned on either side of the bag. It can be carried by hand or over the shoulder with a detachable strap and is available in several sizes.

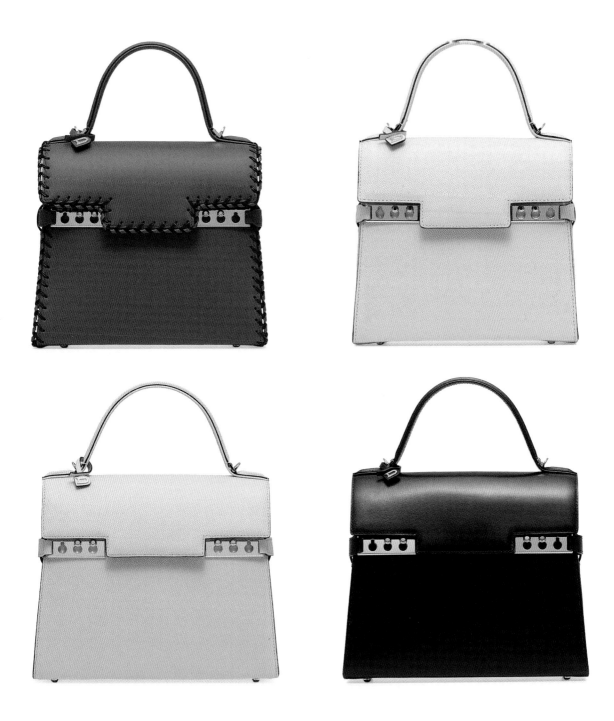

PIN

1972

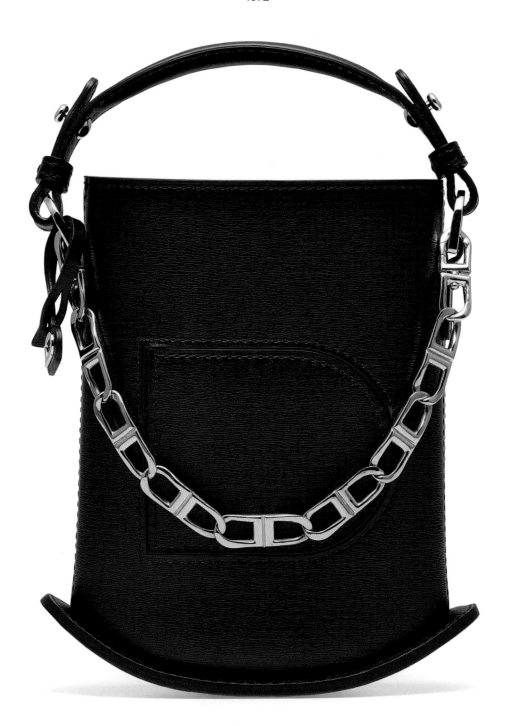

Inspired by feed sacks that hang from the necks of horses in North Africa, the Pin bag embodies the freedom of the seventies through its suppleness. Extremely simple, without a lining, it only has a small D-shaped pocket—the *D* of Delvaux—to identify it. The letter also appears on each model, with topstitching, and in different colors and leathers. The Pin comes in several shapes and sizes and can be carried by hand or worn on the shoulder or as a crossbody.

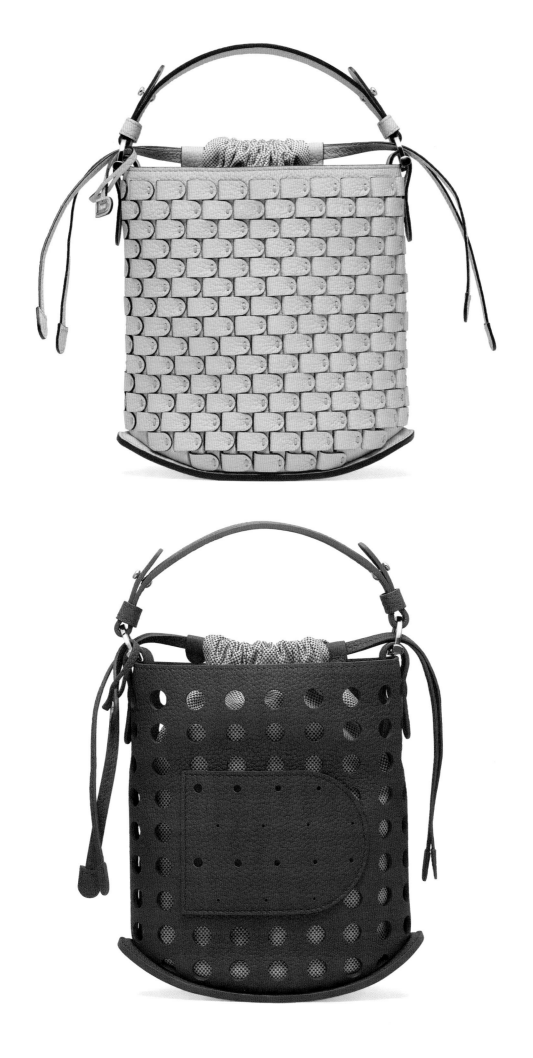

DESTREE
PURE
ARTISTRY

"I like to combine purity with uniqueness."

Géraldine Guyot, cofounder of Destree

Founded: 2016

The story: Géraldine Guyot, a graduate of Central Saint Martins College of Art and Design in London, and Laetitia Lumbroso, who holds an MBA from the French business school ESSEC and a master's degree from the French Institute of Fashion in Paris, started with hats before launching a collection of handbags, jewelry, and, in 2021, a ready-to-wear line. The brand's primary inspiration is contemporary art, a passion of Géraldine's, who creates the collections. Destree bags have a very graphic charm that gives them a little extra soul. Their colors are surprising, and their asymmetries make them modern. It's as if the bags could be a work of art displayed on a shelf.

The style: Graphic and extremely chic. There is always an atypical detail that is very recognizable.

Heard on the street: *"Although Destree bags don't have a logo, you can recognize them right away. Now that's style!"*

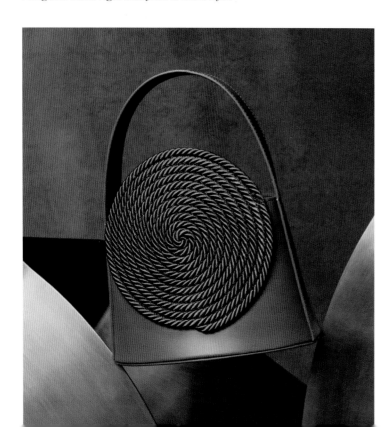

FASHION HOUSE FACT
Celebrities who have invested with Destree include Jessica Alba, Beyoncé, Gisele Bündchen, Gabriela Hearst, Rihanna, and Reese Witherspoon. This should be convincing enough to make everyone acknowledge the brand's success.

WHO WEARS DESTREE?
Beyoncé, Sofia Richie, and Kelly Rutherford.

GUNTHER

2020

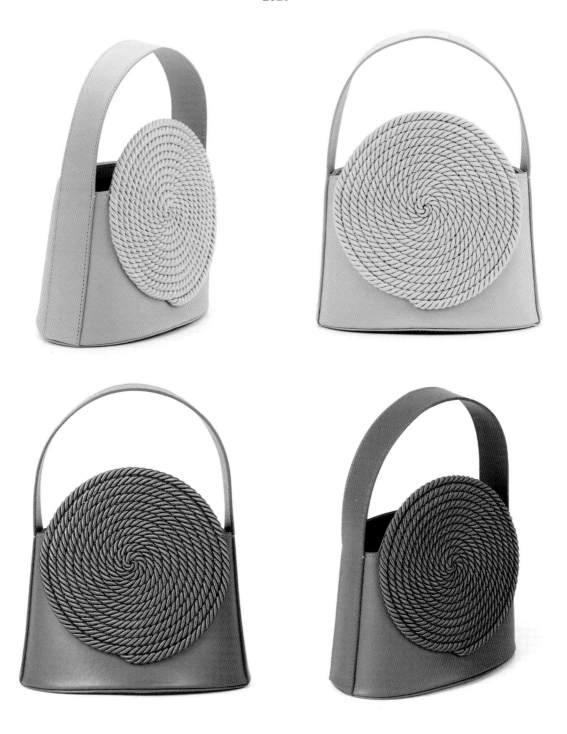

The brand's iconic bag. The ornamental round tone-on-tone passementerie contributes a certain chic to the smooth calfskin. But, above all, it lends a bit of an artistic side to the bag, almost transforming it into an object more than an accessory. The Gunther can also be worn as a crossbody. In rust, tobacco, or anise, the bag's colors are just like its design, a departure from the norm (although it's also available in black). It's enough to spice up any look.

SOL TOTE

2022

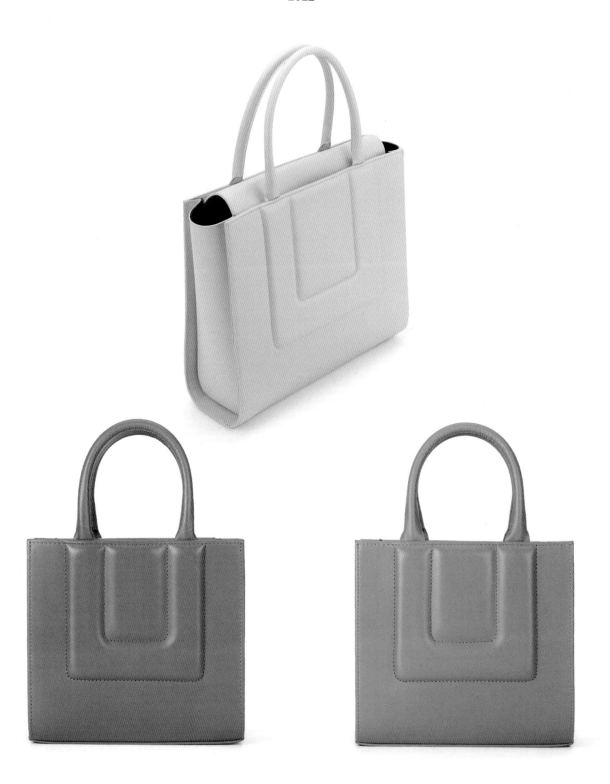

A tote bag of great purity, whose well-placed lines make it an artsy accessory. It also comes with the round ornamental passementerie, which could serve as the brand's logo. It's made of soft and smooth calfskin.

SIMONE

2023

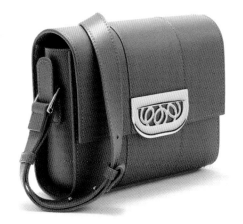
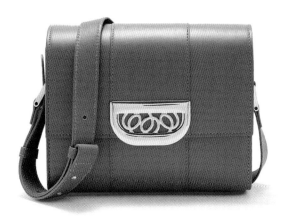
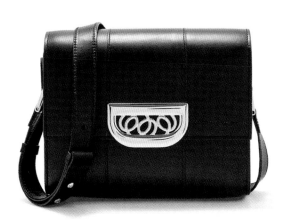
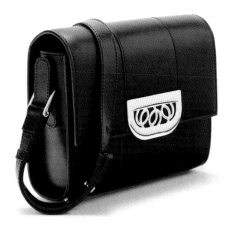
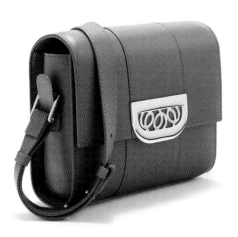
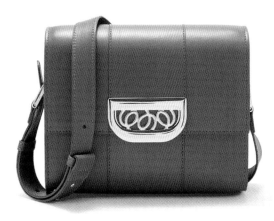

Although it has a more classic form than other bags in the line, this bag still displays a touch of originality thanks to its jewel-like clasp. It is made of calfskin and worn over the shoulder.

DIOR
THE EPITOME OF ELEGANCE

"Respect tradition and dare to be bold. One can't go without the other."

Christian Dior

DIOR. These four letters evoke all the elegance of France. Christian Dior (1905–1957), who introduced the "New Look" in 1947, revolutionized the female silhouette with his first haute couture show, which emphasized the waist and hips and highlighted women's busts. Everyone fell under his spell. Committed to embellishing feminine allure from head to toe, Christian Dior developed accessories with just as much style , from scarves and shoes to jewelry and, naturally, handbags. The work of the couturier, who established his fashion house in Paris at 30 avenue Montaigne, lives on thanks to his successors, and the handbags have diversified under their leadership. Between the Dior Book Tote and the 30 Montaigne, Maria Grazia Chiuri, the brand's creative director of womenswear since 2016, reinterprets and invents new iconic bags. With Dior, elegance is, without a doubt, a style that lives on.

7 KEY DATES

1935
Christian Dior creates fashion sketches at age thirty. He sells his drawings to fashion houses and works as an illustrator for *Le Figaro* and *Le Jardin des modes*. Three years later, he becomes a design assistant for the couturier Robert Piguet and then, starting in 1941, for Lucien Lelong.

1947
On February 12, Christian Dior presents his first Spring/Summer haute couture show at 30 avenue Montaigne. The press release announces: *"The lines of this first collection are typically feminine and made to enhance those who wear them."* This is the famous "New Look." The house's perfume, Miss Dior, is released on December 1. By 1955, the company employs more than one thousand people. The brand also opens its large boutique at the corner of avenue Montaigne and rue François 1er.

1957
Christian Dior dies of a heart attack at age fifty-two. As he had wished, his first assistant, Yves Saint Laurent, succeeds him. Laurent causes a sensation by presenting his "Trapèze" line.

1960
Marc Bohan is appointed creative director of the fashion house and creates the Slim Look. He remains at Dior for nearly thirty years.

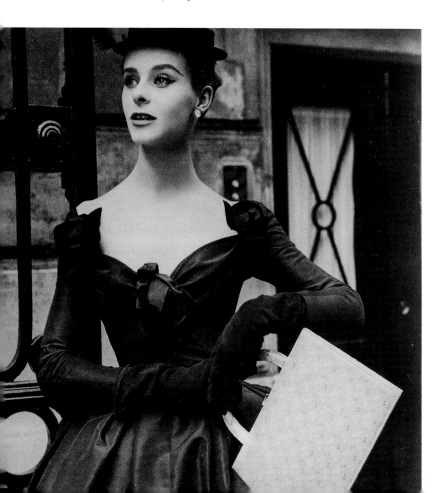

1989
Gianfranco Ferré, from Italy, takes over as artistic director.

1996
John Galliano puts his stamp on the Dior style: *"The Dior woman is the very essence of glamour, strength, and sophistication,"* says the British couturier. Raf Simons succeeds him as artistic director from 2012 to 2015.

2016
Maria Grazia Chiuri becomes the new artistic director. *"I decided to approach my work like that of a museum curator: I arrive at a fashion house, I discover an incredible heritage, and I use the different aspects of it very freely,"* explains the Italian, who collaborates with artists and artisans from all over the world.

01

02

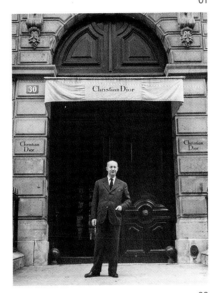

03

04

05

"If you had to settle for just one handbag color, choose either black or brown, because it will go with everything. And if you want an evening bag, make it gold!"

Christian Dior, *Le Petit Dictionnaire de la mode* (1954)

THE 5 HOUSE CODES OF DIOR

01.
Gray and pink
These two colors evoke Christian Dior's childhood home in Granville.

02.
Flowers
Christian Dior was very fond of lily of the valley and often wore a sprig of it on his jacket.

03.
Paris
30 avenue Montaigne, where the fashion house was founded, embodies fashion in the eyes of the world.

04.
Neoclassicism
Christian Dior's taste for the eighteenth century is the origin of many of the house codes (toile de Jouy, fontange knot, oval medallion, etc.).

05.
The star
Christian Dior once found a gold-plated star, which became his good luck charm.

MONSIEUR DIOR'S OBJECTS OF FANTASY

Christian Dior was aware of the importance of accessories: "The elegant woman cannot do without them. The more limited your clothing budget, the more careful you need to be about your accessory choice." This is why, from his first collection, he opened a tiny shop at 30 avenue Montaigne in the tradition of eighteenth-century frivolity shops. The shop outgrew its location and closed in 1955 in favor of a large boutique where the brand's various artistic directors perpetuated the spirit of the "total look" instilled by Dior.

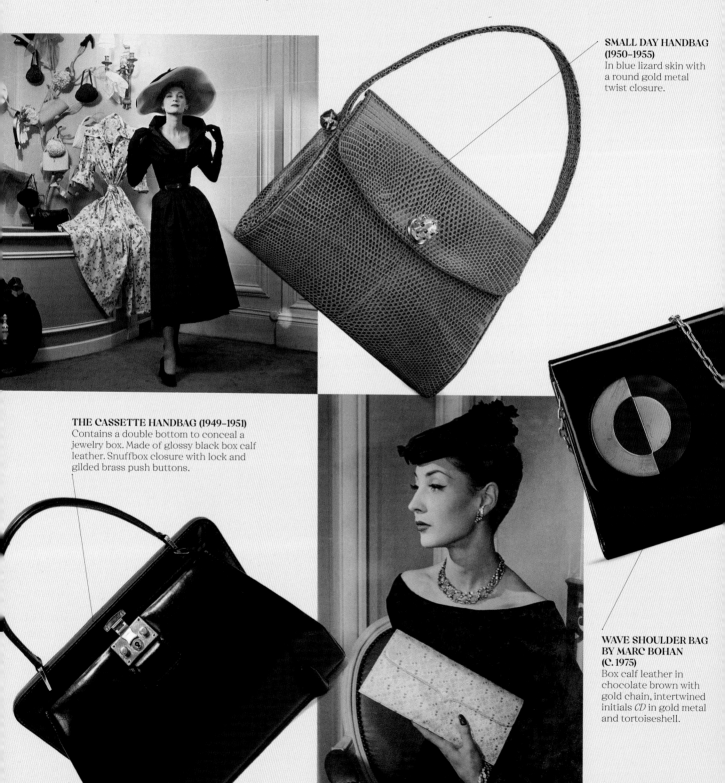

SMALL DAY HANDBAG (1950–1955)
In blue lizard skin with a round gold metal twist closure.

THE CASSETTE HANDBAG (1949–1951)
Contains a double bottom to conceal a jewelry box. Made of glossy black box calf leather. Snuffbox closure with lock and gilded brass push buttons.

WAVE SHOULDER BAG BY MARC BOHAN (C. 1975)
Box calf leather in chocolate brown with gold chain, intertwined initials *CD* in gold metal and tortoiseshell.

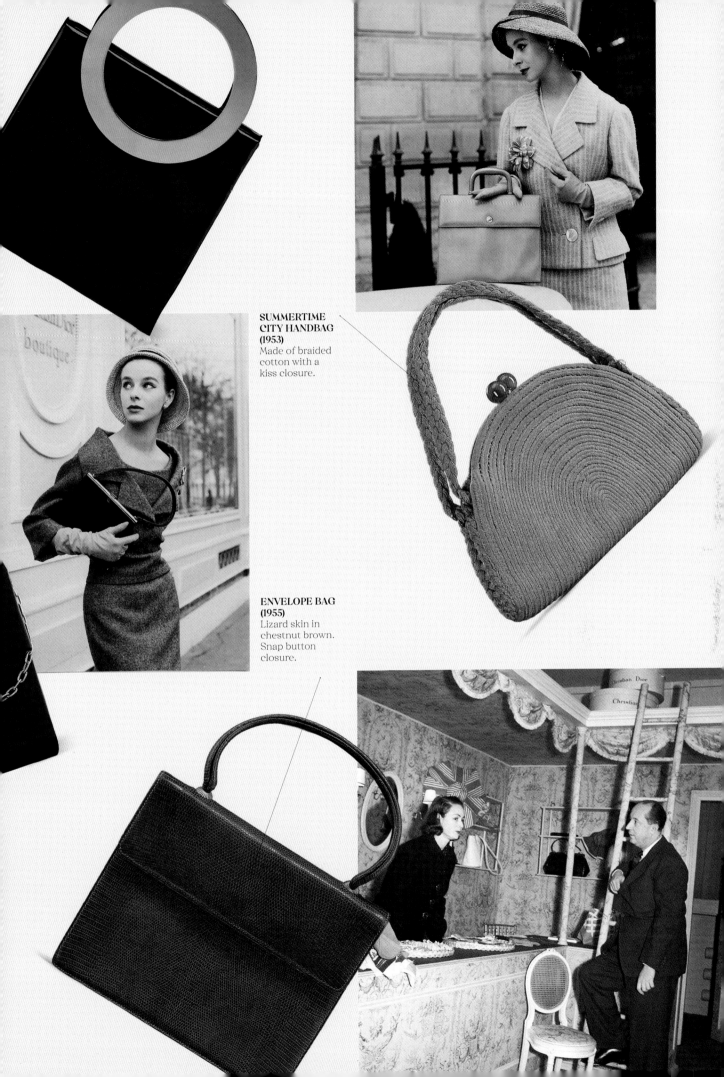

SUMMERTIME CITY HANDBAG (1953)
Made of braided cotton with a kiss closure.

ENVELOPE BAG (1955)
Lizard skin in chestnut brown. Snap button closure.

THE OBLIQUE PATTERN

Created in 1967 by Marc Bohan, the *toile oblique* takes its name from Christian Dior's Fall/Winter 1950–1951 haute couture collection. It has become a signature of the brand. The four letters of Dior are reproduced diagonally in a repeating pattern, symbolizing the heritage of elegance without limits.

Originally, Marc Bohan and stylist Philippe Guibourgé, with whom Bohan worked, had contacted suppliers to develop a waterproof cotton toile with a logo for luggage. Today, the fabric continues to be made in the historic weaving ateliers in the heart of Flanders.

The Oblique pattern first appeared on a bag during the Spring/Summer 1969 haute couture show. It appeared on several pieces of luggage in the 1970s.

John Galliano has often used it, not hesitating to create a total logo look. Maria Grazia Chiuri, inspired by the brand's archives, uses this material on many bags, including the Dior Book Tote. Even when logos aren't popular in fashion, Christian Dior's does well, no doubt because it is considered a part of French heritage. It has become timeless.

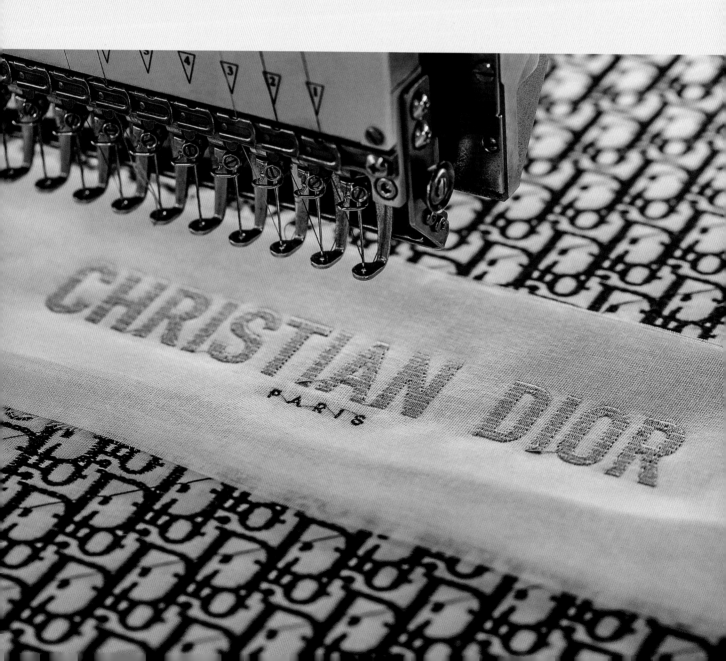

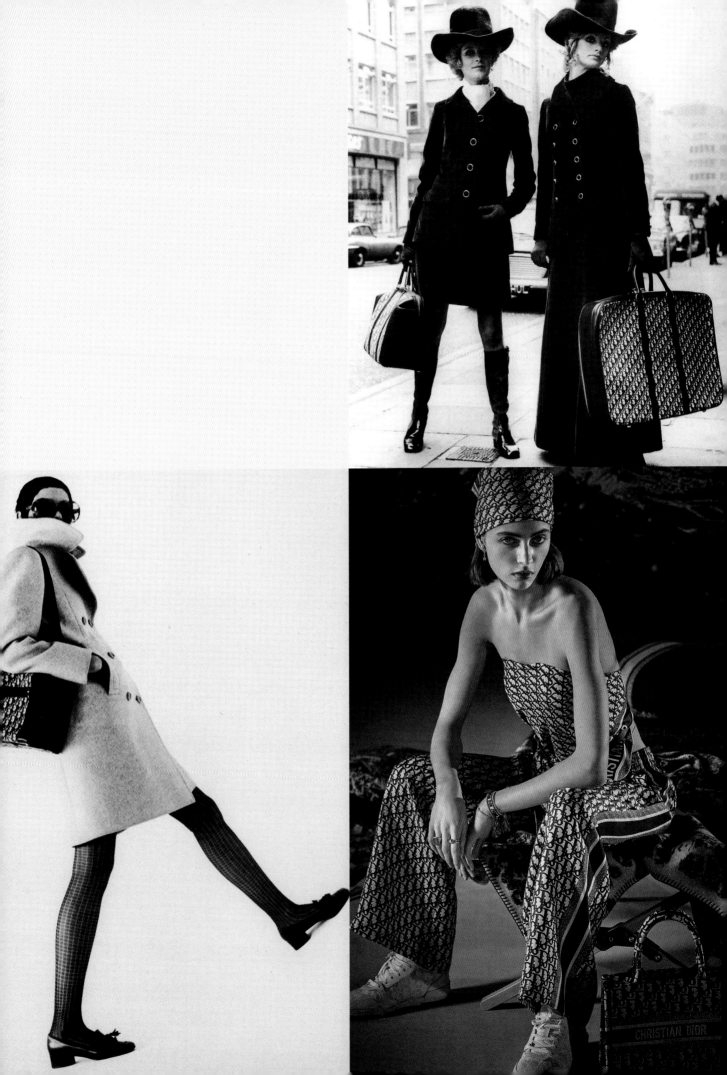

LADY DIOR

1995

Almost thirty years after its creation, this bag is still as desirable as ever. Its highly structured line with its two top handles earned it the label "classic" as soon as it was released. It is the kind of handbag of which Mizza Bricard, Christian Dior's muse, was fond. It is made of quilted leather and adopts the motif of the *cannage* weaving dear to the brand, notably present on the Napoleon III cane chairs in the presentation rooms of the haute couture house. The letters *DIOR*, as charms hanging from one of the handles, are a nod to the charms that Monsieur Dior loved. The bag was designed by Gianfranco Ferré, the house's artistic director, who was passionate about architecture, just like Christian Dior. He named the bag Chouchou.

Under the artistic direction of John Galliano, the bag was created in many colors to associate it with collections, and it was often tinged with an extra flair such as satin, fringes, or a houndstooth pattern (another design that represents the brand's codes); many other materials and patterns followed.

In 2012, Raf Simons interpreted this legendary bag. He made it very artistic by imprinting on it a sketch of a shoe by Andy Warhol. Additionally, he showcased the brand's many types of expertise in craftsmanship by adorning it with pearls and floral embroidery.

With Maria Grazia Chiuri, the Lady Dior was reinterpreted in a very modern way, but without ever losing sight of the house's codes. Chiuri softened it somewhat, widened the shoulder strap, and added the brand's little signature charms. The *macrocannage* motif is represented with studs, the toile de Jouy is in leather, and the leather and metal details are matte.

Thanks to these fashion designers, the Lady Dior has spanned the decades while remaining very modern, a hallmark of any iconic bag.

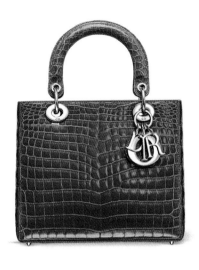

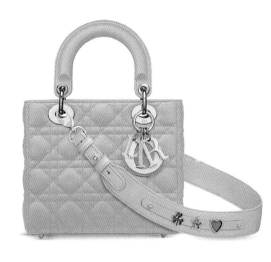
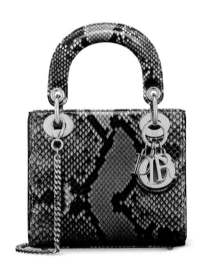
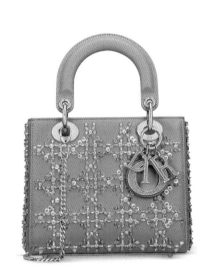

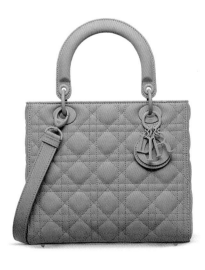
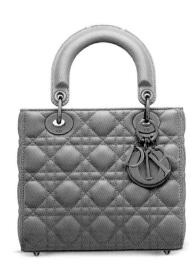
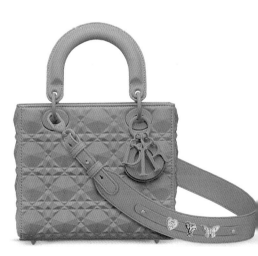

A LADY'S HANDBAG

Why was the Chouchou bag
renamed Lady Dior?

THE BEGINNINGS

Bernadette Chirac, then first lady of France, wanted to give a gift to
Princess Diana, who was expected in Paris on September 25, 1995, for
the opening by President Jacques Chirac of a retrospective of Paul
Cézanne's work at the Grand Palais. The LVMH group, the event's
sponsor, organized a private viewing dinner for the benefit of several
charitable foundations, including Great Ormond Street Hospital in
London, whose patron was the princess of Wales.

CHOOSING THE GIFT

A week before Lady Diana's visit, Bernadette
Chirac telephoned Jean-Paul Claverie, a long-
time friend of the princess and advisor to
Bernard Arnault, to ask him to make her a gift to
present to the princess because he was familiar
with the princess's tastes. Bernard Arnault came
up with the idea of this new bag, which at the
time was still just a prototype.

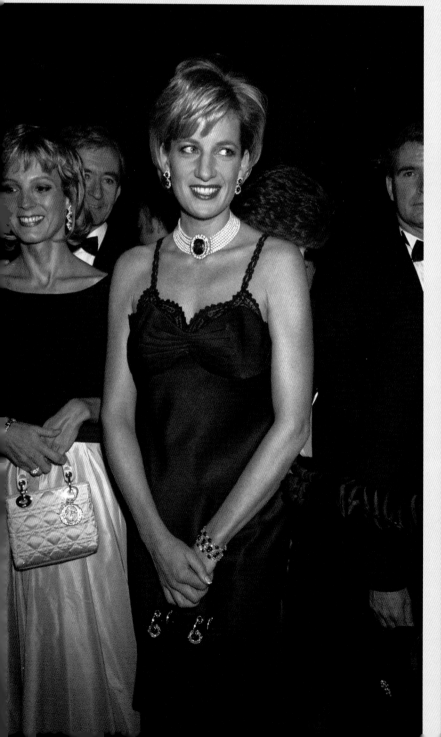

PRODUCING THE BAG

A week is a very short time to develop such a model. But the ateliers worked day and night to ensure the black leather bag, embellished with gold-plated charms, was ready for the princess's arrival.

PRESENTING THE BAG

It was at the Élysée Palace, at teatime, that Mrs. Chirac, in the presence of Mr. and Mrs. Arnault and President Chirac, offered the bag to the princess.

THE DECISIVE OUTING

Two months later, in November 1995, on an official visit to Argentina, Princess Diana got off the plane in Buenos Aires carrying the handbag gifted by Mrs. Chirac. The photo spread around the world,

A LADY'S HANDBAG

Diana was often seen carrying the bag. She would eventually order more, including in navy blue and sky blue. The bag naturally adopted the name Lady Dior—once again a story of elegance.

THE CREATION OF A LADY DIOR

In Scandicci, near Florence, where Dior has its Italian manufacturing operations, the prototypes of the handbags, special orders, and limited editions are developed.

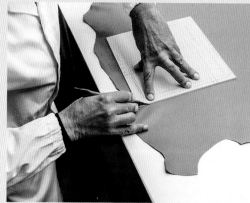
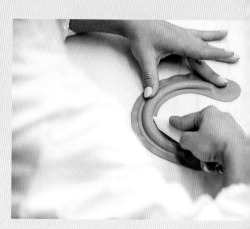
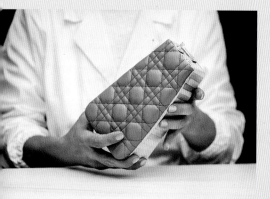
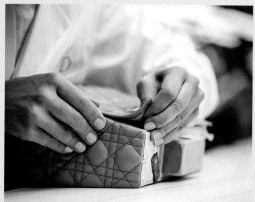

01.
The stylist makes an "artistic" drawing of the bag, in perspective, including a detailed technical drawing for each piece.

02.
A cardboard version of the bag is made to test the conformity of the model.

03.
From the technical drawings, templates are cut out of a rigid and thick cardboard material.

04.
The craftsperson cuts the skin with a blade to obtain the different parts of the bag. This is an extremely meticulous task, as the skins are not naturally uniform and their thickness differs depending on the part from which they are made.

THE ASSEMBLY
One hundred and forty
different pieces (leather,
quilting, reinforcements,
lining, metal elements) can
make up a Lady Dior.

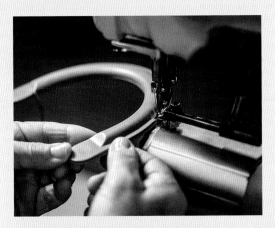
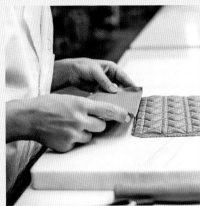
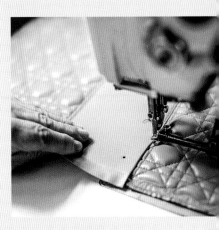

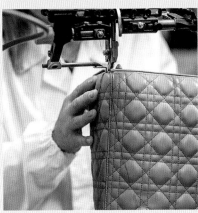
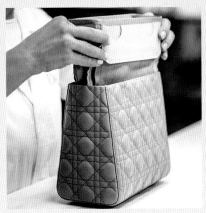

05.
The pieces are reinforced, quilted,
and lined.

06.
The cannage motif is machine-stitched.

07.
The assembly is done on a wooden frame. The bot-
tom and four sides are bonded using a brush.

08.
The craftsperson applies the leather to the fine
steel handles.

09.
The assembled bag is machine-stitched.

ART ON DISPLAY
ON THE LADY DIOR

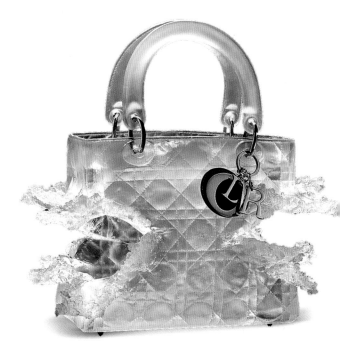
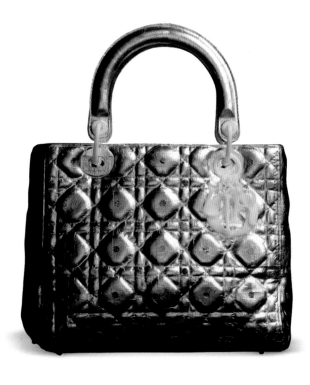
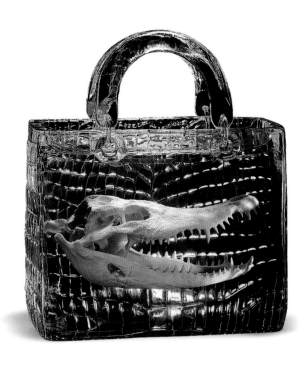

In 2011, Dior organized an exhibition in Shanghai called *Lady Dior As Seen By*, presenting works of art representing and reinterpreting the Lady Dior bag. Artists from all over the world continue to enrich this collection, which is exhibited worldwide.

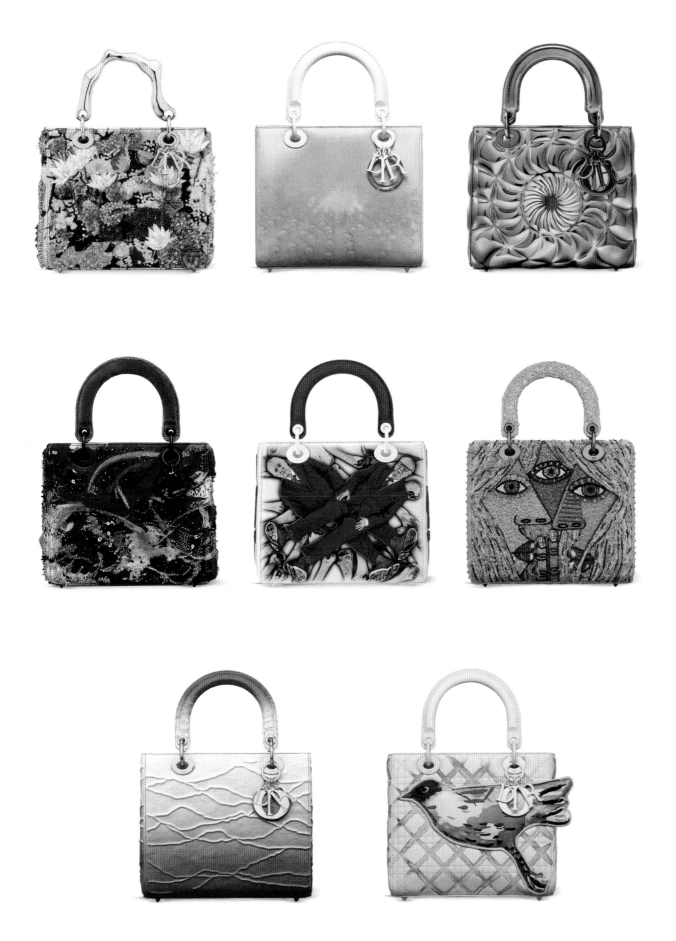

Since 2016, the house of Dior has invited artists to express their styles on the Lady Dior bag through the "Dior Lady Art" collection, which creates highly sought-after limited editions of the handbag.

SADDLE

2000

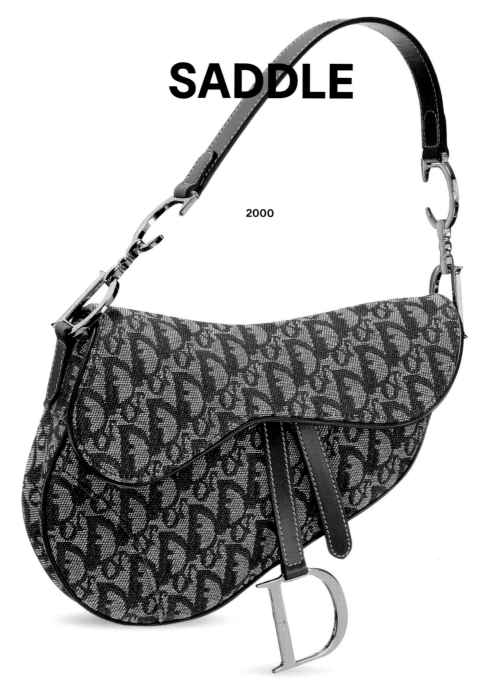

How do you go from an It bag to a legendary bag?

Create a handbag with a recognizable shape.
For Spring/Summer 2000, John Galliano had a taste for the Wild West and put together a collection inspired by the world of cowboys. With his eccentric style, he created his very first women's handbag in the shape of a saddle, with the *D* (for Dior) acting as a stirrup. It was made in the Dior Oblique pattern and called the "logo" bag.

Make it available in all materials and colors.
John Galliano reinterpreted the handbag the following season, capturing everyone's attention. All the VIPs of the time carried it and, in 2002, it was renamed Saddle. The bag even appeared in the television series *Sex and the City* with Sarah Jessica Parker—a true endorsement for the time.

Let it be.
Other bags arrived on the scene and took a little bit of the limelight from the Saddle.

Believe in its lucky star.
In 2014, Beyoncé stepped out with a Saddle on her arm, as did K-pop singer CL in 2016. In 2017, Bella Hadid carried it and made it an object of desire. The fashion furor was underway: The Saddle's price witnessed a rapid rise on resale sites.

Orchestrate its rebirth.
In 2018, Maria Grazia Chiuri put the Saddle back in the saddle. It earned its moniker as an iconic bag and became highly sought after in rarer leathers, becoming a look for high-end outfits. The Saddle will indeed prove difficult to unseat as an icon.

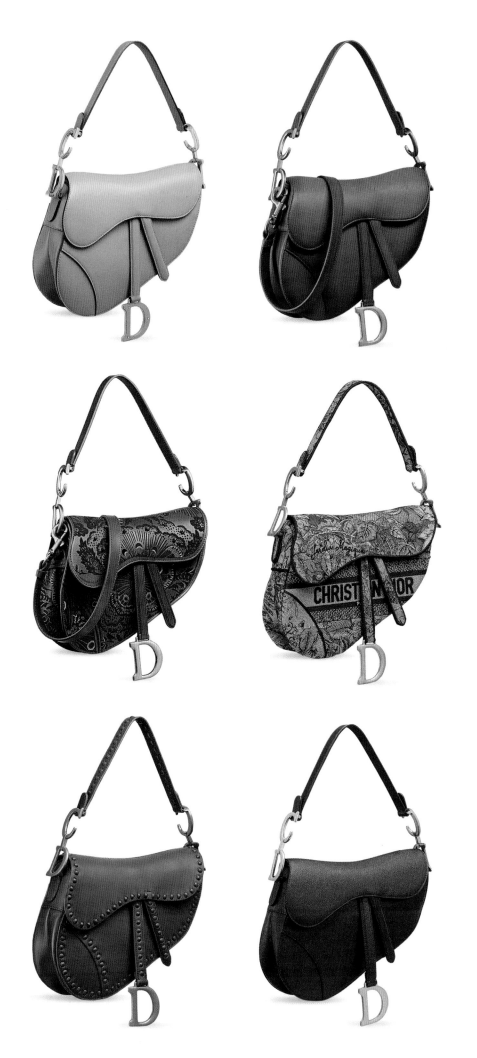

THE SADDLE
"ALL AROUND THE WORLD"

by John Galliano, in 2007

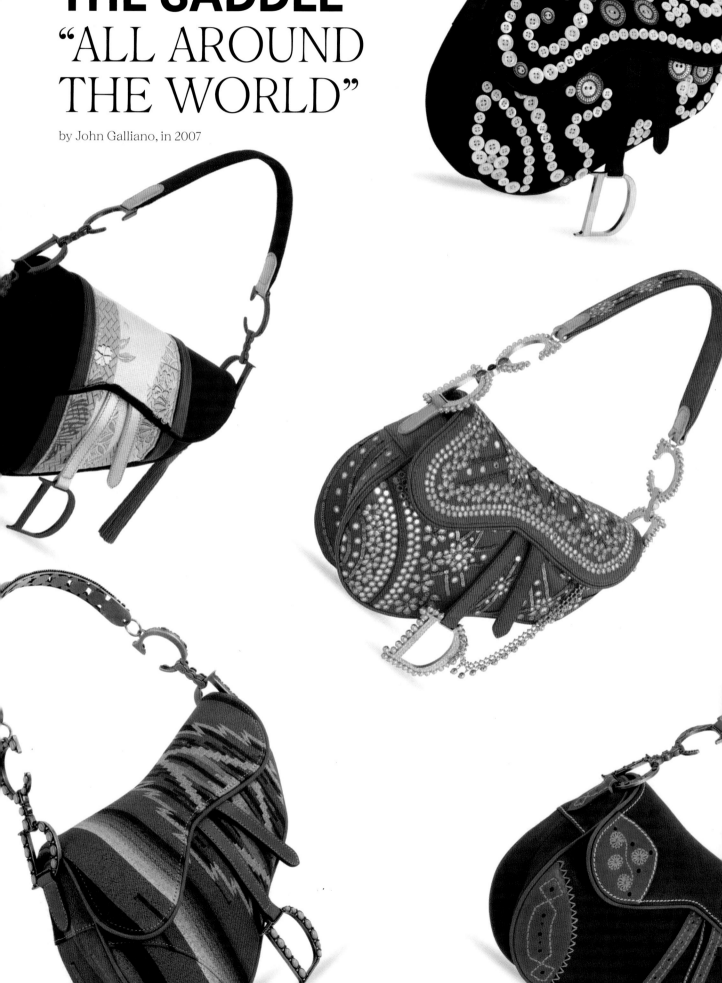

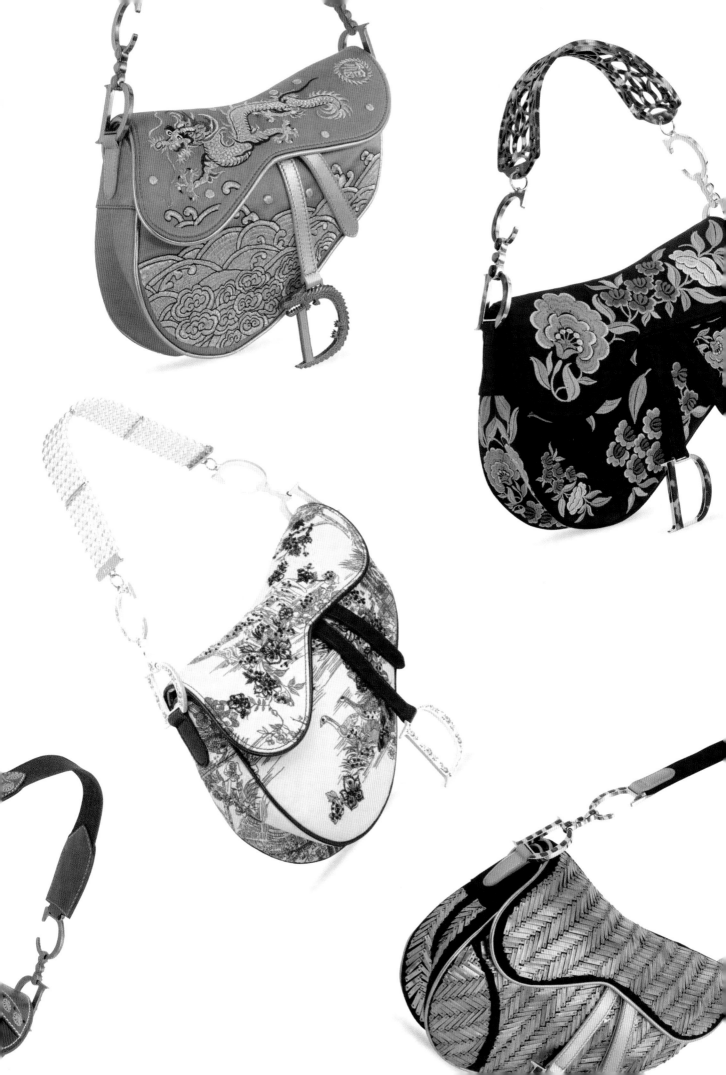

DIORAMA

2015

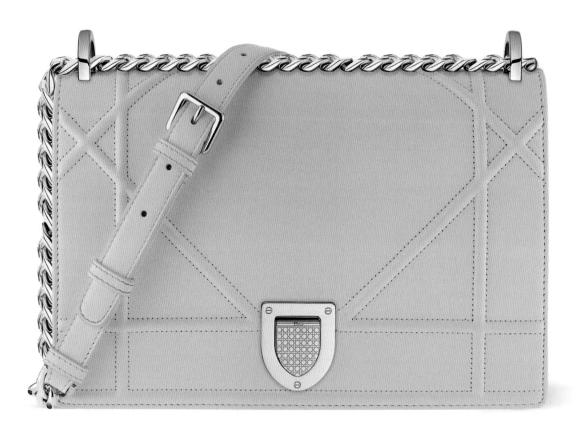

The Diorama was created under the direction of Raf Simons. Ultramodern, it adopts a very architectural representation of the cannage motif as oversized. It is patterned or ribbed. It has a crest-shaped clasp and a double handle with an open-link chain engraved with the initials *CD*.

Elegance comes together with modernity. The bag comes in many combinations: the "essentials"; the classic leathers with the Archicannage motif seen on the runway, which are more futuristic; and the "coutures," luxurious pieces made of exotic leathers.

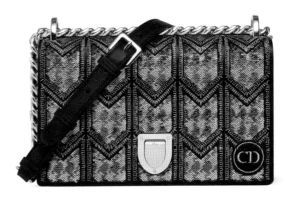

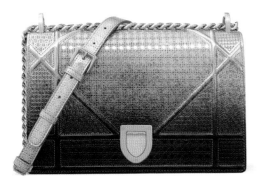

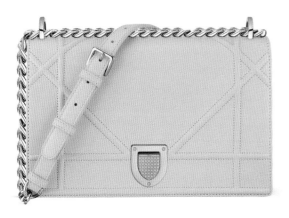

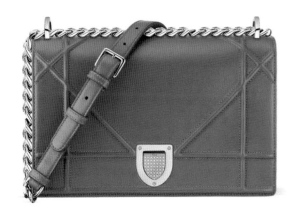

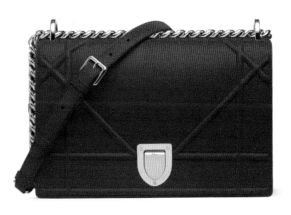

DIOR
BOOK TOTE

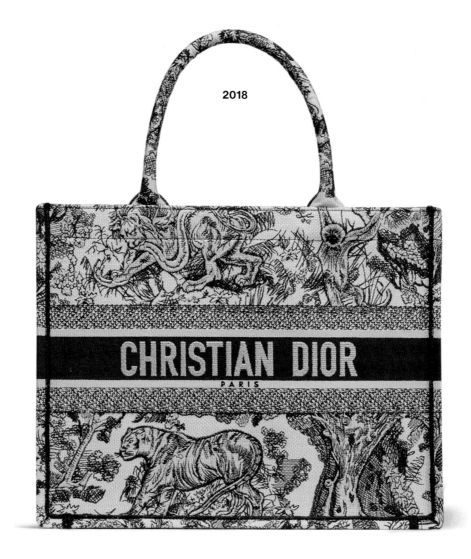

2018

As soon as it appeared on the runway in 2018, this rectangular bag, which bears the name Christian Dior in capital letters, became an obvious choice in Maria Grazia Chiuri's collections.

What to know about the Dior Book Tote?
Its creation requires exceptional skill. A three-dimensional embroidery technique was developed just for this handbag. This particular toile requires many hours of construction. Each of the stitches in the bag's designs is first reproduced by hand before being woven. The embroidery that creates a relief becomes a material in itself. The bag is available in mini, small, medium, or large sizes and is transformed to suit the different themes of the seasons: in Dior Oblique, toile de Jouy, the cannage motif, small floral print, exotic garden, or a map of Paris.

For fans of customization, a personalization service on the company website called ABCDior allows you to put your first name or initials on the bag to make it a true one-of-a-kind.

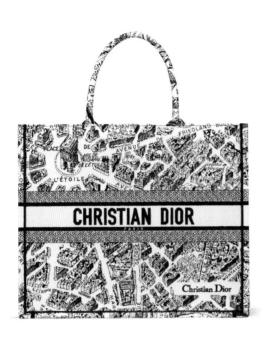

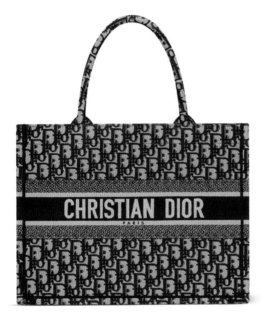

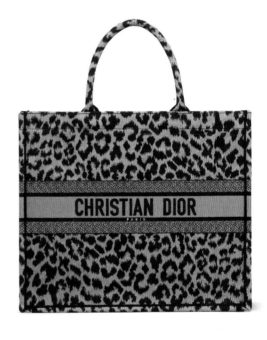

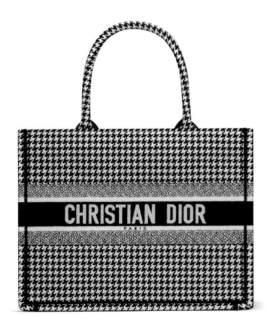

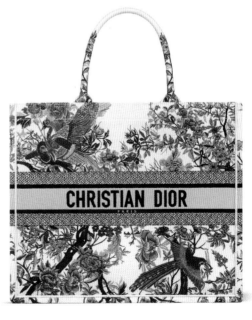

30
MONTAIGNE

2019

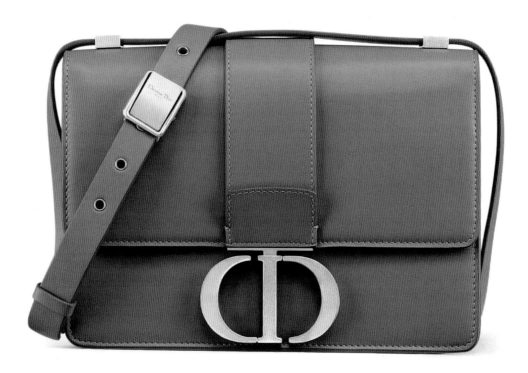

Designed by Maria Grazia Chiuri, this bag is part of the "30 Montaigne" line, which was inspired by Dior's iconic looks and which offers bags with classic lines. It bears the initials of the brand's creator and reveals a certain idea of today's Dior woman: free, modern, and always elegant.

It is made of box calf leather and is handmade in Dior's ateliers in Italy. The 30 Montaigne signature is embossed on the back of the bag. Its leather strap with military-inspired buckle allows it to be carried by hand or over the shoulder. New variations are created each season, including with crushed leather, raffia, and smooth or hammered metal chains. It's a handbag here to stay.

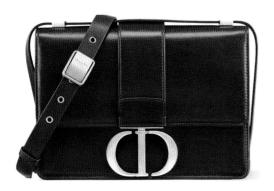

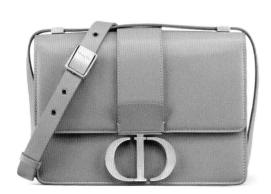

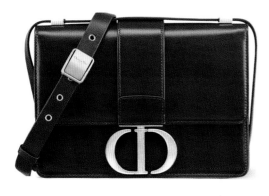

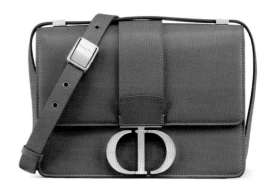

DOLCE & GABBANA

SICILY

This is Dolce & Gabbana's iconic bag par excellence. With its structured shape, which appears to be inspired by the 1950s, you can immediately see that the Sicily can stand the test of time without losing its beauty. Created in 2009, it has since been reimagined in many colors, prints, and sizes. Its name is a reminder of the importance of Sicily, the birthplace of Domenico Dolce, from where the two creators regularly draw inspiration. *Viva Italia*!

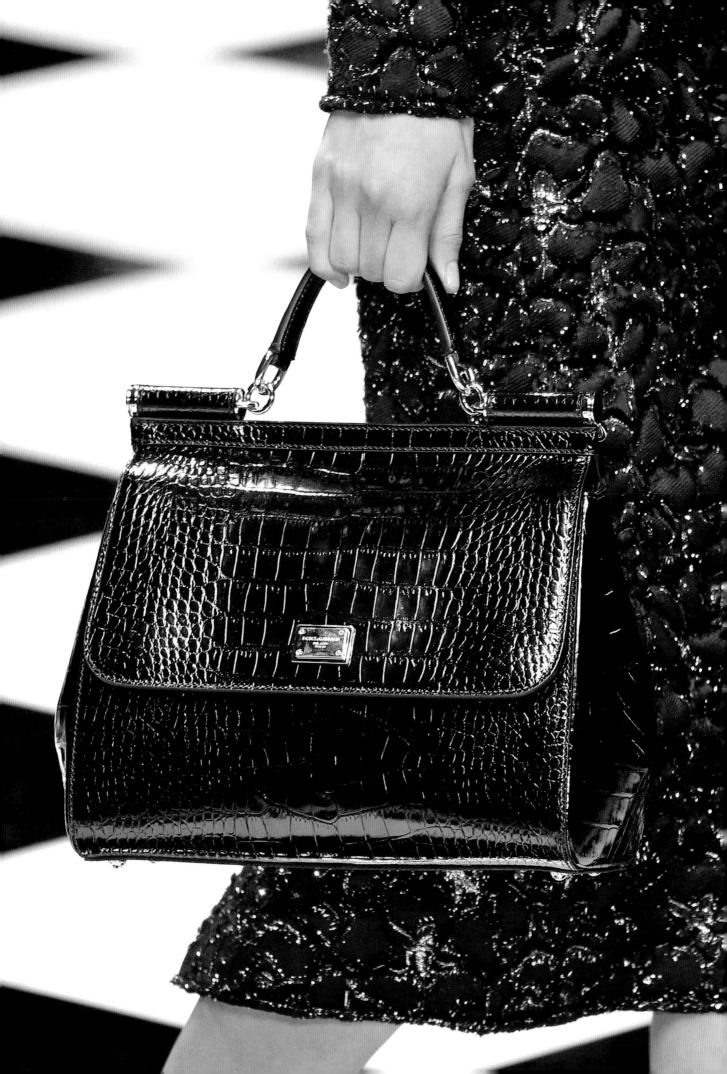

FENDI
MASTERS OF CREATIVITY

"A bag should have its own sensuality: not too soft, not too rigid. The alchemy of proportions is an art!" **Silvia Venturini Fendi**

Although almost one hundred years old, this fashion house has used its know-how to stay current. It all started with bags and fur. Today, Fendi also offers women's, men's, and children's clothing, decorative objects, shoes, high jewelry, and Fendi couture. After Karl Lagerfeld reigned for more than fifty years as artistic director of the ready-to-wear collections, Kim Jones took the reins. Known in its early days for its furs imagined in original ways, the luxury label is now just as famous for its two iconic bags: the Baguette and the Peekaboo. Created by Silvia Venturini Fendi, the granddaughter of the founders, these bags are now the jewels of the brand worldwide.

7 KEY DATES

1925
Edoardo Fendi and Adele Casagrande create Fendi. They open their first store in Rome in 1926.

1946
Paola, Anna, Franca, Carla, and Alda, the five daughters of the founders, become part of the family business and found the fashion house, notably by creating a high-end fur line called "Amore."

1965
The young designer Karl Lagerfeld is hired to reinvent the way the fur is fashioned.

1966
The first ready-to-wear fur collection appears. In 1977, Karl Lagerfeld designs the first ready-to-wear collection.

1992
Silvia Venturini Fendi, Anna's daughter, joins the fashion house. She takes over managing the leather goods, reinterprets the "Selleria" line, and creates the iconic Baguette bag.

2001
LVMH acquires a majority stake in Fendi and promotes the brand worldwide.

2020
After the death of Karl Lagerfeld, Kim Jones arrives at the brand as the new artistic director of the ready-to-wear collections. Silvia Venturini Fendi continues to head the accessories department. Delfina Delettrez Fendi, the fourth generation of the Fendi family, is the artistic director of jewelry and high jewelry.

01

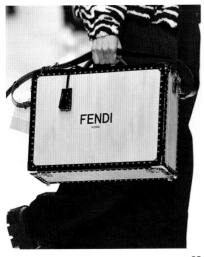

02

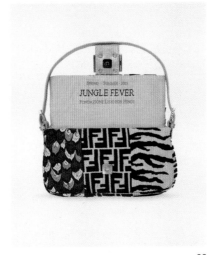

03

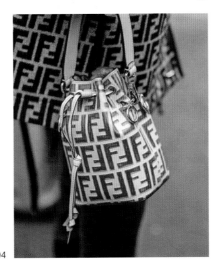

04

THE 5 HOUSE CODES OF FENDI

01.
Fur
with a creative twist using innovative techniques.

02.
The color yellow

03.
Craftsmanship
of classic bags.

04.
The *FF* logo

05.
The city of Rome

THE SELLERIA LINE

1938

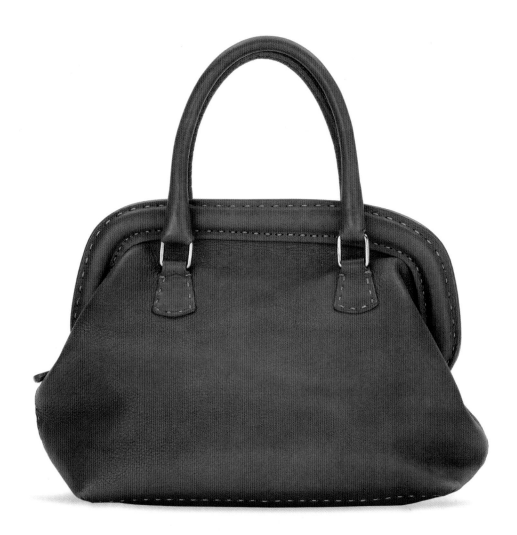

Launched by founders Edoardo and Adele, this collection, called "Selleria," is character- ized by hand manufacturing techniques inherited from Roman master saddlemakers. The bags are made of Cuoio Romano, a soft, grainy leather pierced and sewn by hand, making it even more precious. When Silvia Venturini Fendi, Anna's daughter, joined the fashion house in the early 1990s, she reinterpreted this emblematic line of handbags, travel bags, and small leather goods, and made it into a limited-edition series. Just as was done in 1938 when the line began, the bags are entirely handcrafted by artisans in Rome.

X-RAY

1950

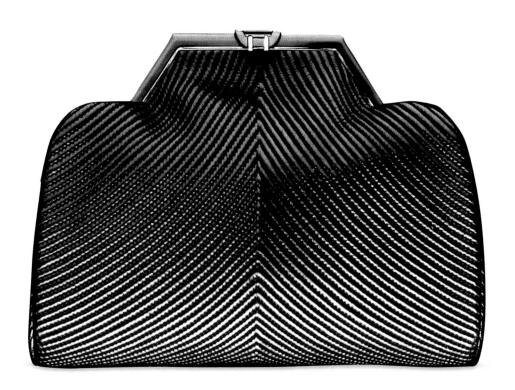

This handbag is considered the brand's first It bag, and is so named because of
the geometric stitching that gives the sense of penetrating through the leather. The
X-Ray is no longer produced today.

BAGUETTE

1997

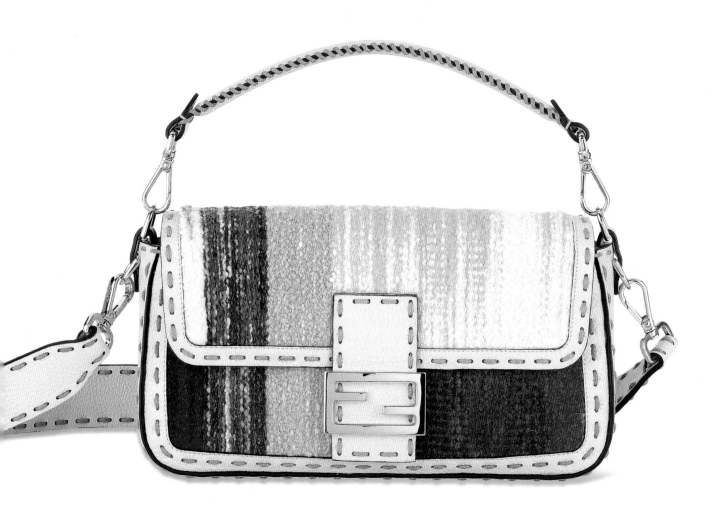

When we think of Fendi's Baguette bag, we immediately think of Sarah Jessica Parker (Carrie Bradshaw) in *Sex and the City*, who made the bag a true character in the television series. Today, the Baguette has made a name for itself and needs no help capturing the spotlight. New generations of young girls followed and dreamed of carrying this little bag as an accessory to their first parties. This is one of those bags that launched bags as a fashion accessory. It is held under the arm, as the French do with their baguettes. Its shape is rather basic, but its design evolved: Rather than settling for a bag with a minimal shape, Silvia Venturini Fendi, its creator, had the idea of releasing different and somewhat refined versions of it in a wide variation of materials. All styles and prices are available. By making myriad bags from one, Silvia invented the concept of the exclusive It bag: You carry the bag that everyone wants, but it constantly changes. In terms of creating desirability, this strategy was perfect. It also played on the desire to collect the different variations—fans rarely settle for just one Baguette bag.

With more than a million sold, the Baguette has been made available in more than a thousand versions: in embroidery, sequins, rhinestones, covered in logos, in lace, and in printed fabrics—all is possible. For those who would like a personalized Baguette, there is even an embroidery or painting kit to customize it.

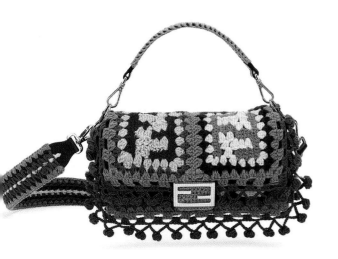

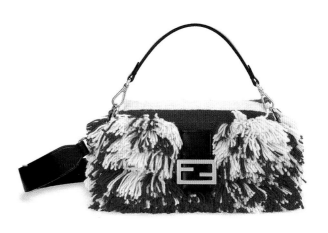

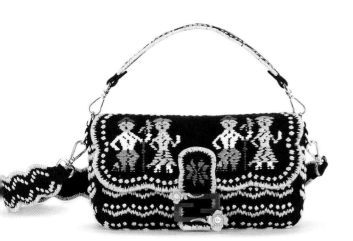

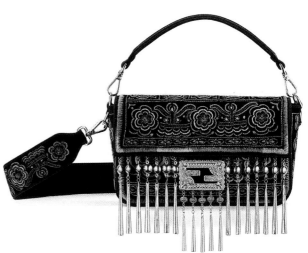

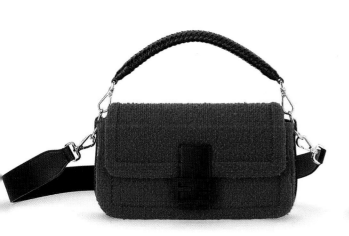

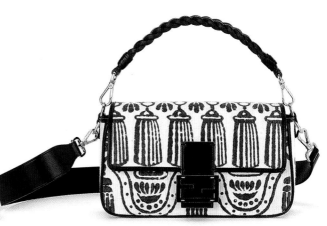

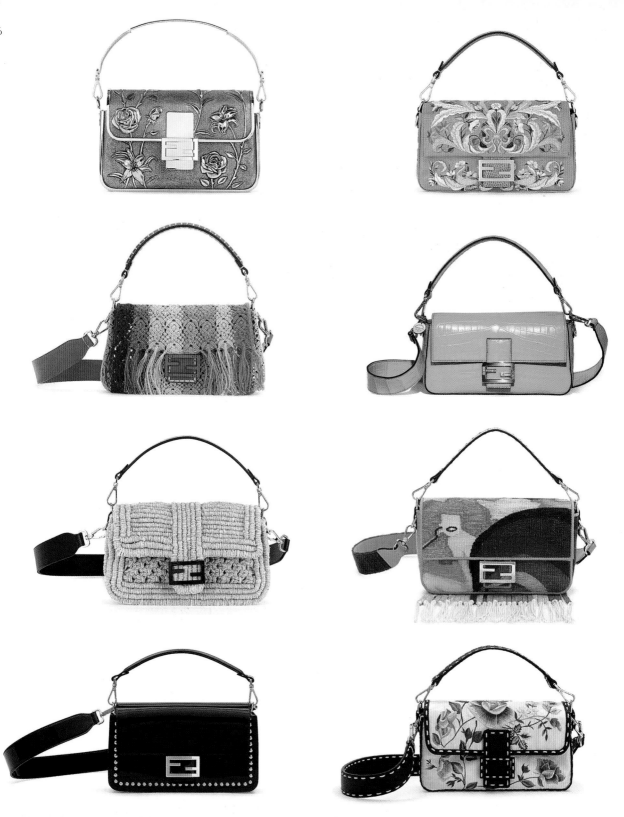

In 2012, the Baguette celebrated its fifteenth anniversary, and Silvia reissued her six favorite styles. For its twenty-fifth anniversary, in 2022, twenty-five styles were reissued, and new ones were created, notably by Marc Jacobs and Sarah Jessica Parker. For the September 2022 runway show in New York, Bella Hadid walked the runway with a soft blue version adorned with silver details from the collaboration with Tiffany & Co. The success was as great as ever, and new styles and reissues continued to be snapped up. The Baguette has a collector's vibe that ensures it will never go out of style. Although many years have passed since the first few seasons of *Sex and the City*, Carrie Bradshaw's response to the man who threatened her with a gun remains clear in the collective memory: "*Give me your bag!*" "*It's a Bag-uette!*" Without a doubt, the Baguette remains a bag unlike all others.

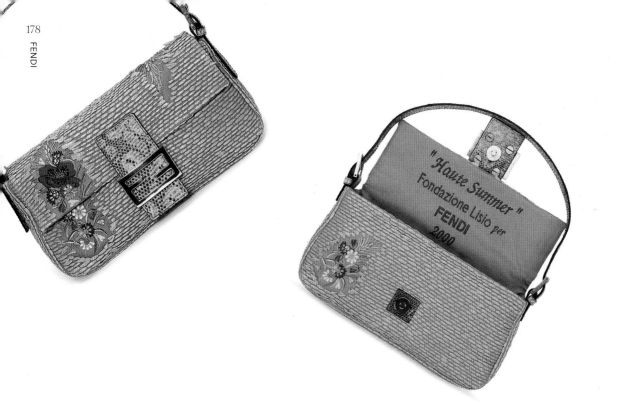

The Fondazione Lisio is an atelier in Florence that makes beautiful velvets and silk brocades by hand on looms dating back to the eighteenth century. For several years after the creation of the Baguette, Fendi and Lisio made only about twenty copies of each style, since it took one full day to weave 2 inches (5 centimeters) of fabric. These little gems have steadfastly increased in value since that time.

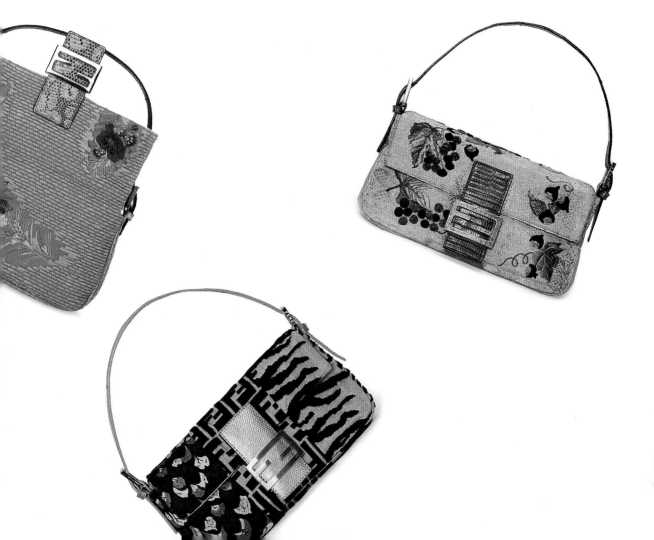

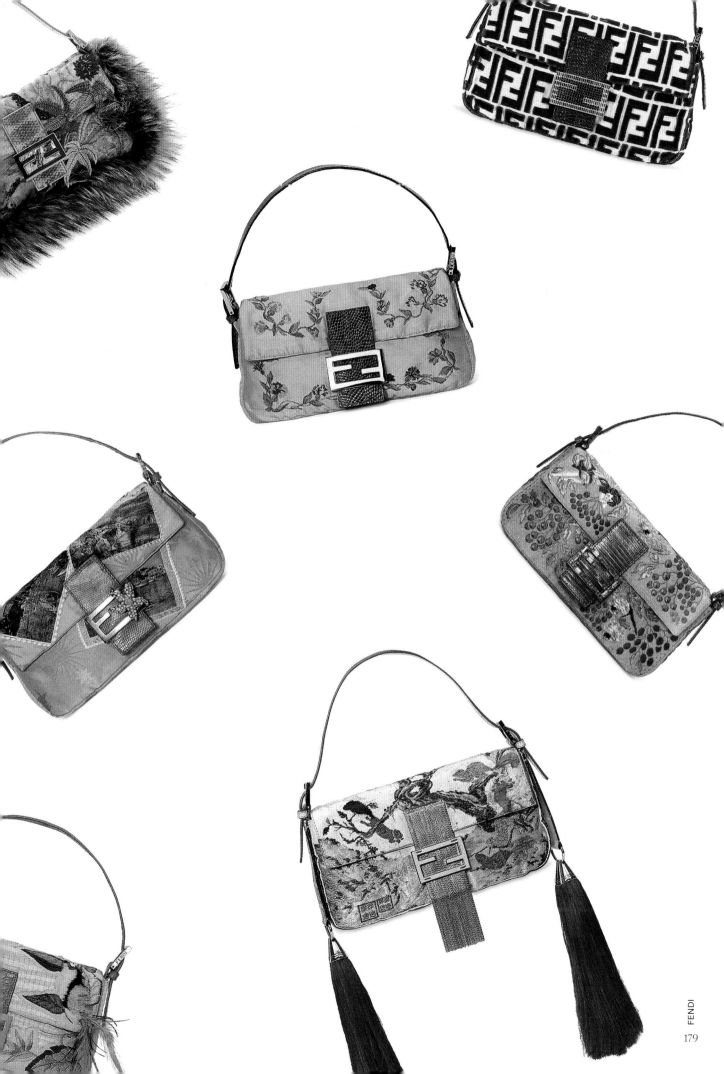

SPY

2005

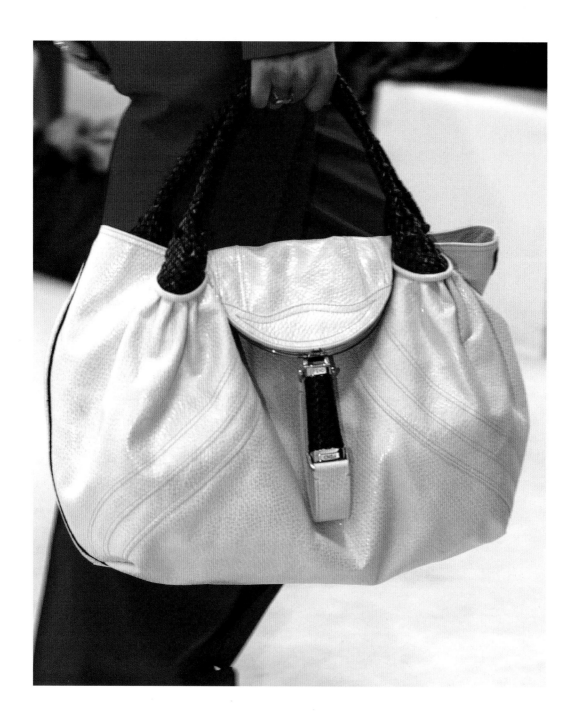

During an era when bags had to have a special shape to stand out in the jungle of It bags, the Spy arrived at the right time. Based on an idea by Silvia Venturini Fendi, this bag was a large purse with two braided handles. It had a flap, with a secret pocket, to which was attached a small compartment with a mirrored closure, to be used to spy around you when looking in it, but without seeming to do so (hence its name). The bag was available in a wide range of styles, from leather to python to logo and embroidered fabric. When released, it was immediately popular among celebrities, including Sharon Stone, Kate Moss, Madonna, and Jennifer Lopez. Fendi has discontinued production of the bag.

B BAG

2006

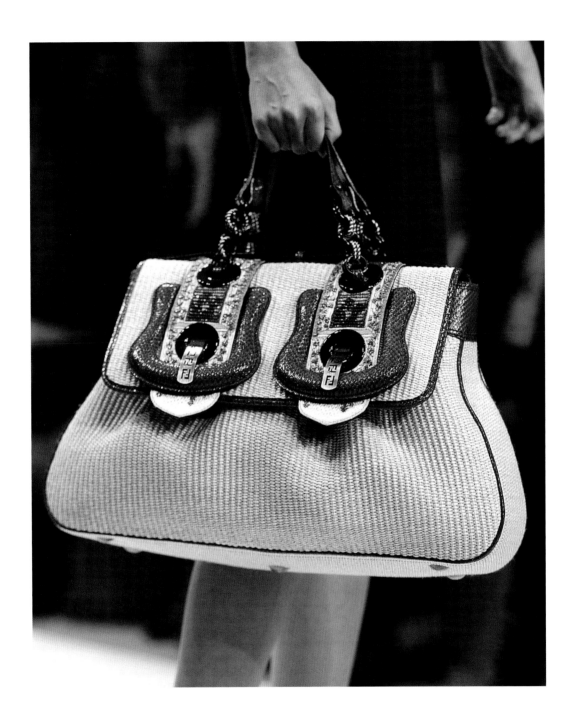

As with the Spy, this handbag has distinct features that make it immediately recognizable among all other bags no matter its range of styles. Silvia Venturini Fendi was inspired by the "B Buckle" belt, with its maxi buckle, to make this bag's oversized clasps. The buckle was doubled on the large styles, but the small and evening styles have a single buckle. Here, too, the B Bag was infinitely varied, appearing in lace, straw, patent leather, and fabric. Despite its success, Fendi stopped production.

PEEKABOO

2009

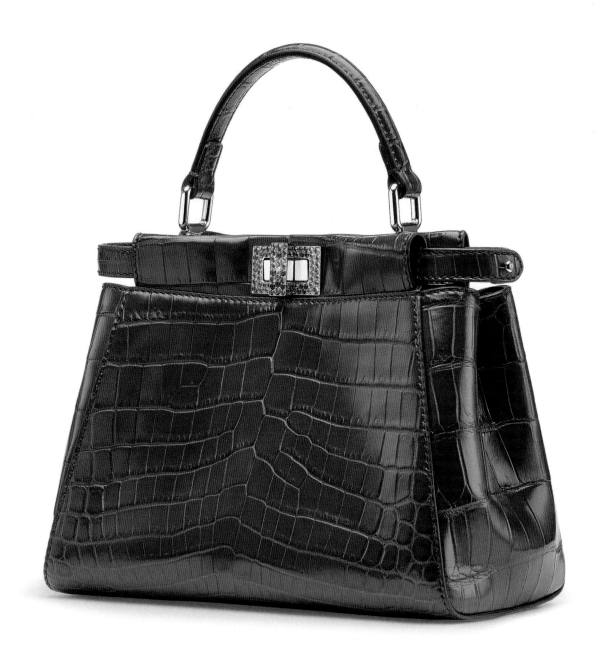

How did designer Silvia Venturini Fendi come up with the idea for the Peekaboo? *"I was looking for a traditional yet modern shape that would satisfy even the most sophisticated woman. Simplicity was based on the concept of quiet luxury, which translates into a unique contrast between rich materials on the inside and essential materials on the outside."*

Sleek, minimal, and at the same time geometric with its trapezoidal shape and two compartments, the Peekaboo combines flexibility and rigidity and testifies to the luxury craftsmanship of the fashion house. The gusseted pockets embellished with twist clasps cause a suspended draping when opened, creating the bag's signature "smile."

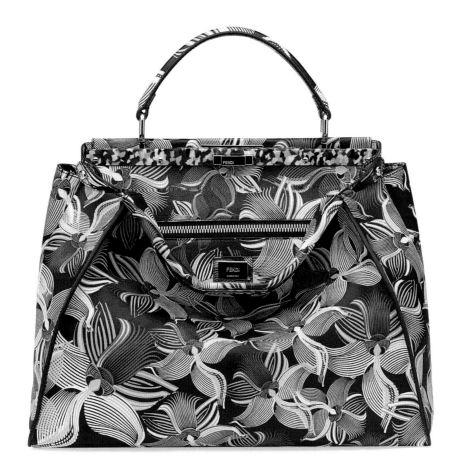

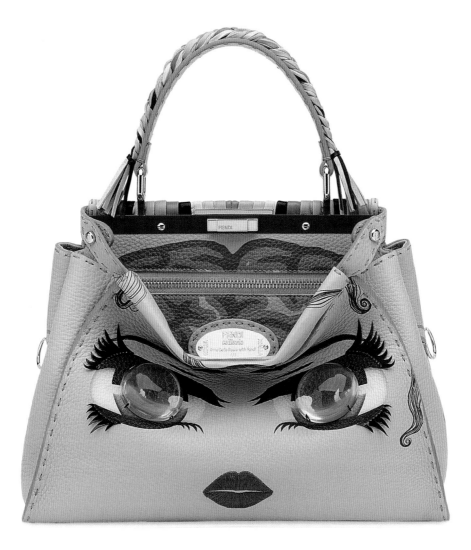

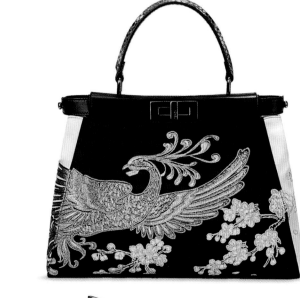
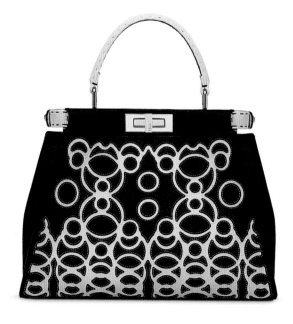
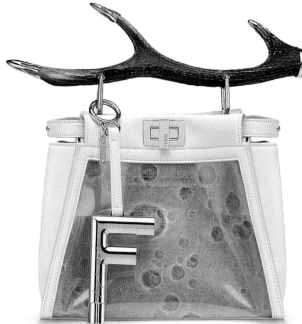
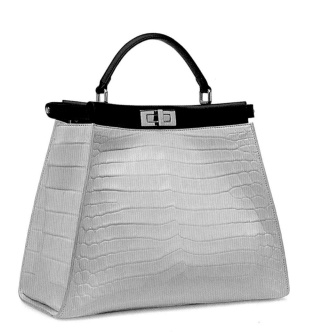

The Peekaboo looks as good on the outside as it does on the inside. "*When you put your hands inside a Peekaboo, you can feel some of the softest leathers in the world,*" says Silvia. It offers all possibilities and comes in many variations. It was quickly offered with a shoulder strap so that it can be carried by hand, on the shoulder, or as a crossbody. It unsurprisingly comes in several sizes and has even seen some variations in shape with the Peekaboo ISeeU and its expandable sides.

This bag not only allows you to carry all necessary belongings, but it also reveals something about its owner: "*A person's bag is full of secrets, which is the idea behind the Peekaboo as a bag that can be worn open,*" says Silvia Venturini Fendi. "*I think carrying a Peekaboo is indicative of a very strong, powerful, and self-reliant personality that has nothing to hide. It has two compartments: One that you can keep closed, and the other that can stay open and thus tell more about you.*" VIPs have jumped to obtain it, including Madonna, Amal Clooney, Jennifer Lopez, Angelina Jolie, Queen Rania of Jordan, and Hailey Bieber. This is a handbag that is destined to become eternal.

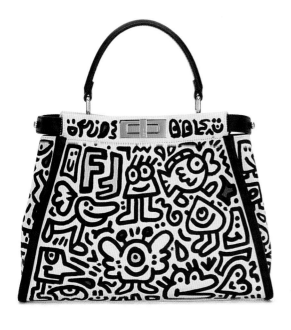

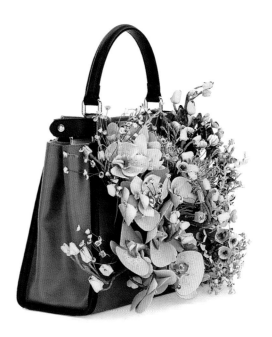

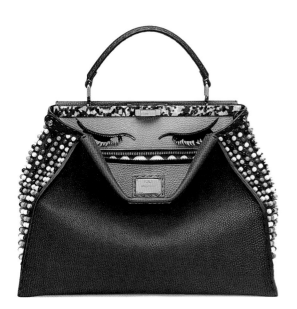

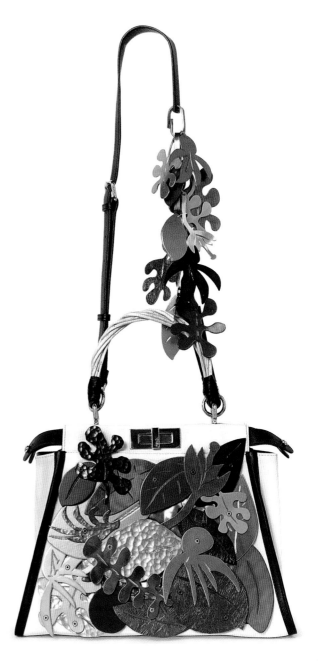

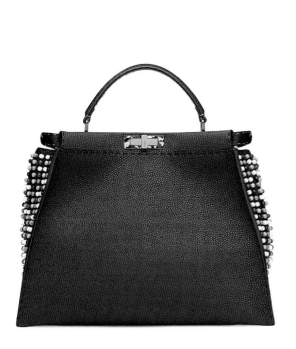

FENDI FIRST

2021

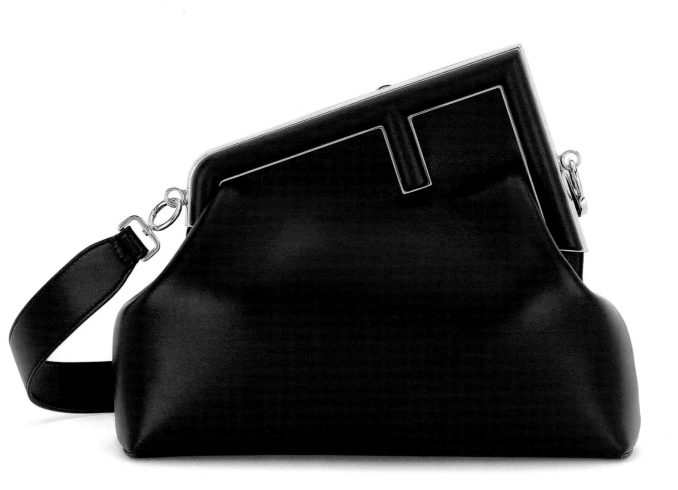

For Kim Jones's first ready-to-wear collection, presented in Spring/Summer 2021, Fendi released this bag inspired by the mule heel. The large letter-*F* frame influences the pouch shape of the bag, designed to be worn day or evening.

Available in supple nappa leather, python, fur, sheepskin, and flannel wool with the Fendi Karligraphy motif, different styles, as always with Fendi, are possible. In medium or small sizes, it has a detachable shoulder strap, making it possible to be carried as a clutch or worn over the shoulder.

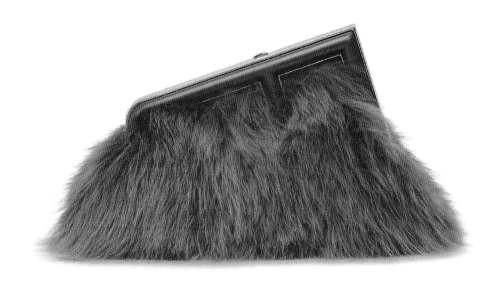

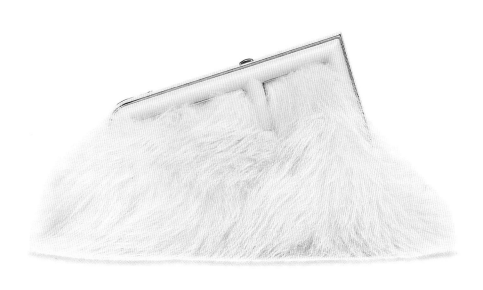

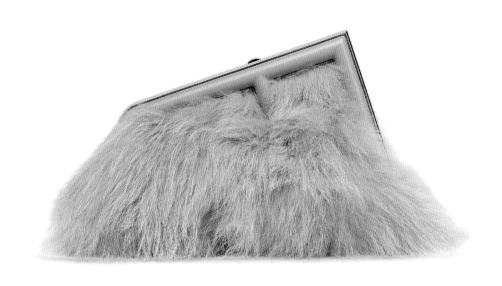

ENDURING CRAFTSMANSHIP

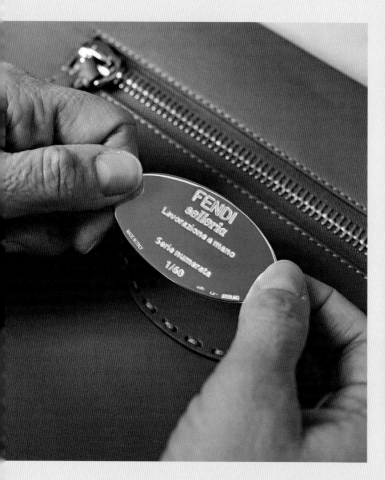

In 2022, Fendi opened a new handbag factory in the heart of Tuscany. The Fendi factory is a source of inspiration for the world thanks to its heritage, ecology, education, and architecture. Designed by the Milanese agency Piuarch and landscape architect Antonio Perazzi, the factory has a harmony between the exterior and interior and blends completely into nature. With its many technical and ecological advances (photovoltaic cells used to produce electricity, recycled water, etc.), it is the first leather goods company to obtain LEED (Leadership in Energy and Environmental Design) Platinum certification.

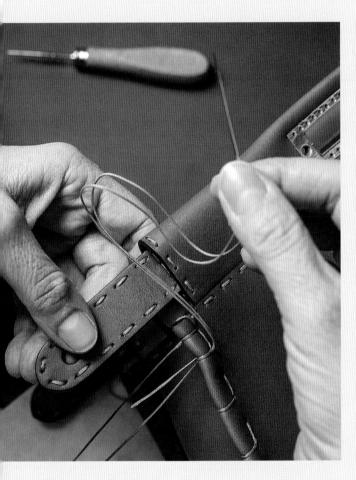

Fendi has always relied on small artisan workshops, often family operated. In this way, the company connects artisanship with an industry that's at the top of sustainable development. The stated objective is also to highlight the skills of hand craftsmanship that are at risk of disappearing.

At the Tuscan site, Fendi unites all its departments under one roof (development, production, etc.) and trains its apprentices in saddle stitching, a method that is considered indestructible. It's a technique with a rich history and emotional connection to the product that no machine can replace.

FERRAGAMO

ICONIC TOP HANDLE

In the late 1970s, Fiamma Ferragamo, Salvatore's daughter, created for her mother a handbag with a clasp resembling a stylized horseshoe. The bag would come to be known as the Gancini (in Italian, a *gancio* is a metal hook). The iconic bag, with its sturdy handle, was an immediate success. Recently reissued in new versions, the Iconic Top Handle is one of the most flamboyant symbols of the Ferragamo house.

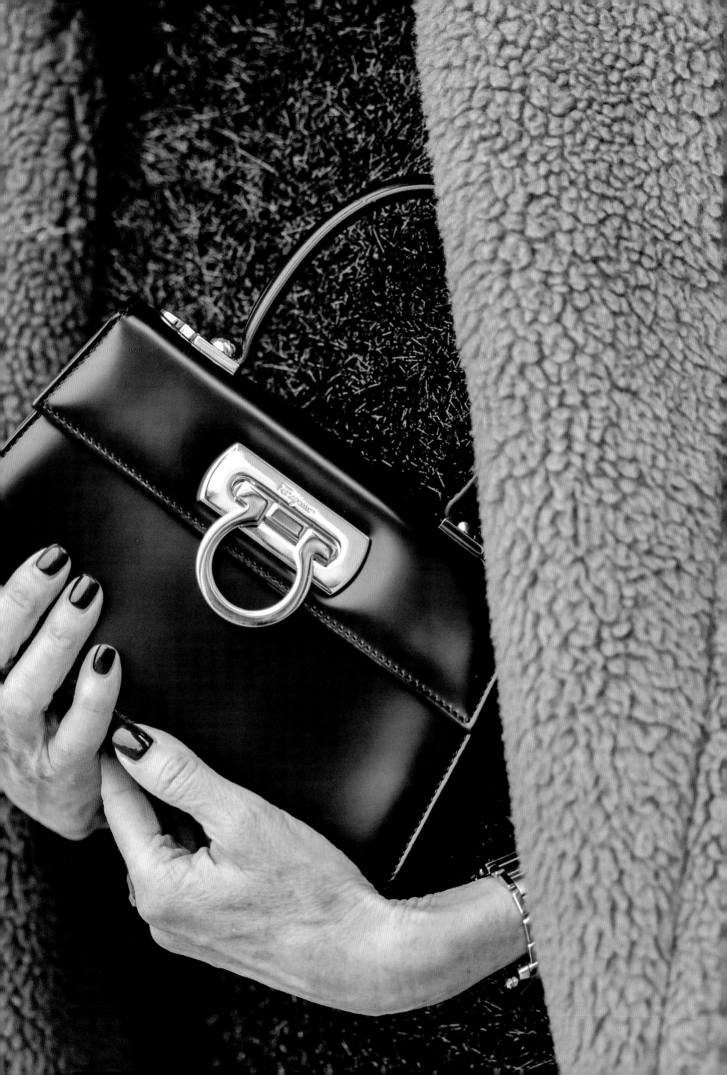

FLEURON PARIS
THE NEW ACCESSIBLE LUXURY

"What is extraordinary attracts us for just a moment, but simplicity captivates us for longer because it contains all that is essential."

Marine Chang, founder of Fleuron, quoting Garry Winogrand, American photographer

Founded: 2020

The story: Marine Chang worked at the leather goods brand Lancaster Paris for seventeen years until she became the assistant general manager. In 2020, she launched her own label. Made in ateliers located in Italy and using materials sourced from renowned tanners, the Fleuron Paris offerings quickly exhibited all the hallmarks of a great collection. These bags have clean lines with refined details (topstitching, brass buttons).

The style: Urban chic. Through its creations, Fleuron Paris displays a sophisticated style with pure lines, thanks especially to the quality of the leathers used.

Heard on the street: *"It's a brand labeled as DNVB (Digital Native Vertical Brands), born in the virtual world."*

FASHION HOUSE FACT
In architecture, the French term *fleuron* is a flower-shaped ornament. In botany, it is each of the small flowers that come together to form a single flower. It is also the most precious thing a person can possess.

WHO WEARS FLEURON PARIS?
Women looking for affordable luxury with sleek bags in high-quality leathers.

SWANN

It has a slightly supple silhouette, a clearly visible top handle accompanied by a shoulder strap, and sides that fold and unfold like wings. The Swann's look is truly ethereal. The bag is made of vegetable-tanned leather, and its interior is fully lined with microsuede (microfiber). Embossed with a heat-stamped gold logo to match the gold metalware, it comes in three sizes and in many colors, including cobalt blue, caramel, olive green, and taupe.

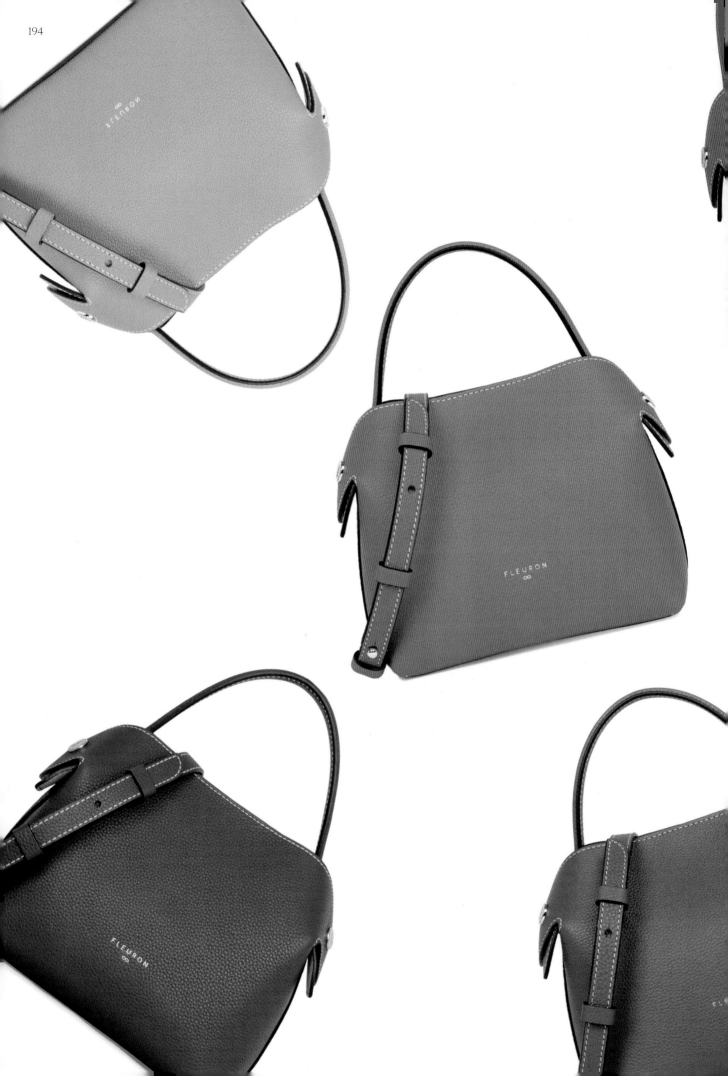

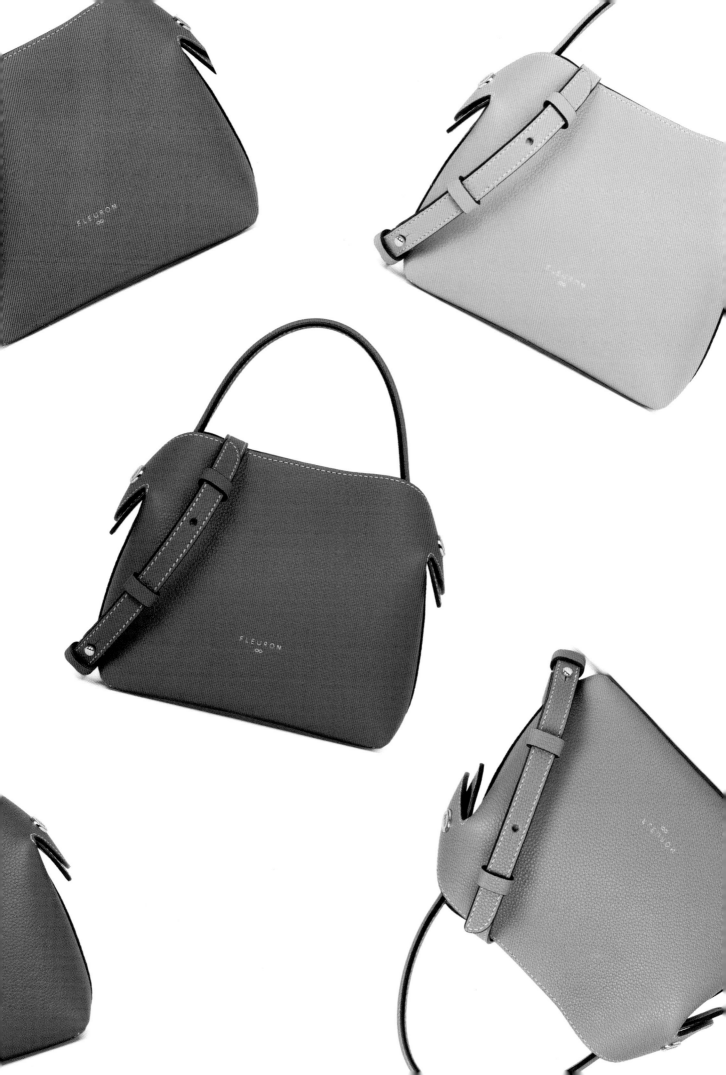

FRANÇOIS-JOSEPH GRAF PARIS

EXCELLENCE IN CRAFTSMANSHIP

"No matter the field, creating is a pleasure. Whether designing a facade, a door, a fabric, a bag, it is all architecture." **François-Joseph Graf**

Founded: 2009

The story: François-Joseph Graf, passionate about *métiers d'art*, began his career as an architect at the Château de Versailles. Although he still contributes his talents to his country's heritage, he also designs furniture, lighting, and fabrics for exceptional interiors. He always wanted to reach the pinnacle of perfection, so he created a line of fine leather goods in 2009. His tote bags with pure lines and artistic patterns are unique pieces made entirely by hand in his Parisian ateliers.

The style: François-Joseph Graf leaves nothing to chance. His leather bags are true works of art. Their shape is sleek and timeless, but thanks to their color combinations and bold, graphic panels, they are unique. Fastened with a magnetic flap, they are lined in a color that matches the bag's pattern. They have an inside zipped pocket, one or two gusseted pockets, and a strap with a key clip. The bags come in two sizes and can be carried by hand or at the elbow (and sometimes on the shoulder, for the ones with a shoulder strap). François-Joseph Graf's art is also available on the small handbags.

Heard on the street: *"François-Joseph is a true artist, a graduate of the École des Beaux-Arts and the École du Louvre et des Monuments Historiques in Paris. His bags deserve a place in a museum!"*

FASHION HOUSE FACT
These high-end leather bags appear in exceptional places. They can be admired "in real life" in the François-Joseph Graf Paris boutique and in the George V hotel (31 avenue George V, Paris 8th).

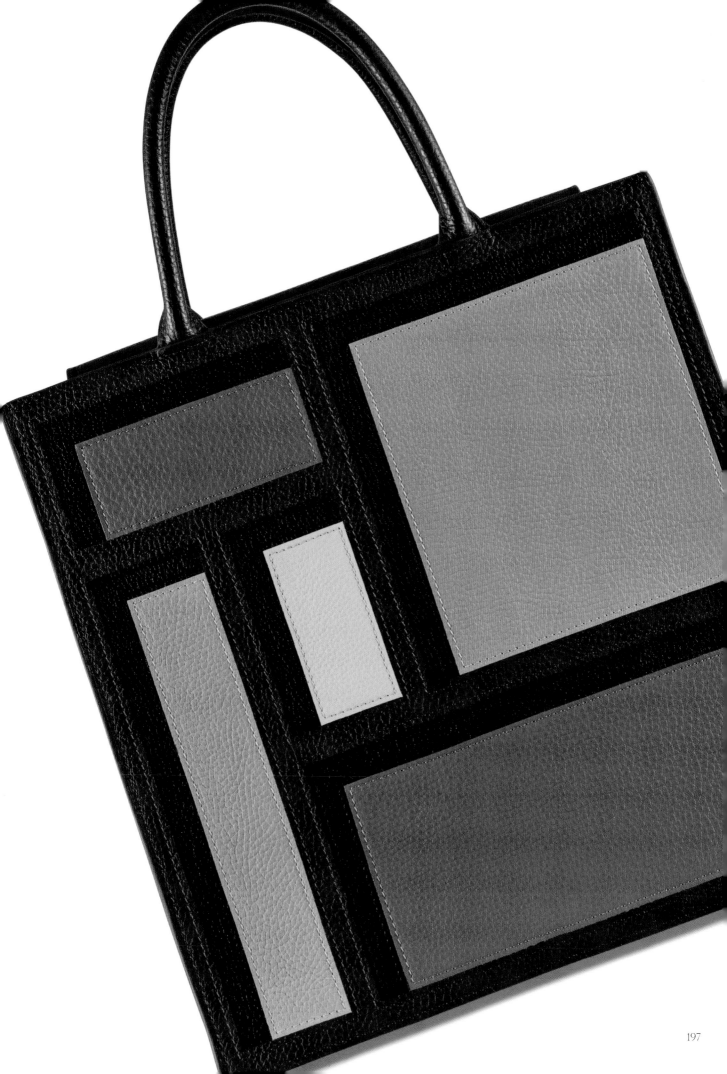

FRANÇOIS-JOSEPH GRAF PARIS

UNIQUE BAGS
ULTIMATE LUXURY

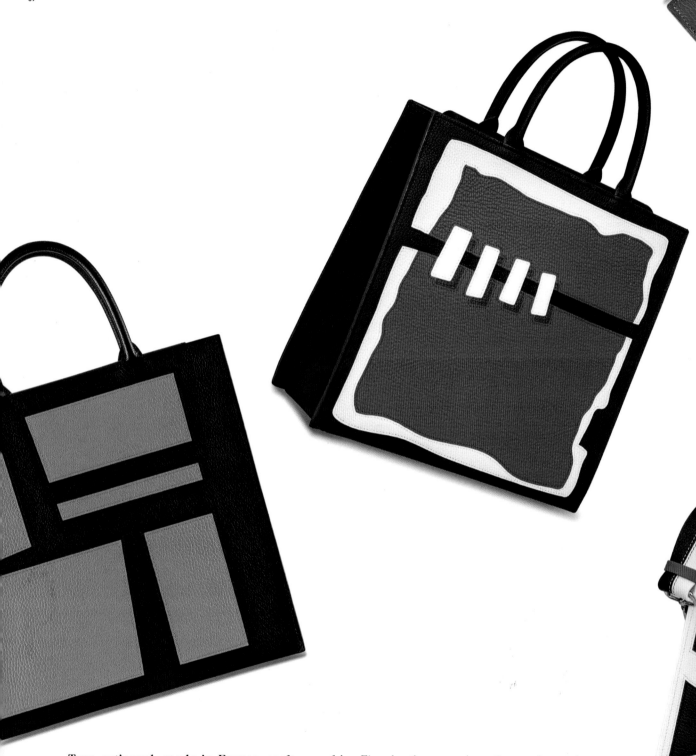

True artisanal, made-in-France craftsmanship. Five leather goods artisans dressed in white coats create these leather patchwork bags under the demanding eye of a lead leather-architect craftsperson. The fourteen steps necessary to make the bags are executed with an eye toward perfection—and they sometimes require more than thirty hours to produce. These exceptional bags are unique.

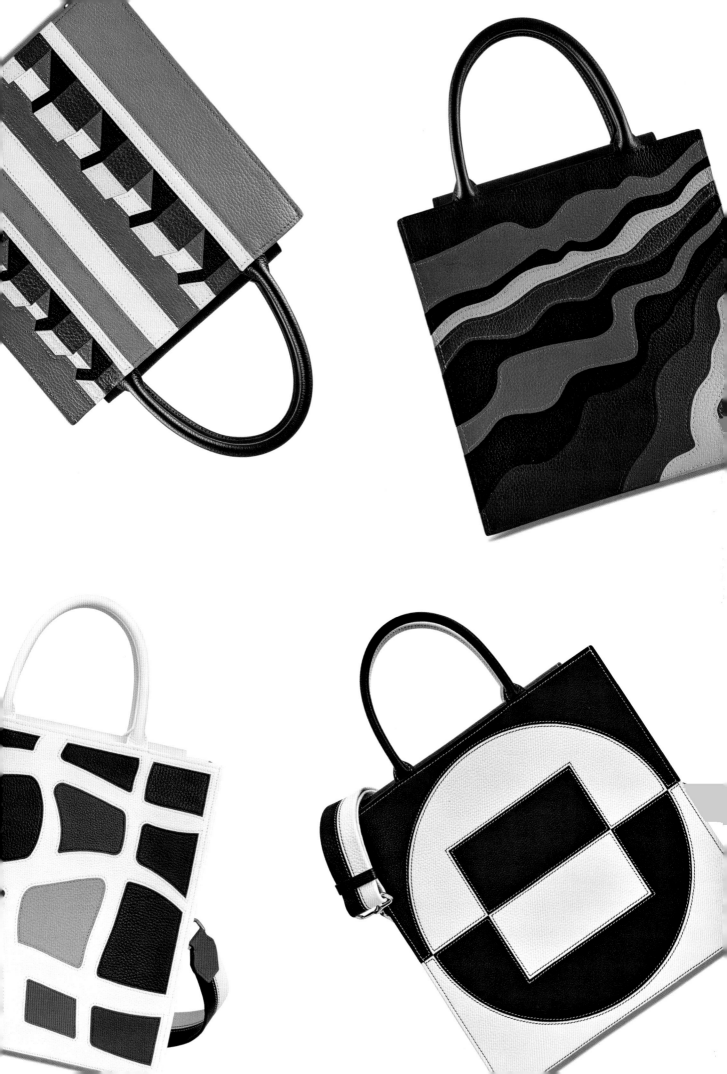

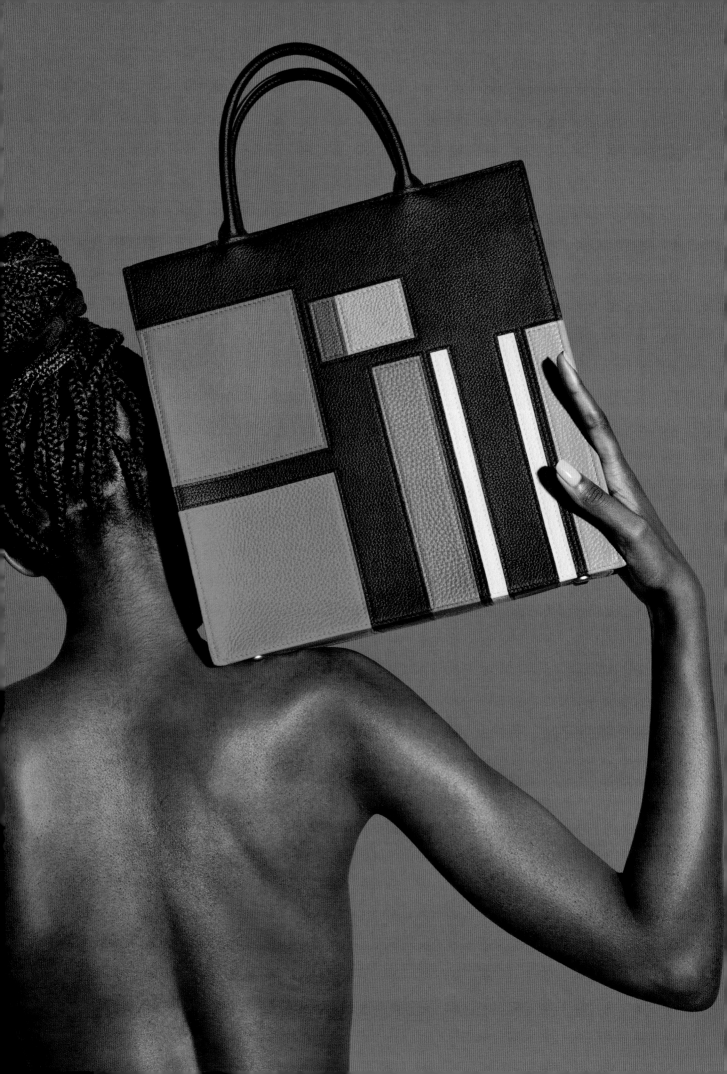

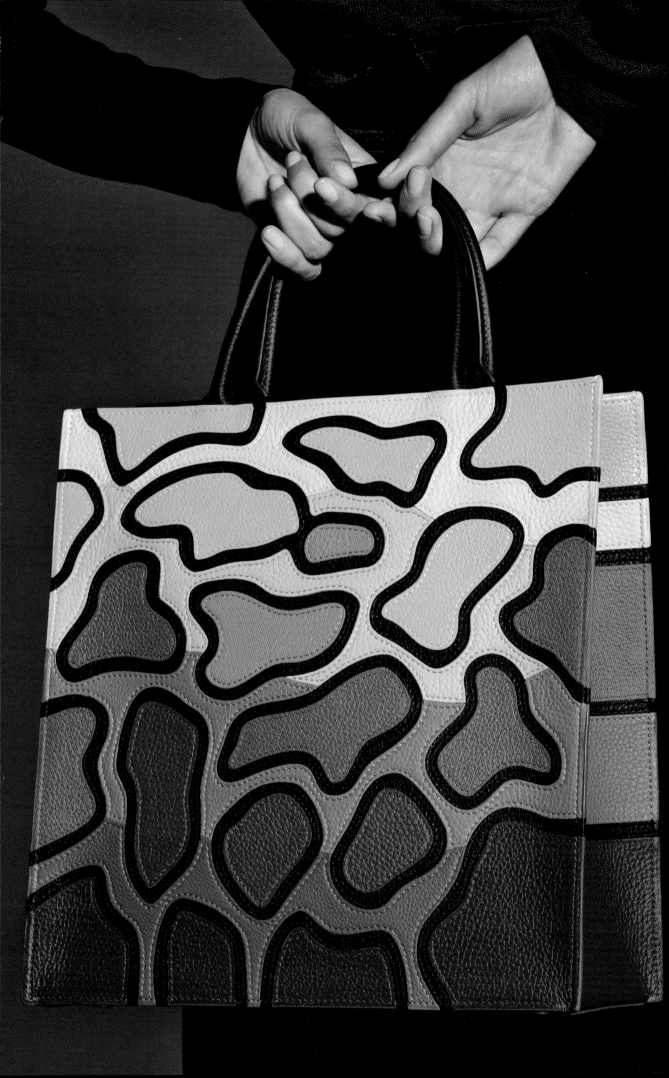

GERARD DAREL

CROSS-GENERATIONAL SUCCESS

"Our creed has always been to strive for quality or else stop." **Laurent Gerbi, son of the founders of Gerard Darel**

Founded: 1971

The story: The label was born out of a love story. In the early 1960s, Danièle was seventeen when she met nineteen-year-old Gérard in Algiers. Both were from families who ran clothing boutiques. In 1962, after Algeria achieved its independence, they moved to Paris together and, in 1971, launched their brand, Gerard Darel (Darel was Danièle's surname). Their success was immediate. In 2008, the Darel family sold most of its shares to an investment fund, which they recovered seven years later.

The style: Timeless and cross-generational. The clothes are classic and simple, with a certain fluidity and casual chic.

Heard on the street: *"I borrowed the 24H bag from my daughter since she's not in school on Sundays."*

FASHION HOUSE FACT
In 1996, Danièle Darel purchased, at Sotheby's, the famous black pearl necklace worn by Jackie Kennedy. *"We didn't have anything planned for it, but when I was asked if we were going to market it, I said yes, without thinking,"* she later remarked. The reissue of the necklace was an international success.

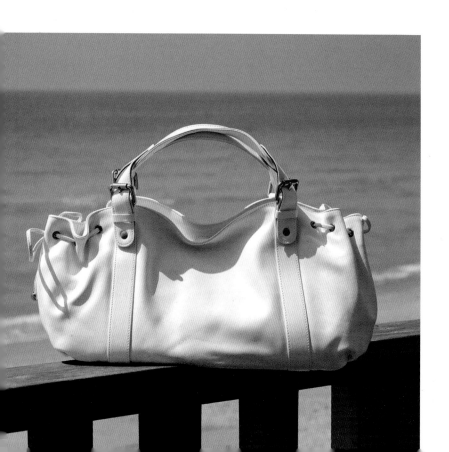

WHO WEARS GERARD DAREL?
Jessica Alba, Angela Jolie, Eva Longoria, Olivia Palermo, and Sarah Jessica Parker have all been spotted with a 24H bag.

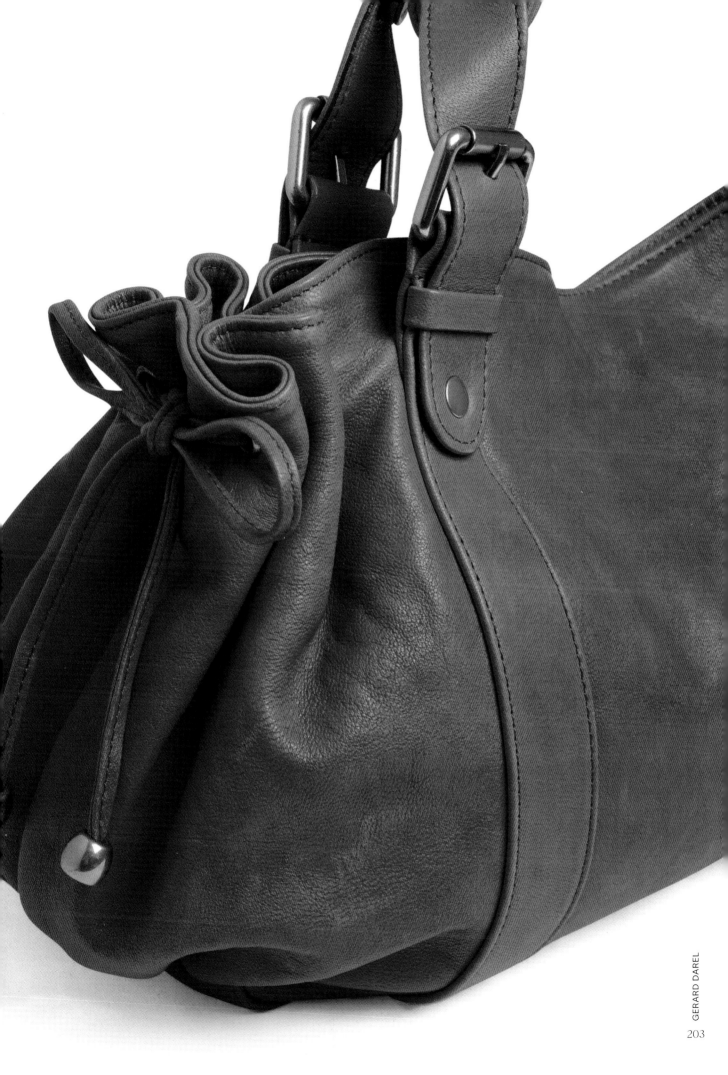

24H

2003

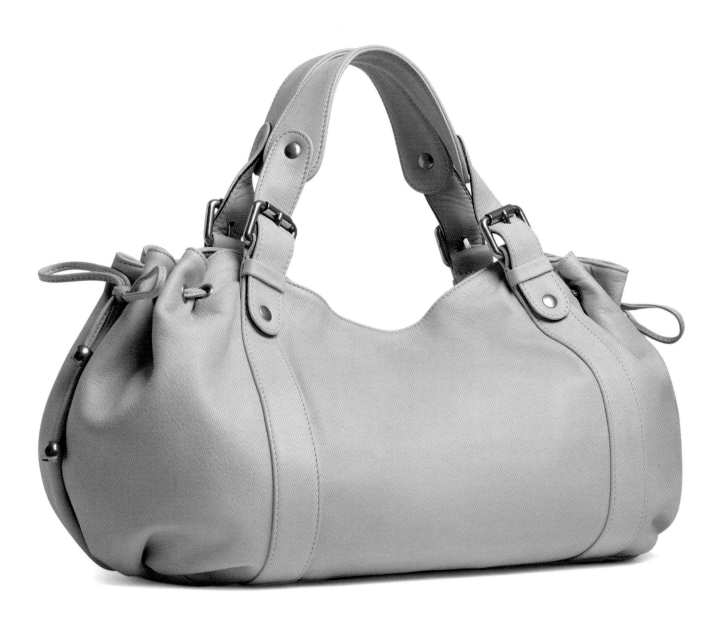

The 24H bag (for "twenty-four hours") appeared in 2003 (it was originally called Drapé). It is the absolute It bag, the one that crosses all trends and all generations without a single misstep. The claim is that one is sold every two seconds somewhere in the world. The bag is very flexible and cinched at the sides with ties. Each bag is made from thirty pieces of leather. The 24H is available in a multitude of styles: leather, raffia, wool, and python, among others. It has been produced in a 36H, 48H, and 72H format. It closes with a magnet and is worn on the shoulder.

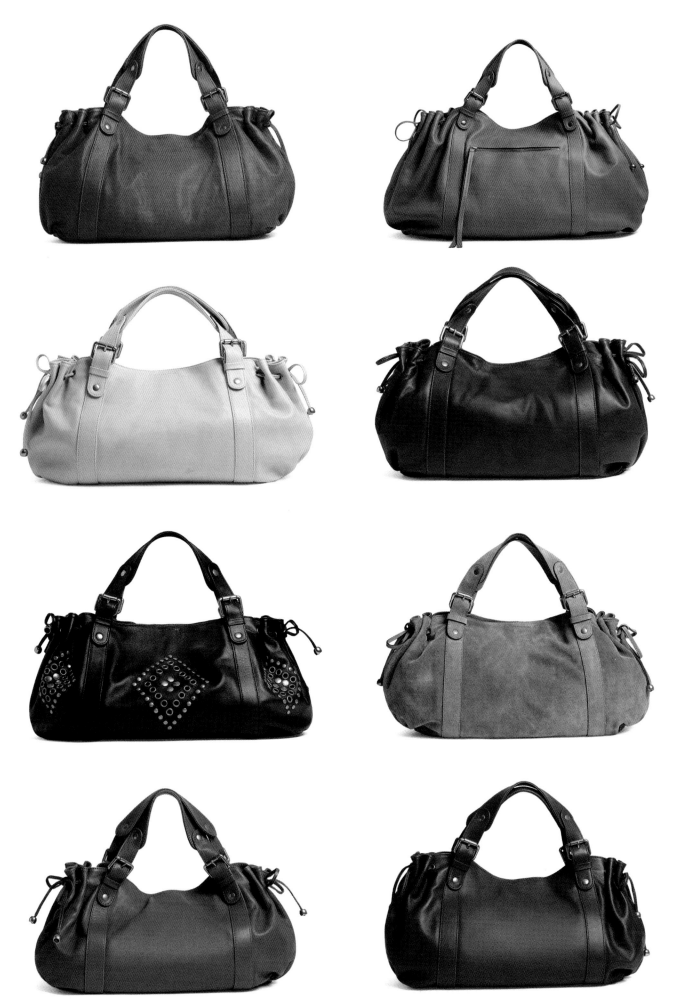

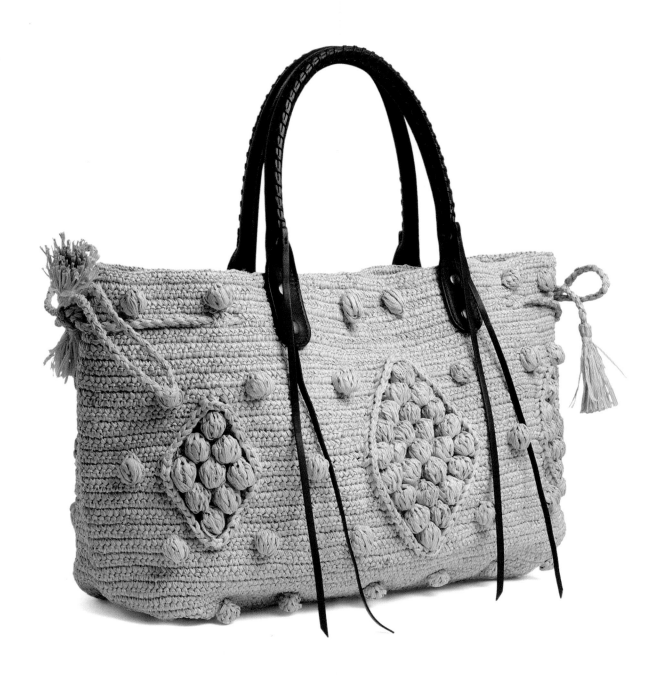

A raffia version of the iconic style, the 24GD has geometric shapes in relief along the bag. It is crocheted by hand of natural raffia, a testament to the craftsmanship that has symbolized the fashion house for years.

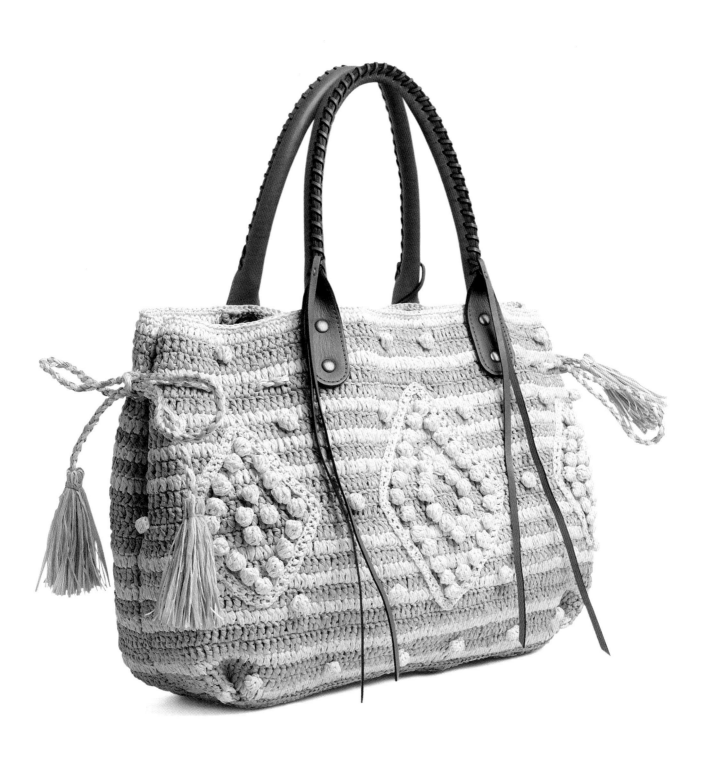

GIORGIO ARMANI
THE LUXURY OF SIMPLICITY

"It's not a good idea to match your shoes to a bag too strictly. Choose instead a subtle similarity."

Giorgio Armani

Founded: 1975

The story: Giorgio Armani began his career in fashion as a window dresser at the department store La Rinascente in Milan. He therefore understood the importance of how to sell before he embarked on designing clothes. In 1961, he worked alongside Nino Cerruti, with whom he learned the craft of tailoring. Armani met Sergio Galeotti and joined forces with him in 1975 to create the Giorgio Armani label. Galeotti took care of the sales while Armani took care of the clothes. Giorgio experienced quick success among Hollywood's stars, and his creations were spotted on the red carpet. He designed Richard Gere's wardrobe in the film *American Gigolo*. Fiercely independent, Giorgio Armani always refused offers from large groups to buy his brand. Today, he is at the head of an empire that, in addition to clothing, sells perfumes, makeup, home decor items, and chocolates. They also run many hotels, restaurants, and nightclubs.

The style: To say that Giorgio Armani is a minimalist would be an obvious statement. The lines are sharp in a very clean style. His masculine-minded suits are a delight for powerful women. The word "elegant" could appear on all the labels of this great Italian designer's creations.

Heard on the street: *"Did you know that some of the calfskins in the La Prima bags come from France?"*

FASHION HOUSE FACT
Beyond fashion, Italians are also famous for their cuisine. Giorgio Armani is a fan of spaghetti with tomato sauce and, apart from his hotels around the world, you can enjoy his favorite pasta at his restaurant Emporio Armani Caffè, located at 149 boulevard Saint-Germain, Paris, in the 6th arrondissement.

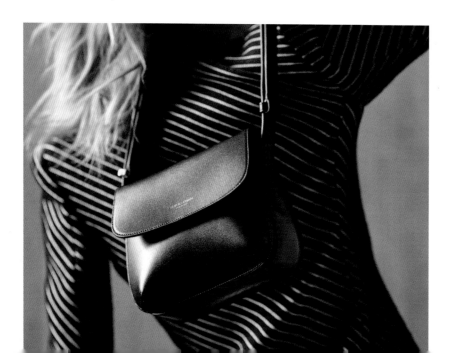

WHO WEARS GIORGIO ARMANI?
Cate Blanchett, Lily Collins, Elle Fanning, Anne Hathaway, Kate Hudson, and Margot Robbie.

LA PRIMA

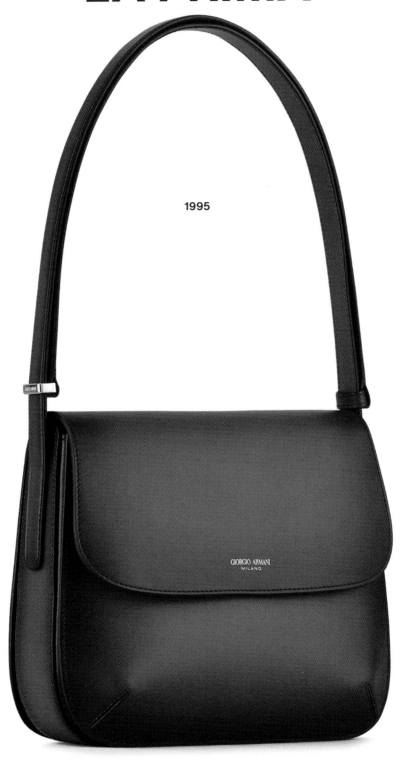

1995

This was the house's first true handbag. With its ultrapure lines, this bag reflects the entire universe of Giorgio Armani. It closes with a magnetic button, and its shoulder strap adapts to three different lengths. Throughout almost thirty years, it has been created in many formats: small, baguette without a flap, clutch, with fringe, handbag (not worn over the shoulder but with two handles), and hobo.

The latest addition to the family is La Prima Soft. The basic features remain the same, especially the two pleats that add volume to its corners. Made of full-grain nappa leather or ultrathin and soft suede, this bag feels as soft as a garment.

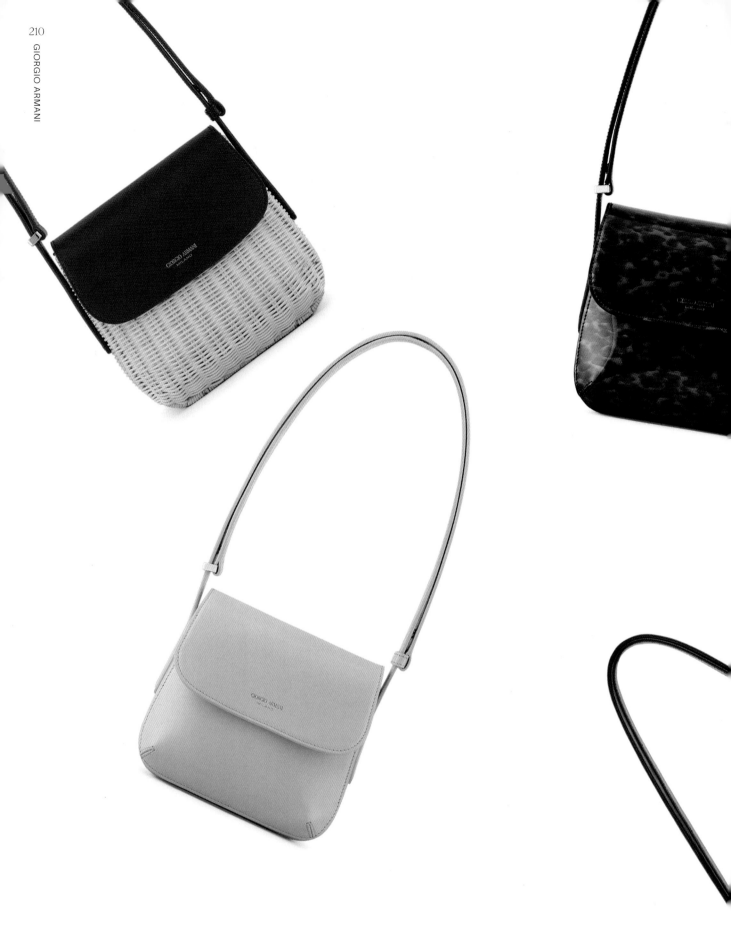

"La Prima is a bag that embodies my idea of elegance and individuality, style and functionality," says Giorgio Armani. *"This bag was born by focusing on the quality and simplicity of the design, which expresses, and continues to express, my idea of an extremely natural femininity."*

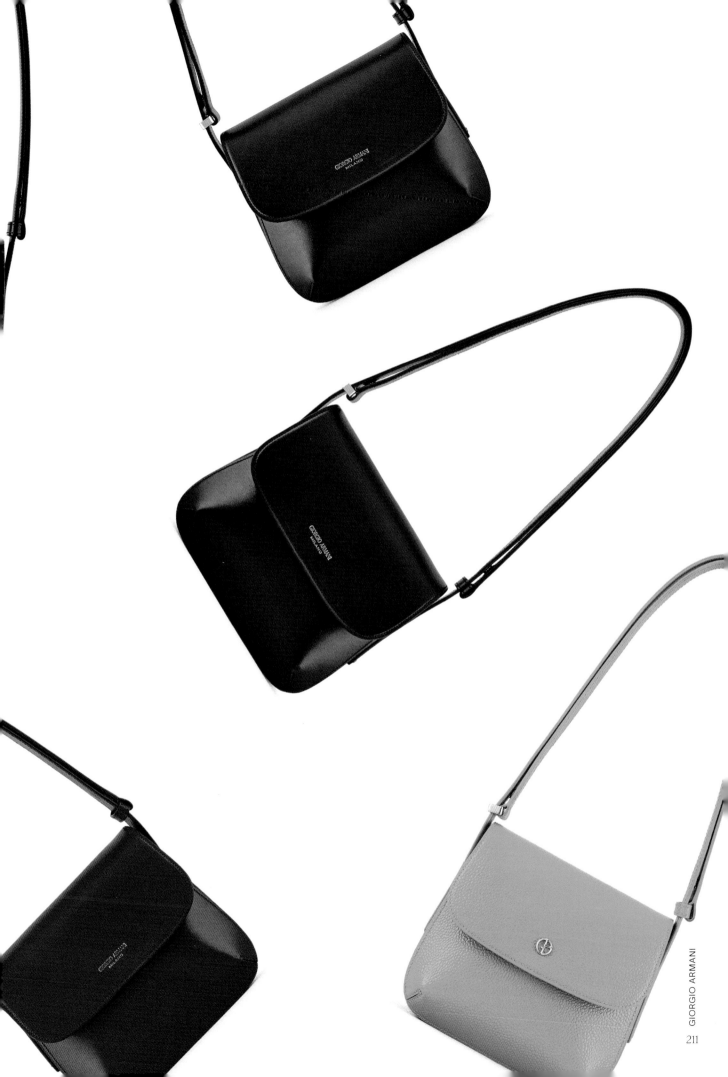

THE BIRTH OF A LA PRIMA BAG

La Prima bags are made according to the codes of
Italian leather goods craftsmanship.

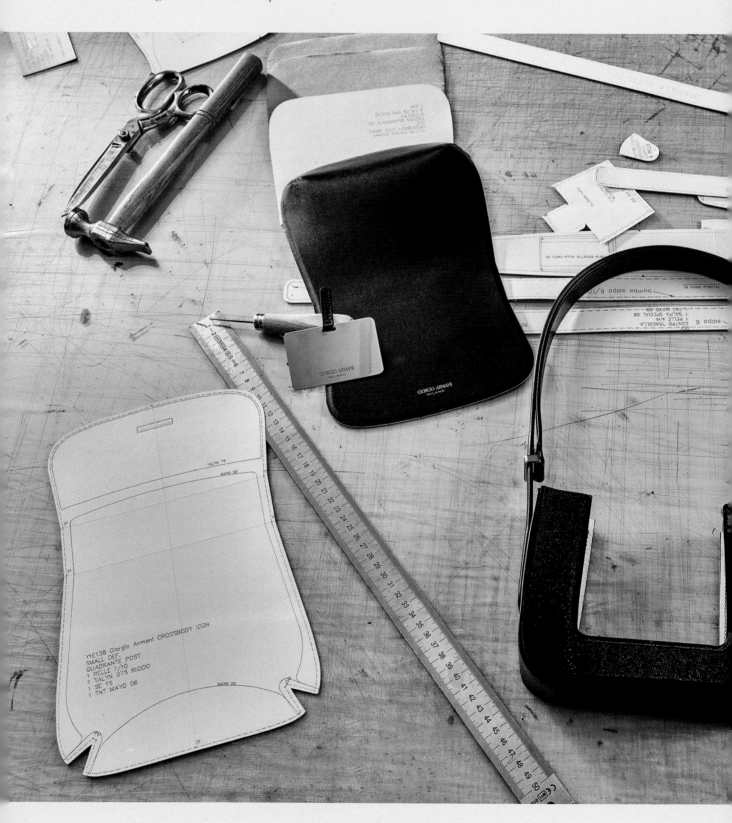

01.
Starting from a sketch, a template is created, followed by a paper pattern that contains all the assembly instructions.

02.
Before assembly, the leather pieces are cut out by hand using a leather-cutting knife.

03.
During construction, the leather panels are assembled, along with the lining, by expert hands. To do this, the artisans use a hammer, an awl, a knife, a metal dowel, and pliers. The dart on the bag's front panel, a hallmark of the entire La Prima line, begins with a cut and displays a "joined edges" seam. It has a stained or raw border.

04.
The sides of the bag are assembled on a wooden form and then sewn on a high post-bed sewing machine, which helps give the bag a rigid form.

05.
The bag has several hand-performed stitches.

06.
Polishing follows, making it possible to stain the raw edges.

07.
After several treatments, the metalware pieces are ready to be placed on the bag.

08.
The logo is added by hot stamping, on all the versions of the bag, with a pale gold film, except for the patent leather version, on which the logo is heat transferred.

09.
The quality check phase is performed before packaging.

10.
Arrival in stores.

GIVENCHY
THE STRENGTH OF FEMININITY

"Luxury is in every detail."

Hubert de Givenchy

Founded: 1952

The story: In 1945, while studying at the École Nationale Supérieure des Beaux-Arts in Paris, Hubert de Givenchy was an apprentice stylist for the Jacques Fath haute couture fashion house. After honing his skills with Robert Piguet, Lucien Lelong, and Elsa Schiaparelli, he founded his own fashion house in 1952 and presented his first haute couture collection, "Les Séparables," in which each piece could be purchased and worn separately—a revolutionary approach! In 1959, he moved his location to avenue George V and opened his shop on the ground floor. He developed his signature products (shoes, jewelry, kimonos, tableware, etc.) and left his mark on an entire era through his elegantly produced items. In 1995, he left his company. John Galliano took over, replaced a year later by Alexander McQueen, who remained with the company until 2001. Julien Macdonald succeeded him and, in 2005, Riccardo Tisci was appointed creative director. Tisci remained in this position until 2017, with the arrival of Clare Waight Keller. Since 2020, Matthew M. Williams has overseen artistic direction but has recently left the company. As of 2024, Givenchy studio designs the collections.

The style: Originally, Hubert de Givenchy had imagined a sophisticated and sensual woman. Today, femininity and elegance are still present, but the style is accented with strength and modernity.

Heard on the street: *"With a Givenchy bag, you immediately feel like a glam superwoman."*

WHO WEARS GIVENCHY?
At the time of Hubert de Givenchy, Audrey Hepburn and Jacqueline Kennedy. Today, Beyoncé, Cate Blanchett, Doja Cat, Gigi Hadid, Kim Kardashian, Dua Lipa, Rooney Mara, Madelaine Petsch, Rihanna, Emma Roberts, and Sigourney Weaver.

FASHION HOUSE FACT
In 2023, Givenchy opened its first boutique in Los Angeles, a 6,500-square-foot (604 square meter) space with metallic and silver decor punctuated by sculptures by British artist Ewan MacFarlane.

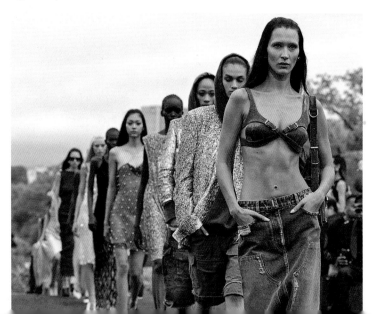

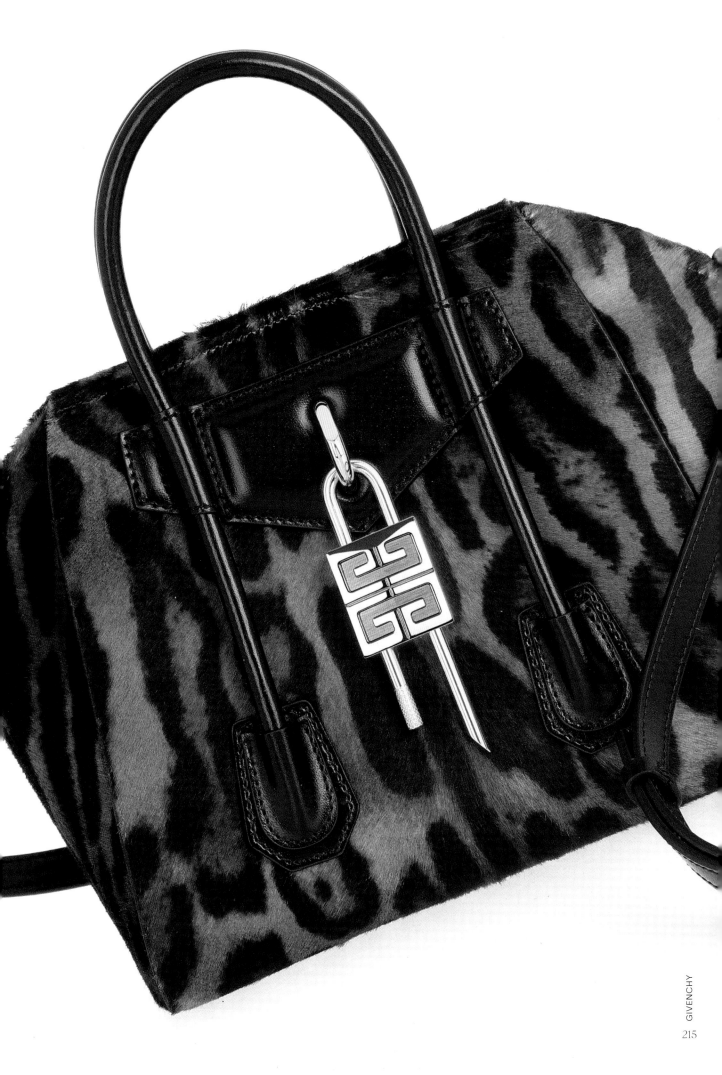

GIVENCHY

215

ANTIGONA

2010

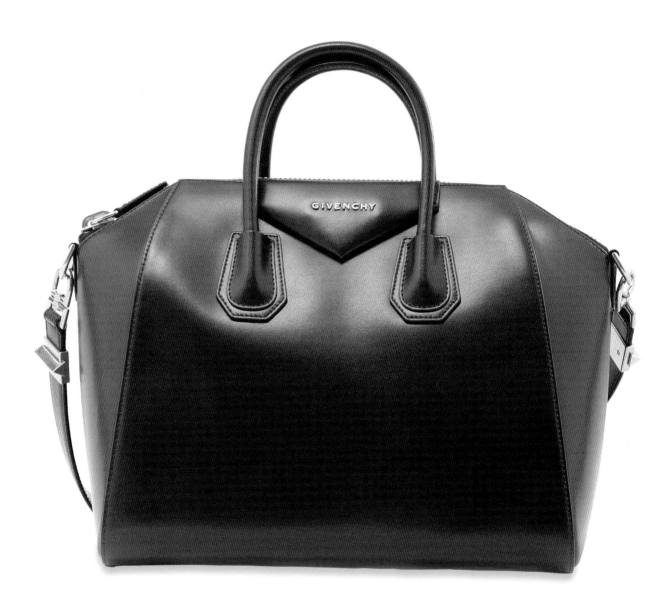

When he was the creative director of the fashion house, Riccardo Tisci had a knack for releasing what would become It bags. After the Nightingale in 2006, he launched the Antigona bag in 2010, inspired by Antigone, a Greek heroine who perfectly embodies the strength and courage of women of conviction. This rigid hexagonal bag has graphic lines, a zipper, two handles, and a shoulder strap. In 2020, it was reinterpreted and became the Antigona Soft, offered in a supple leather and a style somewhere between a handbag and a weekend bag, with a vibe between masculine and feminine. A new Antigona, closer to its original rigid version, was launched in 2021, adorned with metalwork and a four-*G* padlock. It is also available in the XXS format.

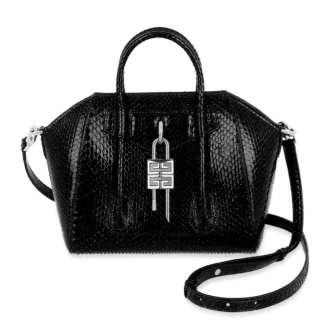
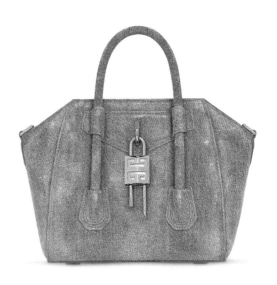
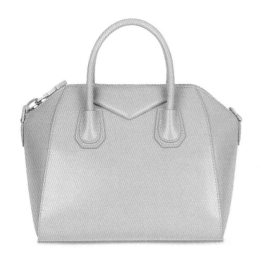
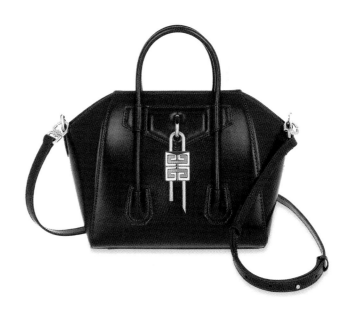
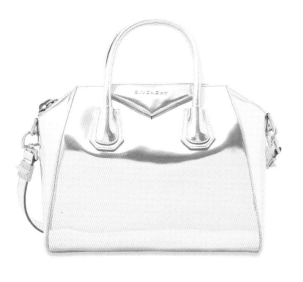
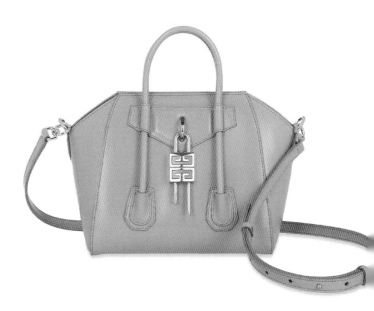

4G

2021

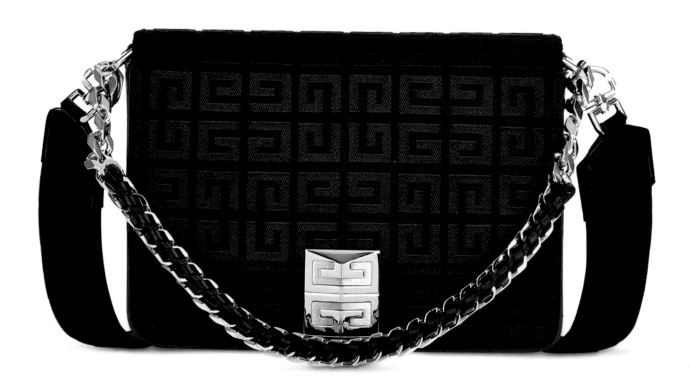

This is the first handbag designed by Matthew M. Williams for Givenchy. 4G owes its name to the brand's logo. With its metalwork details and magnetic clasp, it can be transformed into a clutch, crossbody bag, or shoulder bag. It can be found in myriad colors, ranging from neutral tones to seasonal colors, including sky blue, pale pink, and celadon. The 4G comes in several materials: exotic leather, patent leather, smooth leather, or embroidered with the 4G monogram motif.

CUT-OUT

2021

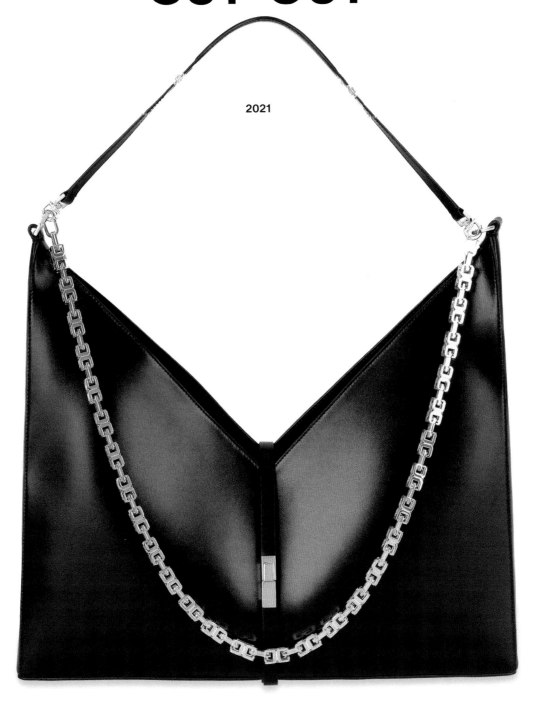

With its futuristic angles and unisex spirit, the Cut-Out, imagined by Matthew M. Williams, stands out for its sharp-lined design, evoking a neckline. This architectural form was inspired by the fashion house's archives. With its metal eyelets and chain, it displays details found in Matthew's other creations. There are several sizes and colors to choose from, including candy pink, neon pink, and pale yellow. The handle and shoulder strap allow it to be carried in multiple ways. Offered in matte leather, embossed crocodile leather, or box calf leather, the materials also play with the masculine-feminine sides.

KENNY

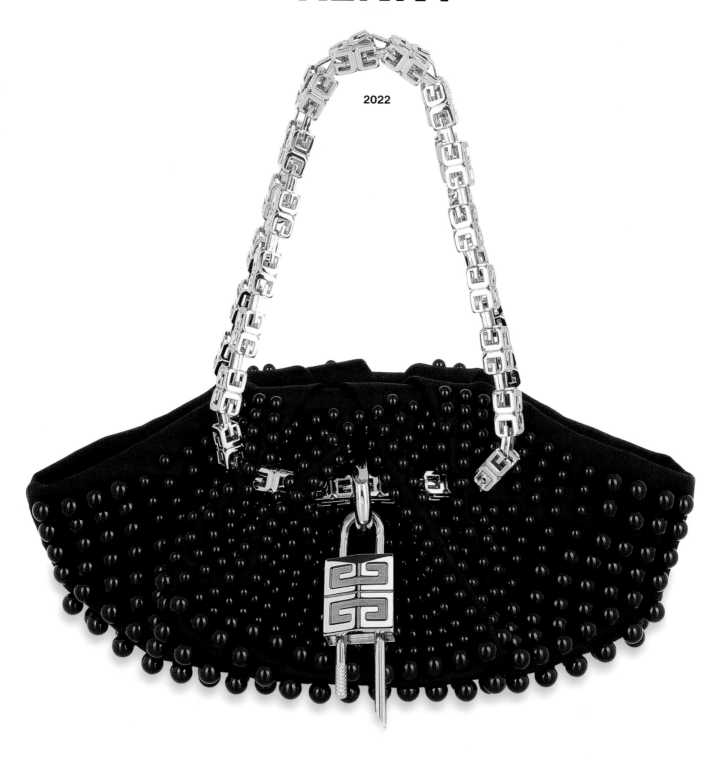

2022

The Kenny is the ultimate evening bag. Designed by Matthew M. Williams, this pouch-style handbag is a nod to the small bags that were all the rage in the 2000s. Made of supple calfskin, it is distinguished by its hand-draped pleats, its double-*G*-cube chain straps, its magnetic clasp, and its padlock, a new Givenchy signature. It is also available in other festive materials, such as rhinestoned satin, silk with feathers, and metallic leather.

VOYOU

2023

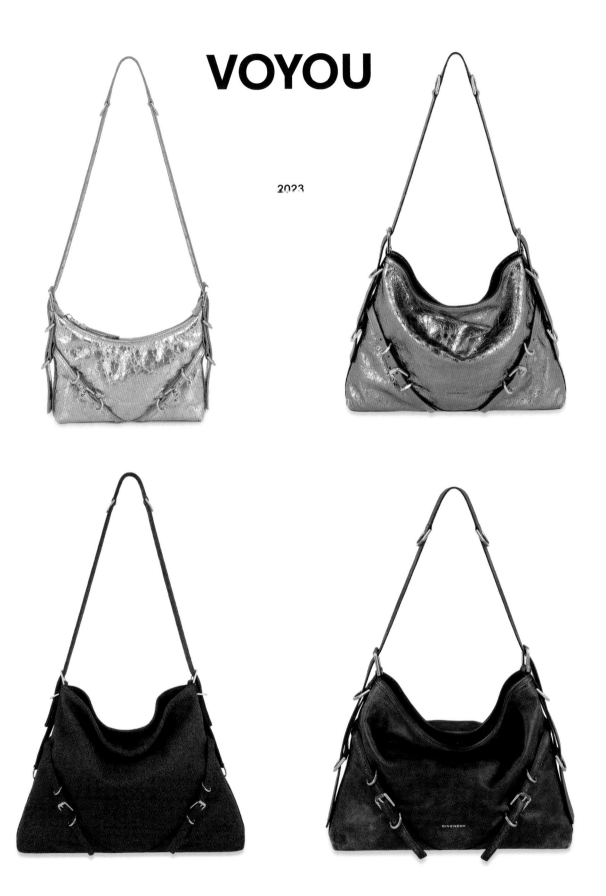

Introduced during the Spring/Summer 2023 fashion show, the Voyou has a cool rock look while still looking sophisticated. What a beautiful stage presence! Its supple *V*-shaped silhouette features silver or gold metal details, including diagonal buckle closures. It is available in three sizes and in a multitude of colors and materials. This is 100 percent nonchalant chic.

GUCCI
THE UPDATED CLASSIC

"You remember the quality long after you forget the price."

Aldo Gucci

Deeply defined by its family history, Gucci is now a label that is very much current, creating trends and playing with the classics that were invented more than sixty years ago. Several iconic bags are an integral part of its heritage.

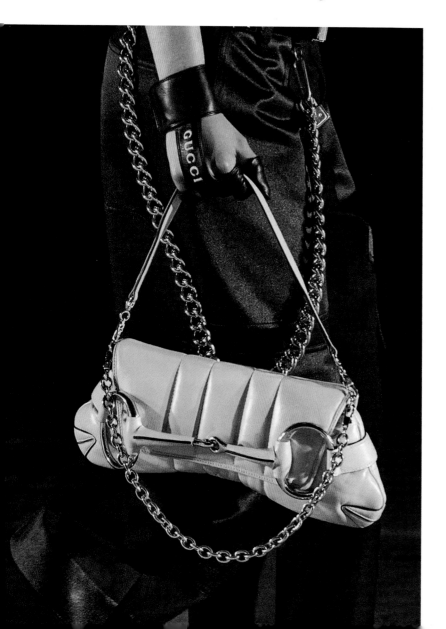

8 KEY DATES

1921
Guccio Gucci, who worked as a baggage handler at the Savoy Hotel in London and trained with a Milanese leather goods manufacturer, establishes the Gucci fashion house in Florence. He offers high-quality leather goods, often inspired by the equestrian world.

1953
After Guccio's death, and two weeks after the opening of a boutique in New York, his sons Aldo, Vasco, and Rodolfo take over the management of the house. They continue to think big and open stores in Miami and London. Aldo Gucci creates the Horsebit loafer (with a double ring and bar across the top). The women's version is released in 1968.

1963
The first Parisian boutique opens on rue du Faubourg-Saint-Honoré in Paris's 8th arrondissement.

1966
This is the brand's golden age, adored by all celebrities, from Jackie Onassis to Grace Kelly (who inspired the Flora print scarf) to Samuel Beckett and Elizabeth Taylor. During these years, Aldo creates the double-G logo, a tribute to his father, Guccio.

1993–1994
The Gucci family sells all its shares. To revive the brand, Tom Ford is hired as creative director. His sexy style breathes life into the brand that once again seduces Hollywood.

01

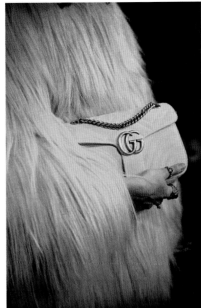

02

MORE TO KNOW
Located in the Palazzo della Mercanzia in Florence, the Gucci Garden highlights the history of Gucci from its inception to the present day. There you can admire clothing, accessories, videos, and artwork. There is also a shop selling exclusive products, and a restaurant. And if you're not going to Florence, you can take a virtual tour on the guccipalazzo.gucci.com website.

2006
After the departure of Tom Ford in 2004 and the somewhat short-lived stints of several designers, Frida Giannini takes over. Her softer, more classic fashion is reminiscent of the brand's earlier style.

2015
Frida Giannini leaves the fashion house and is replaced by her assistant, Alessandro Michele. He presents a more androgynous and, above all, ultramaximalist tone to the brand. The baroque side becomes a new signature.

2023
After spending twenty years with the fashion house, Alessandro Michele is replaced by Sabato De Sarno, who trained at Prada, Dolce & Gabbana, and Valentino.

03

04

FASHION HOUSE FACT
In 2022, the Gucci Valigeria boutique, dedicated to the brand's luggage line, opens in Paris. Located in the 1st arrondissement at 229 rue Saint-Honoré, the two-story boutique is inspired by the luxurious travels of the belle époque. The store sells travel bags, travel trunks, tote bags, suitcases, vanity cases, and hat boxes.

THE 5 HOUSE CODES OF GUCCI

01.
The bit

02.
The Double-G

03.
Bamboo

04.
The green-red-green stripe
It was inspired by the straps on riding saddles.

05.
The Flora print

05

BAMBOO

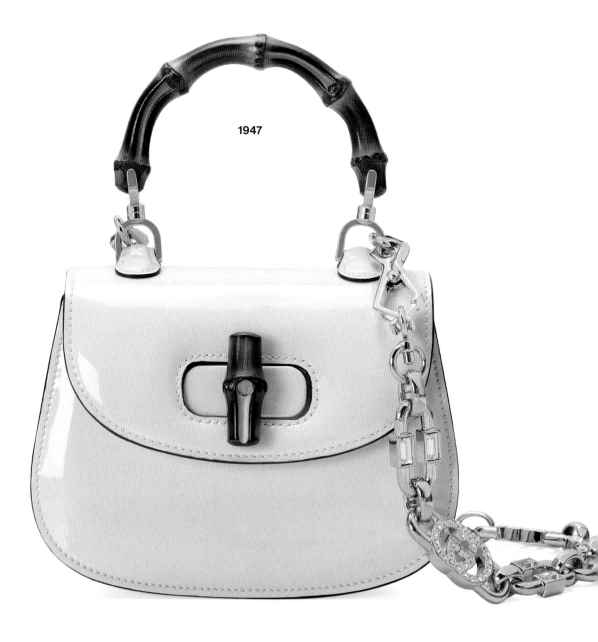

1947

This bag proves that constraints can lead to success. In the postwar period, Italy experienced a leather shortage. Guccio Gucci had the idea of importing a little-known material from Japan: bamboo. He created this bag with a bamboo handle and clasp. The curved handle is made using a highly technical process, which Gucci has patented to make it a brand exclusive. After being softened and worked by hand over a flame to give them a semicircular shape, the bamboo pieces are covered with several layers of lacquer and then baked to achieve a glossy, golden-brown finish. The success was immediate. In 2010, Frida Giannini, then creative director of the fashion house, modernized it and renamed it the New Bamboo! On the occasion of the Fall/Winter 2017–2018 collection, the bag was presented with its new, and current, name Gucci Bamboo 1947, in reference to the year in which it was designed. It takes thirteen hours for artisans working in Gucci's ateliers in Florence to assemble the 140 pieces required to make it, following the same manufacturing process used in 1947. The bag comes with a handle and has a pocket with a mirror on the inside.

In 2021, Gucci launched a new version of its Bamboo tote from 1991, one frequently carried by Lady Diana. Its new name pays homage to her: the Gucci Diana. Bamboo is now one of the codes of the brand and is also available in its jewelry and many other accessories.

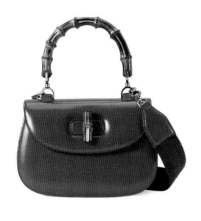
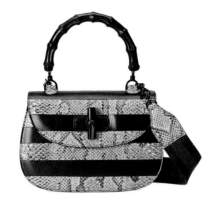
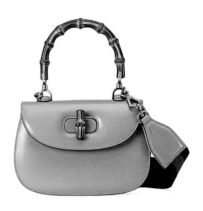
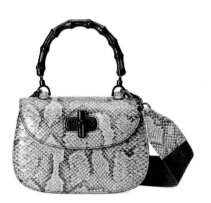
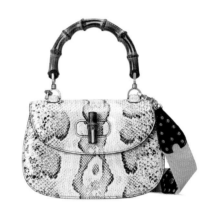
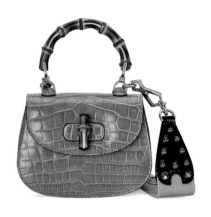
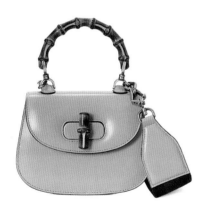
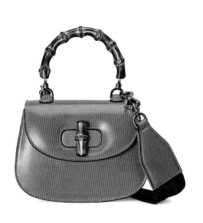
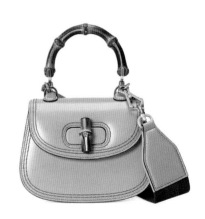
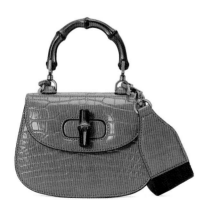
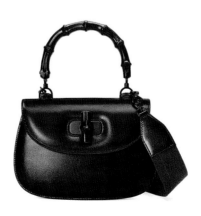
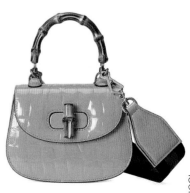

HORSEBIT 1955

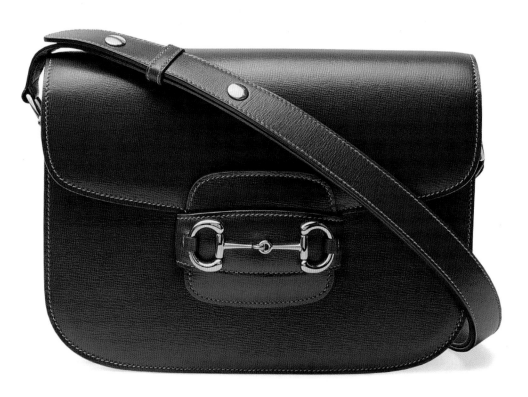

This bag perpetuates the fashion house's heritage with the revival of the double ring and bar, one of the house codes, established in 1955. The bit adornment first appeared in 1953 on loafers. It reinforced the link to the equestrian world, which has always inspired the Gucci brand and served as a connection to a leisure activity popular among many of Gucci's clients. Since then, the emblem has been represented in various forms, defining a range of the house's accessories and prints. The Horsebit 1955 collection, one of the brand's iconic bag collections, has stood the test of time thanks to its sleek and timeless design and the exceptional materials and craftsmanship that have always distinguished Gucci. The bag comes in several designs, from the original rectangular version with an adjustable shoulder strap and top flap to one with a hooped top handle.

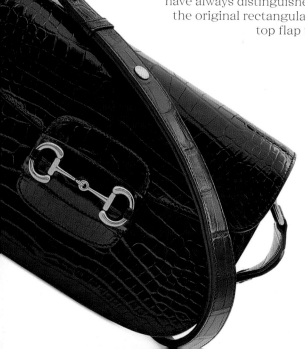

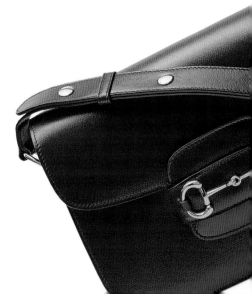

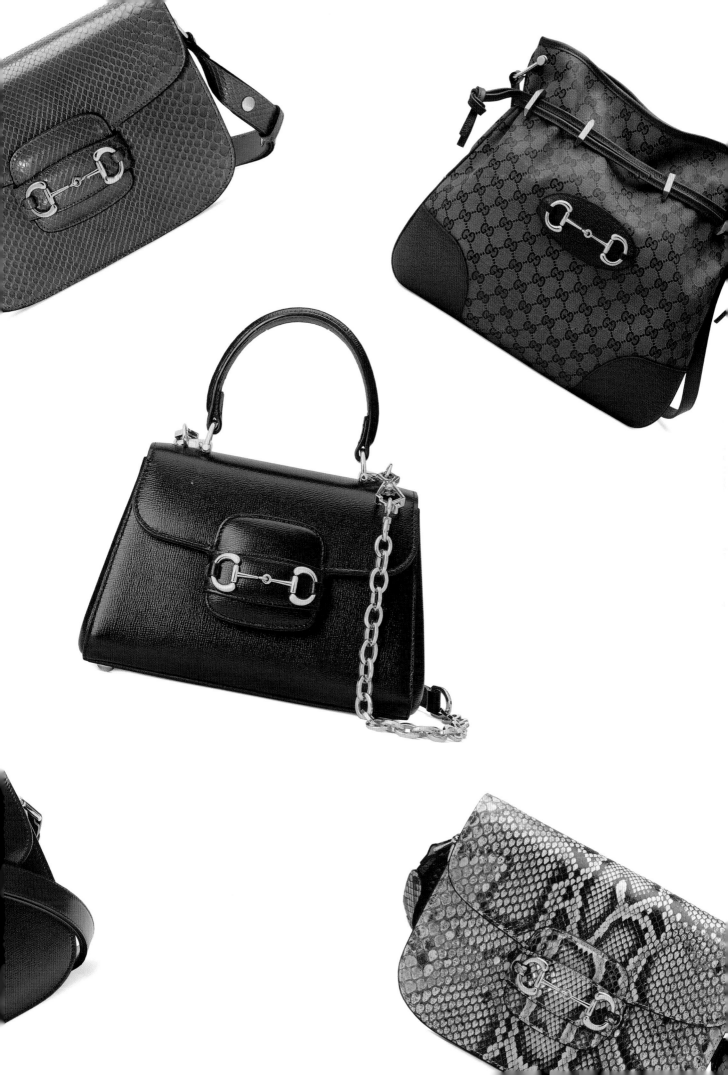

JACKIE
1961

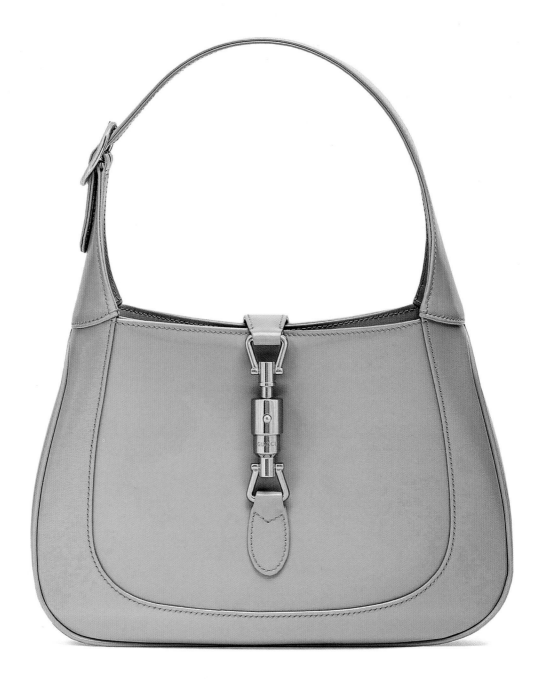

Created in 1961, this half-moon bag with a piston-style closure stands out from the bags of the time. Its timeless mystique has made it unchanging, yet just as popular, after more than sixty years since its inception. During the Fall/Winter 2020 fashion show, Alessandro Michele modified the Jackie somewhat. Smaller in size, the bag, renamed Jackie 1961, comes in three sizes: medium, small, and mini. Available in many colors, it has a long detachable shoulder strap for a new way to wear it.

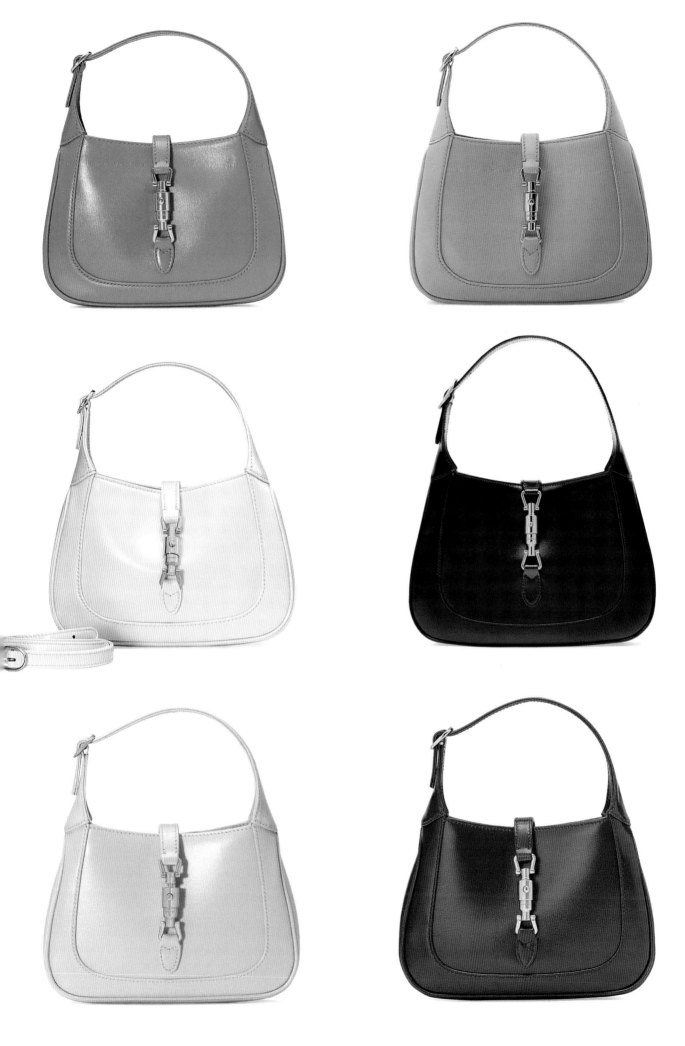

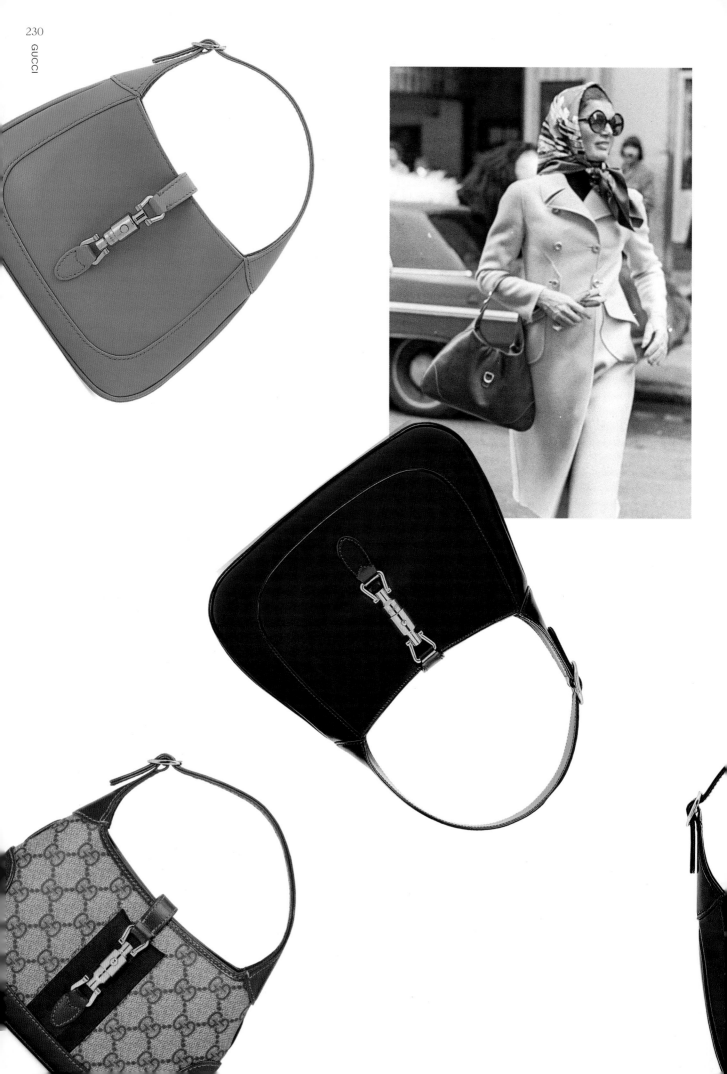

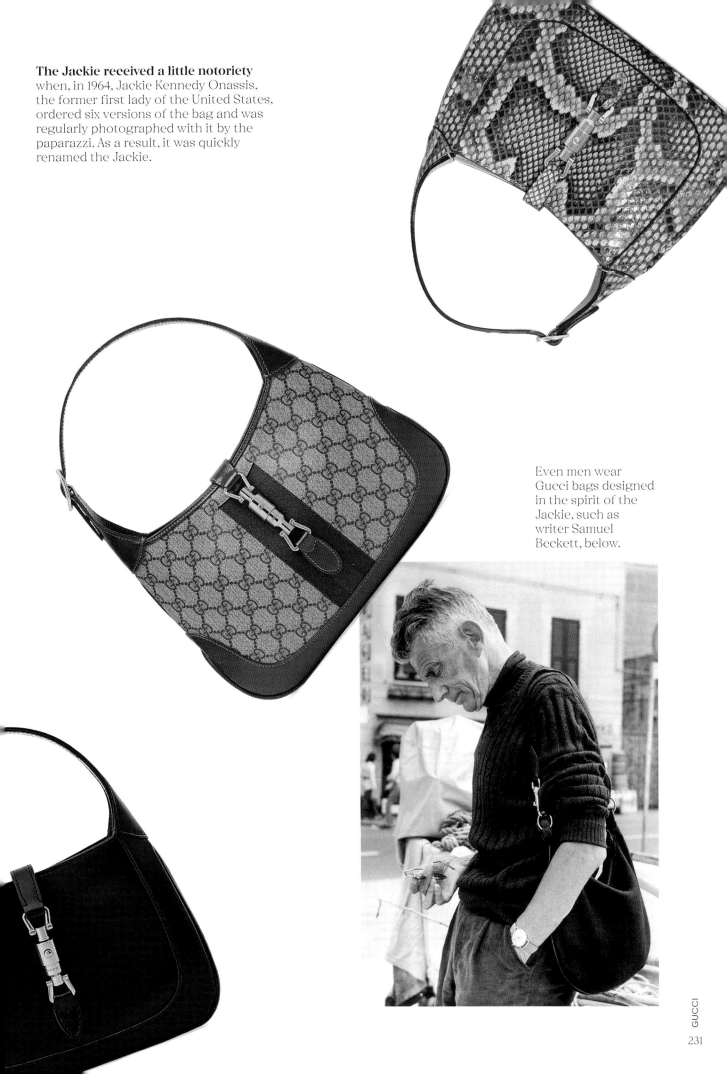

The Jackie received a little notoriety when, in 1964, Jackie Kennedy Onassis, the former first lady of the United States, ordered six versions of the bag and was regularly photographed with it by the paparazzi. As a result, it was quickly renamed the Jackie.

Even men wear Gucci bags designed in the spirit of the Jackie, such as writer Samuel Beckett, below.

HERMÈS
ARTISANS OF LUXURY

"Luxury is that which can be restored." **Robert Dumas**

Since its creation in 1837, Hermès, an independently owned, family-operated French fashion house, has remained faithful to its model of artisanal excellence. The freedom of creation, the constant search for the most beautiful materials, the passing-on of exceptional know-how, and the thoughtfulness for the function of every detail have forged the company's uniqueness and global success. Evolving from harness and saddle making for the carriage industry during the time of horse-drawn transportation, Hermès, which today has sixteen artisan ateliers, draws on its equestrian roots and excellence in craftsmanship to create bags whose simple lines and shapes result in a unique style—an aesthetic of function—perfectly balancing functionality, quality, and durability. The house stays in step with current trends and the evolution of function, constantly innovating to reinvent itself. Design, placed under the artistic direction of Pierre-Alexis Dumas, creates a dialogue between what is beautiful and what is useful, and has been transmitted to each generation of new artisans since the company's inception. The house brings to life its iconic pieces, such as the Kelly, Birkin, and Constance bags, and never ceases to invent new models that are just as desirable: Hermès Della Cavalleria, Roulis, Arçon, and others. Hermès manufactures all its luxury leather goods in France and continues to open new factories throughout the country. What these objects have in common is that they are designed to last, to be restored, to develop a patina, and to become even more beautiful over time. That's the magic of artisanship.

9 KEY DATES

1837
Thierry Hermès opens a harness and bridle atelier in Paris. He succeeds by manufacturing refined, high-quality equestrian harnesses that have incredible durability.

1880
Charles-Émile Hermès, Thierry Hermès's son, moves the ateliers and opens a boutique at 24 rue du Faubourg-Saint-Honoré in Paris.

1922
During a trip to Canada, Émile Hermès, son of Charles-Émile, discovers the zipper system, which he obtains exclusivity to in France, and uses it on the brand's luggage.

1937
The first silk square is introduced: Jeu des omnibus et dames blanches.

1967
First women's ready-to-wear collection.

1978
Jean-Louis Dumas takes over leadership. He orchestrates the acquisition of new expert trades as well as new global markets.

2013
Axel Dumas, of the sixth generation, is appointed executive chairman of Hermès. He embodies Hermès's values, vision, and approach to multi-local commerce that have made the company successful. Under his leadership, the company's momentum for growth increases.

2020
Creation of the beauty line.

2021
Creation of the École Hermès des Savoir-Faire (CFA), which offers a national diploma in leather goods making.

01

02

03

04

05

THE 5 HOUSE CODES OF HERMÈS

01.
Equestrian roots

02.
Leather

03.
Silk

04.
Color: orange

05.
The pyramid stud

FASHION HOUSE FACT

After making equipment for horses, at the beginning of the twentieth century the company started manufacturing collars for dogs, some of which displayed pyramid studs. From the end of the 1920s, the stud was reinterpreted in various ways among the fashion house's accessories or leather goods trades. Since then, the pyramid stud has inspired all the ateliers and can be found on the Médor watch and the Clou Médor minaudière.

MORE TO KNOW

Alfred de Dreux's sketch *Duc attelé, groom à l'attente* became the emblem of the house in 1945.

THE HISTORIC BAG
HAUT À COURROIES

**EARLY TWENTIETH
CENTURY**

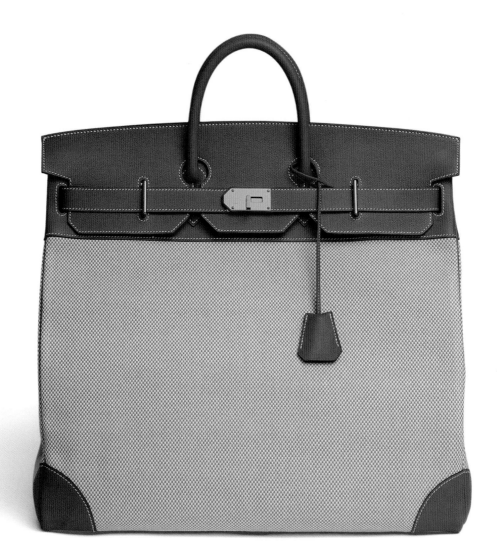

The Haut à Courroies was the first handbag made by the luxury fashion house. Created at the beginning of the twentieth century, the bag allowed horse riders to carry their boots and saddles more easily and elegantly. With the arrival of the automobile, the trapezoidal bag, with its sculptural look, was adapted for a new use as a travel bag. Since then, the straps that held the saddle flaps in place, the emblematic polished bottom corners, and the saddle stitching, turn lock, padlock, and straps have remained a part of it. A bag of character with large proportions, the Haut à Courroies lends itself to all interpretations, in an infinite play of materials: raw or printed canvas or leather and felt, as well as myriad expressions in printed patterns, including checked and Western motifs embroidered directly into the material.

BOLIDE

1923

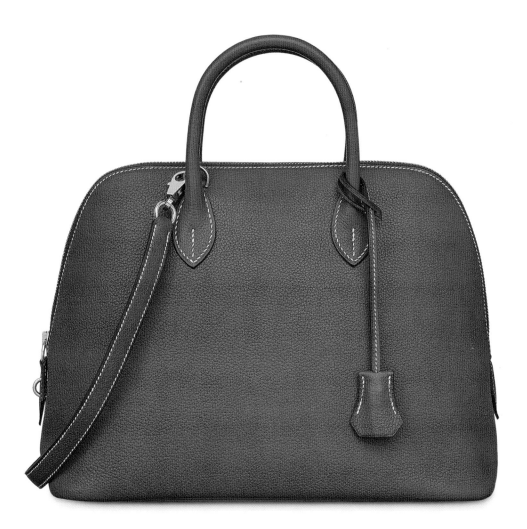

The Bolide bag, created in 1923, owes its distinctive and innovative rounded shape to the zipper, discovered by Émile Hermès a few years earlier in Canada, used on an automobile's soft hood. By adapting it to leather goods, he created a model simply called an "automobile bag," designed to fit easily into the rounded trunks of cars of the time. Designed to complement new lifestyles, the Bolide was characterized by the purity of its shapes, as if sculpted in leather. It has two handles inspired by the brand's equestrian expertise in crafting round bridles, which were more difficult to make than flat bridles, and ideal for highlighting a horse's coat. The Bolide, in its archetypal form, is both a handbag and a travel bag, thus expanding its function.

KELLY

The 1930s

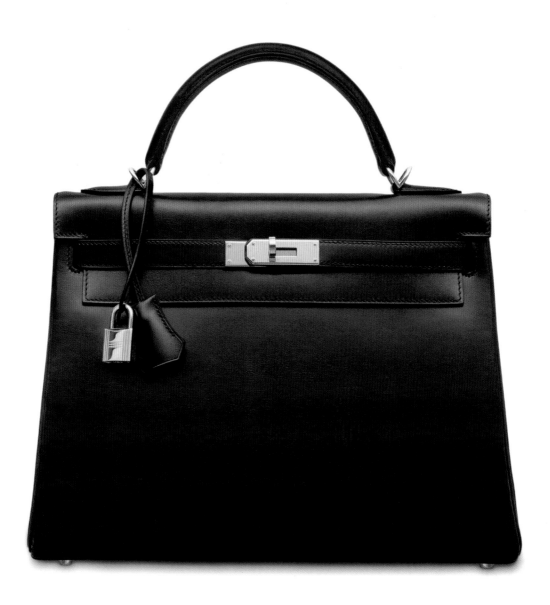

In the 1930s, Robert Dumas created a handbag with a pure and radical aesthetic: a trapezoidal shape, two triangular gussets, a rounded handle, a flap closed by two straps, and a turn lock. This archetypal model embodied the essence of Hermès leather goods. With its skillfully cut and geometric structure in straight lines, the bag gained worldwide fame at the end of the 1950s when Grace Kelly, Hollywood star turned princess, was photographed with it on several occasions: in her dressing room, exiting a plane, and concealing the first curves of her pregnancy; the pictures traveled around the world. The Kelly, voluminous for the time, offered greater autonomy to women, thus bearing witness to society's evolution. It was quintessential chic in its structured version and sportier in its softer version. Variants of the bag include the Kelly Ado, Kelly Doll, Kelly Picnic, Kellygraphie, Kelly Danse, and Kelly en Désordre.

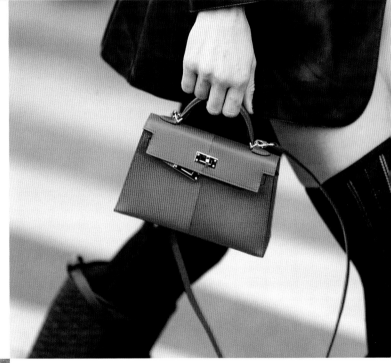

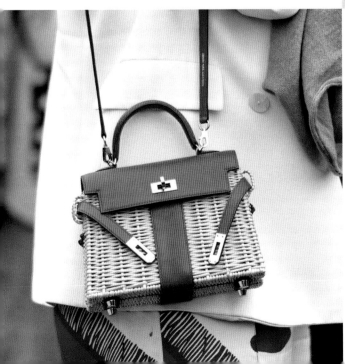

WHAT IS
THE BAG'S CALLING CARD?

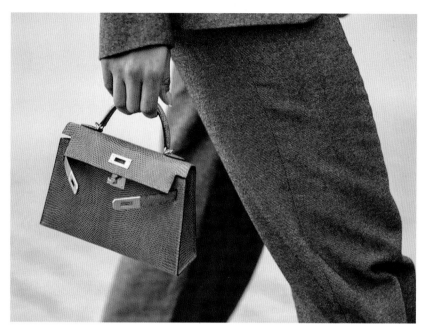

Two styles: the Sellier and the Retourné
The Kelly comes in two different constructions.
—The original Kelly Sellier: The edges are raw, and the seams are saddled, i.e., exposed. It is structured and often made of rather rigid leathers.
—Softer, the Kelly Retourné is constructed inside out to hand stitch it, then turned right side out in the final stage of its construction. Its look is more casual.

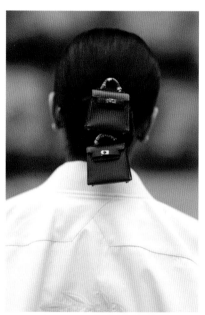

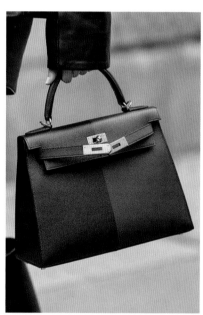

Colors
Today, the Kelly can be found in myriad shades: curry, crevette, bleu encre, bleu paradis, vert criquet, sésame, or biscuit. The shades have names that lend the bag a particular spirit. The fashion house works with tanners to create classic or bright exclusive colors. The most sought-after color by collectors is rouge H, a burgundy with a touch of brown, created by Hermès in 1925. With rouge H, Hermès was the first fashion house to create leathers in vivid colors.

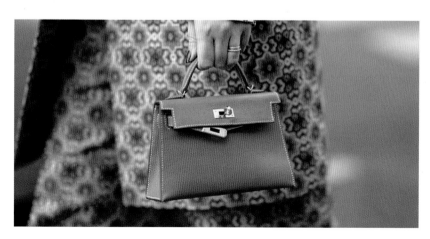

Sizes
From micro to travel size, the Kelly is available in many sizes, identified in name by their measurements in centimeters: the Kelly 15, 20, 25, 28, 32, 35, 40, and 50.

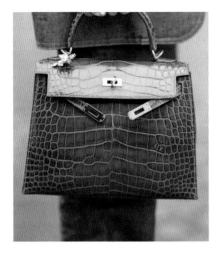

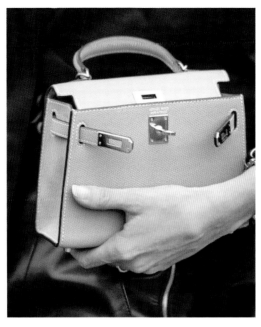

Materials

At Hermès, leather is always full grained. As a guarantee of durability, the grain is not altered, and its natural characteristics are not covered up during the tanning process, lending the hide great distinctness that gradually acquires a patina. This also makes the piece unique.

Among the leathers:
—Box calf leather, nicknamed the "king of leathers," is smooth and very soft. It has a certain shine that is hard to find elsewhere. Supple yet firm, it has a character known as a "boardy": It bounces back slightly, with a delicate sound, when touched. It is fragile but has a wonderful patina.
—The Clémence bull calf leather is slightly satin-finished, and its relief seems to float: When the fingers glide over its surface, it feels as if the grain is lying down and then rising.
—Barenia calf leather is a smooth leather that easily develops a patina and appears magical because, when massaged, it absorbs light scratches.
—Epsom calf leather and Togo calf leather are grained leathers, so they are less fragile.

All the leathers develop a patina, which explains their resiliency. Over time, each bag evolves, and each owner recognizes their own distinct bag. Thus, the patina becomes a signature that forms a bond between the bag and possessor.

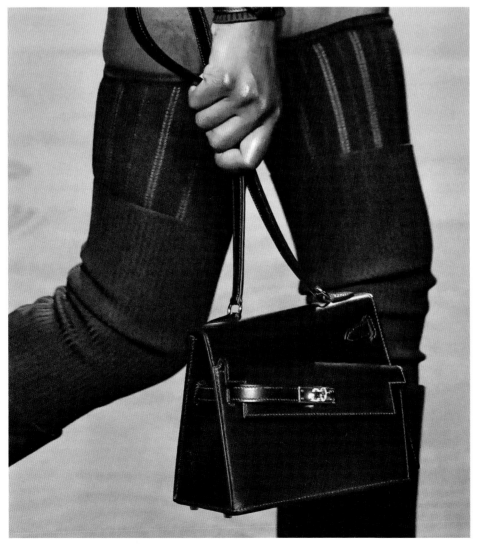

THE GRACE
OF A KELLY

The Princess of Monaco was the perfect embodiment of this bag. It completed her entire look. In the 1950s, Grace Kelly was spotted multiple times with this Petit Sac à Courroies Pour Dame. The connection between her and the bag was obvious, and in the early 1960s, it was officially renamed Kelly. With her look of a Hollywood star living a fairy tale, Grace Kelly laid the foundation for an ultrachic bag.

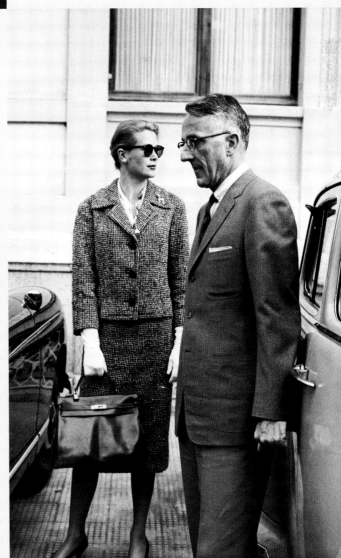

PLUME

The 1960s

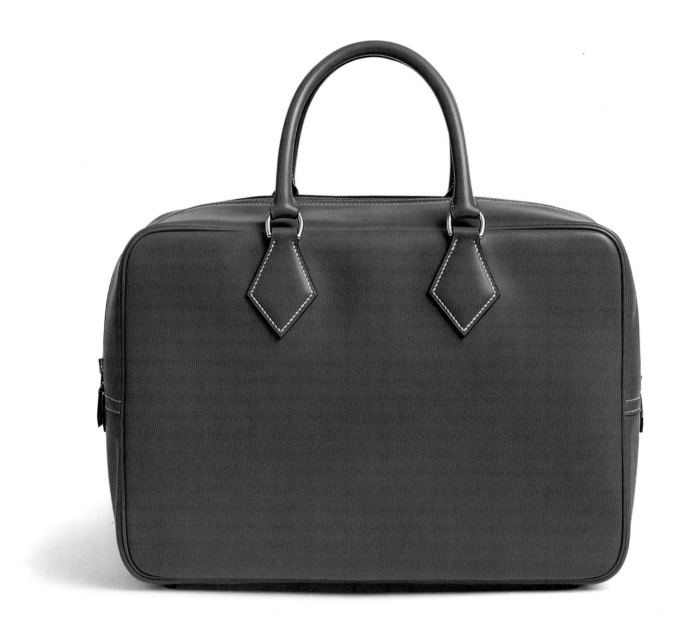

Lightweight and minimalist, the Plume bag, designed in the 1960s, owes its name to its extreme lightness. Its rectangular, unlined shape was inspired by a blanket bag created in the 1920s. Practical with a single three-sided zipper, it is especially difficult to construct. It is completely sewn inside out and then flipped right side out like a glove. With the large leather handles, saddle stitching, metal links on the polished handles, and diamond-shaped leather attachments, the Plume expresses all the facets of the fashion house's craftsmanship.

The bag is very versatile and can be made in all sizes—mini, handbag, briefcase, and weekend bag—and always with the same simplicity of lines and shape.

CONSTANCE

1967

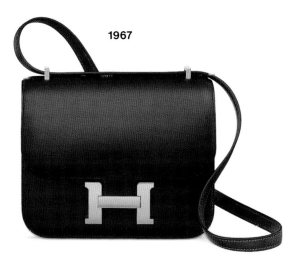

Created in 1967, the Constance, named after its creator's daughter, is innovative for its simplicity and ease of wear. It is a small architectural gem with graceful proportions, a sense of harmony, and elegance in motion. It is distinguished by its clever *H*-clasp—sometimes gilded, silver-plated, lacquered, covered with enamel, or inlaid with stones—and by its double gussets and saddle assembly with polished raw edges. The Constance cultivates a taste for variations, whether through its different sizes or how it is worn or styled— long or short, adorned with leather or canvas, or in monochrome or multicolored—but without ever losing its distinctive signature curved flap, which catches the light.

EVELYNE

1978

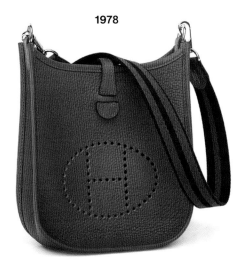

One of the characteristics of the Evelyne model is its oval-shaped *H* perforation, suggesting the shape of a horse's hoof. Created in 1978, the model owes its name to its creator, then head of the equestrian goods department, who imagined a functional bag for riders, ideal for transporting necessary equipment used to groom horses. The perforations allowed tools (a sponge, brush, or combs), which were sometimes still damp when placed in the bag, to dry. Eventually adopted for everyday use by both women and men, this very sporty bag has retained its shoulder strap. Revisited in saddle construction, the Evelyne displays the *H* diamond embossed in leather, which was a motif inspired by an insignia on a riding blanket appearing in an Hermès catalogue from 1926.

BIRKIN

1984

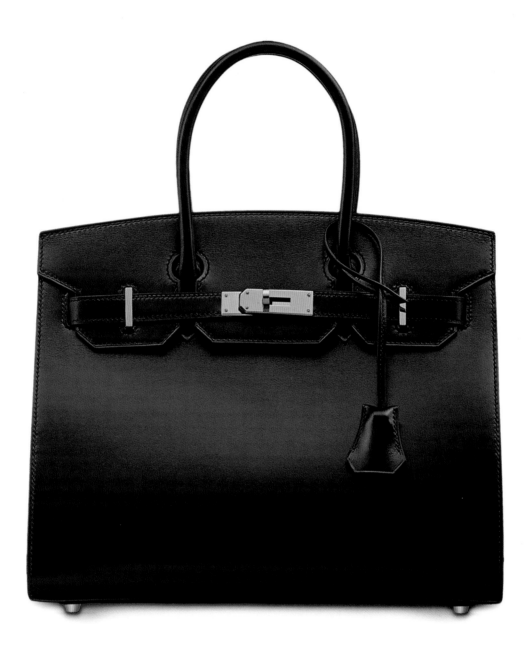

This object of desire is the result of an impromptu encounter. In 1984, Jean-Louis Dumas, then president of Hermès, met English actress Jane Birkin on a plane from London to Paris. She told him that she couldn't find a tote suitable for her life as a young mother. A born creative, Jean-Louis Dumas immediately designed for her a soft and spacious tote with a casual style and natural look. It was equipped with the emblematic Hermès codes: burnished flap, saddle stitching, two rounded handles, cross straps, and a lock closure. Today, it is made in a multitude of colors, sizes, and materials. Its modern design lends itself to all kinds of experiments: Birkin Shadow with trompe l'oeil, Birkin So Black, which is black right down to its metalware, the Birkin Sellier with its structured lines, and the Birkin Cargo, supple and functional in cotton canvas. The bag is constantly reinvented.

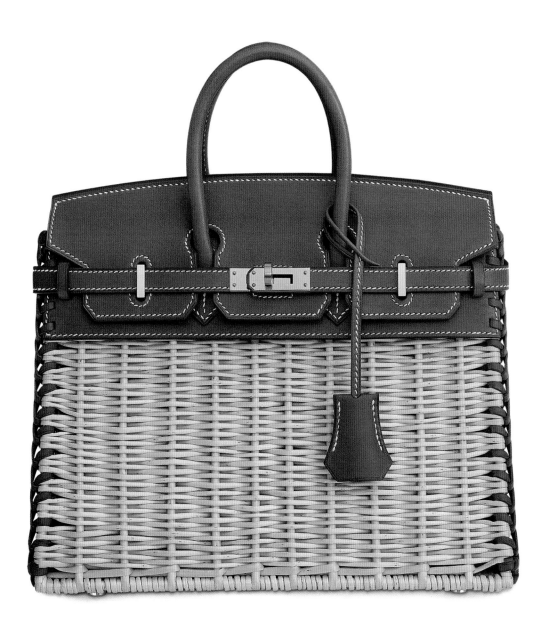

The Birkin is available in many colors and four sizes (20, 25, 30, and 35 centimeters). Like the Kelly, it is often reimagined and, even though the original version is the object of all desires, variations have also been a great success, such as the Birkin Faubourg, depicting the front of the Faubourg-Saint-Honoré store, or the Birkin Picnic, a marriage of wicker and leather.

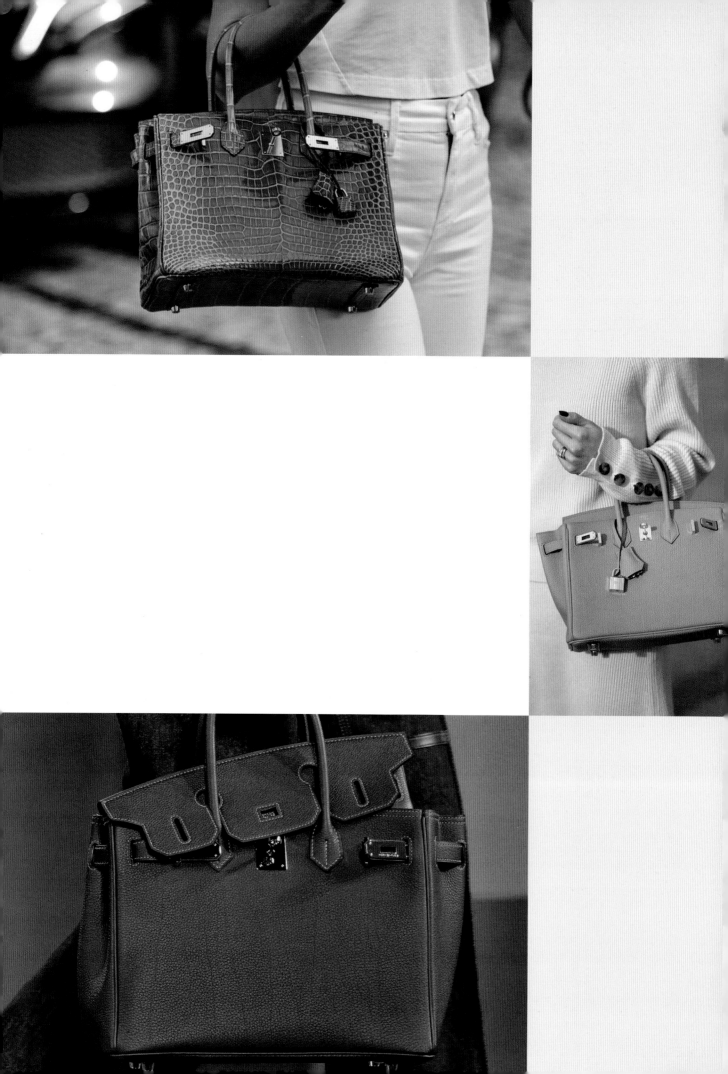

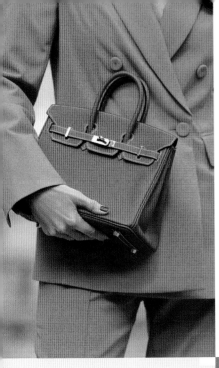

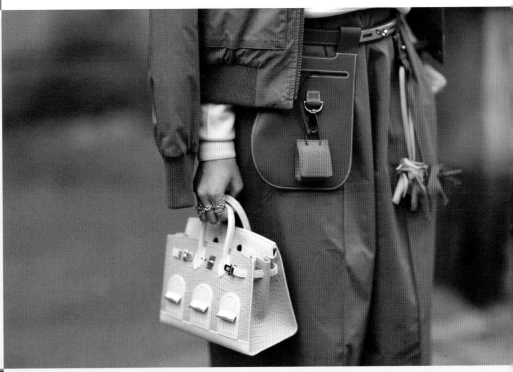

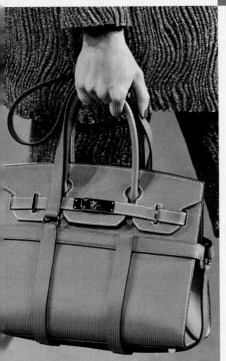

ROULIS

2011

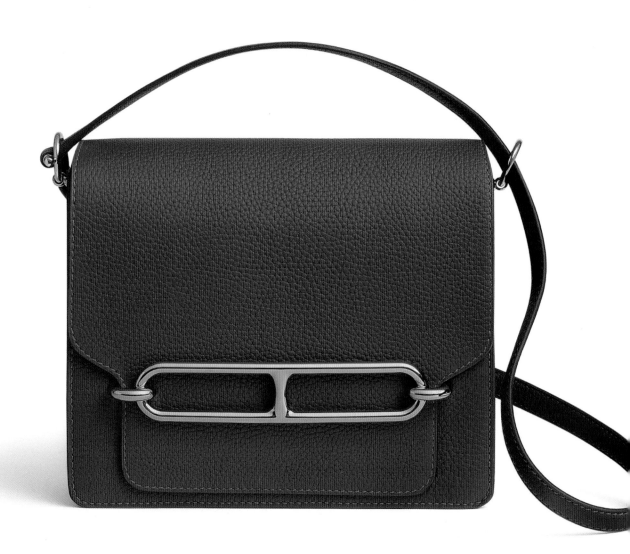

In 1938, Robert Dumas designed the Chaîne d'ancre bracelet, imitating the links of a boat's mooring lines. On the Roulis bag, the jewel clasp is shaped into a stylized link, as if stretched, under which the flap delicately slips. The Roulis navigates between retro allure and futuristic aesthetics combined with robust materials and finesse of its features. Functional, with a very simple silhouette, it can be worn short at the shoulder or across the body in a play of movements that echoes its name.

HERMÈS
DELLA CAVALLERIA

2020

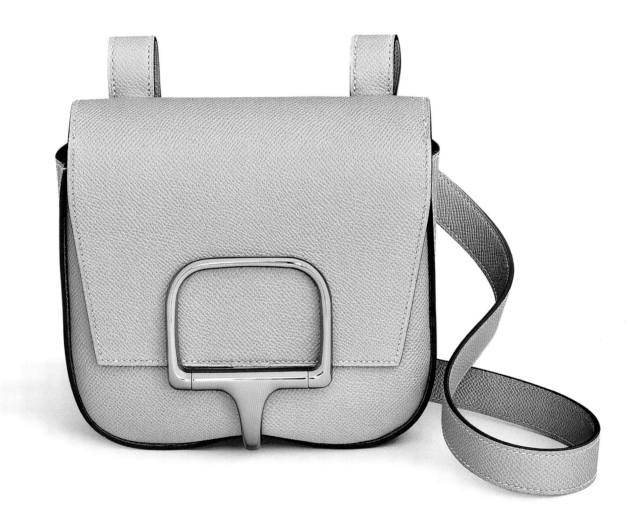

Its half-bit-shaped clasp makes it an instant classic. Although the look suggests the bag has long been part of the collections, it is among the latest arrivals. Expert craftsmanship is an obvious necessity for the metal to bend along the curve of the leather with such precision. It can be worn over the shoulder or across the body.

PETITE COURSE

2023

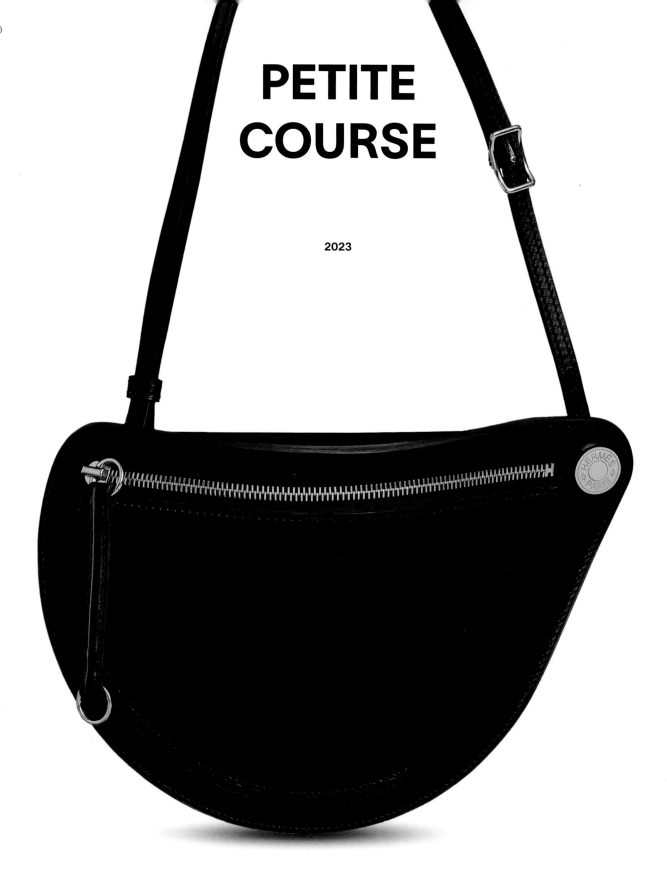

A saddle was the object of inspiration for this bag. Its leather fashioning highlights the taut, domed, and rounded construction of a saddle flap. It has a zipper and a saddle stud reminiscent of the equestrian world and is carried by a leather shoulder strap.

ARÇON

2023

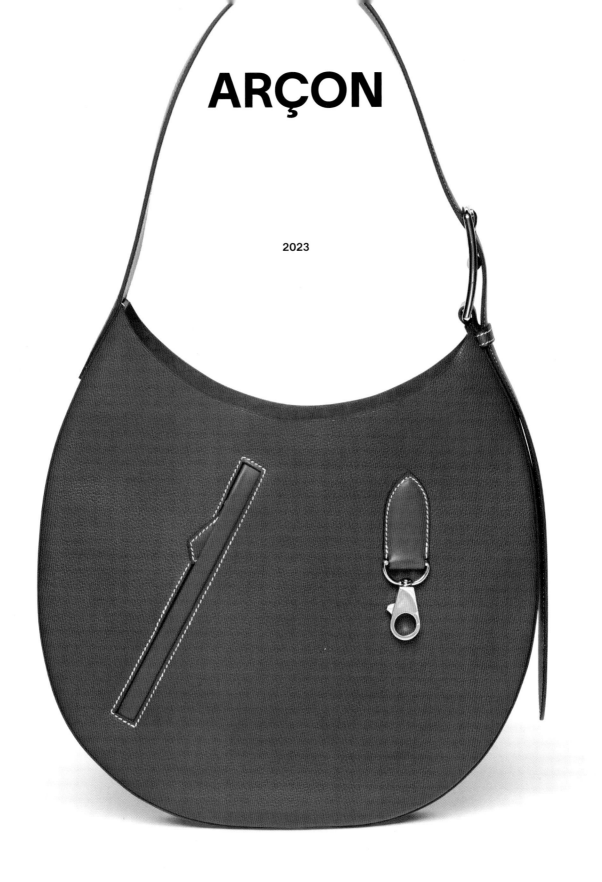

A cross between ready-to-wear and saddlery, the Arçon bag links these two artisan trades of the brand. This bag is shaped like a saddle flap, with the practicality of a garment thanks to its side pocket that invites the natural insertion of the hand. The bag also has a snap hook to hang a pair of gloves or keys.

ARTISANAL
SKILLS

"MADE IN FRANCE" KNOW-HOW

Although Hermès is associated with the Faubourg-Saint-Honoré boutique where it was first established in 1880, the fashion house has production sites throughout France that define it as much as its original location. Hermès sets up its manufacturing sites in areas known for their workforce skilled in special trades, such as in Lyon for silk or in Haute-Vienne for glove making. Since 2010, a new leather goods atelier has opened every year, on average. Each site accommodates 250 to 280 artisans, an ideal size to facilitate the transmission of know-how. All Hermès leather goods are made exclusively in France. More than 4,700 saddlers and leather artisans work in more than twenty factories.

ARTISTS OF ARTISANSHIP

At Hermès, every bag is handmade by leather goods and saddlery artisans who go through nearly eighteen months of training. And learning never stops, as the artisans continue to enrich their expertise throughout their professional lives. Patience and high standards are key in the construction of these luxury leather goods, such as when it comes to hand carving the bend of the rigid handle of a Kelly bag made up of five different pieces of leather. Expertise is essential for executing the delicate gestures required to assemble the forty pieces of leather that make up a Kelly bag. The leather pieces are held between the fingers of a wooden stitching clamp while the artisan completes a saddle stitch.

Epsom calf leather is not cut in the same way as Togo calf leather, for example, and a Constance bag is not assembled in the same way as a Birkin bag. Each task and each bag require specific training. The model that requires the most expertise is the Kelly bag. A craftsperson training with Hermès often begins with this bag. Each bag is made from beginning to end by the same person, who marks it with a signature when completed, thus making the craftsperson responsible for the construction. This accountability leads to trust as well as ownership of the work.

SPECIAL ORDERS, THE ULTIMATE LUXURY

Hermès bags can be personalized thanks to a service that gives the purchaser a chance to play with colors, finishes, and linings. The craftsperson expresses creativity and expertise to meet each request, from the most formal to the most extravagant, such as a conductor's baton case, a cat-shaped suitcase, an apple-shaped abstract bag, or a painting reproduced on leather, as a few examples. Everything is possible for these unique pieces, but with one common denominator: They must be designed in the spirit of the brand.

RESTORATION IS THE SAVOIR VIVRE OF SAVOIR FAIRE

An Hermès bag is designed to last, to be restored when needed, and then passed on. That's what luxury is all about. The leather repair manufacturer masters the expertise of a leather goods saddle-maker. Repairing a saddle stitch or reviving a color restores youth and elegance to the bag. An Hermès bag is for a lifetime. Customers regularly return them to the ateliers for restoration and rejuvenation after years of use. In this way, the craftsperson allows the objects to continue along their journey. An Hermès bag carries with it a host of emotions, and its patina can reveal a life's story. At Hermès, they say: "*Above all, we restore histories.*"

HERVÉ CHAPELIER
THE STAR OF THE 1980s

"'Made in France' quality is important to us." **Hervé Chapelier**

Founded: 1976

The story: Born in Biarritz, Hervé Chapelier divided his time between the United States and Bordeaux, where he studied economics. He settled in Saint-Tropez, where he began selling his first handbags. They were reinterpretations of the travel bag in bright colors (orange, red, pink, yellow, purple, and so on) with handles inspired by automobile seat belts. Saint-Tropez soon became too small for his business, so he left for Paris, where, in the early 1980s, he launched a line of backpacks that became popular among teenagers. The Chapelier style and its made-in-France quality are now world renowned.

The style: Functional bags made of nylon in various colors.

Heard on the street: *"My tote? Yes, it looks like the one I had when I was in high school, but this one is leopard, which didn't exist then!"*

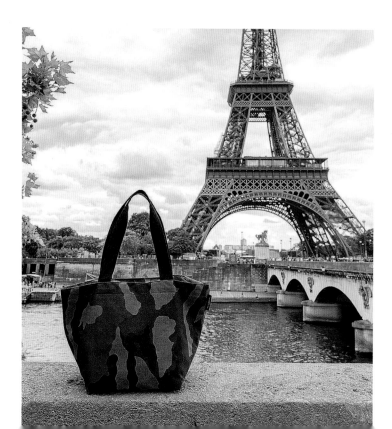

FASHION HOUSE FACT
The tote is also available in a mini format without a handle, which can be worn as a crossbody.

WHO WEARS HERVÉ CHAPELIER?
Women who were teenagers in the 1980s, and their daughters today.

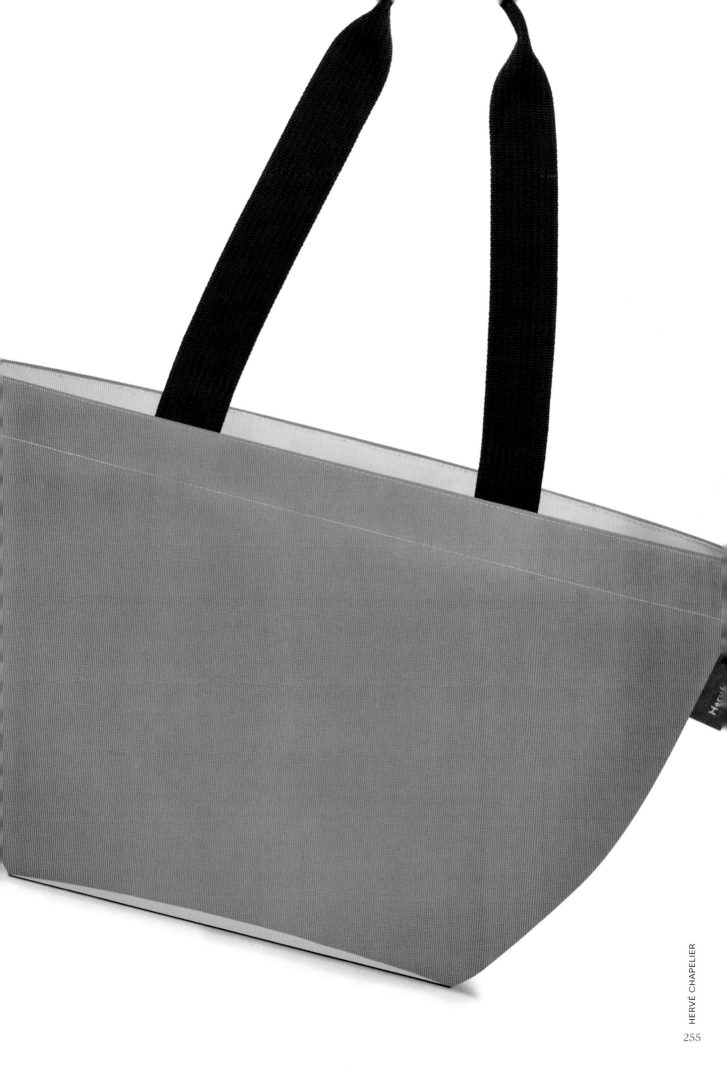

925

1985

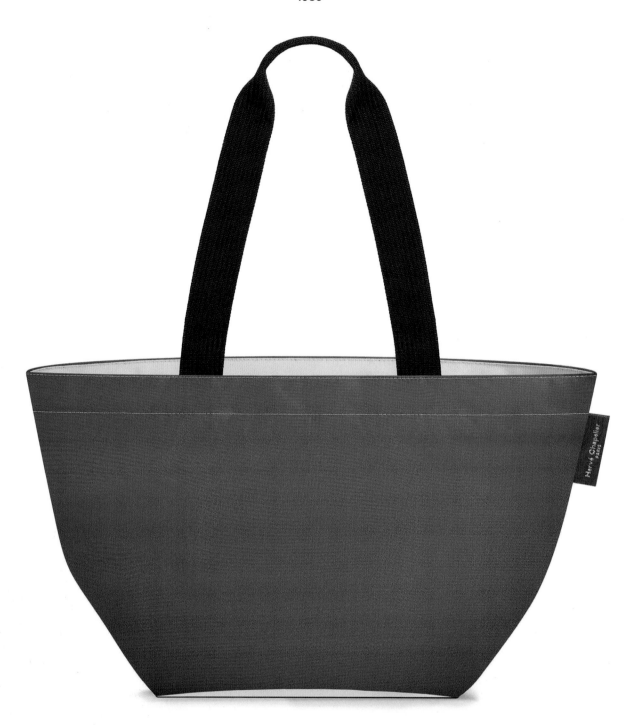

Simple. Essential. Unmistakable. In 1985, this two-tone nylon shopping bag (the color of its square bottom differs from the color of its sides) hit the spot with teenage girls, especially as a school bag. It is known for its unfailing durability and large capacity (about 5 gallons/19 liters). More than a million have sold worldwide, especially in Asia, where it has a cult following. Its made-in-France origins contribute to its status as an icon. The 925 is available in nylon or polyamide and as two-tone, plain, or patterned (leopard, camouflage, and bandana).

INES DE LA FRESSANGE PARIS
PARISIAN CHIC

"A bag that matches your shoes immediately ages you by ten years." **Ines de la Fressange**

Founded: 1991

The story: In her early days as a model, Ines made a name for herself with her antics on the runway. She was nicknamed "the talking fashion model." In 1983, Karl Lagerfeld chose Ines as the face of the Chanel brand, and she remained so for six years. In 1991, Ines launched her own clothing and accessories label. She left her company in 1999 and reappeared in 2002 as creative ambassador at Roger Vivier, alongside artistic director Bruno Frisoni. In 2013, she took over the artistic direction of her brand, which has been growing rapidly with several stores and exports worldwide.

The style: Ines offers her description: *"It's a brand that wishes you well. It's for all women who love moments of frivolity while reading a book by Erri De Luca, the Italian novelist, poet, and playwright."* That's true Parisian chic.

Heard on the street: *"When you wear a bag created by Ines de la Fressange, you are bound to have style."*

FASHION HOUSE FACT
Ines is more than just the artistic director of the brand that bears her name! She has created collections for Uniqlo, written books, and, currently, publishes a newsletter, *La Lettre d'Ines*, every week and a magazine in her name every year.

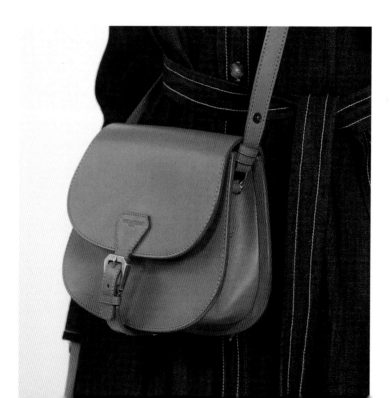

WHO WEARS INES DE LA FRESSANGE?
Lily Collins in *Emily in Paris*, Pauline Lefèvre, Brigitte Macron, and Ophélie Meunier.

FLÂNEUR

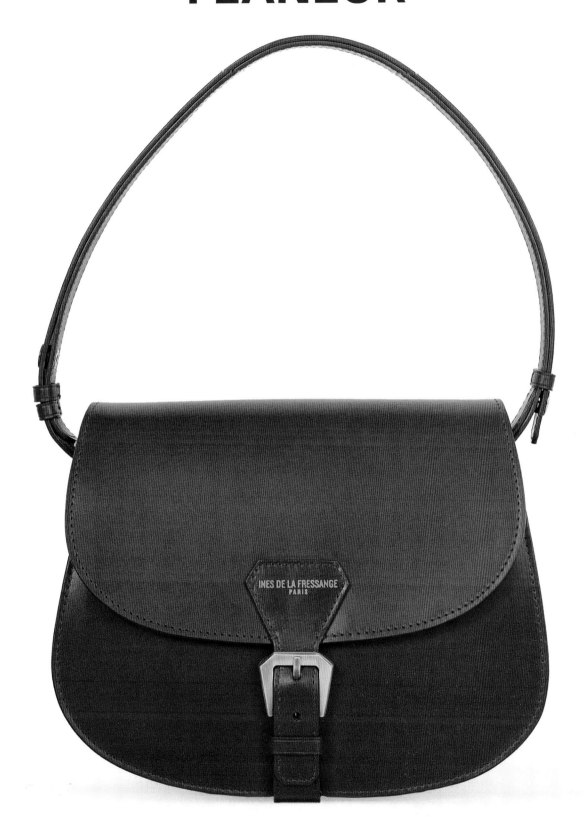

The name of this tote (meaning "one who strolls") was inspired by Victor Hugo's phrase in *Les Misérables*: "*To roam is human, to stroll is Parisian.*" With its rounded curves and smooth leather, the Flâneur is a timeless bag that can be with you all day long, whether on the streets of Paris or anywhere else. It can be worn on the shoulder or across the body.

ISABEL MARANT
THE URBAN BOHEMIAN

"There's something playful about fashion. Don't take any of it seriously either!"
Isabel Marant

Founded: 1995

The story: In 1989, Isabel Marant launched Twen, her first knit-wear and jersey brand. She was twenty-two years old at the time. Six years later, she introduced her collection under her own name and, in 1998, opened her first boutique on rue de Charonne in Paris. It was a success, and growth was fast. She expanded her label with the Isabel Marant Étoile line for an even more bohemian style. Starting in 2017, she added a men's collection. Isabel draws inspiration from the four corners of the globe to dress urbanites in cool clothes with a touch of free-spirited chic.

The style: Cool, rock, urban, and a tad bohemian.

Heard on the street: *"Isabel waited twenty-two years before launching her first line of bags, so they have been well thought out and are all ultra-desirable."*

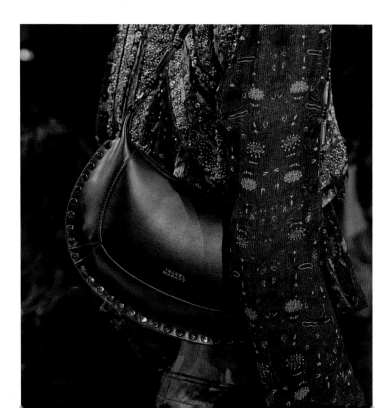

FASHION HOUSE FACT
Passionate about artisanal know-how, Isabel has always encouraged a handmade approach and the preservation of craftsmanship in textiles. In the same spirit of sustainable fashion, she launched Isabel Marant Vintage, a website that gives a second life to garments from her collections.

WHO WEARS ISABEL MARANT?
Gisele Bündchen, Gigi Hadid, Elsa Hosk, Kate Hudson, Rita Ora, and Vanessa Paradis.

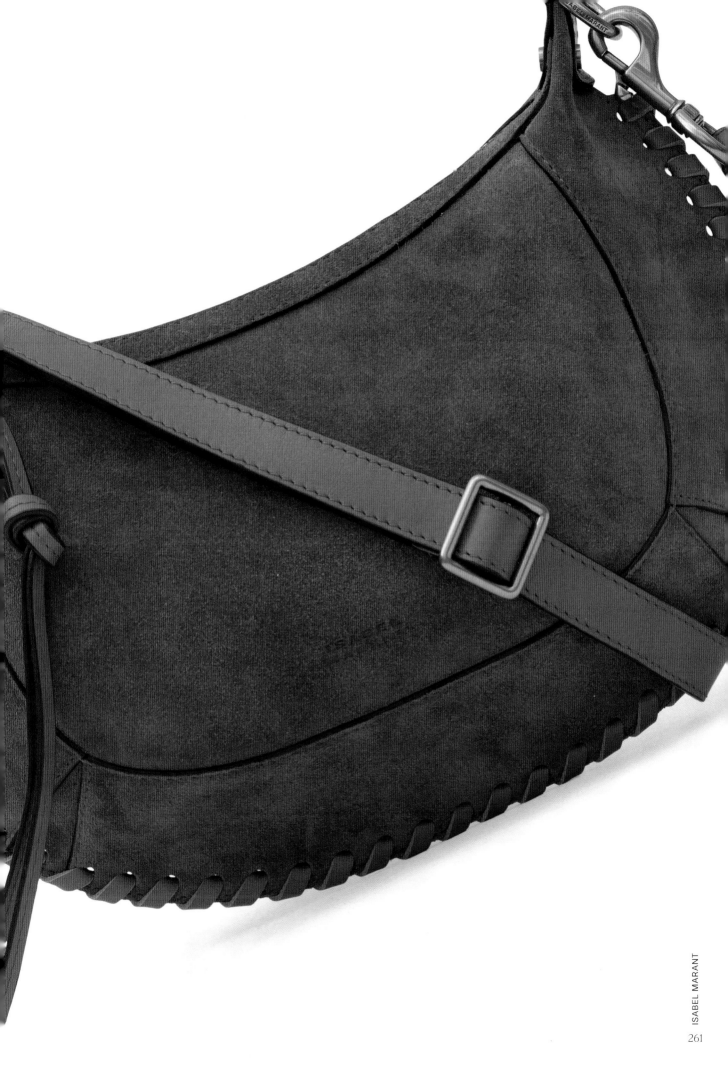

OSKAN MOON

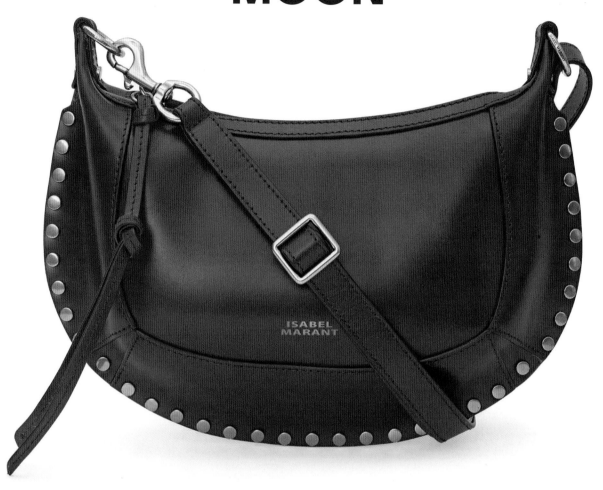

This studded baguette bag is the epitome of Isabel Marant's style. The studs lend a rock air to its bohemian look, and the bag blends in perfectly when worn in the city. Crafted from vegetable-tanned leather, the Oskan Moon is available in several styles: tote, belt bag, and square format. The Moon version is worn on the shoulder. The brand name is inscribed in gold on the front, like most Isabel Marant bags.

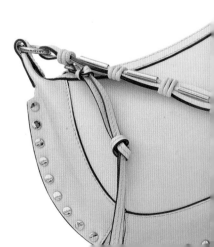

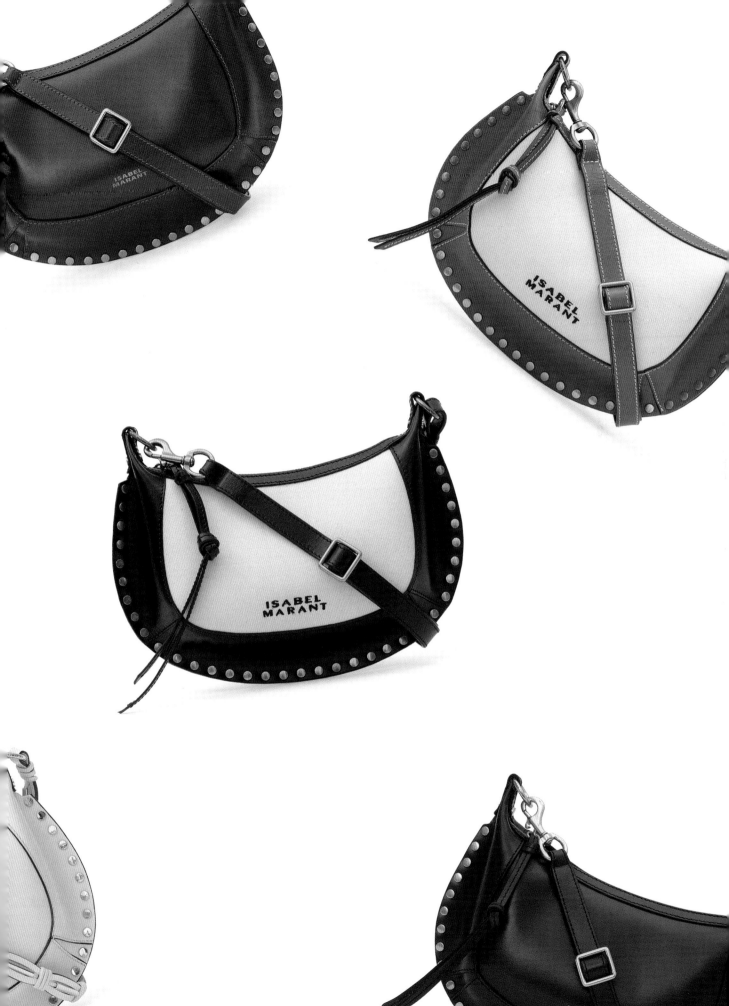

LUZ

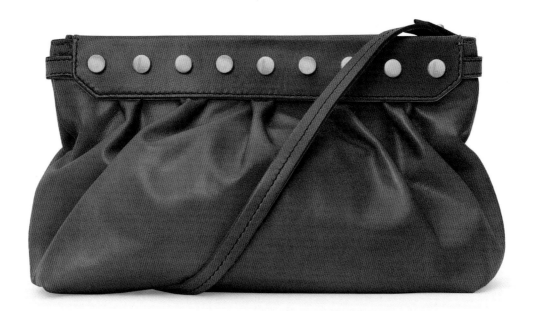

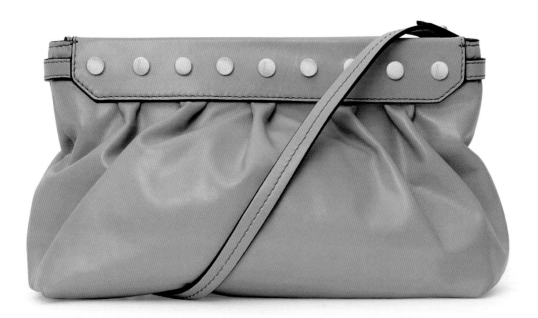

A versatile clutch. When worn with a shoulder strap, it is a very practical small bag for carrying around all day. Without a shoulder strap, it becomes an ideal clutch for evening. Made of supple lambskin and in a very bohemian-chic style, it has small studs on the top edge that lend it a rock vibe. It is also available in cotton.

BAYIA

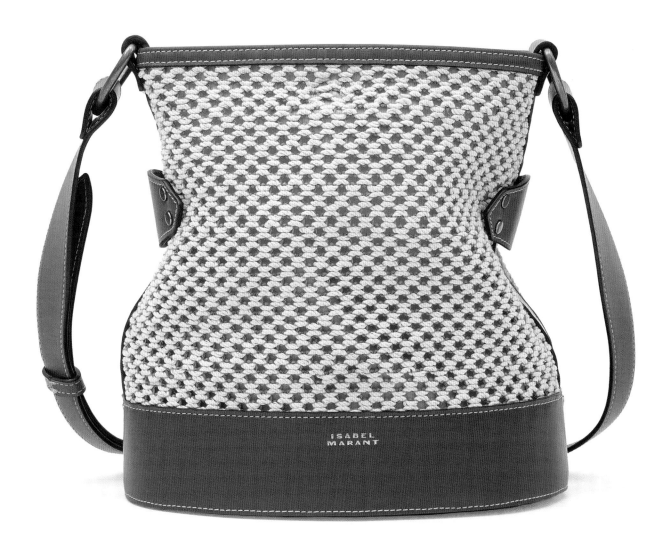

A bucket bag is the answer! The Bayia, made of cotton, is worn on the shoulder and is available in natural colors (cognac leather and ivory cotton).

TYAG

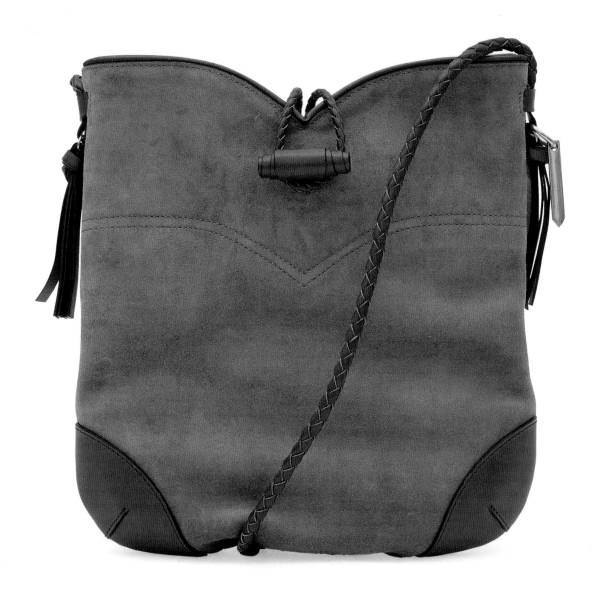

A super practical bag with a large capacity, it has a braided leather shoulder strap that lends it an attractive look. It is available in suede, raffia, and leather.

NIAMEY

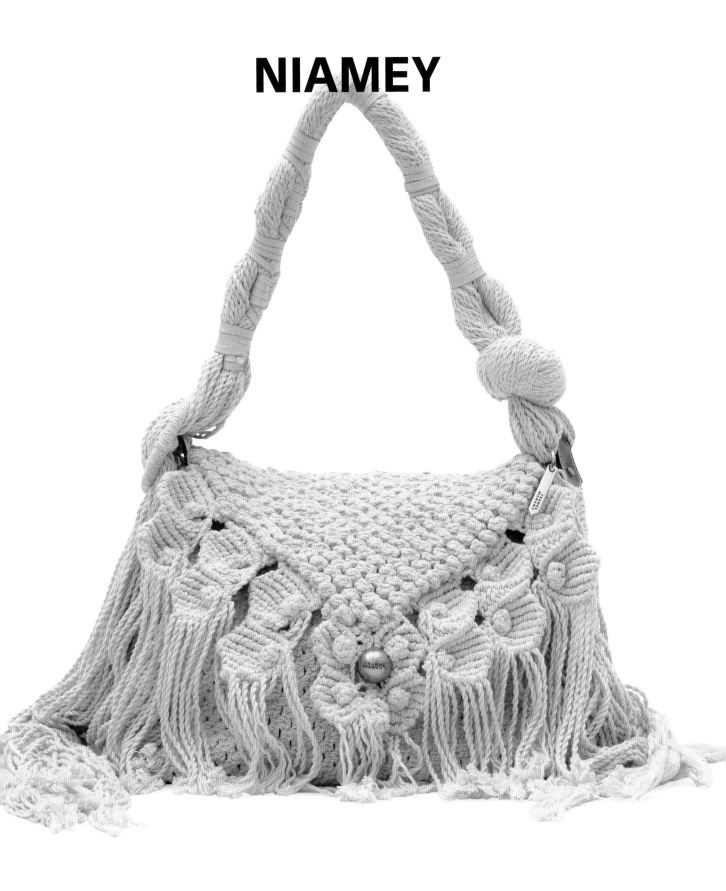

Those who carry this bag have clearly adopted the Isabel Marant attitude!
The Niamey is made of 100 percent cotton macramé, and its details pay tribute
to true craftsmanship. Its softness provides a cool edge to its look. It is worn on
the shoulder.

VIGO

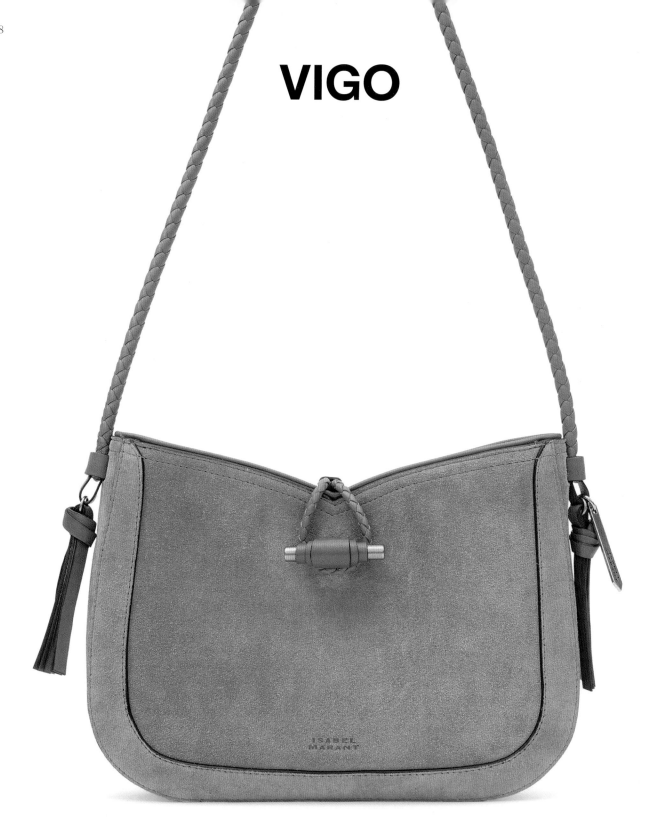

The Vigo is the most refined bag among the Isabel Marant collections. Made of leather or suede, it closes with a leather-wrapped hook. Like the Tyag, its shoulder strap is braided leather. It is also available with a flap.

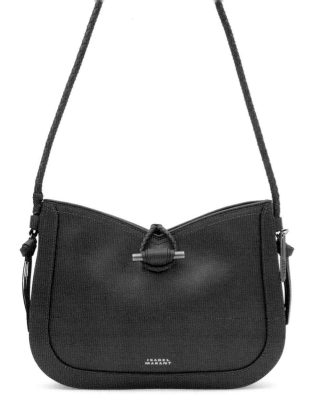
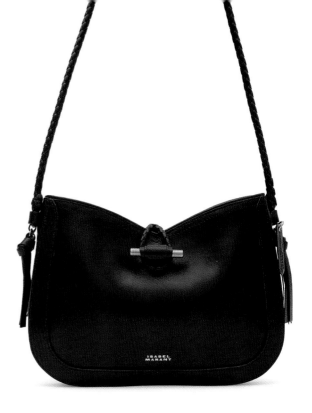
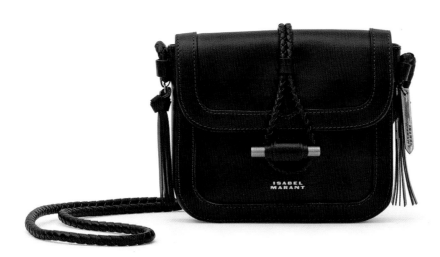
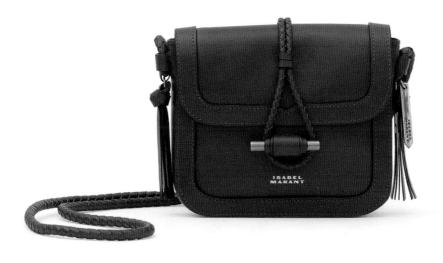

ISSEY MIYAKE

BAO BAO

The first Bao Bao bag made its appearance during the Fall/Winter 2010 season. The bag is constructed using triangular pieces of material, allowing it to take on various shapes or to be flattened. The triangles' colors, and any patterns applied to them, change the bag's look, and the same colors and patterns have been available continuously as a style choice for more than ten years. This signature bag, designed by Japanese designer Issey Miyake, who died in 2022 and was adored by Steve Jobs (his black turtleneck was designed by him), is an ultra-artsy standout in the world of bags.

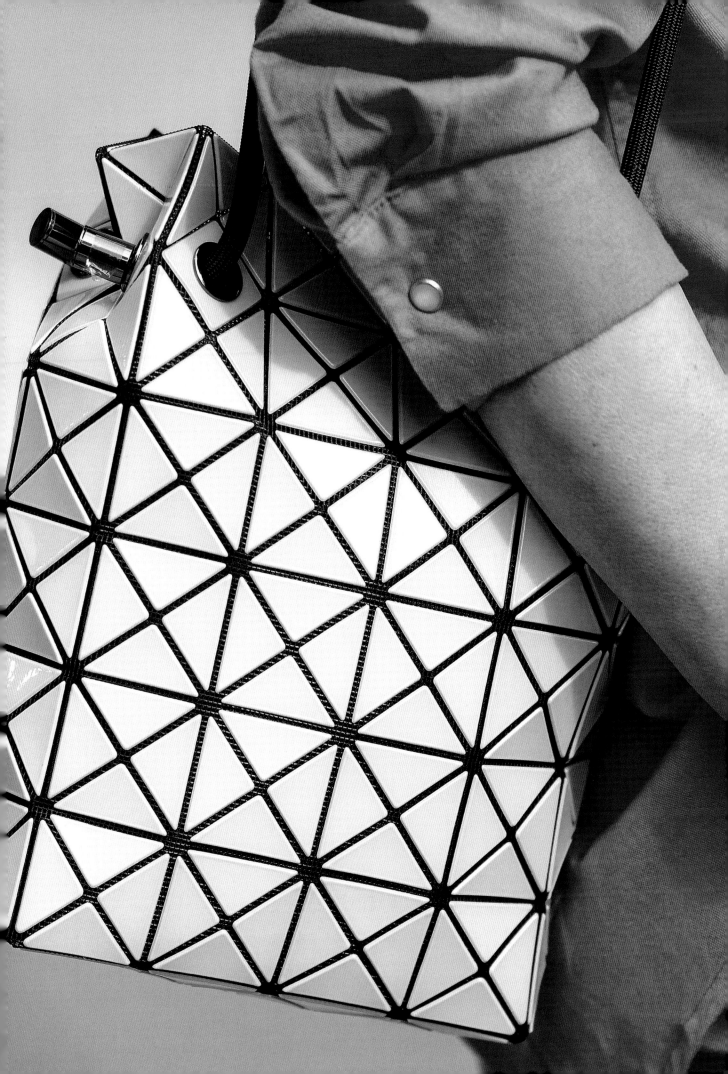

JACQUEMUS
REFRESHING SENSUALITY

"I've always wanted Jacquemus to be a label that is easy to identify with and welcoming." **Simon Porte Jacquemus**

Founded: 2009

The story: Simon, born in 1990 in the south of France, arrived in Paris at age eighteen to study fashion. A month later, he lost his mother, and his plans changed as a result. In 2009, he launched his own label, Jacquemus, his mother's maiden name. Simon was inspired by his native Provence and his mother, a beautiful and free Mediterranean woman. In 2018, he launched a men's line, but a year later, he started a unisex collection instead. His fashion shows are always preeminent in the fashion world and take place in spectacular locations, such as France's lavender or wheat fields, the pink lake of Salin-de-Giraud, or the gardens of Versailles. Given his worldwide success, the young designer is now playing in the big leagues of the larger brands.

The style: Above all, Jacquemus tells stories with a generous dose of sensuality, a pinch of minimalism, a great deal of freshness, and a touch of playfulness.

Heard on the street: *"The mini Chiquito bag proves that what seems trivial is not so incidental."*

WHO WEARS JACQUEMUS?
It would be easier to list those who aren't wearing Jacquemus these days, but a few of those who are include Adele, Charli D'Amelio, Angèle, Beyoncé, Hailey Bieber, Penélope Cruz, Karol G, Bella and Gigi Hadid, Jennie Kim, Dua Lipa, Eva Longoria, Jennifer Lopez, Emily Ratajkowski, and Rihanna.

FASHION HOUSE FACT
Simon Porte Jacquemus has mastered the art of the pop-up store. In 2021, he demonstrated the power of flowers by opening his first pop-up shop, Les Fleurs, in which you could find bouquets of flowers wrapped in scraps of fabric. Also in 2021, for the launch of the Bambino Long, he installed a vending machine open twenty-four hours a day with his creations inside, and he regularly opens pop-up shops in popular places, such as Saint-Tropez in the summer.

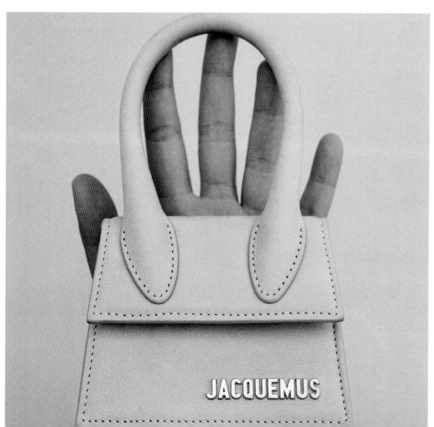

CHIQUITO

2017

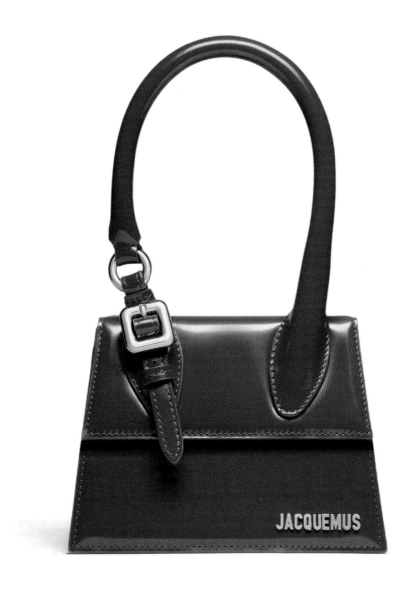

This was the bag that quickly earned the designer notoriety. From fashionistas to fashion professionals, the Chiquito has drawn crowds. Immediately recognizable, its handles—considered large in relation to its small body—have seduced all those in search of stand-out bags. Ultrafeminine with controversial dimensions (apart from a credit card and a key, it cannot hold much) and in cheerful colors, it has real personality. It is made of leather, comes in several sizes, and has a removable shoulder strap. The brand name is written in full on the front. Several variants have appeared: the Chiquito Knot, with its extendable handle that can be wrapped and snapped closed, and the Chiquito Long, the elongated version of the original.

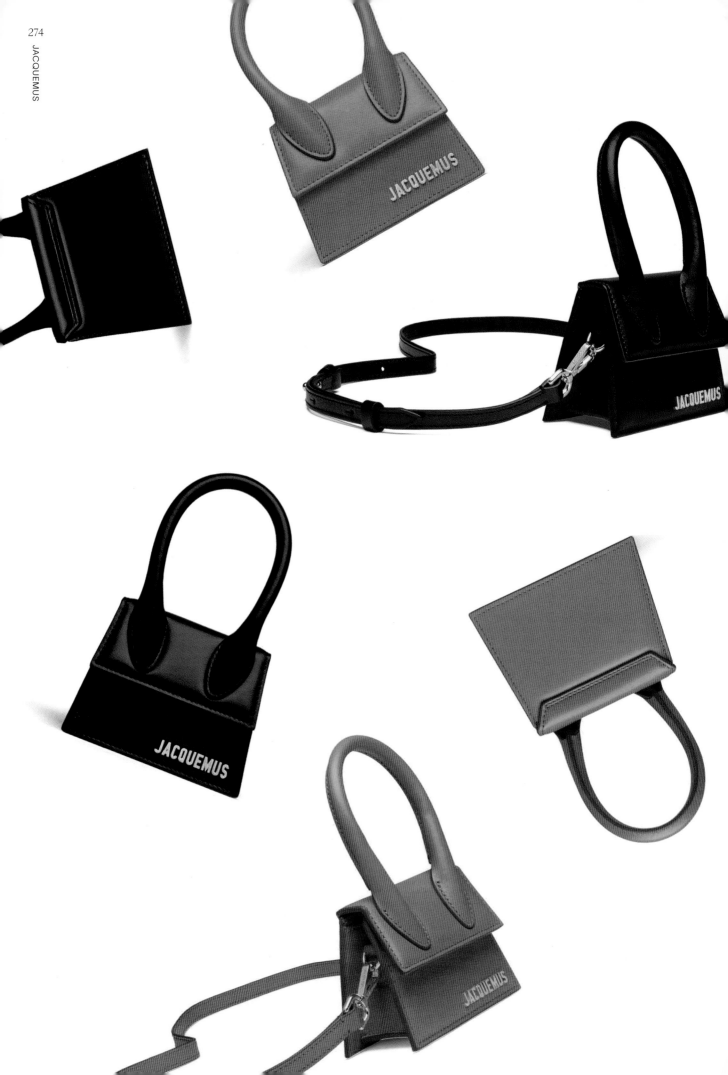

BAMBINO

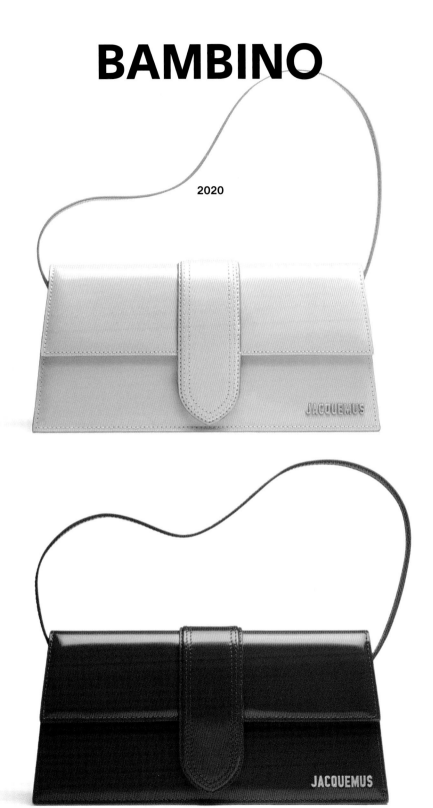

2020

The brand's second iconic bag, after the Chiquito, the Bambino is a bit more demure. It still has sharp lines but with a more rectangular style. Its distinctive feature is its central tab closure. The bag is made of leather, can be carried by hand or worn over the shoulder, and comes, like the Chiquito, in myriad cheerful colors. It also has several versions: elongated (Bambino Long), with a handle made of strands of leather (Bambino Long Ficiu), wicker (Bambino Long Osier), a softer model in padded leather (Bambimou), sheepskin (Bambidou), and smooth leather (Bambinou).

JÉRÔME DREYFUSS

APPROACHABLE ALLURE

"The bag defines the allure of a woman."
Jérôme Dreyfuss

Founded: 2002

The story: Jérôme Dreyfuss was seventeen when he arrived in Paris to enter the fashion industry. Soon after his arrival, he joined John Galliano's team and became his assistant. In 1998, at twenty-three, he presented his first collection, "Couture à Porter." The collection was an immediate success, winning the ANDAM prize, and the following year, Michael Jackson asked him to design his outfits. He created his first collection of accessories in 2002. *"I started by making a bag. I took a skin and fashioned it similarly to a dress, which is why the bag was soft all over."* Jérôme works only with organic leathers (free-range animals, vegetable tanning methods, etc.). Each of the brand's bags is christened with a masculine name (Billy, Bobi, Jerry, Philippe, etc.) because, as the brand claims, they are destined to serve women, which he believes allows a woman to forge a more sentimental relationship with the bag.

The style: Jérôme creates soft bags that conform to women's bodies without constraining them. The designs are not ostentatious and are made of noble materials. The result is an authentic and approachable luxury.

Heard on the street: *"I fell in love with Bobi. I don't know how I'm going to tell Billy."*

FASHION HOUSE FACT
Jérôme likes to point out that *"leather is an ancestral ecological material because it is durable, repairable, and recyclable. A noble material, which develops a patina, evolves, and becomes more beautiful over time."*

WHO WEARS JÉRÔME DREYFUSS?
Jessica Biel, Carla Bruni, Sarah Jessica Parker, Emma Roberts, Taylor Swift, and Naomi Watts.

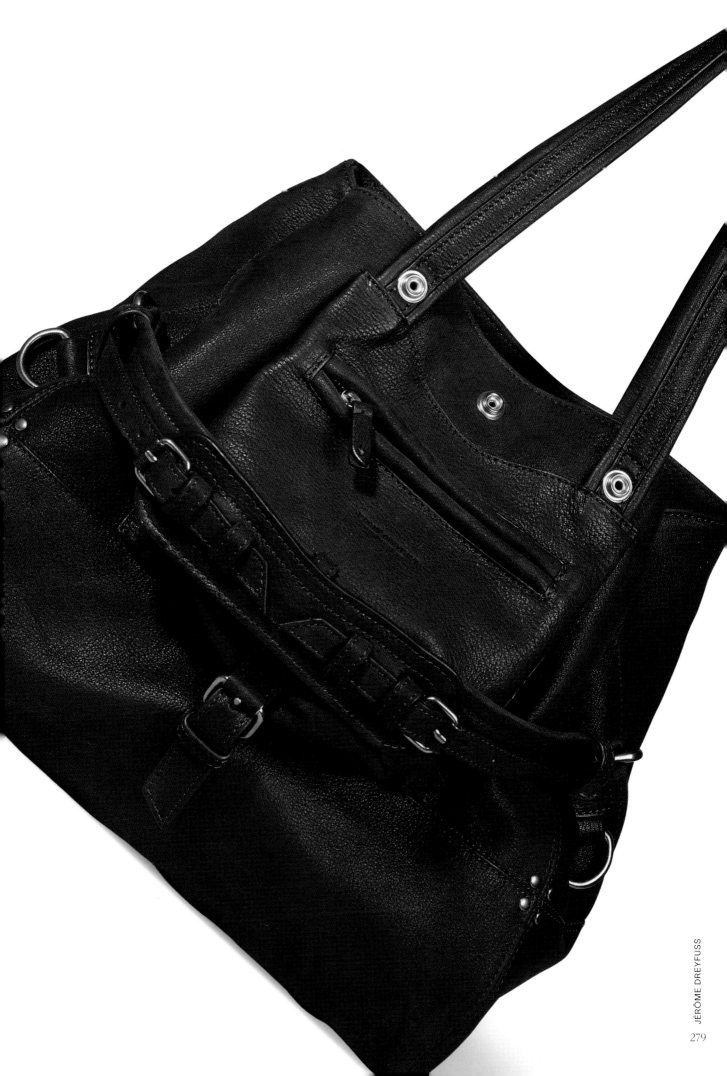

BILLY

2002

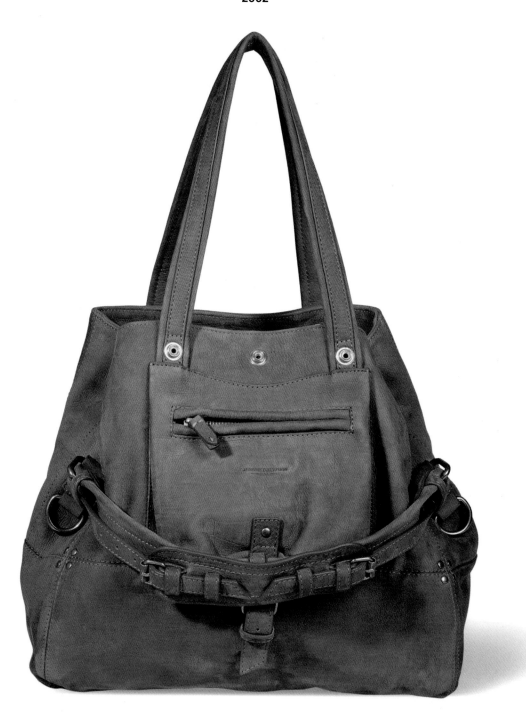

This large, soft tote has stood the test of time while remaining the brand's iconic bag. During its first season, only fifty bags were sold. At last count, ninety thousand are sold worldwide each year. The Billy remains an indispensable companion for active women and young mothers. It closes with snaps, has two handles and a leather shoulder strap. It has an external zippered pocket on the front and a key chain on the inside. It is made of calfskin and comes in several sizes (the Billy S or Nano) and styles (the Billy Banane). The assemblage of small studs on both sides at the front are a distinctive detail that indicates you are looking at a Jérôme Dreyfuss bag.

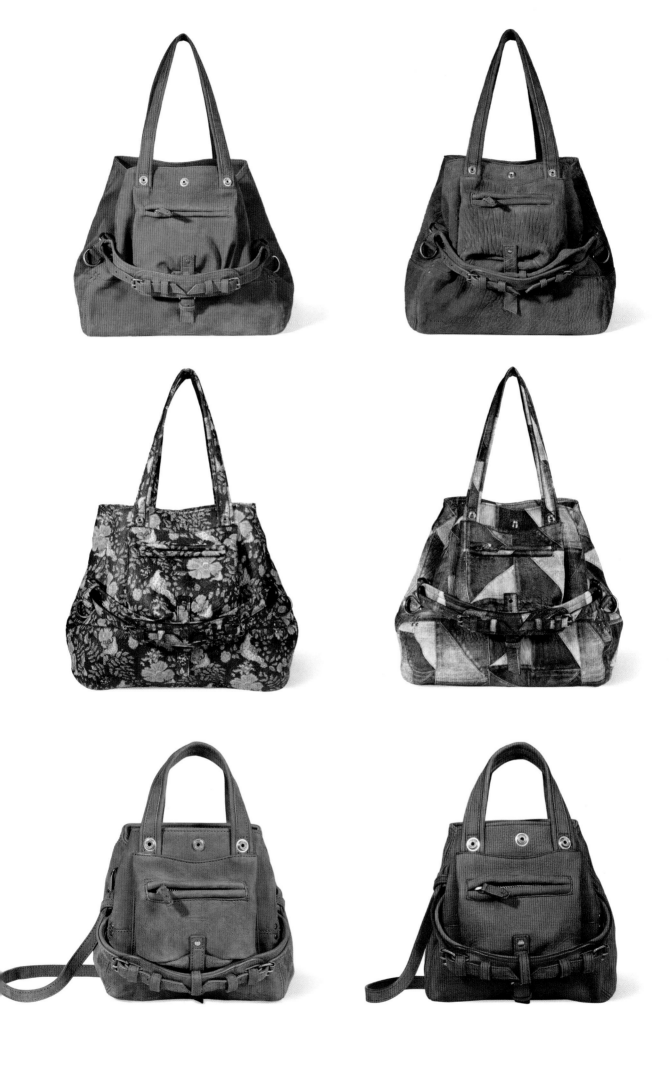

BOBI

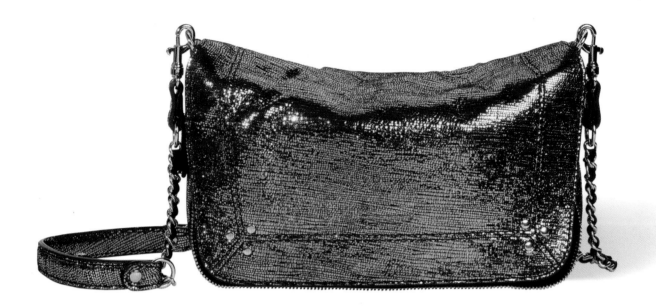

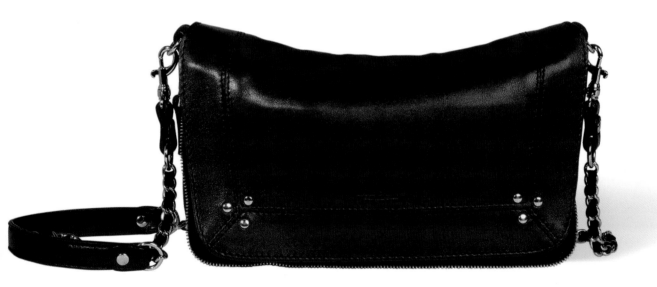

The Bobi is without a doubt a bag that appeals to many. It's practical, with several compartments inside, and even has a removable mirror—an ideal design. Its volume changes by two zipped gussets. The shoulder strap is a braided leather chain with a leather strip at the shoulder. It is made of calf or goatskin or sometimes calf and goatskin combined. There is also a version in python. It comes in three sizes. The six small studs are a signature of the brand.

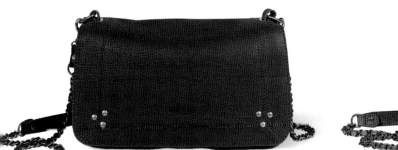
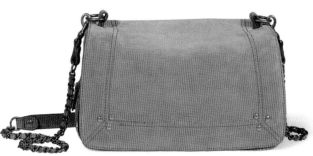
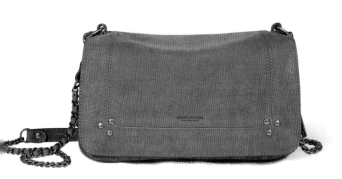
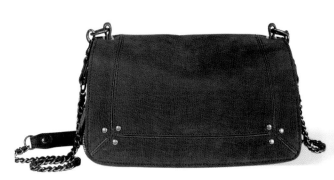
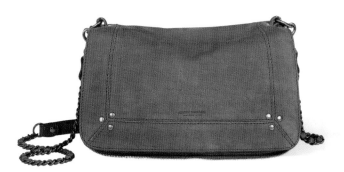
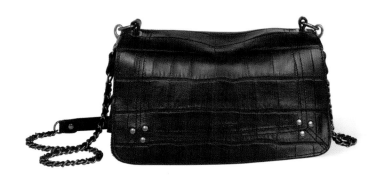

LULU

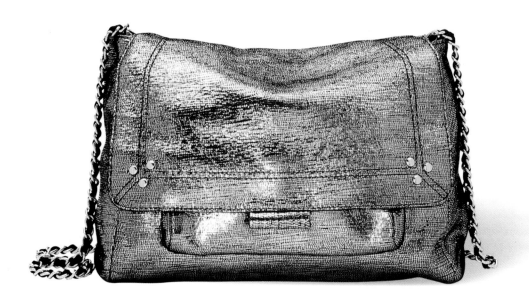

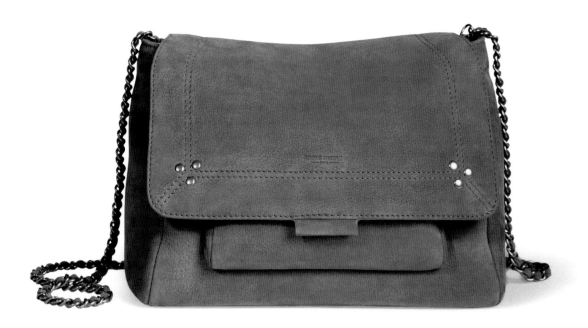

A bag as timeless as the Bobi, which it resembles in a small way. It has more curves than the Bobi but is just as practical. The flap closes onto a small outer pocket, and the chain is braided with leather. Available in calfskin, bull calf leather, goatskin, python, and viscose-blended cotton, the Lulu is available in five sizes, from XS to XL. The six small signature studs are found on the front.

LINO BANANE

The Lino Banane is ultrapopular with on-the-go Parisian women. This belt bag can be worn at the waist or as a short crossbody. Like all Jérôme Dreyfuss bags, it is available in several materials: calfskin, bull calf leather, goatskin, goatskin lamé, or velvet.

JERRY

A messenger bag with a fashionable look thanks to its fringe. What's more, the fringe is removable to create a look suitable for the office. It has a short handle to carry on the shoulder and a detachable braided shoulder strap for crossbody wear. The bag has a snap closure. The Jerry is available in many materials (buffalo, python, goatskin, cotton, etc.) and in several sizes.

LÉON

The ultimate oversized tote. The Léon allows you to take seemingly everything with you. For everyday, it is the ideal ally for carrying a laptop. It has four leather handles of two different lengths on top. Available in calfskin, velvet, and cotton canvas, the Léon contains a large compartment and a leather pouch hanging from a tie. The small signature studs are found at the base of the handles.

JIMMY CHOO
THE EPITOME OF GLAM

"A designer knows that perfection has been reached not when there is nothing more to add, but when there is nothing more to take away."

Jimmy Choo

Founded: 1996

The story: Jimmy Chow (his name became Choo after it was listed with a spelling error in the civil register) was born in Malaysia into a family of shoemakers from China. At thirty-four, he left to study at the London College of Fashion. He began designing exclusive models of shoes for very high-end clientele, including Lady Diana. In 1996, he teamed up with Tamara Mellon to launch his brand. He quickly rose to be the darling among celebrities, including Madonna, Katie Holmes, and Reese Witherspoon. In 2001, he launched a line of handbags. After the departure of Tamara Mellon from the brand in 2011, the creative direction was entrusted to Simon Holloway and Sandra Choi, Jimmy's niece. In addition to shoes and bags, the brand designs sunglasses, makeup, and perfume.

The style: The epitome of glam. Whether shoes or bags, Jimmy Choo accessories add a bit of sparkle to our lives.

Heard on the street: *"Jimmy Choo is the darling of VIPs!"*

FASHION HOUSE FACT
To extend the life of the bags, Jimmy Choo provides this advice: *"Always store your handbags and small leather goods in protective covers and upright. Make sure the straps or chains are placed inside the item to prevent damage to the material. All closures should be properly closed when the item is put away."*

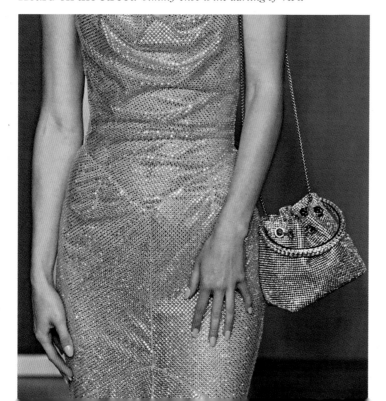

WHO WEARS JIMMY CHOO?
Lady Diana was one of Jimmy Choo's earliest fans. Since then, there have been many others captivated by the brand, including Beyoncé, Jennifer Lopez, Hailey Bieber, Jourdan Dunn, Lizzo, Kendall Jenner, Kate Moss, Emma Roberts, and Sienna Miller.

BON BON

This iconic bucket bag can be carried by hand or as a crossbody and fastens with tasseled sliding cords. Designed in Italy, it comes in two sizes, the classic Bon Bon and the Bon Bon Bucket. The daytime version, often in smooth calfskin and completed with a leather shoulder strap, also comes in raffia or is studded. The evening version, in eco-friendly satin (28 percent organic silk and 72 percent certified viscose) or satin mesh embellished with crystals, is paired with a small chain strap. It takes three hours to apply the one hundred Swarovski crystals by hand on the bracelet handle.

AVENUE

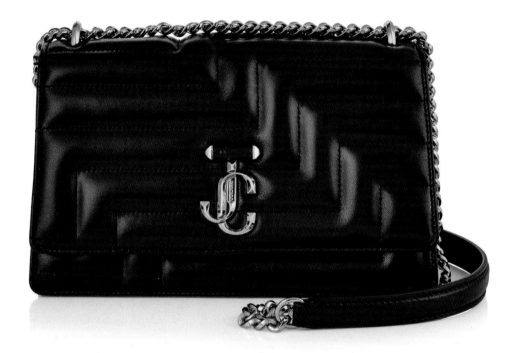

The most recognizable of Jimmy Choo bags thanks to the clearly visible golden *JC* logo. With a chain shoulder strap, the Avenue bag is made of quilted leather and is available as a day bag (Quad or Shoulder model), as a tote (Tote), in mini format (for lipstick, phone, and keys), or as a pochette (Pouch or Clutch). Whether in pink, gold, burgundy, or black, this bag, released in 2022, has all the makings of a timeless accessory.

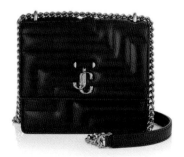
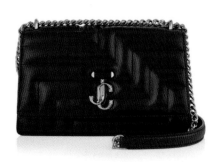
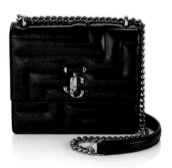

CALLIE

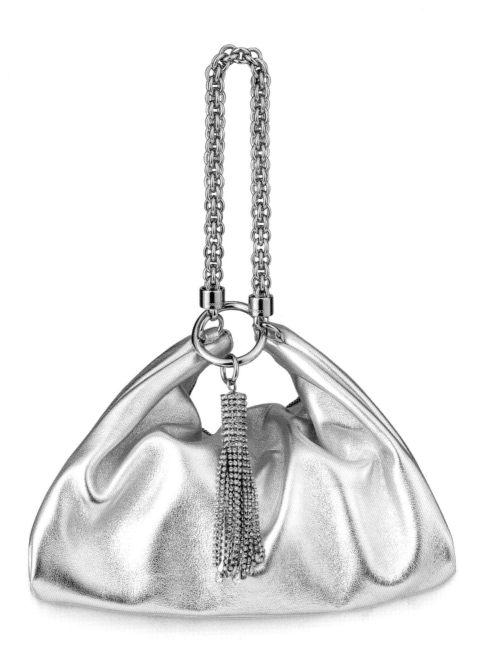

This very supple small pouch bag, designed for evening wear, takes on a distinct shape when you pull the entire chain shoulder strap through the metal ring adorned with a tassel. The Callie comes in metallic leather, shimmering suede, and embellished with crystals—all materials that lend a touch of glam.

BONNY

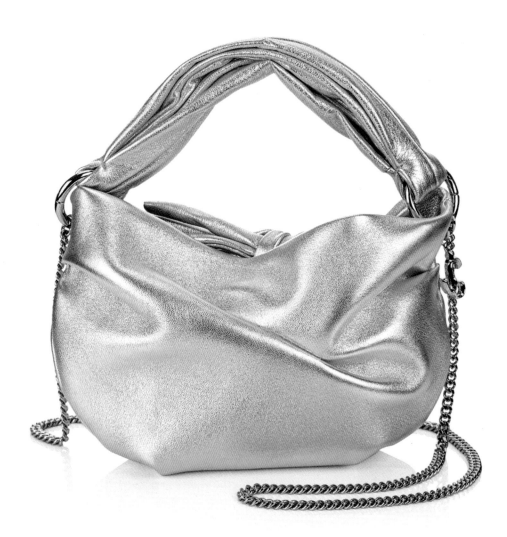

The twisted handle is a recognizable feature among Jimmy Choo bags. Made of metallic nappa leather or in satin, it has the appearance of a draped garment. It can be carried in the hand, on the shoulder, or across the body thanks to its chain.

MICRO CLOUD

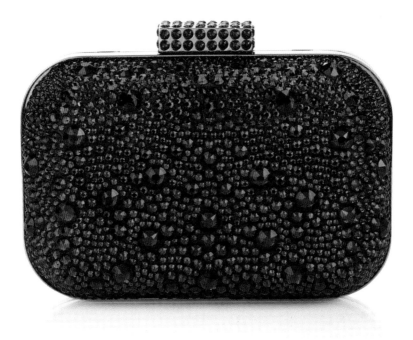

The ultimate evening minaudière. This bag is very practical because it can be carried both by hand or across the body thanks to its long detachable chain. Each season, the Micro Cloud changes style, often spotted in suede or leather covered with pearls or crystals, in satin adorned with pearls, or adorned with crystals— anything is possible to make it a perfect evening accessory. Its clasp, sometimes dome shaped, can be adorned with crystals.

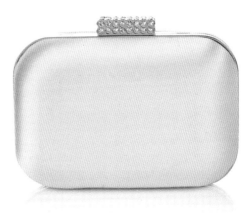

DIAMOND

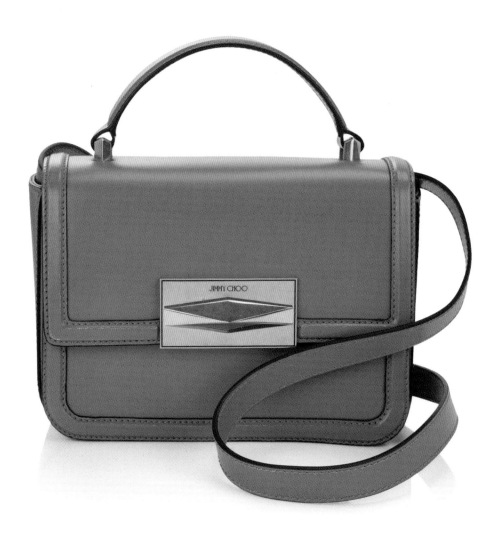

At Jimmy Choo, diamonds are often one of the many sources of inspiration, so it's only natural that a bag would be dedicated to them. With its sharp geometric lines and sculptural chain, the Diamond bag is available as a soft bohemian-style bag as well as a rectangular and structured clutch with a diamond-shaped clasp. The chain is removable, making it easy to switch from day to night. It is made in Italy from ultrasoft calfskin.

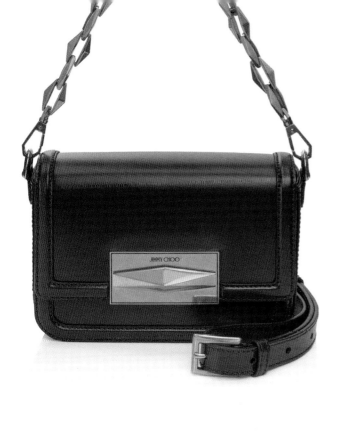

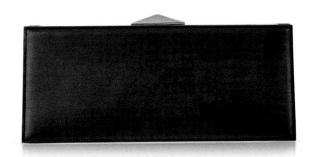

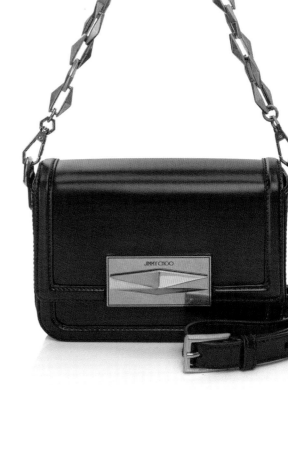

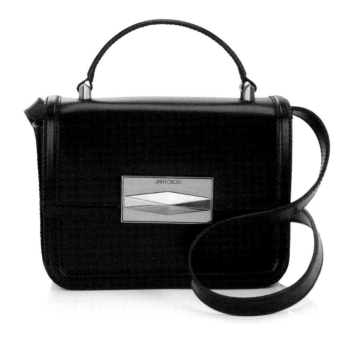

JUDITH LEIBER

CLASSIC SLIM SLIDE

When it comes to choices for fashionable minau-
dières, Judith Leiber is at the top of the list! Stars
have always loved wearing her little rhinestone bags
on Hollywood's red carpets. The designer retired in
1998 (she passed away in 2018), but her little rigid bags,
which sometimes take the shape of animals or every-
day objects, continue to shine in the evenings, such
as the Classic Slim Slide often seen in the hands of
A-list celebrities, from Hilary Swank to Natalie Port-
man to Evan Rachel Wood.

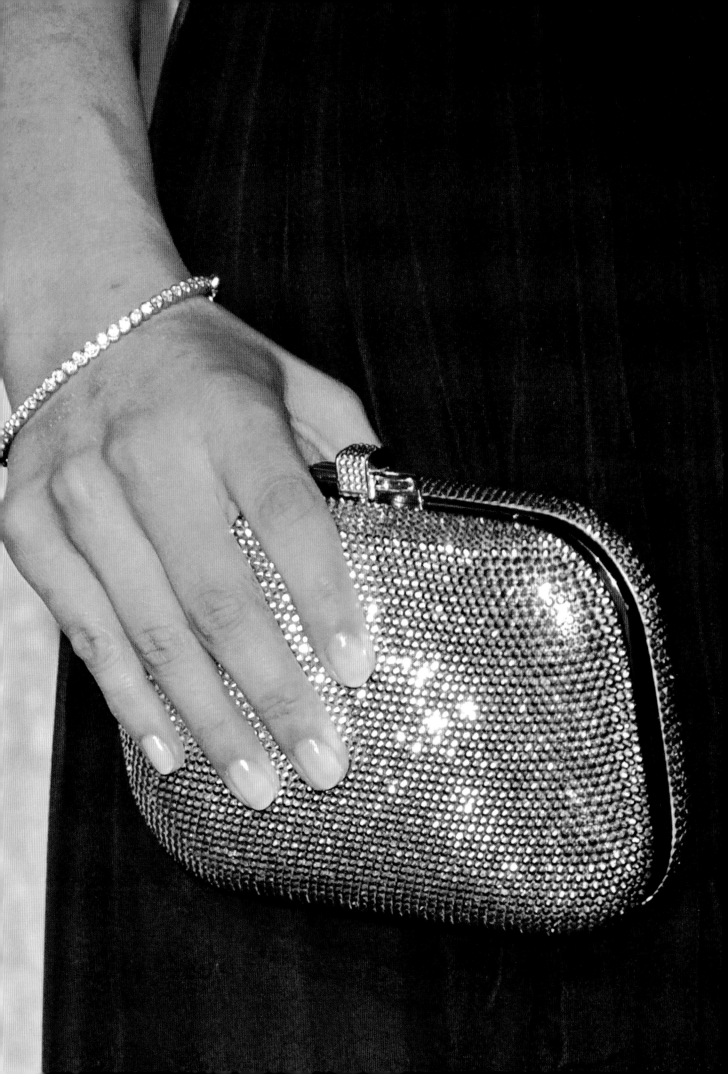

JW ANDERSON
MODERN CHARM

"We live in a world where people do not want a handbag unless it has a story behind it." **Jonathan Anderson**

Founded: 2008

The story: Before becoming a designer, Irishman Jonathan Anderson was an actor. After graduating from the London College of Fashion in 2005, he gained experience in visual merchandising at Prada before launching his brand in 2008. Initially dedicated to menswear, his brand quickly expanded to womenswear, which was a perfect transition considering the two lines coexist within his brand in complete harmony. In 2012, JW Anderson created capsule collections in collaboration with Topshop, bringing him immediate notoriety. He then designed a collection for Versace's Versus line before becoming Loewe's artistic director in 2013.

The style: JW Anderson's creations attract fashion addicts, and the designer does not give in to trends. Flirting between masculine and feminine looks, he invents new proportions. JW Anderson has mastered the art of fashion.

Heard on the street: *"Remember the Harry Styles color-block knit patchwork cardigan that everyone wanted? That was JW Anderson."*

WHO WEARS JW ANDERSON?
Alexa Chung, Jourdan Dunn, Gal Gadot, Gigi Hadid, Dua Lipa, Chloë Grace Moretz, Emily Ratajkowski, and Harry Styles, of course.

FASHION HOUSE FACT
Jonathan Anderson has set up a fund to support the acquisition of works of emerging artists by museums in Great Britain.

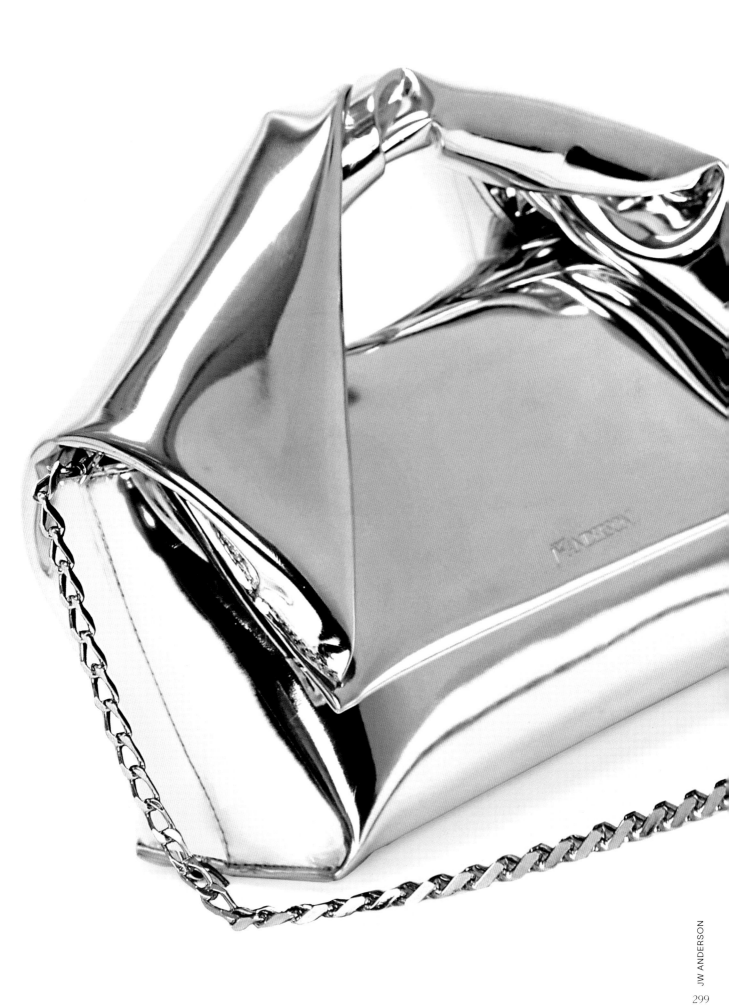

TWISTER

2015

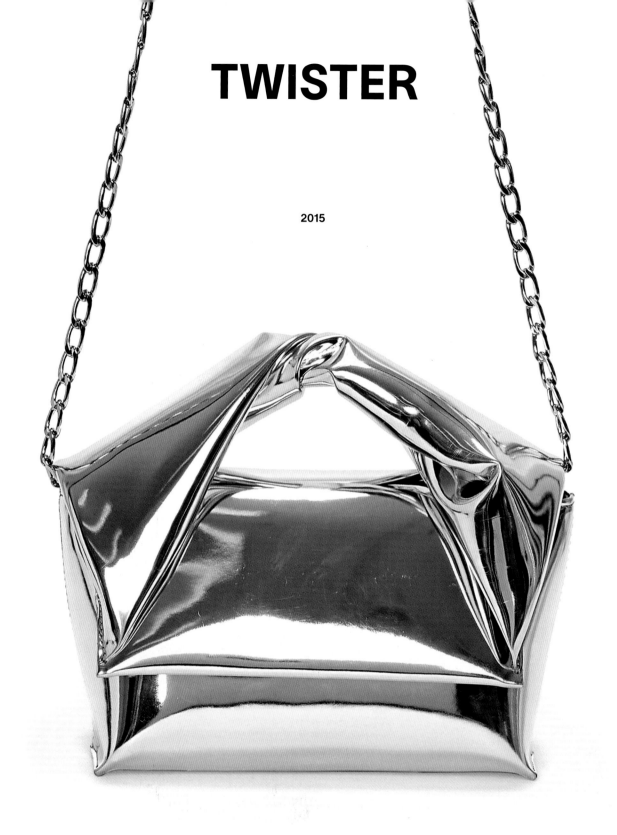

Easily recognizable though its logo is subtle, this bag has a twisted handle that
gives it great allure. It closes with a magnetic clasp. It can be carried by hand or
over the body by its chain. While most often made of leather, it can also be found
in faux fur or denim. The Twister comes in three sizes and many colors, including
mustard yellow and pale pink.

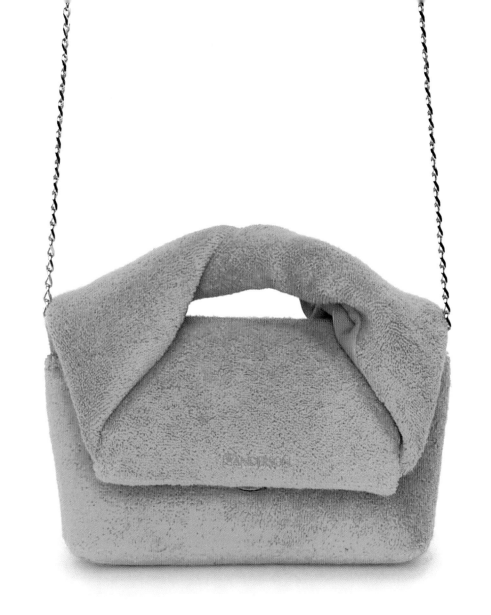

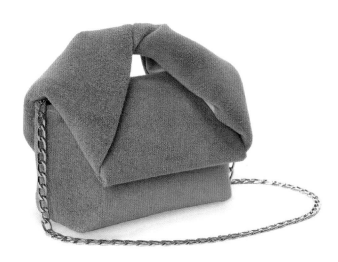

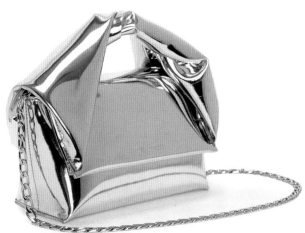

BUMPER

2022

A bag that looks like it could protect us from life's small bumps is always welcome! In just one year, the Bumper established itself as one of the brand's iconic bags. Often in two contrasting colors—one for the bag's body and one for the padded piping that extends around the edge—the bag comes in several materials, including leather, leather studded with crystals, and canvas displaying the name JW Anderson. It is worn over the shoulder, and some models have a longer shoulder strap to serve as a crossbody. Its sister, the Bumper Moon, which, as its name suggests, is a rounded shape, can be worn on the shoulder or as a crossbody using the shoulder strap.

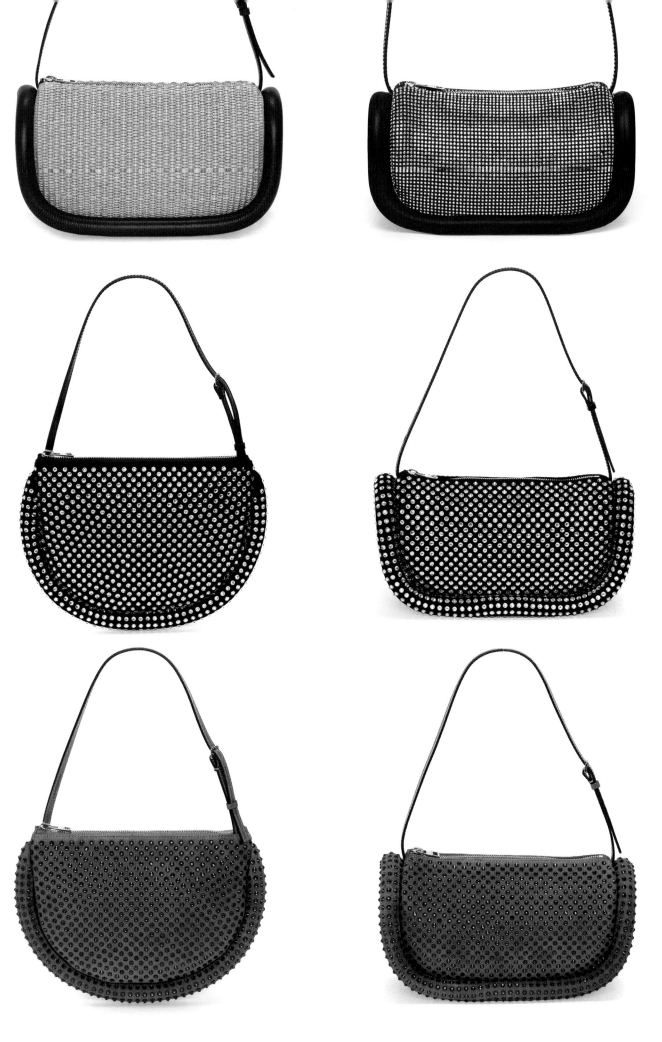

PIGEON

2022

This could be the totem bag for all urbanites! Presented on the runway during the Fall 2022 men's show, this bag was destined to soar high beyond its first season, as its impression on the crowd was unmistakable. This 3D-printed minaudière has a movable wing that can be opened to slip in a tube of lip gloss and keys. Sarah Jessica Parker appeared with it during an episode of *And Just Like That*, the sequel to *Sex and the City*. That was enough to make it a forever It bag!

ANCHOR

2012

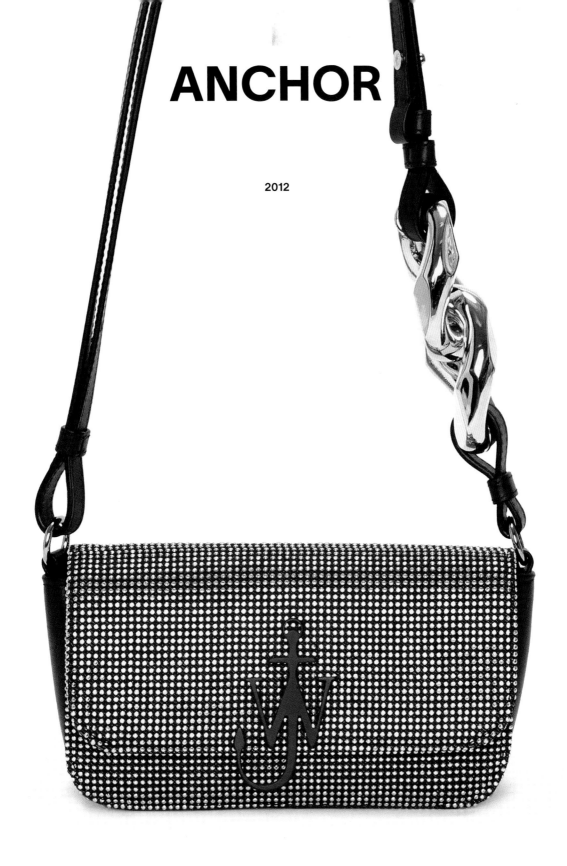

Even when designed simply, JW Anderson's bags have a detail that lends them a certain creative flair. This is the case with this baguette bag, with its very classic look. Here, the large links on the shoulder strap make the bag fashionably on point. The anchor-shaped logo of the designer's initials on the front adds even more personality. The bag is made of leather or canvas and with a shoulder strap so it can be worn two ways.

LANCEL
A PARIS LEGACY

"For my bags, there's only one brand: Lancel." **Arletty**

Founded: 1876

The story: Angèle and Alphonse Lancel founded the company at the end of the nineteenth century. Initially, the couple sold tobacco pipes and smoking accessories. In 1901, the founders' son, Albert, decided to transform the family business into a luxury goods company selling goldsmith objects, clocks, lamps, and similar items, all produced by artisans. In 1929, Albert opened a boutique in Paris at 8 place de l'Opéra and offered high-end luggage and bags in rare leathers. The instant success of the Elsa bucket bag, which was introduced in 1987, kicked off the brand's global expansion. With its rich heritage, Lancel constantly releases new models, sometimes inspired by its archives, or a very limited-edition series. It also honors special orders, created in its Parisian ateliers.

The style: Often inspired by its archives, Lancel bags have a modest and minimalist look. Combining beauty with utility has always been the brand's credo.

Heard on the street: *"The brand has more than three thousand pieces in its archives—now that's heritage!"*

FASHION HOUSE FACT
In 1956, Lancel created the first soft suitcase in nylon canvas, named Kangaroo in reference to its exterior pouch.

WHO WEARS LANCEL?
Isabelle Adjani, Laure Manaudou, and Lili Reinhart, brand ambassador in 2023, who can often be spotted carrying the Ninon bag.

THESE BAGS SHAPED LANCEL'S HISTORY

DALIGRAMME

1970

A bag created by Salvador Dalí in the 1970s. To illustrate his love for Gala, his wife and muse, the artist invented a secret alphabet with symbols called Daligrams that only they could understand. When asked to design a bag for Lancel, he used the symbols as a print. As a signature of his distinct style, he used a bicycle chain as a shoulder strap. The bag, originally intended for Gala, was reissued in 2011 but is no longer on sale today.

ADJANI

2008

"A handbag is a whole story, or rather a rendezvous of stories, that hold a particular secret: The exterior's elegance adorns and conceals–with either a smooth or textured softness–an inner adventure that is only revealed if the bag inadvertently spills and scatters its contents." These are the words of actress Isabelle Adjani in January 2008, when she helped launch this bag she created for Lancel. With its very practical format, it was available in leather or crocodile-print leather. It quickly sold out when released. It is no longer found in stores, but fans keep an eye out for it on resale sites.

PREMIER FLIRT

2006

In 1927, Lancel created its legendary bucket bag that made the brand famous. In 1987, the new Elsa bucket bag was inspired by the original. Almost twenty years later, it was once again redesigned to become the Premier Flirt in 2006. Imbued with the brand's heritage, this bag retains the codes of the line: leather tassels and a front pocket highlighted by contrasting stitching. In its latest version, it is adorned with a charm ring holding a removable enamel *L* adorned with metal studs, and a removable shoulder strap. It is available in three sizes and in several materials: grained and smooth cowhide leather, recycled cotton, and raffia-style cloth.

NINON

2018

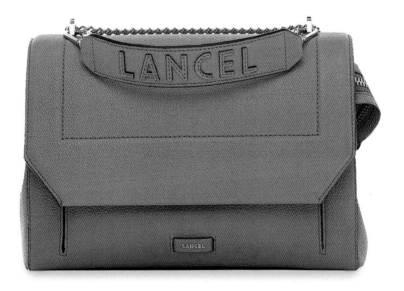

It's not easy to look both flexible and structured! However, the Ninon bag pulls it off with its recognizable shape, especially with its detachable handle stamped with the brand's name. It has a chain and leather shoulder strap that can be worn in different ways and three pockets (on the back, under the flap, and inside). Its asymmetrical zipper lends it a bit of a rock feel. It is made of grained cowhide leather and sometimes leather and nylon. Several sizes are available, and there are many color choices, including Lancel's famous signature red.

LOEWE
TIMELESS AND MODERN

"Loewe is Spain, artisanship, a way of treating raw leather, and a certain reserve."

Jonathan Anderson

Founded: 1846

The story: Originally, Loewe (pronounced *lo-weh-vay*) was a small leather workshop in Madrid, Spain. In 1872, the brand was organized as a leather goods collective led by the German leathermaker Enrique Loewe Roessberg. The company created bags and small accessories in very high-quality leathers and with remarkable craftsmanship under the name E. Loewe. In 1910, a shop was opened in Barcelona. As early as 1945, box calf leather (full-grain calfskin) handbags became brand classics. In the 1970s, the first ready-to-wear collections and a line of perfumes appeared. Several designers (Narciso Rodriguez, José Enrique Oña Selfa, and Stuart Vevers) succeeded each other as creative director. Since 2013, Irishman Jonathan Anderson (who also has his own label, JW Anderson) has been designing the collections, infusing them with his cleverly artsy and ultramodern style.

The style: A discreet, refined luxury, always shaken up by a little artistic twist. Exceptional creations combining traditional know-how and innovation.

Heard on the street: *"Loewe is the craftsmanship of the future."*

FASHION HOUSE FACT
Craftsmanship is the essence of Loewe. Since 2016, the Loewe Foundation has been granting an award that highlights the excellence, innovation, and artistic vision of contemporary artisans. Entries pour in from more than one hundred countries.

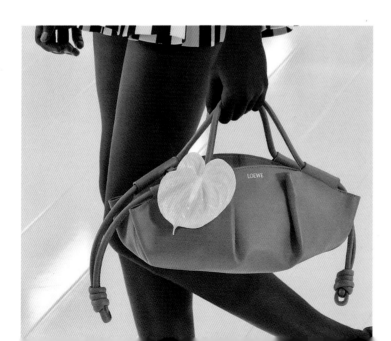

WHO WEARS LOEWE?
Beyoncé, Jeanne Cadieu, Emma Corrin, Kirsten Dunst, Ariana Grande, Jennifer Lawrence, Dua Lipa, Emma Watson, Reese Witherspoon, and Zendaya.

AMAZONA

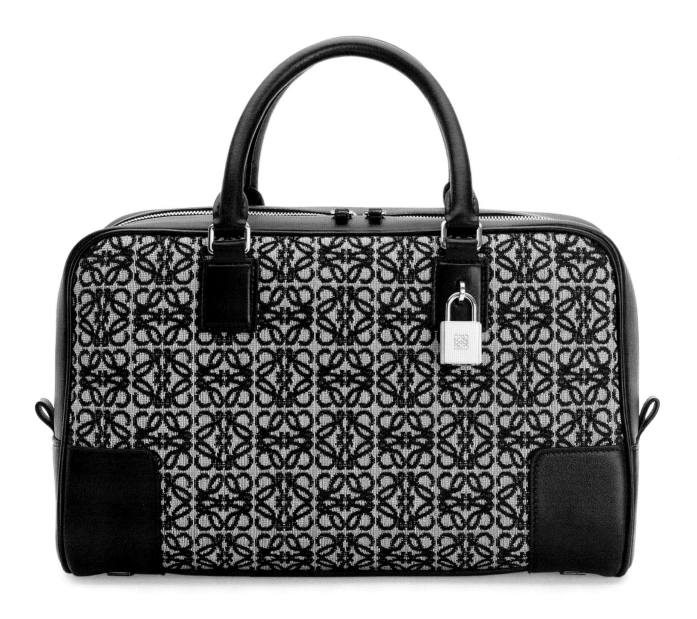

Released in 1975, the Amazona bag refers to the Amazons, those legendary female warriors and hunters. Since its launch, the bag has seduced those in search of a daily carryall for essentials. Cut from soft leather, the bag is reinforced with interior grained-leather panels stamped with the logo. Jonathan Anderson revisited this cult bag for the Fall/Winter 2021–2022 collection. While it is still made in ultra-luxury leathers or Anagram jacquard—a canvas featuring the brand's logo—it has since been made available in several sizes and now has a shoulder strap. The brand's logo appears on the small padlock attached to the bag.

THE AMAZONA, A GEM OF CRAFTSMANSHIP

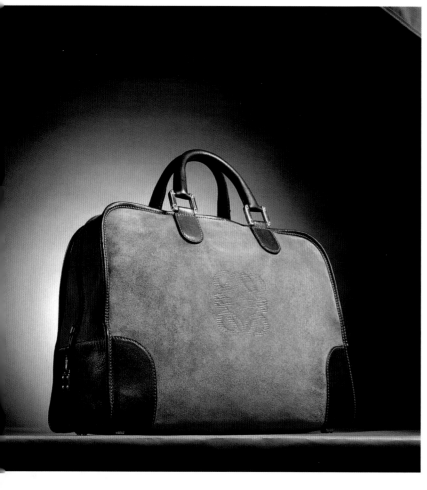

PUZZLE

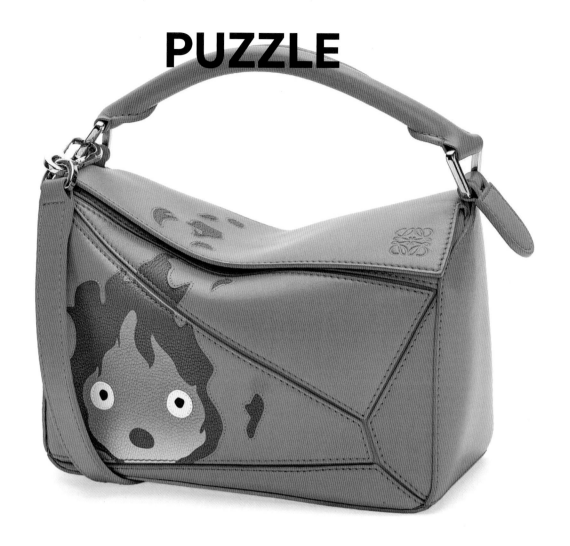

This is the first bag designed by Jonathan Anderson for Loewe. Its cube shape and precise cutting technique give it distinctive geometric lines. The Puzzle has become as iconic as the Amazona bag. It can change into different versions (belt bag or tote) and is collapsible. Often made of calfskin and available in a plethora of colors, it can be worn over the shoulder with its detachable strap, as a crossbody, or carried by hand. The limited-edition orange bag (above) is from a collaboration with Studio Ghibli for Hayao Miyazaki's film *Howl's Moving Castle*.

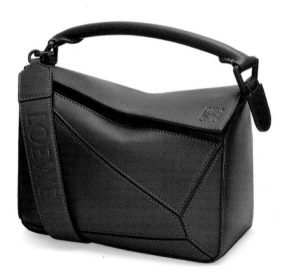

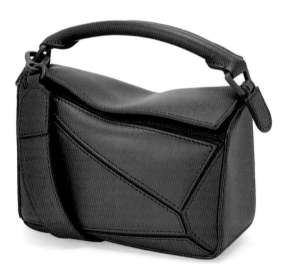

FLAMENCO

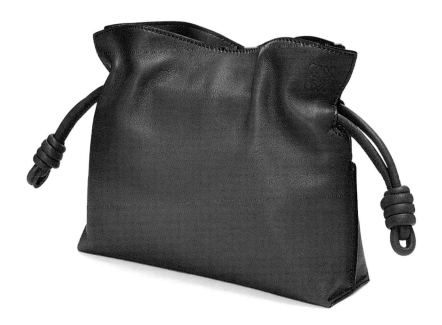

Launched in the 1970s, Flamenco closes with cords with the fashion house's characteristic knots at the end. Made of nappa calfskin, it is available as a bag or small pouch and has a removable shoulder strap.

PASEO

The Paseo is a sort of sister to the Flamenco, with a soft body and knotted ties. Its structure is a standout among other bags, delicately pleated and with handles that extend across the top. You don't need to spot the brand's name that appears in full under the handles to recognize it's a Loewe; you know at first glance, as this bag is emblematic of this modern luxury brand.

GATE

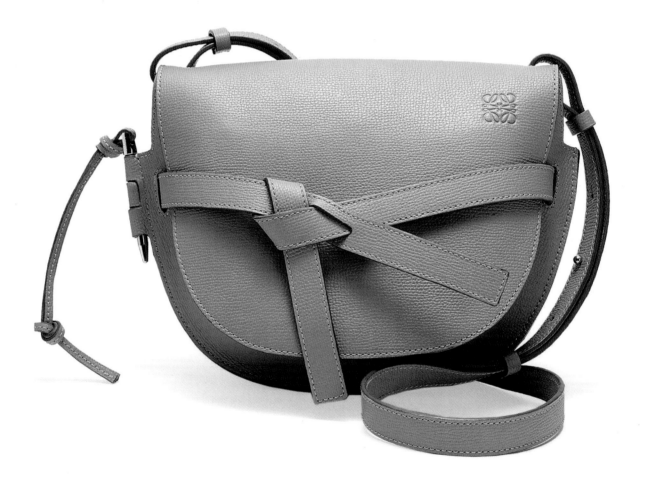

Made of supple calfskin, the Gate is further proof of Loewe's exceptional know-how. It has a handsewn knotted leather shoulder strap and a metal pin attached to the side in a hinge, which gives the bag its name. It can be worn on the shoulder or as a crossbody (the shoulder strap, sometimes stamped with the logo, is adjustable) and is available in several sizes and colors. The Anagram pattern is embossed on the front flap.

HAMMOCK

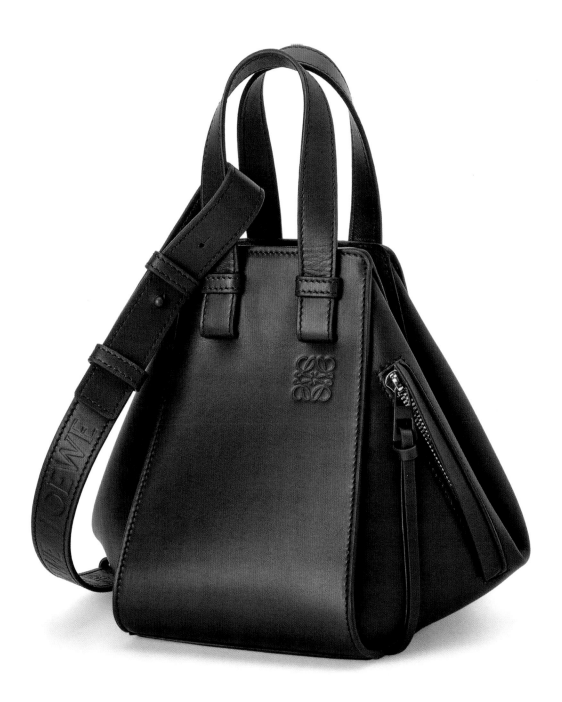

Thanks to its versatile design, the Hammock transforms in an instant. Its soft side panels open to change its shape. It has one zippered outer pocket and two inside pockets. The shoulder strap (sometimes stamped with the name Loewe) is detachable, and the buckle straps allow the bag to be carried in a variety of ways. It can be found in calfskin, satin calfskin, or grained calfskin. The Anagram pattern is embossed under the strap.

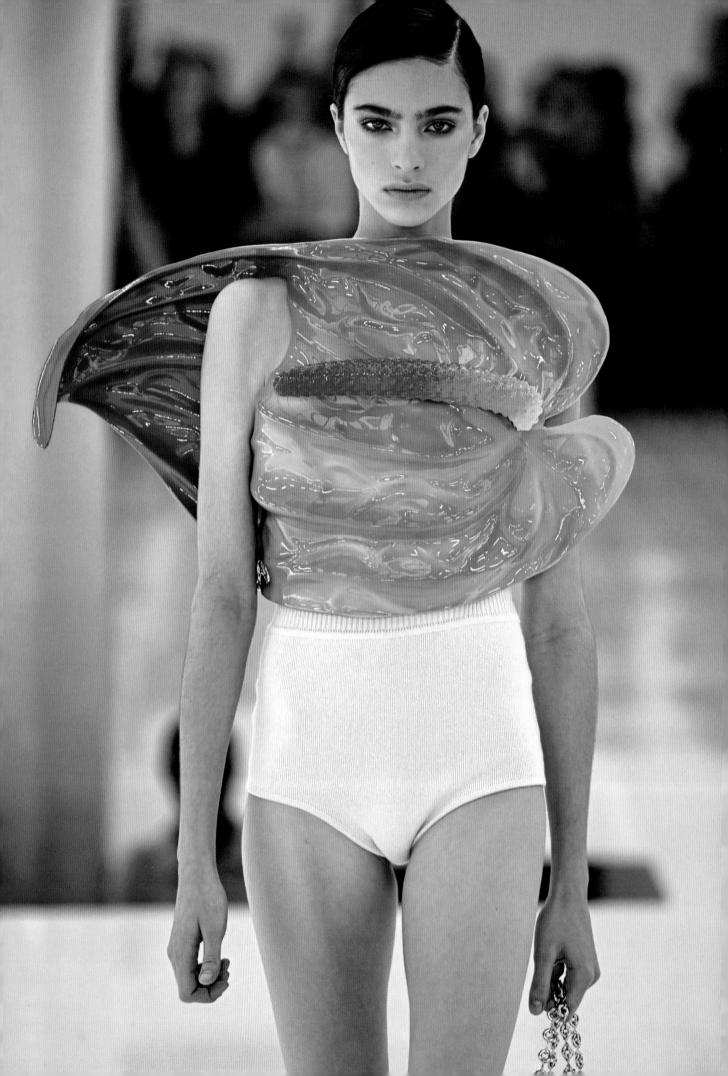

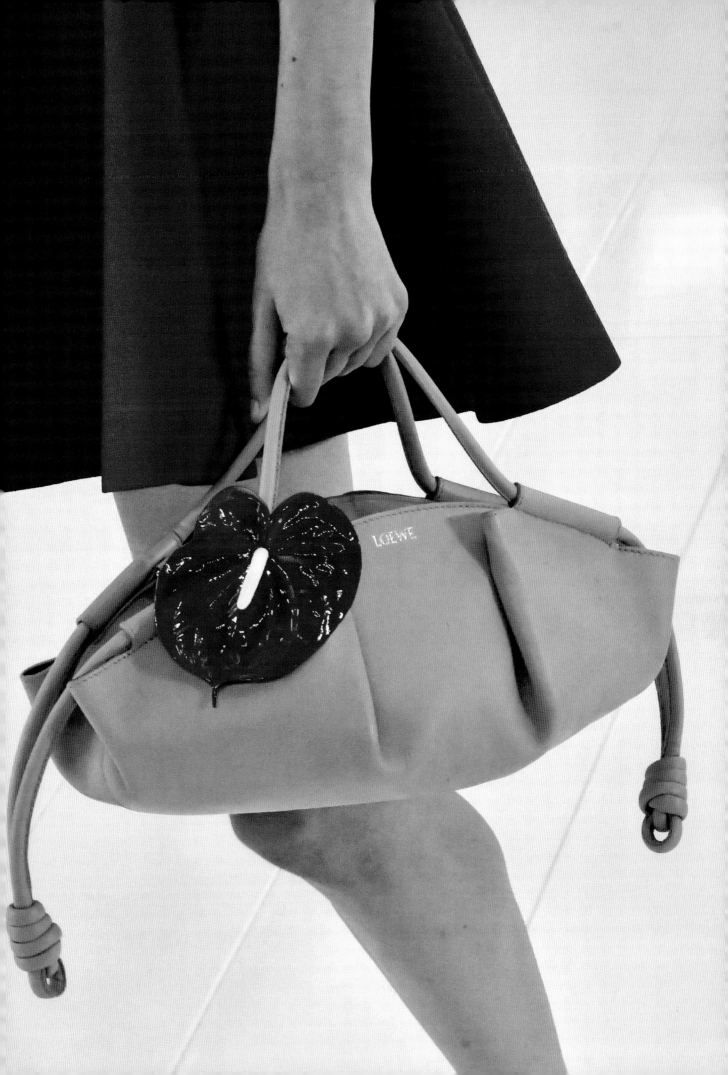

LONGCHAMP
JOYFULLY PARISIAN

"I create for real women with real lives."
Sophie Delafontaine, creative director of Longchamp

Founded: 1948

The story: Longchamp is, first and foremost, the story of a family. In 1926, Jean Cassegrain took over the tobacco shop founded by his parents. In 1948, he created Longchamp and began offering luxury leather-wrapped pipes. In May of that same year, he presented his first collection at the Foire de Paris. It was a hit. He soon set up a luggage shop in the new Orly airport terminal in 1961. Longchamp was quickly exported all over the world. In 1972, Philippe Cassegrain, Jean's son, took over the company's management. In 1993, he created the iconic Le Pliage bag, made of nylon. In addition to leather goods and accessories, the fashion house also makes ready-to-wear clothing and shoes. Today, the third generation of Cassegrains is at the helm: Jean is the general manager, his sister Sophie Delafontaine is the creative director, and their brother, Olivier, manages the American boutiques.

The style: Everyday Parisian. Energetic urbanite. Always with the desire to preserve French know-how through the use of high-quality materials.

Heard on the street: *"I always have a Le Pliage bag in my Le Pliage bag. Life is full of unforeseen events, and I like to be prepared."*

WHO WEARS LONGCHAMP?
Jessica Alba, Ashley Benson, Lily Collins in the TV series *Emily in Paris*, Miley Cyrus, Elle Fanning, Gigi Hadid, Martha Hunt, Kendall Jenner, Kate Middleton, Lila Moss, Lupita Nyong'o, Rita Ora, Olivia Palermo, Barbara Palvin, Coco Rocha, Suki Waterhouse, and Naomi Watts.

FASHION HOUSE FACT
Longchamp has always been committed to responsible and sustainable production and supports the group initiative Les MétamorFoses (showcasing artistic upcycling, which are works of art made from imperfect materials obtained from the finest French producers) through its charitable patronage.

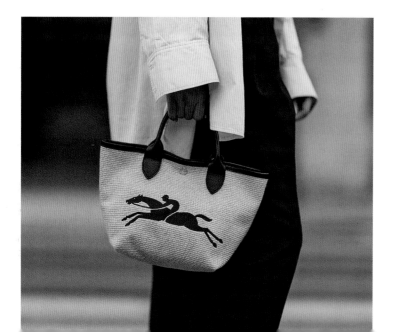

LE PLIAGE

1993

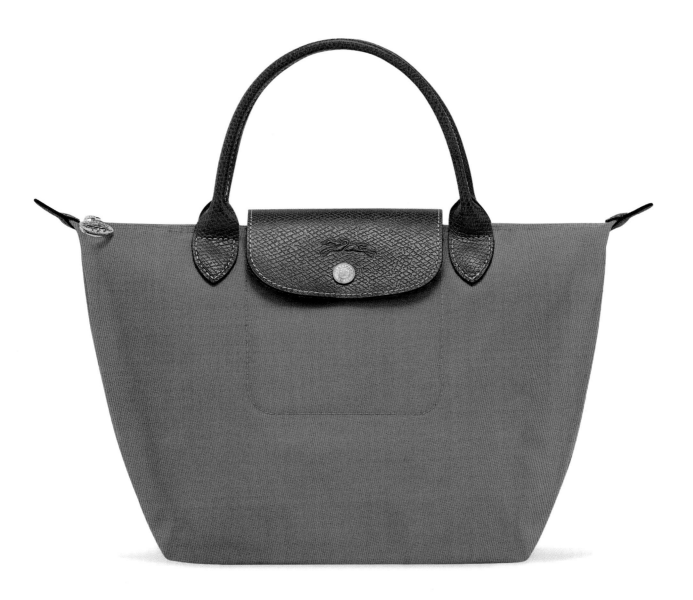

It's the ultimate cult bag, recognizable by all, and appealing to both young and mature consumers. This model combines functionality (it folds into a very small size, to be unfolded when needed), durability, and lightness with attractive design. Inspired by the Japanese art of origami, the tote is made of ultralight nylon canvas with a flap closure and handles made of Russia leather. When folded, it is no larger than a paperback book (although most keep it unfolded), and it's a great evening accessory. It has a zipper and comes in a multitude of lines (Le Pliage Xtra, Le Pliage Collection), styles (tote, backpack, briefcase, handbag, travel bag), and sizes. It's available in several colors each season. It is highly popular in Asia, where it is referred to as the "French national bag." Today, Le Pliage is made of recycled polyamide canvas and is also available in rigid leather (which does not fold) and sheepskin. Le Pliage Energy is made of certified ECONYL regenerated nylon.

The design and creative process are of French origin, and everything is produced in France. On average, fifty steps are required to make a Le Pliage bag. The flap and handles are made of Russia leather, which has a particular grain that reproduces the appearance of reindeer skins. These hides, from St. Petersburg, were recovered off Plymouth Sound two hundred years after the 1786 shipwreck of the *Metta Catharina*, which was transporting them during a storm.

Make it your own. The My Pliage Signature and My Pliage Club bags can be customized by choosing from a range of sizes, handle lengths, and color combinations. You can also have your initials printed on the bag or have them embossed on the leather flap.

Under the guidance of the brand's creative director, Sophie Delafontaine, Longchamp has regularly teamed up with artists and designers to offer new limited-edition collections. Jeremy Scott and Mary Katrantzou have participated.

Le Pliage has sold tens of millions of pieces. It is said that ten bags are sold every minute in the world.

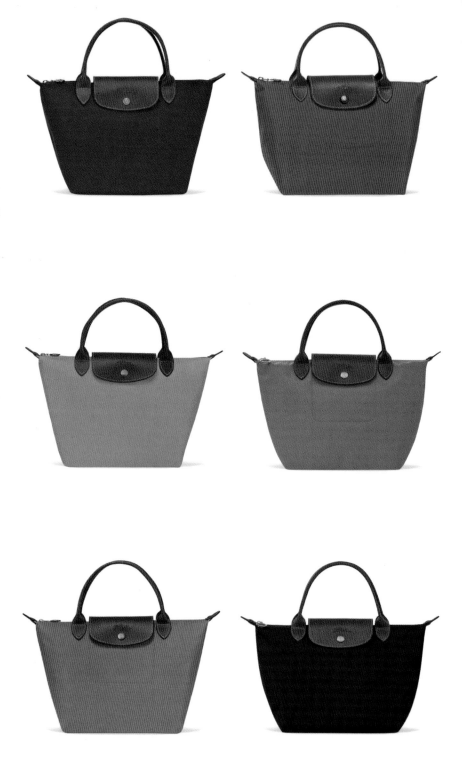

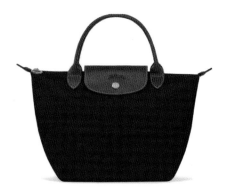

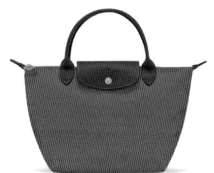

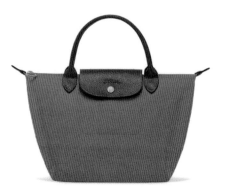

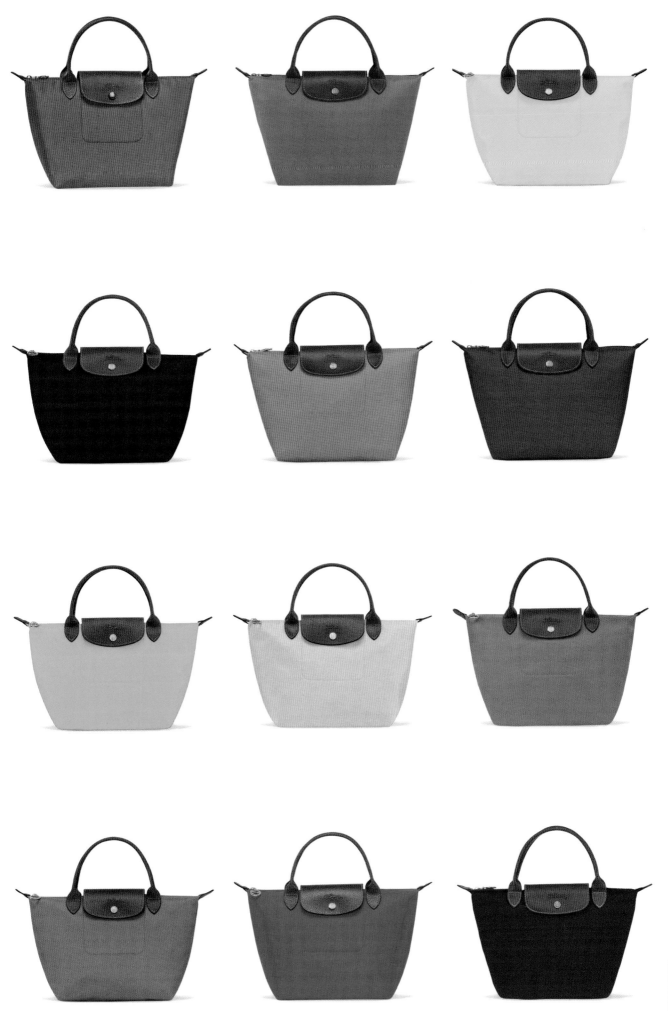

ROSEAU

The closure system of this line of bags (a clasp imitating a bamboo stem and inserted into a loop) is reminiscent of the duffle coats of English sailors, who, thanks to this clever system, could close their coats while wearing gloves. Today, in addition to the tote, handbag, and bucket bag, the line includes a shoulder bag on which the bamboo closure appears solely as decoration on the handle. These timeless bags blend into the everyday. As can be expected, the colors change with each season, ranging from pomegranate to black to cobalt blue to cognac.

LE FOULONNÉ

It would be difficult to find any bag more essential and timeless! Le Foulonné presents its signature look through its supple cowhide leather and iconic grain. It is available as a satchel, shoulder bag, or tote. It is pure classic chic, with the Longchamp name embossed into the leather. There is a wide range of 100-percent-chic colors, including turtledove, caramel, navy, black, or "love" red.

ÉPURE

These bags live up to their name as a bucket bag. With their clean lines that immediately place them in the category of an essential, they can go with any look. They are available in several styles (bucket, small phone case, coin purse) and are made of Russia leather—the brand's signature leather—and close with a snap button. The colors range from pink, green, black, brown, cobalt blue to striped. Some styles are true standouts, such as the limited-edition wicker bucket bag.

LORO PIANA
DISCREET LUXURY

Founded: 1924

The story: Originally from Trivero in northern Italy, the Loro Piana family entered the wool business in the early nineteenth century. In 1924, Pietro Loro Piana created a company in his own name, which was passed down among family members. At a time when haute couture was booming, Loro Piana made a name for itself by providing high-quality wool and cashmere to fashion houses. In the 1970s, Sergio and Pier Luigi Loro Piana took over the company's leadership. They developed the brand by creating other luxury products whose excellence was recognized worldwide. All ready-to-wear and accessory collections are made in Italy by artisans.

The style: Discreet luxury of rare quality, noble materials, impeccable cuts, a timeless spirit, and soft colors. Loro Piana is pure luxury.

Heard on the street: *"I never say where my bag comes from out of respect for this fashion house that wants to remain discreet."*

WHO WEARS LORO PIANA?
Lily-Rose Depp, Selena Gomez, Gigi Hadid, Angelina Jolie, Karlie Kloss, Gwyneth Paltrow, and Rosie Huntington-Whiteley.

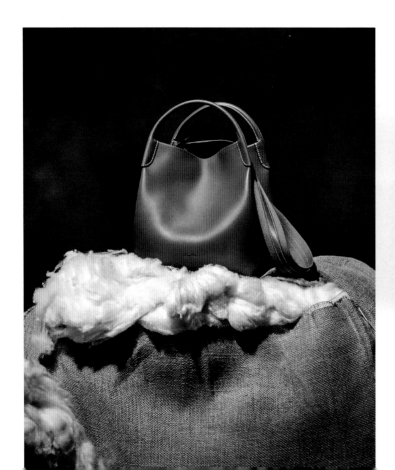

FASHION HOUSE FACT
Even though Loro Piana excels in making leather goods, the fashion house is best known for using the rarest raw materials: baby cashmere from northern China and Mongolia, vicuña wool from the Andes, extra-fine merino wool from Australia and New Zealand, and lotus flower fiber from Myanmar.

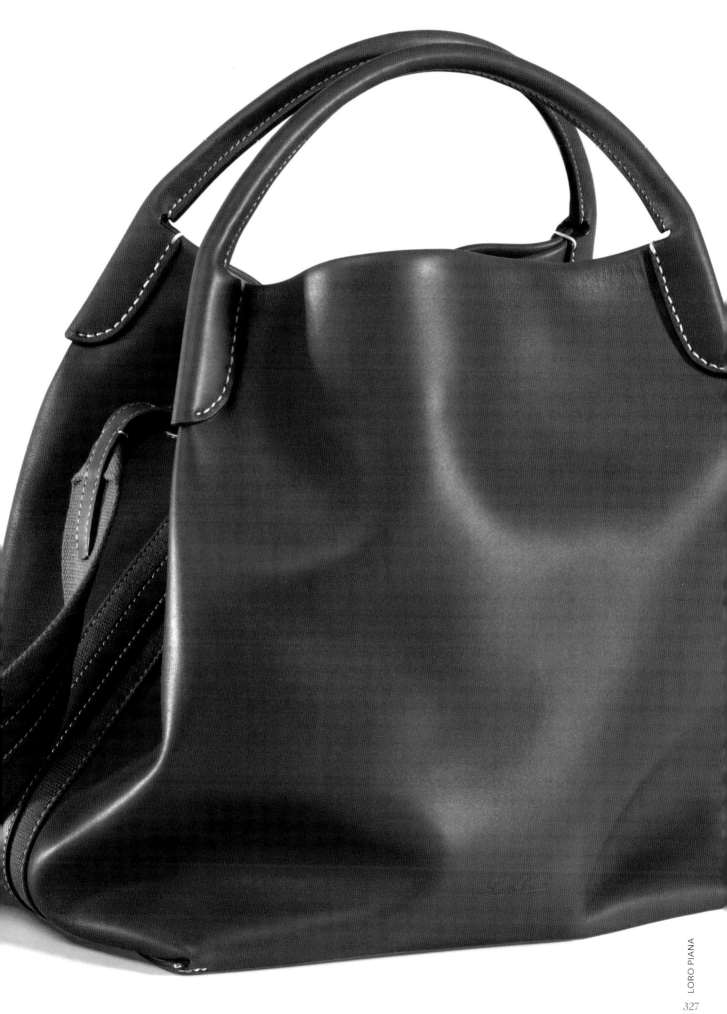

BALE

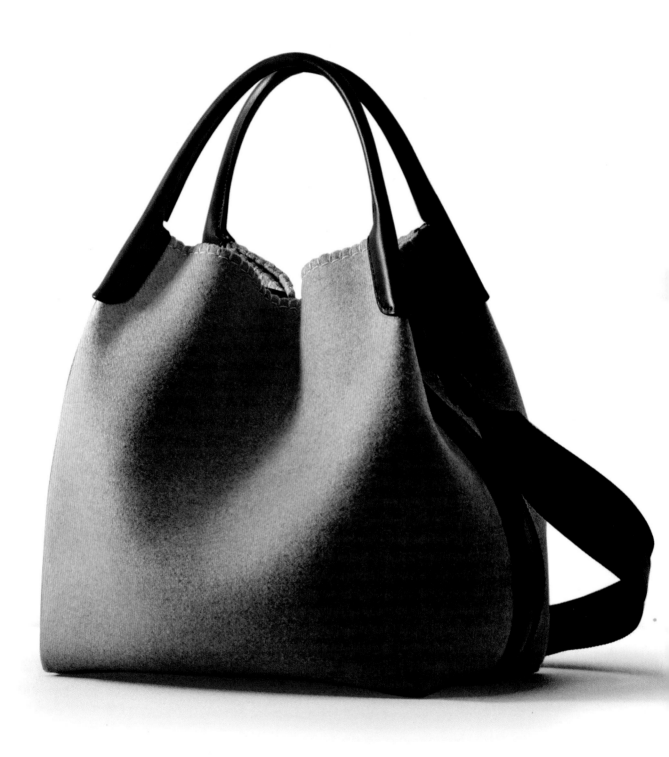

An ultradiscreet bag with soft curves. The name and its cubic design are inspired by the bags used to transport cashmere. It is handmade in calfskin. It closes from the inside by bringing two leather extensions together with a metal twist lock, similar to a cuff link. In addition to the two handles, it has a detachable shoulder strap. The name Loro Piana is discreetly stamped on the front. It is available in several sizes and, as expected, discreet shades.

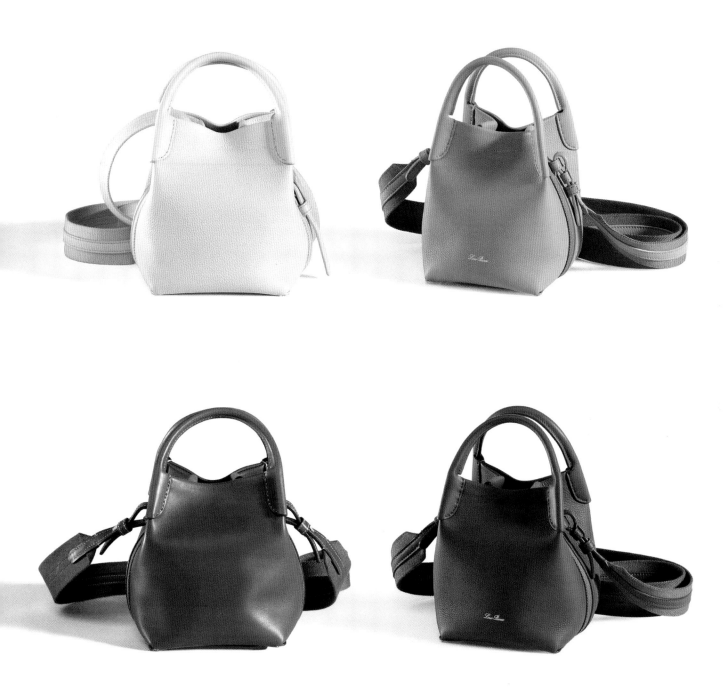

EXTRA POCKET

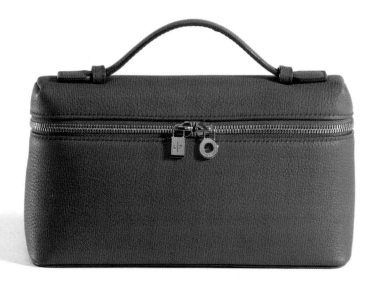

As the name suggests, this small bag serves as an extra pocket. Equipped with a detachable shoulder strap, it is available in a wide range of colors. The Extra Pocket is available in calfskin, linen, ostrich leather, and Ayers snakeskin. It's a very small bag with maximum style impact.

HAPPY DAY

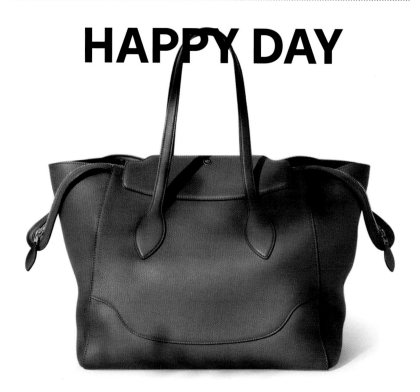

Here's a bag that can put you in a good mood! With its topstitching on the bottom and around the handles, it looks like it has eyes and a smiling mouth. It is made of calfskin or cotton and linen. Several sizes are available, including the micro. All bags have a detachable shoulder strap to carry the bag in multiple ways. Whether in off-white, putty, nude, or navy, the colors are nicely neutral.

SESIA

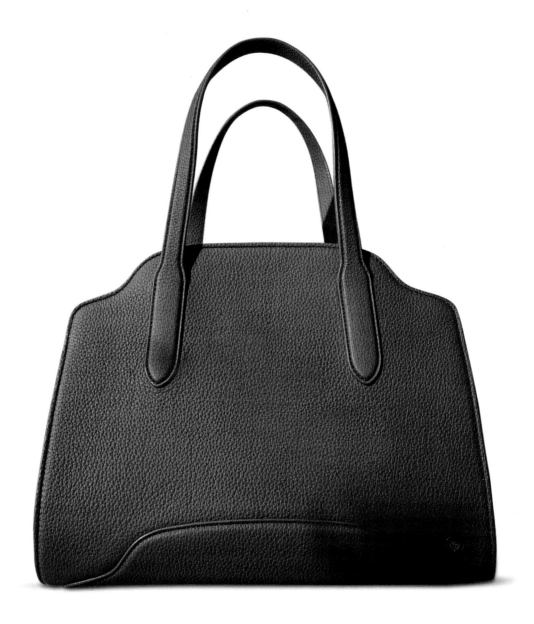

The brand's signature tote bag. Its generous volume makes it very practical for both everyday and travel. It has two pockets on the inside, one zipped and one open. It is available in calfskin or cotton and linen for summer.

LOUIS VUITTON
A LOGO WITHIN

"Never forget that what becomes timeless was originally completely new."

Nicolas Ghesquière, artistic director of Louis Vuitton women's collections

As one of the most recognizable logos in the world, the Louis Vuitton monogram is the common thread running through all its collections. Louis Vuitton, who started as an artisan trunk maker, had some of the world's most important personalities traveling the globe with his *LV*-branded luggage. Little did he imagine that his brand would one day become a global fashion icon. Marc Jacobs, later artistic director of the company, envisioned fun ways the *LV* monogram could be presented on the bags. He explored many colors by involving artists in the design of the collections. Nicolas Ghesquière, the artistic director of the women's collections since 2013, also released It bags destined to remain sought after, and collaborations with artists continue. Fashion may change, but the Louis Vuitton monogram remains.

7 KEY DATES

1854
After working for seventeen years as an artisan trunk maker and packer for M. Maréchal, Louis Vuitton opens his workshop at 4 rue Neuve-des-Capucines in the 2nd arrondissement of Paris, near place Vendôme.

1858
To make it possible to stack his trunks, Louis Vuitton invented a flat lid (they were originally domed). He also abandoned the heavy skins used as exterior covering and chose a light, coated canvas. This was a small revolution in design.

1859
Louis Vuitton's brand grows, and he moves into ateliers in Asnières-sur-Seine, with twenty employees. These workshops still exist today, and it is here that rare products and special orders are created. The adjoining family home has been converted into a private museum.

1886
Georges Vuitton, Louis's son, revolutionizes luggage locks. He invents a lock that transforms trunks into a sort of treasure chest with an improved locking mechanism, better protecting customers from thieves. This unique locking system, equipped with two spring buckles, was unpickable. It is still in use today.

01

02

03

1886 (continued)
All the heirs of the fashion house continued to perpetuate this tradition of French luggage and developed it into a luxury goods brand with a worldwide reputation.

1989
Bernard Arnault takes over as head of the LVMH group.

1997
Marc Jacobs arrives at the brand to launch the ready-to-wear collections.

2013
Nicolas Ghesquière takes over the artistic direction of the women's collections from Marc Jacobs.

04

MORE TO KNOW

Counterfeiting of the brand's products is nothing new! Since the company's first successes with its iconic accessories, people have attempted to steal Louis Vuitton's creativity. Georges Vuitton (who became head of the brand when his father, Louis, died in 1892) envisioned ways to avoid such scams by inventing and legally registering the *LV* Monogram canvas to deter counterfeiters. The letters *LV* are obviously a tribute to his father. The small flower pattern appears Japanese inspired, but some claim they were on the tiles in the family's kitchen. One fact is clear: Despite the intention to create a pattern that couldn't be copied, the idea failed. Georges did not foresee that the logo itself would be copied. Although counterfeits are still produced, they all have one thing in common: They are not made with expert craftsmanship.

05

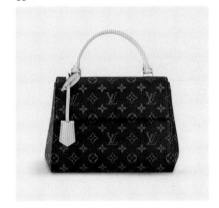

THE 5 HOUSE CODES OF LOUIS VUITTON

Louis Vuitton's style displays many very recognizable elements:

01.
The *LV* monogram
It is included on everything, from bags and clothes to jewelry and shoes.

02.
Trunks

03.
Bags created in collaboration with artists

04.
The lock
Instantly recognizable among thousands.

05.
Brown
The color of the monogram canvas.

THE MONOGRAM
IN ALL ITS FORMS

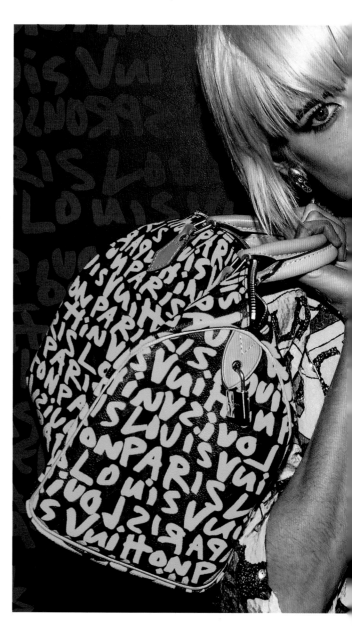

01.

As soon as Marc Jacobs took over artistic direction, he placed the monogram center stage. His mission was to bring Louis Vuitton into vogue. The clothes he created were very minimalist in style but also very luxurious, and including the famous monogram was a must! In 1999, he introduced bags on which the monogram was displayed in cheerful colors. Marc Jacobs was brought into the company to not only create a luxurious and timeless wardrobe, but to also, through partnerships with artists, give the bags desirability and attract new customers.

02.

The first collaboration that made a splash in 2001 was with American designer and artist Stephen Sprouse, who "dared" to do graffiti on the monogrammed canvas. Although some purists were a little upset by this seemingly radical approach, the response was immediate: Tagged bags became ultra-sought-after It bags. This bold move had an unintended consequence: The monogram was made sacred, giving it more value. Stephen passed away in 2004, but Marc Jacobs paid tribute to him by using the famous leopard camouflage that the artist had created in 1987 for his 2006 collection.

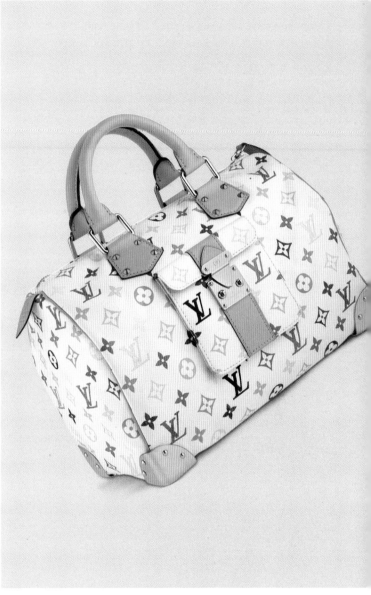

03.

In 2002, Marc Jacobs gave creative freedom to Japanese artist Takashi Murakami. The idea was to "pop" the monogram. Takashi imagined the famous logo in multiple colors (thirty-three to be exact) for the Spring/Summer 2003 show. It was *kawaii*, and everyone loved it. The collaboration with Takashi lasted thirteen years and left its mark on the collections with his "Cherry Blossom" (2003), "Panda" (2004), "Monogramouflage" (2008), and "Cosmic Blossom" (2010) motifs.

THE MONOGRAM
IN ALL ITS FORMS

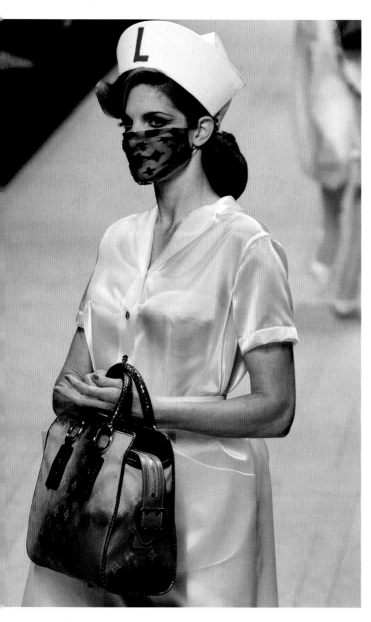

04.

In parallel with the collaborations with Murakami, in 2008, Marc Jacobs approached painter and photographer Richard Prince, known for his collages of photographs. This was a very controversial move since the artist was embroiled in a controversy over his artistic appropriations (this was a clever play by Jacobs to have Prince therefore intervene on the Louis Vuitton monogram). Richard was inspired by cities at dusk. Like a watercolor, he transformed the canvas and used seventeen colors to fade and blur the logo. He also printed texts on a faded version of the monogram and embellished the leather details with snakeskin.

05.

In 2012, Japanese artist Yayoi Kusama, known as the "Princess of Polka Dots," painted a trunk with her famous dots. In 2023, at the age of ninety-four, she was back in action: She covered all the bags with her visual signature in a collection called "Infinity Dots." Yayoi Kusama views these polka dots as more than just a motif; they are an ode to infinity. Although covering the monogram, the dots convey that the famous monogram has a long life as infinite as the round form, as if to definitively grant it eternal life.

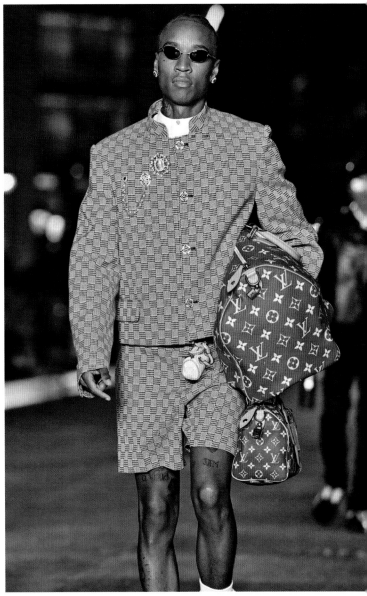

06.

For his first collection as creative director of the men's line, Pharrell Williams reinterpreted the monogram in primary colors. Rihanna was the face of his men's collection, and of course women love carrying these ultra-cheerful bags.

KEEPALL

1930

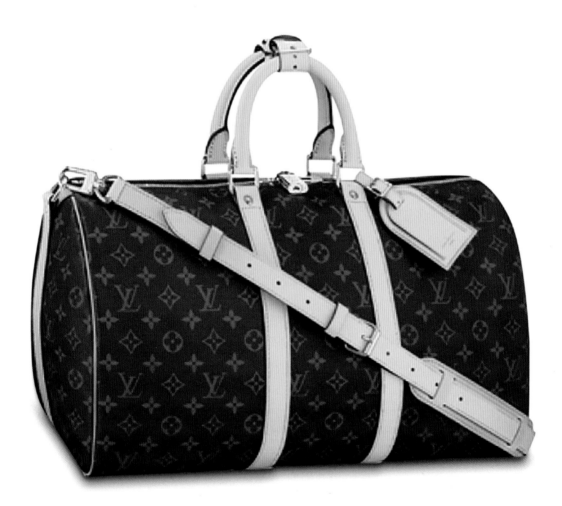

A Keepall to keep it all. And that's exactly why this travel bag was created, allowing the owner to travel with as much stuff as possible. This bag measures at least 18 inches (45 centimeters) and is available in several sizes up to 24 inches (60 centimeters). It immediately became a must-have. Made of soft leather, it offers an alternative to the rigid trunks. It can be carried by hand or with a shoulder strap and is embellished with a padlock, key, and address tag.

NOÉ

1932

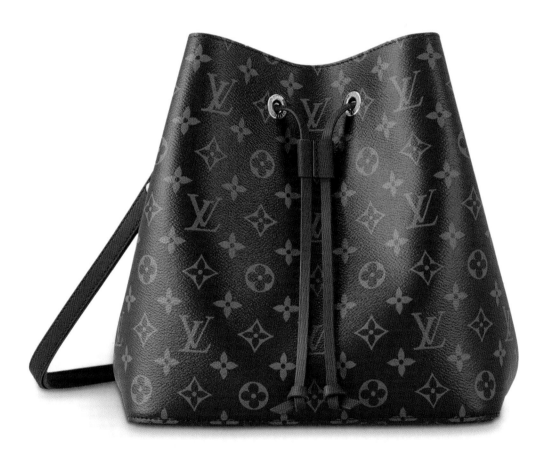

The Noé is a bucket bag designed by Gaston-Louis Vuitton, Louis's grandson. A champagne producer and customer of the brand asked him to develop a bag for carrying up to five bottles of champagne. In 1987, the company thought it made sense then to join forces with Moët Hennessy champagnes. The first Noé was made of natural leather. Its simple and roomy shape made it timeless, and it has been made in several sizes. In 2017, it was reworked slightly and renamed the NéoNoé. It's a bag that's built to last.

SPEEDY

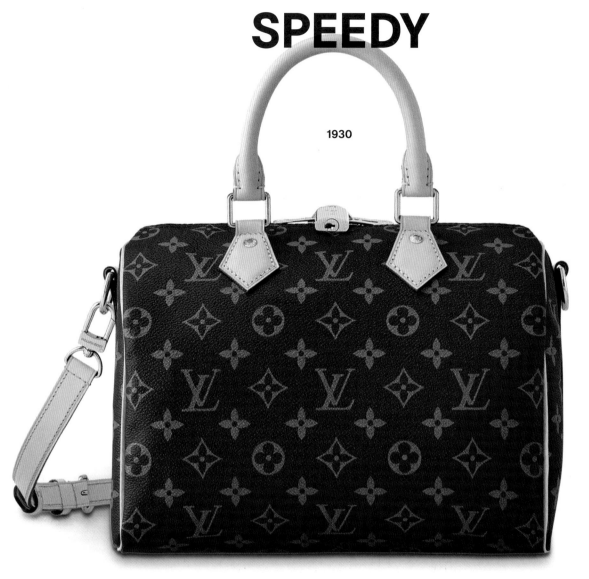

1930

In addition to his luggage, **Louis Vuitton offered a range of more accessible bags**. This one was originally called the Express and was made of beige rubberized canvas. It was available in four sizes. The original format was 12 inches (30 centimeters). In 1959, actress Audrey Hepburn requested a special order to reduce the size of the Express to make it an everyday bag. Shortened by 2 inches (5 centimeters), it became known as the Speedy 25 and was reimagined in several dimensions. During a visit to the Asnières ateliers in 2009, director Sofia Coppola was inspired by the Speedy 25 to create the SC, which became an immediate hit.

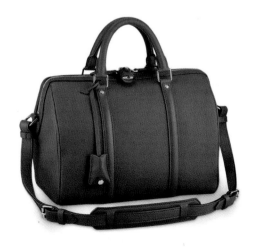

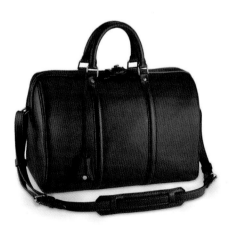

ALMA

1934

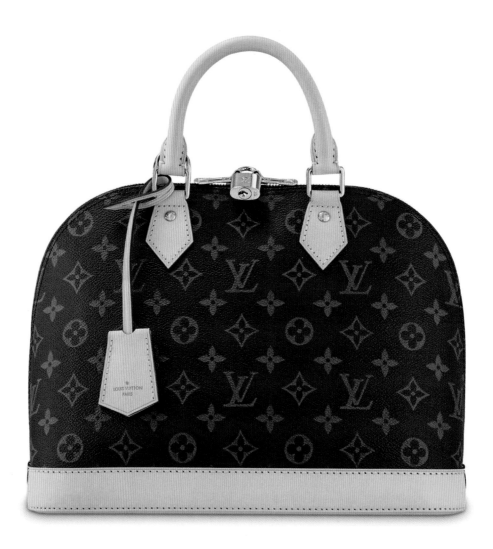

In 1901, Louis Vuitton developed the steamer bag, an indispensable companion for transatlantic travelers. This trapezoid-shaped bag included compartments to separate clean from worn clothes. In 1925, Gabrielle Chanel requested the bag as a handbag. It was called the Squire and was sold almost ten years later (in 1934). In 1955, the bag was made lighter and renamed the Champs-Élysées, which was eventually abandoned in favor of the Squire shape, which endured. In 1992, the bag was named Alma, in homage to the square near avenue Montaigne. The Alma includes gold keys and a padlock, twin Toron top handles, and a leather clochette for keys. A detachable shoulder strap allows for crossbody wear. Like all Louis Vuitton bags, the Alma is available in the fashion house's various materials, including Epi leather and Damier canvas. In 2010, the Alma was made available in a mini format called the Alma BB.

NEVERFULL

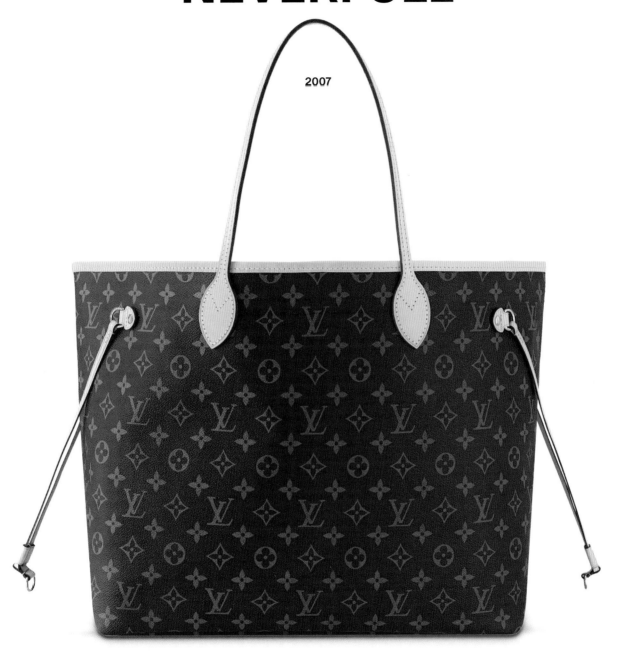

2007

This is the perfect tote bag! It seems bottomless because you can keep filling it up. It's a versatile bag that you can take with you when traveling, going to the office, or when carrying a laptop. The straps on the sides can be tightened or kept loose. The bag takes forty-five hours to construct. Its leather handles look thin, but they have been reinforced by double stitching, and you can carry heavy objects without it ever showing a sign of weakness. (The story goes that someone dared carry 198 pounds/90 kilograms in it, and it held up!) The bag includes an inside pocket as well as a removable pouch. It comes in several sizes.

CAPUCINES

2013

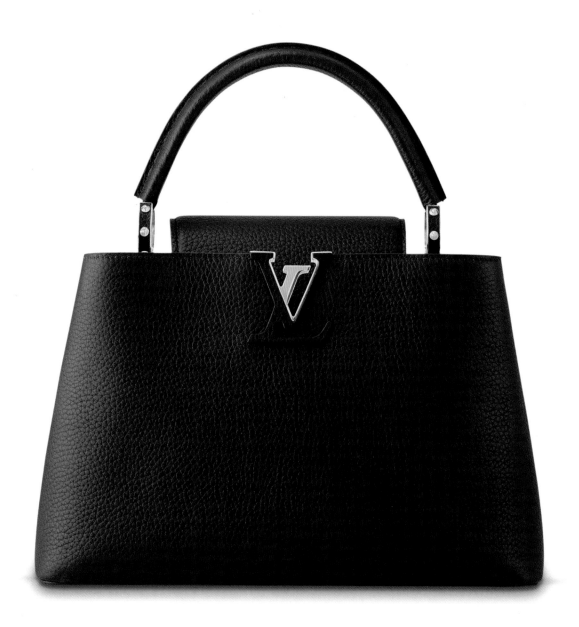

Designed by Nicolas Ghesquière, the name of this bag refers to the address of the first Louis Vuitton boutique at 4 rue Neuve-des-Capucines (now called rue des Capucines) in Paris. Each bag is the result of 250 assembled pieces and several hundred manufacturing steps. Two leather sections of full-grain Taurillon leather and calfskin are combined to make the handbag. It can be carried by hand or with a shoulder strap and has become a house classic in less than ten years.

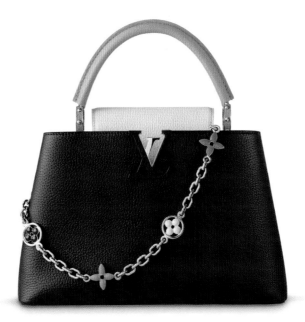

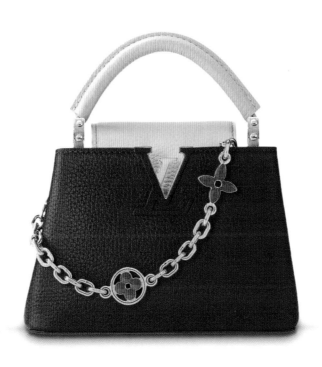

ONTHEGO

2019

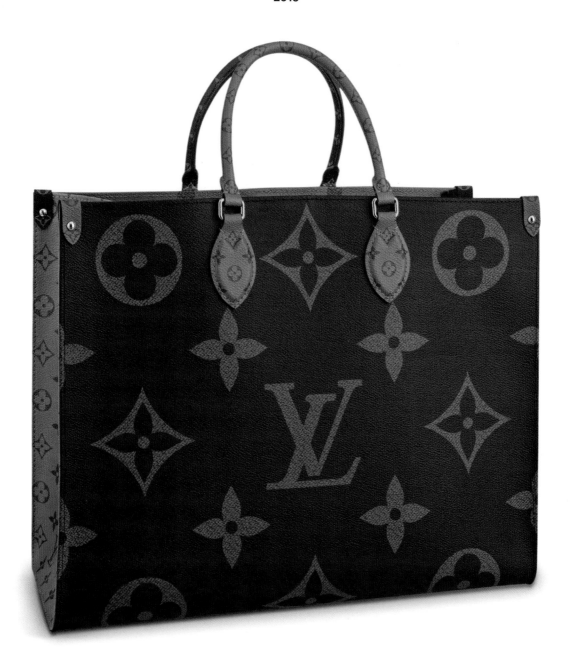

A more structured tote than the Neverfull, the OnTheGo comes in three sizes. Its monogram is much bigger than the original one (it's referred to as the giant monogram). It's an everyday or travel bag. As soon as it was created, it was considered a permanent part of the product offering. The one for the collaboration with Yayoi Kusama is in the normalsize monogram. It is also available as Monogram Empreinte Giant in supple grained and embossed leather, which has a more discreet logo. It can be carried by hand with its two handles or on the shoulder thanks to its two long handles.

PETITE MALLE

2014

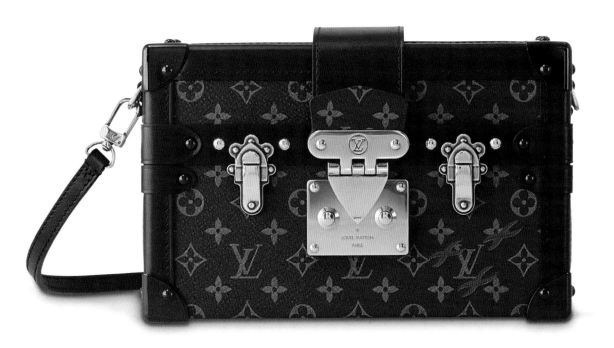

With its iconic shape and emblematic 8-lock, the Petite Malle was created by Nicolas Ghesquière for his first fashion show. It is clearly the most representative bag of the brand, since it recalls the trunk-making heritage of Louis Vuitton. This miniature trunk can be worn as a clutch in the evening or across the body with its (removable) shoulder strap for daytime. The three small crosses adorning some of the models in the first collection are the signature of traveling photographer Albert Kahn, a great reporter from the 1920s and a major influence of the Fall/Winter 2014–2015 show.

THE PETITE MALLE
OUT ON THE STREET

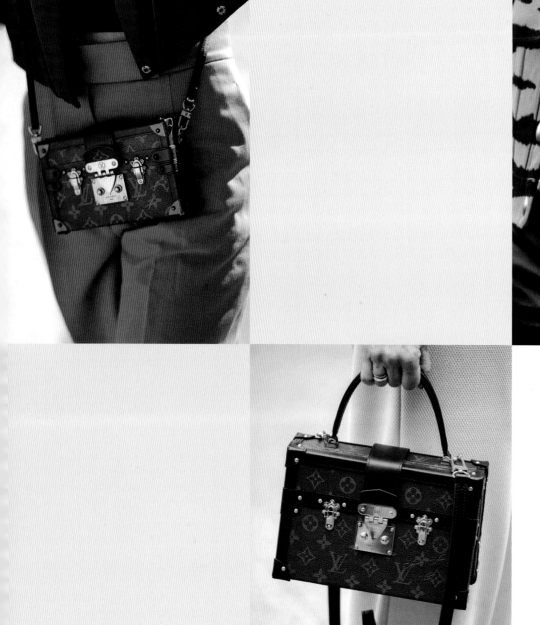
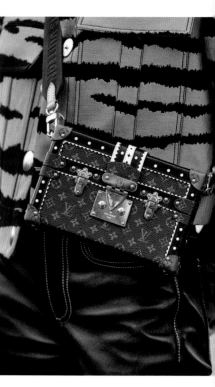

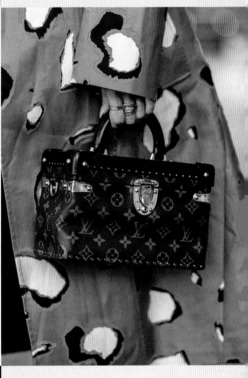

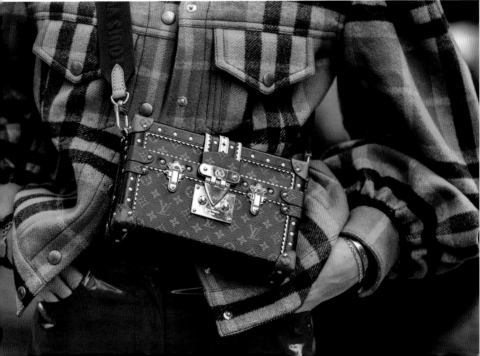

TRIBUTE PATCHWORK

2007

Considered a "best of" among Louis Vuitton bags, this bag was made from fourteen different bags that were cut and sewn together. It is a limited edition, with only twenty-nine pieces produced. The bag is difficult to design and was also created to discourage counterfeiters.

L/UNIFORM
FUNCTIONAL STYLE

"My bags are simple, no frills. I like the idea of a bag that you want to keep for a long time."

Jeanne Signoles

Founded: 2013

The story: Jeanne Signoles, designer and cofounder with her husband, Alex, of the label L/Uniform, worked in finance and aeronautics before taking off into fashion. While one day arranging her many cases for vacation, Jeanne had the idea of creating well-thought-out bags with sleek designs. From their atelier in Carcassonne, Alex's hometown region, they have expanded this small brand, now with a beautiful shop on the banks of the Seine in Paris (1 quai Voltaire, 7th) and another in Tokyo (3-1-1, Marunouchi, Chiyoda-ku).

The style: Extremely simple and timeless. Sturdy and beautiful. Intended for everyday function. The collection of these canvas and leather bags plays on color combinations. Personalization, which is done on the house's website, is at the heart of the concept. All the bags can be personalized by choosing leather details or by affixing initials or an insignia. Each accessory is associated with a number. *"Simplicity is the resolution of complexity,"* said sculptor Constantin Brâncuşi. The bags from L/Uniform are a perfect illustration of this.

Heard on the street: *"I made it!"* People don't need to know that all you did was change the colors and choose two letters . . .

FASHION HOUSE FACT
L/Uniform not only creates bags and luggage, but also cases for guitars and Ping-Pong paddles, bread bags, and even travel backgammon boards.

WHO WEARS L/UNIFORM?
This brand is for everyone who wants something beautiful without being flashy, or discreet while being in tune with a certain quality. Some believe that the N°43 knapsack is the ideal bag to wear during a job interview.

N°151
THE TOTE BAG

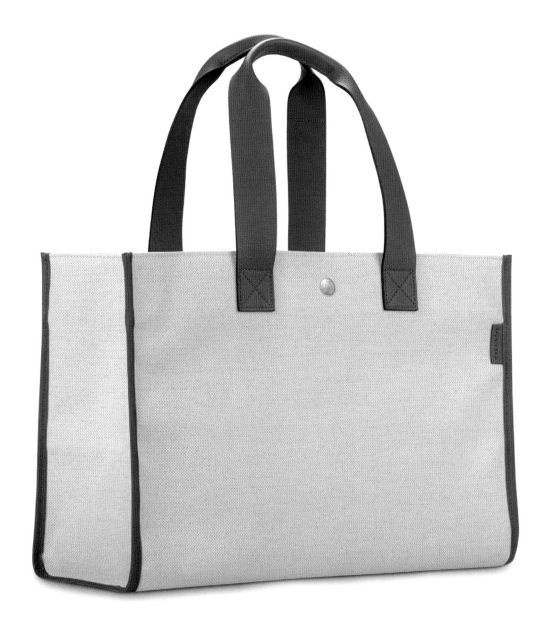

"*Freedom, sturdiness, lightness.*" That's how the brand describes the N°151 tote bag, considered the quintessential tote in an ideal size (L 15 × D 6 × H 10 inches/L 38 × D 16 × H 26 centimeters). It can be worn on the arm or shoulder or carried by hand. Its inside bottom is removable, and it has a small inside pocket and a snap button closure. The bag is made of natural canvas, and you can customize the details and handles with more than twenty color choices of leather. As on all L/Uniform bags, monogrammed initials can be added.

N°177
THE MINI RIGGER BAG

Inspired by bags used by shipyard workers, it has five exterior pockets for easy access to essential items. It's a rather large tote (it also exists in a larger size with the name N°77) produced in natural canvas and leather. It can be worn on the shoulder or across the body thanks to its strap, and it fastens with a leather tie.

N°3
THE TOOL BAG

This was originally a work bag for plumbers and electricians. The N°3 tool bag is made of canvas with two handles reinforced at the top with leather. It has a large number of flat or extendable pockets (center, side, and front). Its bottom is reinforced, and the sides are bonded to ensure a strong hold and durability. It's available in a large or small format (N°176) and can be worn across the body or carried by hand. And if you decide you want to carry tools in it, no one will stop you . . .

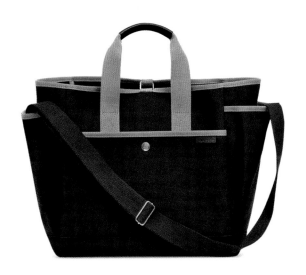

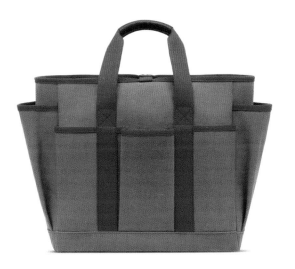

N°131
MINI PRESS BAG

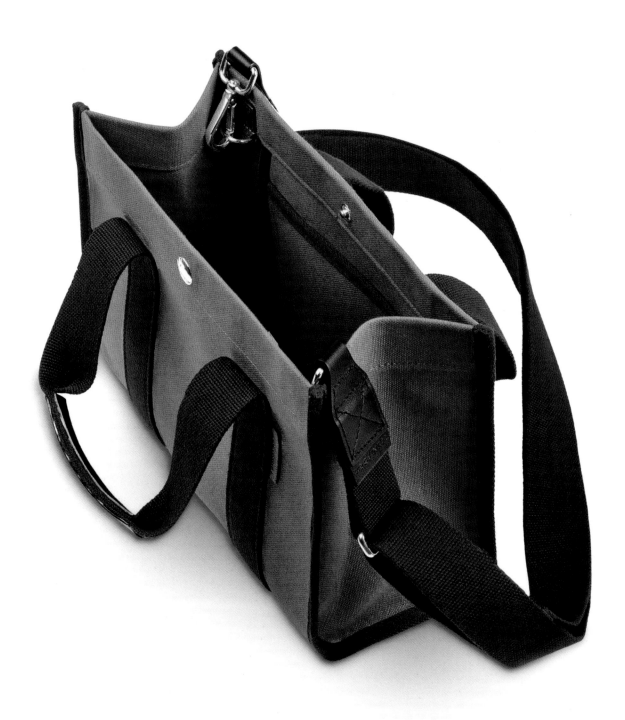

From the tote bag family, the N°131 mini press bag is the perfect companion for every day. It can be carried by hand or on the shoulder and is available in two versions: cotton and linen woven canvas or 100 percent cotton canvas. It closes with a snap button and has a small pocket inside. Like all L/Uniform fabrics, the material is water repellent and stain resistant. A practical bag.

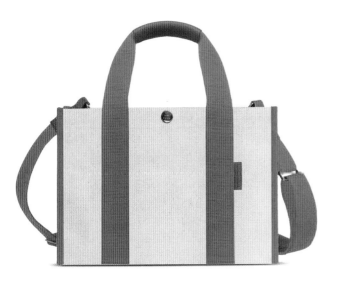

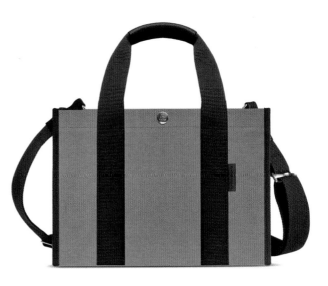

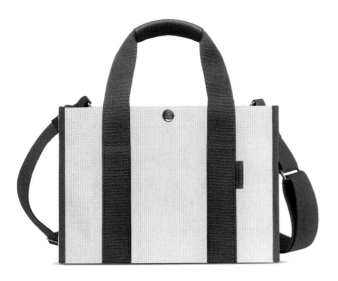

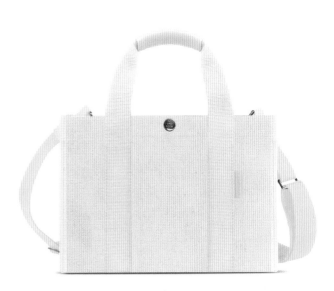

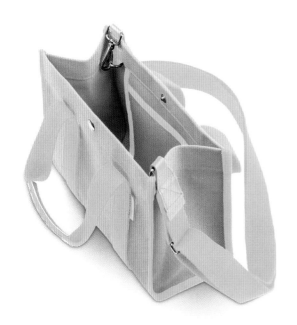

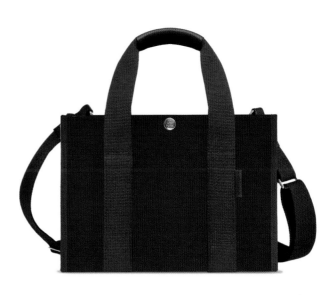

N°182
THE SMALL SHOPPING BAG

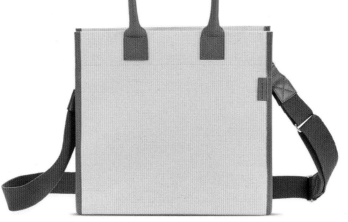

What if a basic shopping bag became a highly desirable bag? This small shopping bag, made of canvas and leather, just like the same ones in a large format (N°96) and mini (N°183), allows you to store all your market purchases without needing paper or plastic bags. It closes with a zip and has two leather handles. Note that it can also be used as an everyday bag.

N°43 THE SMALL SATCHEL

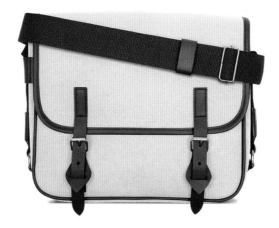

A few years ago, this satchel bag rose to fame thanks to a generation of teenagers who drew on it or hung buttons on it. At the time, it was very soft but rather shapeless. This one, made of canvas, has an impressive shape, closes with two leather tabs, and can be worn over the shoulder or on the back thanks to its adjustable strap. It is also available in a large format (N°23). Collaborations with Mackintosh, Lauren Rubinski, and La Fetiche have resulted in iconic versions. Today, the N°43 is loved by all generations.

N°146
THE SMALL
CROSSBODY BAG

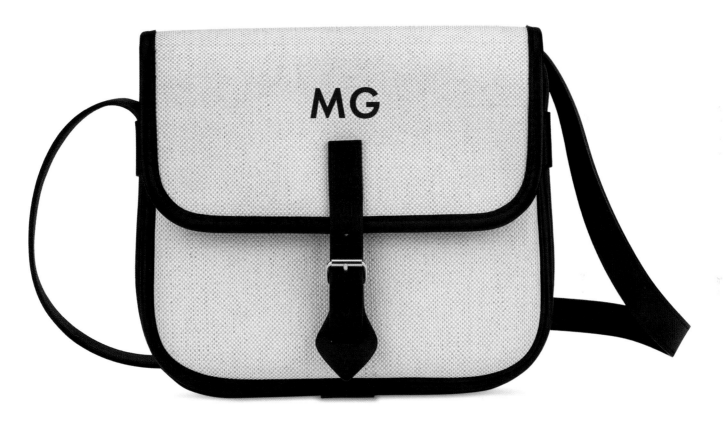

This is the ideal bag to go from the office to dinner out: It's neither too big nor too small and allows for the storage of all essentials. It's a classic that will never do too much or too little. This bag, reminiscent of the bags that hunters used for carrying their small catches, has a zipped inside pocket and is lined with leather. The gussets and the outer patch pocket are made of leather.

MAISON MICHEL
STRAW AS FASHION

"I'm inspired by tradition to bring it up to date."

Priscilla Royer, creative director of Maison Michel

Founded: 1936

The story: In 1936, Auguste Michel set up his studio at 65 rue Sainte-Anne in Paris. In the 1960s, he handed control to Pierre and Claudine Debard; he was an entrepreneur, she a milliner. Both remained at the head of the company until 2002. In the 1970s, Maison Michel became a partner of the burgeoning Parisian haute couture circle. In addition to its collaborations with ready-to-wear and haute couture ateliers and bespoke offerings, Maison Michel launched its own line in 2006 under the artistic direction of Laetitia Crahay. In 2015, Priscilla Royer took over the role. The bag collection was launched in 2023.

The style: The bags are based on the emblematic material of the brand's straw hats. The hats are braided and sewn by hand, thus perpetuating a recognized artisanal expertise. It's pure natural chic.

Heard on the street: *"I really don't know which bag to choose. I'm going to draw a straw…"*

WHO WEARS MAISON MICHEL?
Nicky Hilton, Vanessa Paradis, Rihanna, and Emma Watson.

FASHION HOUSE FACT
As the embodiment of exceptional craftsmanship and French luxury, Maison Michel joined Chanel's *Métiers d'art* in 1997.

AUDREY

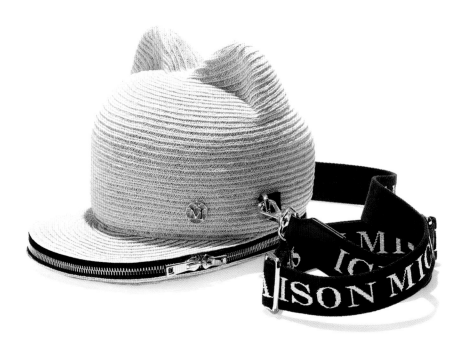

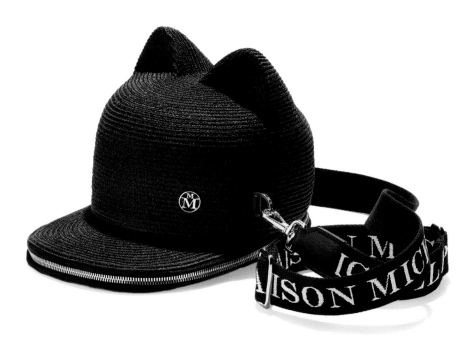

Inspired by Maison Michel's iconic Jamie cap with small ears, this bag can be worn across the body (with a strap bearing the brand's name), comes in black or pink, and closes with a zipper. The golden Maison Michel monogram is on the front.

JUDIE

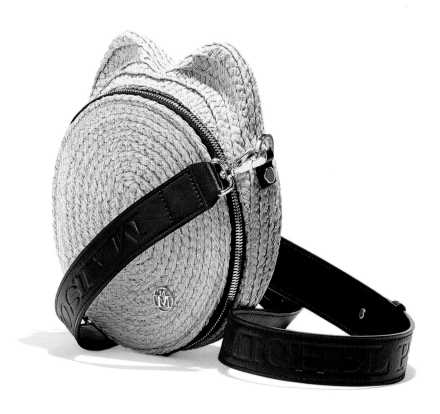

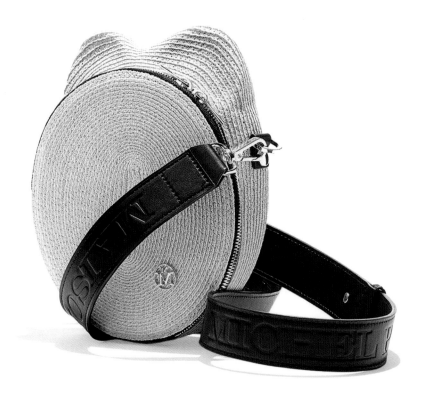

This small bag looks like a cat's head. It closes with a zipper, has a leather shoulder strap, and comes in pink and natural colors. The brand's name is printed on the nylon lining.

LIZA

A pink or natural straw banana-shaped bag is bound to be chic when it sports a removable shoulder strap made of three strands of pearls.

SHARON

Maison Michel knows how to be sensible with this small bucket bag in white or pink straw, which can be carried by hand with its single handle or carried across the body with the black leather shoulder strap embossed with the brand's name. The house monogram is on the front, and the nylon lining is printed with Maison Michel.

MARC JACOBS

ICONIC HIT – ICONIC HIT – ICONIC HIT – ICONIC HIT

THE TOTE BAG

Over the course of his career, Marc Jacobs has released many It bags. Some have never-before-seen shapes and innovative details—originality has always been the order of the day for this label. But the brand's most iconic bag is also its simplest. Its name, The Tote Bag, appears on the front in case you didn't spot it! It's a touch of humor that perfectly illustrates the spirit of the designer and has become his signature. When the designer collaborated with Fendi, all he had to do was place the words The Baguette on the Italian brand's legendary bag for the capsule collection to be immediately recognizable as Marc Jacobs. Simple. Basic. Effective.

MICHAEL KORS
AMERICAN LUXURY

"I've always thought of accessories as the exclamation points of a woman's outfit." **Michael Kors**

Founded: 1981

The story: A native Long Islander, Michael Kors has American style in his blood. After studying at the Fashion Institute of Technology in New York, he worked for a prestigious clientele in a boutique on 57th Street. In 1981, he created his line and offered ultrachic clothes whose comfortable style made them perfect for everyday. He quickly became the king of American luxury sportswear and the idol of jet-setters. His style spread worldwide. In conjunction with developing his brand (he created a men's line and a lifestyle line called MICHAEL Michael Kors), he worked as artistic director of the Celine brand from 1997 to 2004. In 2004, he launched his bags, which became It bags around the world.

The style: Luxury sportswear, but also chic styles. Nothing is bling. Even his golden dresses have an air of simplicity.

Heard on the street: *"I saw Amal Clooney with a Michael Kors bag. She's a brilliant lawyer, married to George, so she can be trusted to choose a good bag."*

FASHION HOUSE FACT
Michael had an eye for fashion starting at an early age. When he was five, he advised his mother, a fashion model who was getting married for the second time, to remove the bows from her wedding dress. She listened to him and cut off the bows. Michael's sleek chic is nothing new.

WHO WEARS MICHAEL KORS?
Michelle Obama (she wore Michael Kors for her official photo as first lady of the United States), Jennifer Lopez, Katie Holmes, Kate Hudson, Lily Collins, and Kerry Washington.

BANCROFT

2017

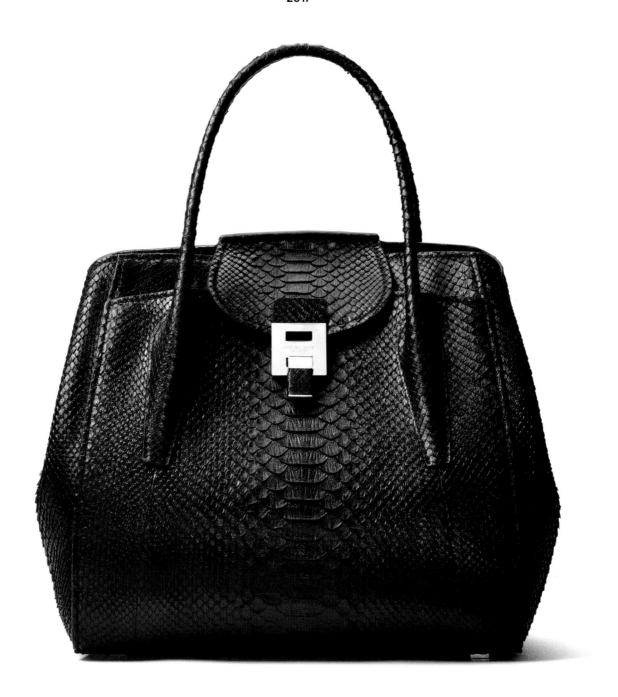

How did Michael come up with the idea for this bag? "*I always say that a good bag is like a pair of jeans: It only gets better with time. When I was on holiday in Corsica, I ran into a woman at a local market carrying a shopping basket. She looked chic. I wanted to create a bag that combines the casual functionality of a shopping basket with an urban spirit—an elegant bag, for every day, for every place. The Bancroft was the result. In the end, there is nothing more sophisticated than understated elegance.*" This leather bag is the perfect illustration of Michael Kors's style.

MIRANDA

2013

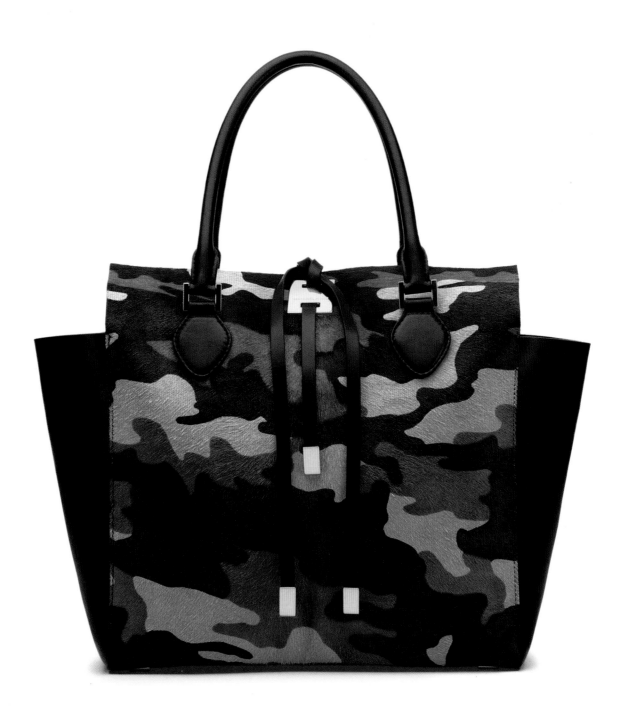

The Miranda is an iconic tote from the Michael Kors collection: It's sophisticated glam in luxurious materials. In 2014, Bespoke Miranda was launched, which is fully customizable with a choice of nineteen finishes.

AUDREY

2022

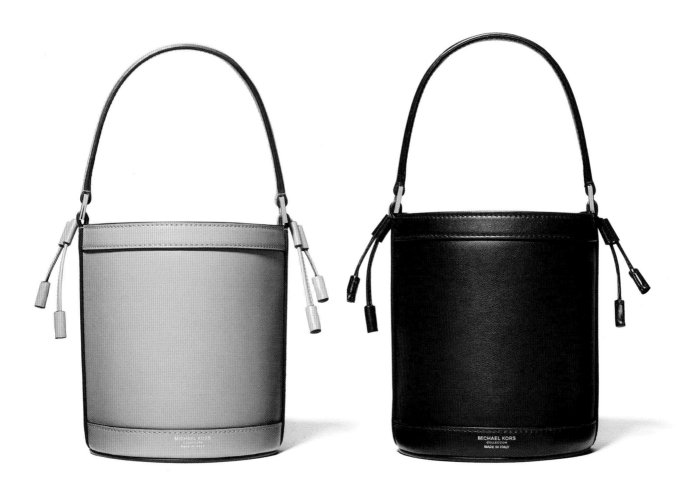

A true bucket bag, carried by hand or at the elbow like a bucket. It is made of leather (and is also available in crocodile embossed leather) and has pure lines. It has a structured handle and is lined with suede. The leather detailing attached to the handle makes it easily recognizable.

CAMPBELL

2022

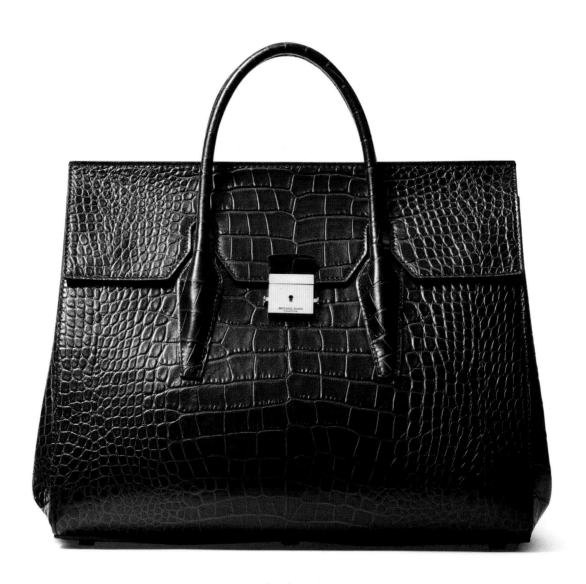

The Campbell exudes luxury. Lined with goatskin suede, it has a gold clasp and large capacity with several inside pockets. Its two hand-carry handles lend it a super stylish look. It is available in smooth cowhide leather in different colors, but also in crocodile embossed leather and in grained leather. And if taking the Campbell on a weekend trip, simply carry the larger format.

TINA

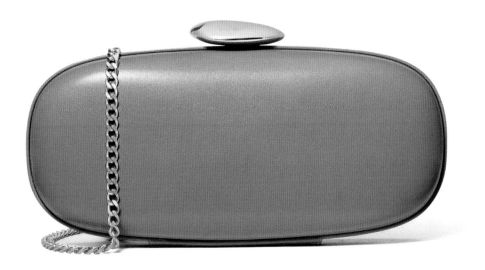

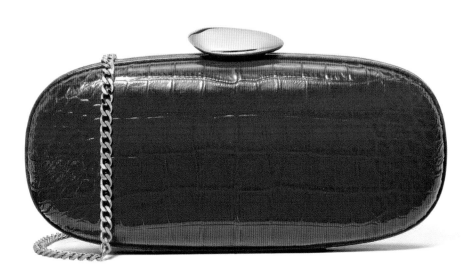

The Tina minaudière is *the* companion for any chic evening. It is made of leather lined with suede or, in some versions, embossed crocodile leather. It is highly structured, with a pebble-shaped clasp. It can also be worn across the body with its chain. Since 2022, it has been available in a micro format. The online store states that it goes perfectly with summer dresses and fitted suits. But no doubt you can also wear it with jeans …

MIU MIU
THE MUTINEER

"I don't trust people who think that clothes aren't important."

Miuccia Prada

Founded: 1993

The story: Miuccia Prada, called Miu Miu when she was a little girl, created this label alongside her Prada brand to have a somewhat less rigid look. But, above all, to create a look that would appeal to all young women who wanted a slightly mischievous luxury.

The style: Miu Miu has fun while adhering to fashion codes. Microskirts worn with loafers and socks; sexy preppy looks with undergarments worn on top. Miuccia designs clothes that give the impression that fashion is a game. While some pieces can be more minimalist, they still have a bit of an irreverent side that makes them fashionable.

Heard on the street: *"Fashion is an instant language!"* said Miuccia.

FASHION HOUSE FACT
Actress Drew Barrymore was the first celebrity face for a Miu Miu campaign in 1995.

WHO WEARS MIU MIU?
Hailey Bieber, Cindy Bruna, Gigi Hadid, Vanessa Hudgens, Dua Lipa, Camila Mendes, Rita Ora (a big fan of the bags who walked the runway for the brand in 2020), Camille Rowe, Chloë Sevigny, and Suki Waterhouse.

WANDER

2022

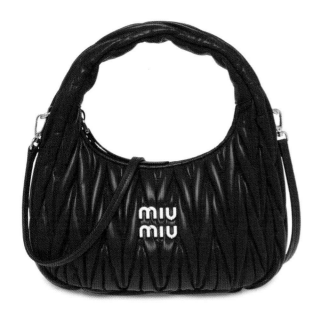
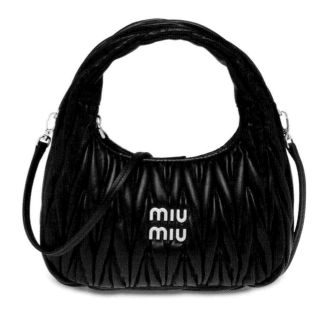
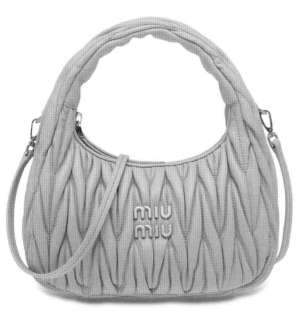
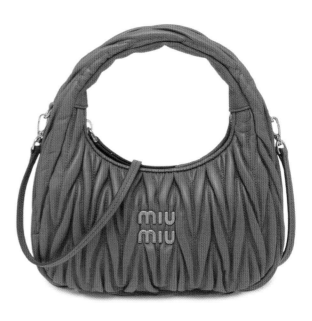

Launched in 2022, this hobo bag immediately became an It bag for the brand. The bag is reinterpreted each season in different materials. Whether in regenerated nylon, satin, wicker, crochet, or in the brand's legendary quilted leather, it features gold details and, as always, the logo on full display. It is available in five sizes and can be worn as a crossbody. Actress Sydney Sweeney (*Euphoria* and *The White Lotus*) appeared in the advertising campaign celebrating its launch. During Paris Fashion Week, you can see it being worn on nearly every street corner.

ARCADIE

2023

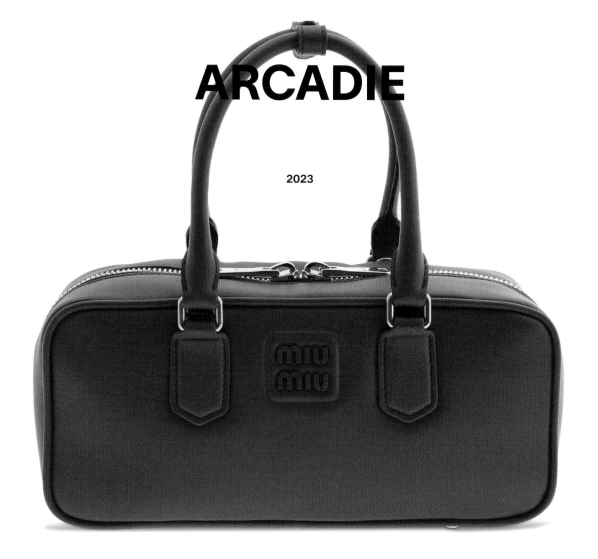

This bag borrows a classic shape but in unusual proportions, immediately making it a brand centerpiece. The material that makes it instantly recognizable (besides the eye-catching logo) is the quilted leather, which now practically serves as the house signature. Introduced at the Fall/Winter 2006 show, the quilted fabric is made of soft leather and is very supple, allowing it to be easily adapted to its contents. Its construction is a testament to true craftsmanship and is far from basic. The Arcadie is also available in smooth leather with tone-on-tone polished metal lettering. Even though the young Miu Miu woman has a reputation for being rather spirited, she also knows how to sometimes keep a low profile with a discreet logo.

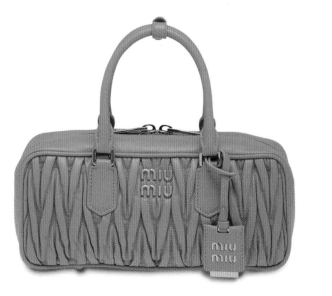

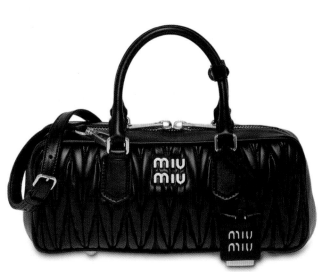

POCKET

2023

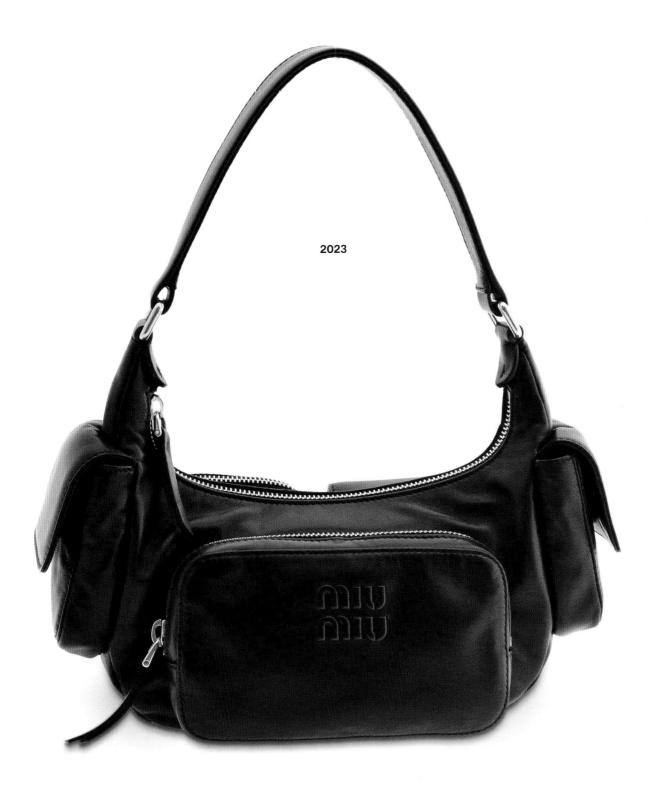

Although a recent addition to the collection in the spring of 2023, the Pocket can already be spotted everywhere. Made of nappa leather, it is both very functional (it has several pockets) and very stylish, with a shape that allows it to be carried just under the arm. It sports gold details, and the logo is embossed into the leather.

MOYNAT
WOMEN'S TRUNKS

Founded: 1849

The story: Pauline Moynat was a pioneer. She was the first woman to enter the profession of luxury trunk maker, a predominantly masculine industry of her time. When she arrived in Paris from her native Haute-Savoie at the age of sixteen, she laid the foundation for her company by opening her boutique on avenue de l'Opéra in 1869. She offered custom-made luggage, including travel trunks for automobiles, which were a new means of transportation for which everything had to be invented. The Malle Anglaise (English trunk), created in 1873, was made of wicker, covered with a revolutionary waterproof canvas, and surprisingly light. In 1880, Pauline had the idea of attaching a red leather pouch to the inside of her trunks for storing travel documents. In 1902, the Limousine trunk appeared, offering a curved bottom that made it possible to better adapt to the body of motor vehicles, and it was customizable to the same color as the automobile. Then, in 1906, the Roue de Moynat trunk was created to hold a spare tire. Today, fashionable young women can wear the mini version of the Wheel for a night out. The brand has stood the test of time and remains as current today as it was at its beginnings. In 2023, Moynat launched a capsule for yoga fans with a mat holder and water bottle holder—so twenty-first century.

The style: The know-how of this brand attests to an undeniable quality. One of the brand's bags has existed since 1903, which says a great deal about its timelessness. All of the products have clean lines and an Art Deco spirit.

Heard on the street: "*I always ask that my initials be hand painted on my Toile 1920 bags. Customization has been a service offered by the fashion house since 1849, a sign of how great service should be done.*"

FASHION HOUSE FACT
The Art Deco artist Henri Rapin, known for his lettering, created the Toile 1920, the one with the famous *M* monogram originally designed to prevent counterfeiting. The Toile 1920 is Moynat's signature motif.

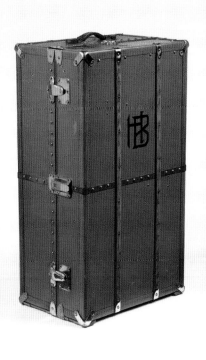

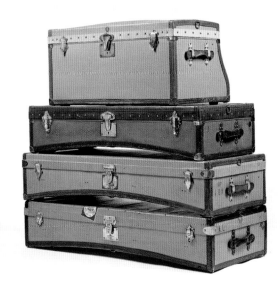

01

02

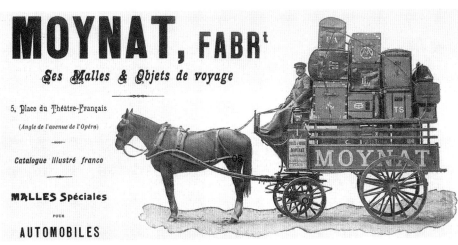

03

04

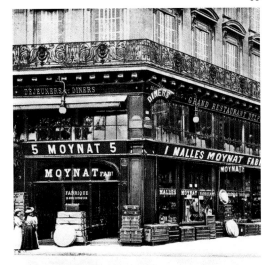

05

01.
Wardrobe trunk.

02.
After the creation of the Malle Anglaise wicker trunk with its revolutionary waterproof canvas, Moynat created the Limousine trunk in 1902 with a curved bottom adapted to the body of automobiles.

03.
Moynat advertisement in the illustrated newspaper *Le Théâtre*, 1900.

04.
"Ask that your car be equipped with a Moynat trunk." This 1927 advertisement extols the merits of the company's first side-loading trunks.

05.
Pauline Moynat opened the first Paris boutique on avenue de l'Opéra in 1869.

OH! TOTE RUBAN

The brand's must-have bag! This tote bag is covered with the brand's famous monogram, with its repeating *M*, a timeless signature more than one hundred years old! It is available in several sizes and colors and has leather trimming and a cotton and linen lining. You can personalize it for free by having your initials printed on it and changing the color of the ribbon.

VANITY BOX

Moynat likes to repurpose travel items to make everyday bags, such as this small minaudière in the Toile 1920. Like many other bags of the brand, it can be carried two ways thanks to its added shoulder strap.

LITTLE SUITCASE

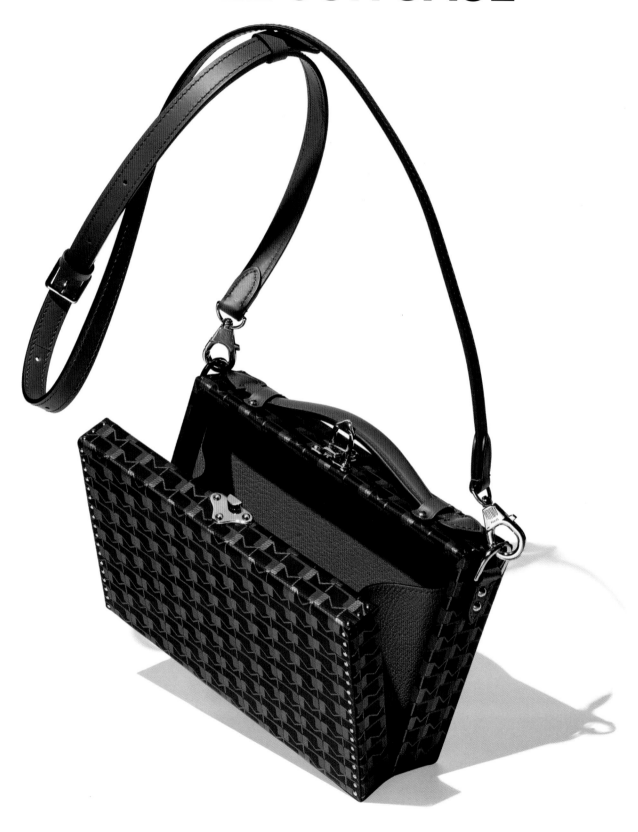

This small, rigid bag illustrates the brand's keen craftsmanship, whose reputation was built by master trunk makers. With its leather touches, this suitcase has all the features of a large suitcase. Of course you can wear it in the evening even if you're not going on a trip.

WHEEL

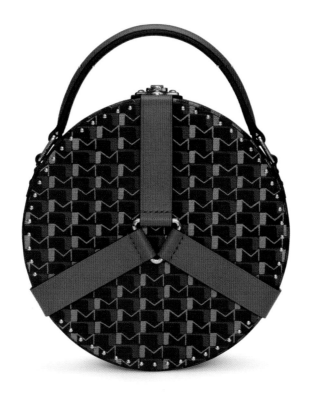

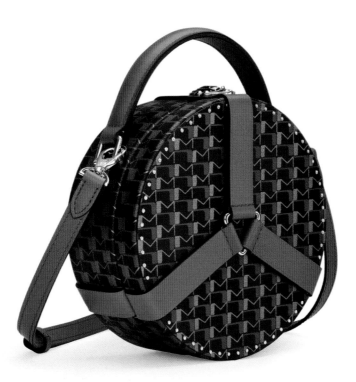

This is the miniature version of the famous Roue de Moynat trunk that was used to store spare tires in early automobiles. This minaudière, in Toile 1920 and with straps and a clasp inspired by old trunks, can also be worn across the body.

GABRIELLE

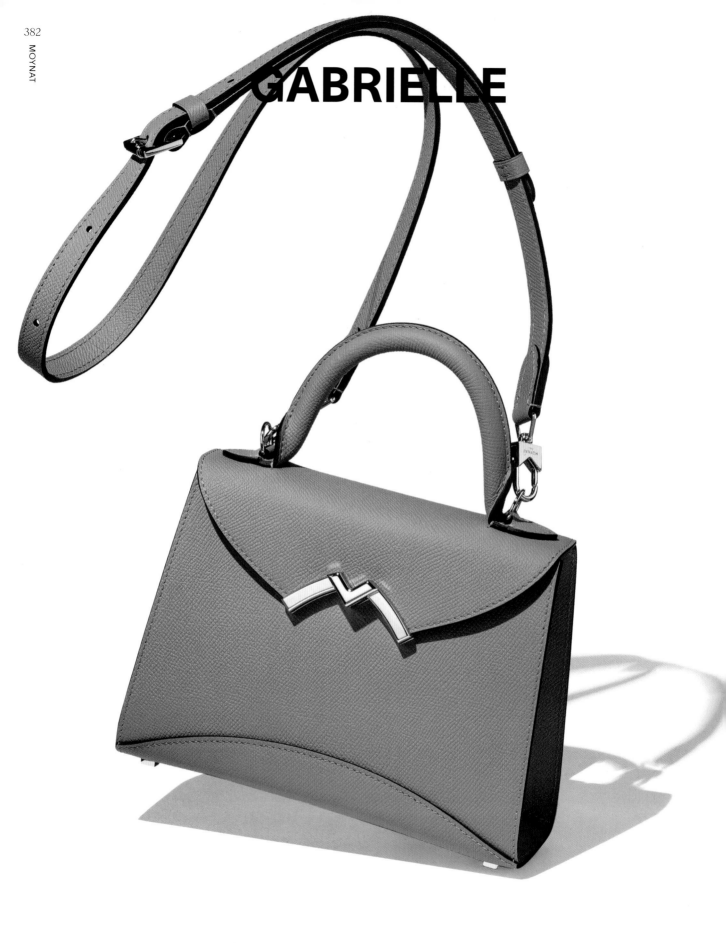

With its structured, curved lines, this calfskin bag is reminiscent of the Limousine trunk. It can be carried by hand or across the body and is available in two sizes as well as a clutch. The brand's signature detail? The *M*-shaped twist-lock clasp, symbolizing Moynat, of course.

RÉJANE

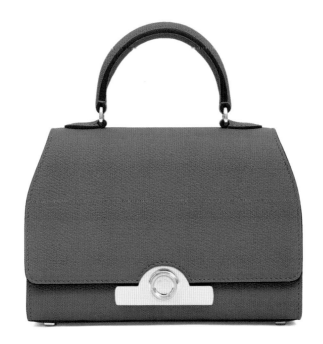

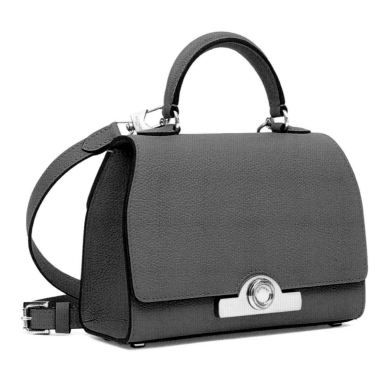

Originally created in 1903 as a tribute to Gabrielle Réjane, the leading actress of French theatre of the time, this bag has been given a revamp with a clasp of an Art Deco–style jewel. It can be carried by hand or worn across the body. It comes in three sizes and is made of bull calf leather.

OFF-WHITE
STREET COUTURE

"My goal was to establish a dialogue between haute couture and streetwear."

Virgil Abloh, founder of Off-White

Founded: 2013

The story: When Virgil Abloh founded Off-White in 2013, he considered his label a multidisciplinary creative adventure. He saw streetwear, luxury, art, music, and architecture as coexisting with fashion. Virgil's visionary approach was highly conceptual yet accessible to a broad audience; he liked to fuse the reality of clothing with the artistic expression of haute couture. Born in Rockford, Illinois, Abloh, who was also artistic director for Louis Vuitton's menswear line, died in 2021 at the age of forty-one. One of his close collaborators, Ibrahim Kamara, became artistic director.

The style: Chic with a street spirit and touch of irony.

Heard on the street: *"Wearing Off-White is above all a state of mind. Virgil was more than a fashion designer; he was a true artist. The style he created is immortal."*

WHO WEARS OFF-WHITE?
Beyoncé, Hailey Bieber, Naomi Campbell, Cindy Crawford, Billie Eilish, Gigi and Bella Hadid, Taylor Hill, Jennifer Lopez, Joan Smalls, and Serena Williams.

FASHION HOUSE FACT
In 2019, the Museum of Contemporary Art in Chicago presented a major traveling exhibit of Virgil Abloh's work called *Figures of Speech*. It was one of the most attended exhibitions in the museum's history.

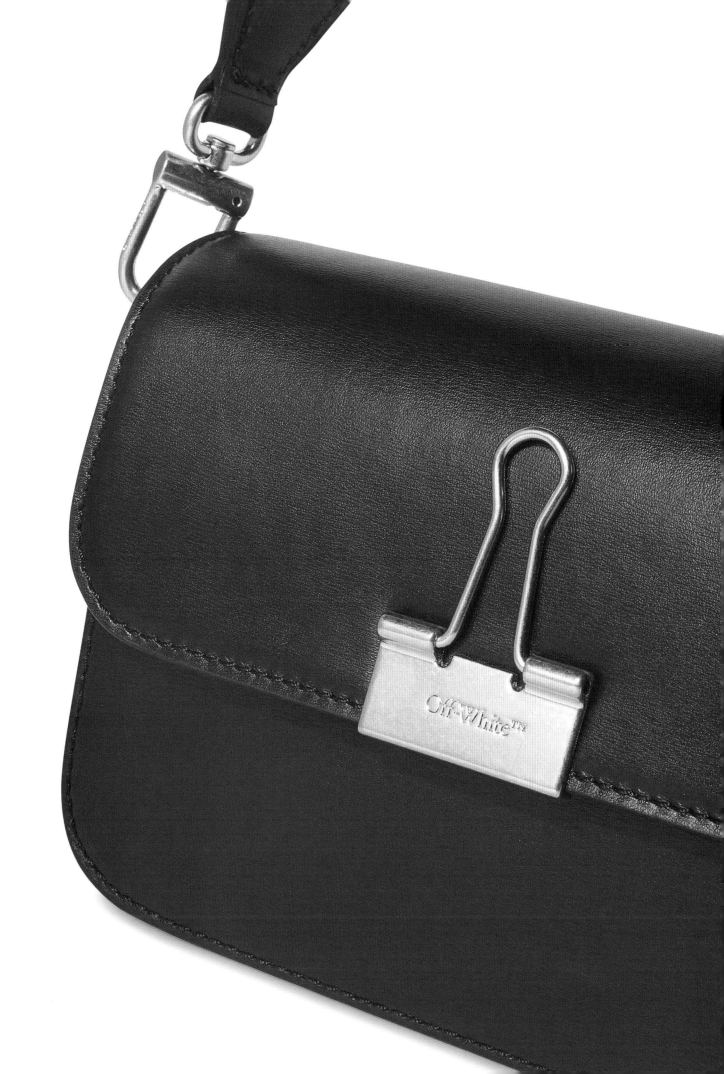

BINDER

2016

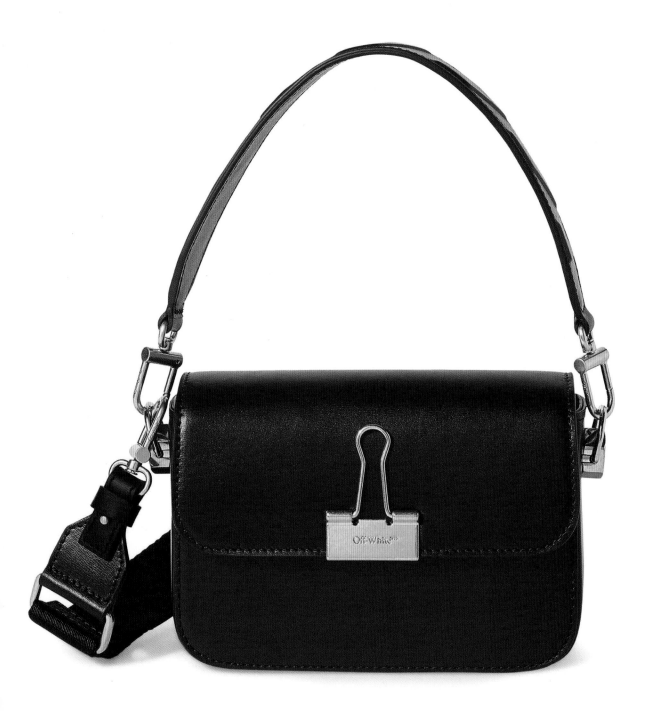

This is Off-White's most iconic bag, designed by Virgil Abloh in 2016. Rather classic, its binder clip clasp makes you smile. It is made of leather and comes in two sizes. It's a perfect style for the office.

JITNEY

2019

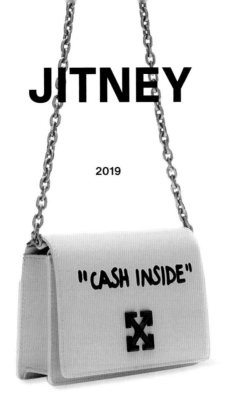

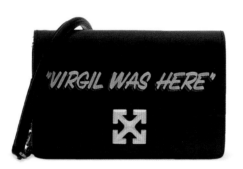

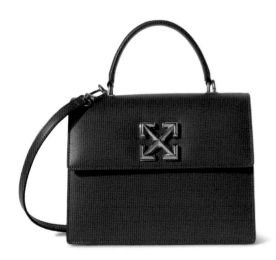

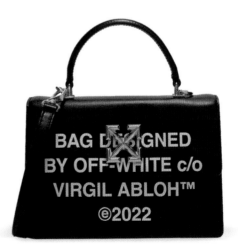

A bag that illustrates the mischievous spirit of Virgil Abloh, who created chic bags with timeless shapes injected with a touch of humor: "Cash Inside," "Virgil Was Here," and "Not for Sale," are printed phrases that illustrate the brand's touch of irony. The line also includes bags without phrases, adorned only with the brand's logo: four diagonal arrows pointing outward, no doubt inspired by that of Glasgow Airport in the 1960s. The Jitney comes in several sizes identified by numbers (0.5, 1.0, 1.4, 1.7, 2.0, 2.8). Depending on its size, this leather bag can be carried by hand or across the body.

OLYMPIA LE-TAN
LITERARY STYLE

Founded: 2009

The story: Created by Olympia Le-Tan and Gregory Bernard, these elaborately hand-embroidered, book-shaped minaudières have brought a touch of whimsy to red carpets around the world. Stars who are fans of literature immediately adopted these bags styled as reproductions of the covers of famous books. In 2018, Olympia Le-Tan left the fashion house she founded with Gregory Bernard, but this brilliant concept has continued. And even more covers of legendary works, magazine covers, paintings, and other pop culture references adorn these small rectangular cases. When you step out with an Olympia Le-Tan minaudière, you know you'll be carrying a conversation piece.

The style: Each case has its own style, ranging from a book by Albert Camus to the cover of *Life* magazine, or from F. Scott Fitzgerald's *The Great Gatsby* to Picasso's *Portrait of Dora Maar*.

Heard on the street: "*I like the idea of a Proust book being a fashion accessory!*"

FASHION HOUSE FACT
All you have to do is send an image of your favorite book, your favorite magazine, or a drawing that evokes an important event to create your own minaudière. If the workshop approves the idea, the embroidered minaudière will arrive at your home a few months later.

WHO WEARS OLYMPIA LE-TAN?
Cardi B, Poppy Delevingne, Katy Perry, Emily Ratajkowski, Emma Roberts, Camille Rowe, Sigourney Weaver, North West, and Princess Maria-Olympia of Greece (pictured at left holding a minaudière from her collaboration with the brand).

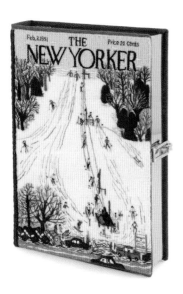

From *Jane Eyre* to *The Plague*, from a Picasso painting to a view of Capri,
these small handheld cases reveal a lot about the wearer.

PATOU
A RADIANT FRESHNESS

"Elegance, beauty, fine art, and fantasy: These are the only four concepts I've used in my collections." **Jean Patou**

Founded: 1914

The story: Jean Patou created his eponymous brand during the First World War. Called to the front to fight, he had to set his work aside but resumed on his return. His goal as a designer was to free women from the rigors of their clothing styles of the time. He sold corset-free dresses and shortened skirts and launched a sporty chic line for city wear. Josephine Baker and Suzanne Lenglen were among his fans. When he died at the age of forty-eight, his sister Madeleine and her husband, Raymond Barbas, took over the brand. Designers—including Marc Bohan and Christian Lacroix—would later become artistic directors. In 2018, the brand was relaunched under the direction of designer Guillaume Henry, who worked for Carven and Nina Ricci.

The style: Guillaume Henry has refreshed this very Parisian brand. With its cheerful colors and rather short skirts and dresses with a couture spirit, there is a lot of joyfulness in Patou collections.

Heard on the street: *"I see Patou bags partout!"*

WHO WEARS PATOU?
Priyanka Chopra, Olivia Culpo, Selena Gomez, Dakota Johnson, Florence Pugh, Camille Razat, Zoe Saldaña, Taylor Swift, and all the trendy Parisian influencers.

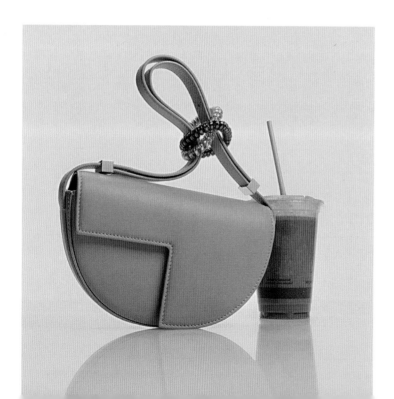

FASHION HOUSE FACT
The bags are made with leathers from unused stock, in tune with today's sustainability movements.

LE PATOU

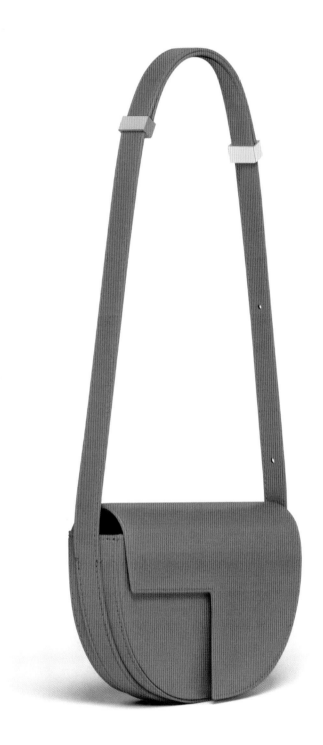

The brand's emblematic bag displays all the house style codes. In the shape of a half-moon, its geometric shape is inspired by the *JP* monogram. The gold-plated metal *JP* detailing resembles a brooch from the Jean Patou archives. The bag's shoulder strap permits three ways to carry it: on the shoulder, across the body, or by hand. It contains several compartments, and its magnetic closure, also with gold *JP* detailing, is invisible when the bag is closed. Le Patou is usually made from upcycled leather, but recycled organic cotton versions are available. Each bag color is a limited edition and numbered. In the same style, Le Petit Patou, as its name suggests, is smaller than the original.

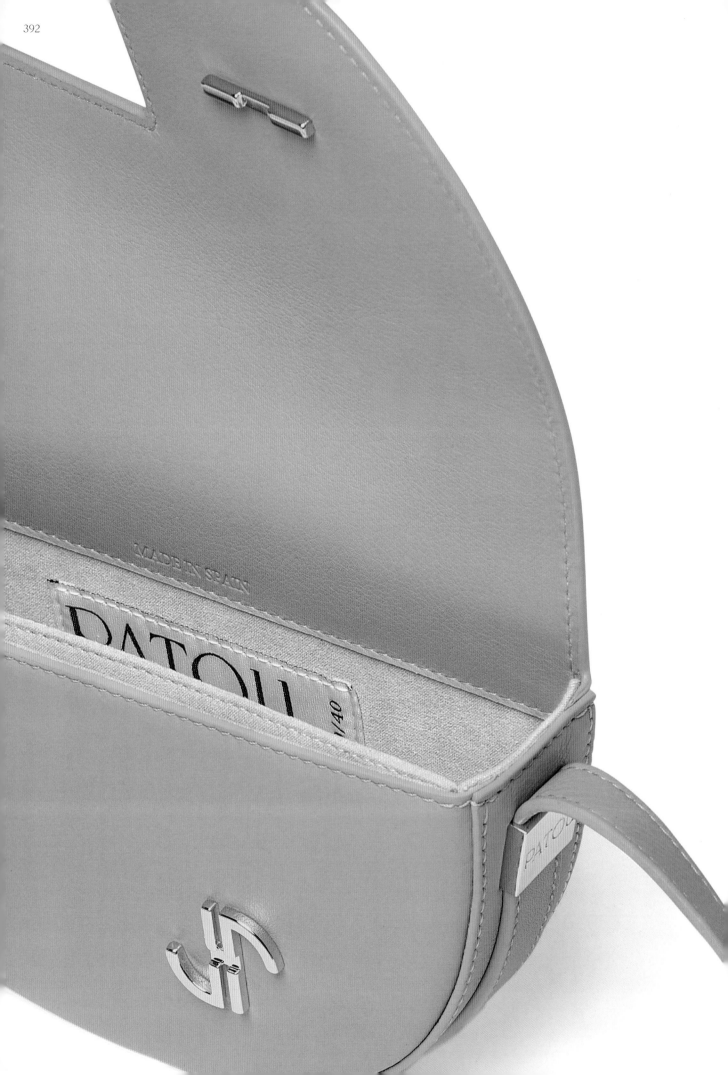

MADE IN SPAIN

PATOU

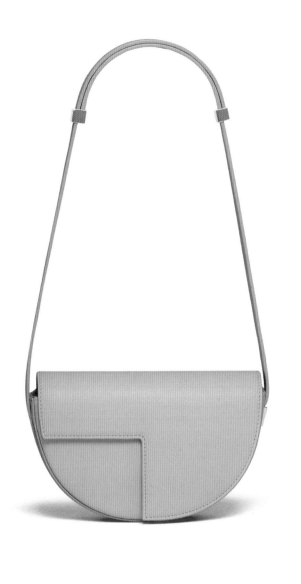
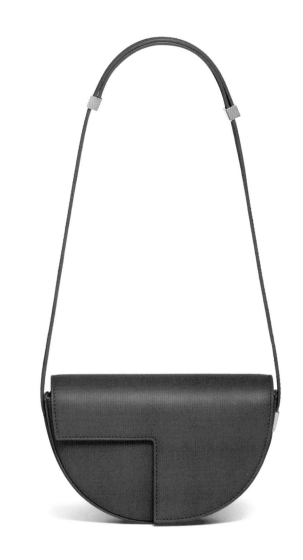
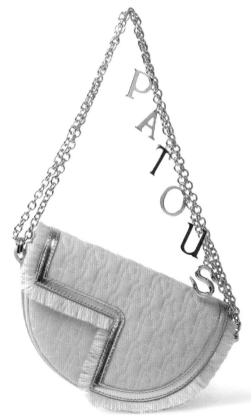
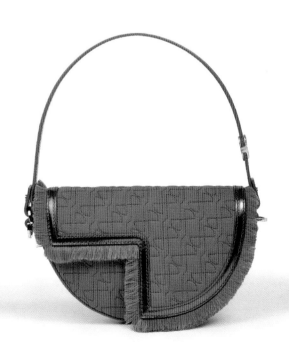

PIERRE HARDY
THE GRAPHIC ARTIST

"Fashion is an applied art." **Pierre Hardy**

Founded: 1999

The story: Parisian native Pierre Hardy did not choose between his two passions of drawing and dancing. As a student at the École Normale Supérieure de Cachan studying visual arts, he joined a contemporary dance company and took his first steps into fashion with his magazine illustrations. Thanks to his sketches, he landed at Christian Dior to design shoes. In 1990, he joined Hermès, where he began by creating collections of women's shoes. He launched his own brand of shoes in 1999, followed by bags in 2006.

The style: Very graphic and artsy, with bold color mixes and clean lines.

Heard on the street: *"Rather than buy a new painting, I prefer to buy a Pierre Hardy bag. The visual pleasure is the same, but a bag is more useful!"*

FASHION HOUSE FACT
The house has embraced sustainable development with the eco-friendly "Pierre Hardy Planet" collection, made using surplus materials.

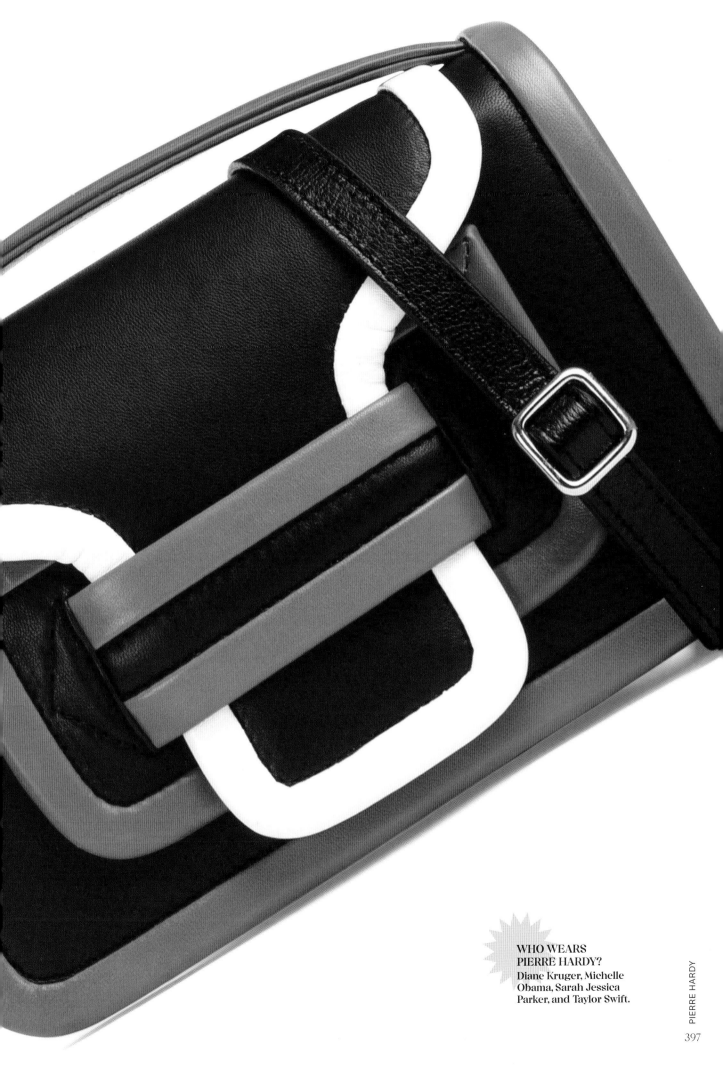

PIERRE HARDY

ALPHA

2006

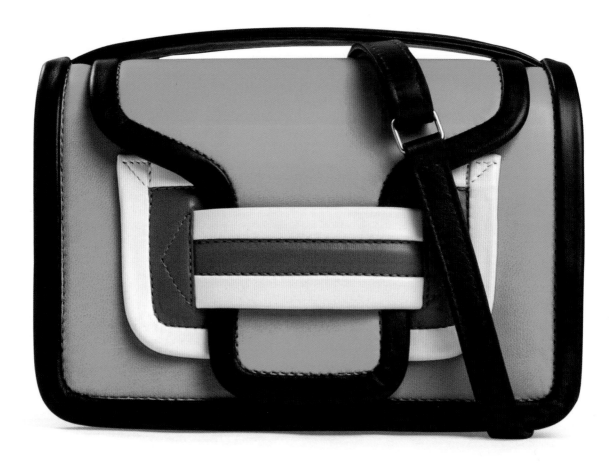

This is *the* signature bag that made its debut in 2006 with the launch of the brand's bag collection. Its style is sleek with curved lines and highlighted with a top handle in a separate color. Its large flap closes by a wide strap—a signature style itself. It can be worn across the body by the strap or carried by hand with the top handle. It is usually made of suede calfskin. Made in Casablanca, Morocco, and constructed entirely by hand, it is constructed in an atelier where nearly forty artisans execute traditional know-how. The leathers come from Italy.

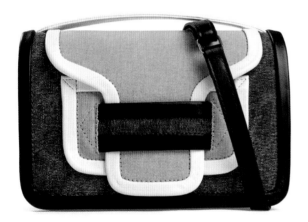
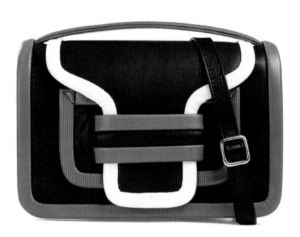
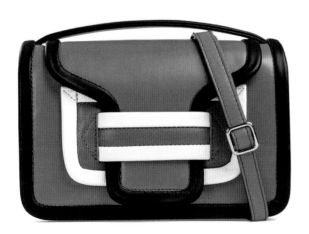
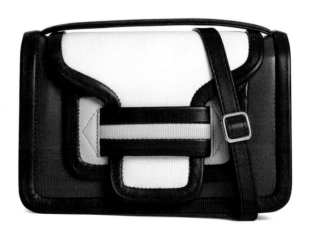

ALPHA
DAY MISS

2023

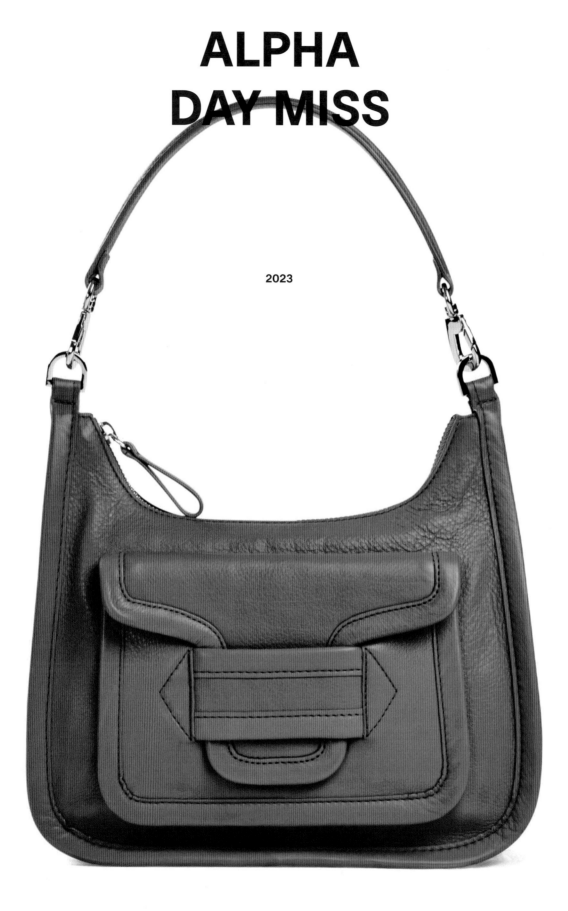

Designed to be a little more curvaceous, this bag adopts the fold-over flap of the Alpha bag on a front pocket. It zips closed and comes in three sizes. It can be worn as a crossbody (it has a removable strap) or on the shoulder by its short handle.

CUBE BOX

2012

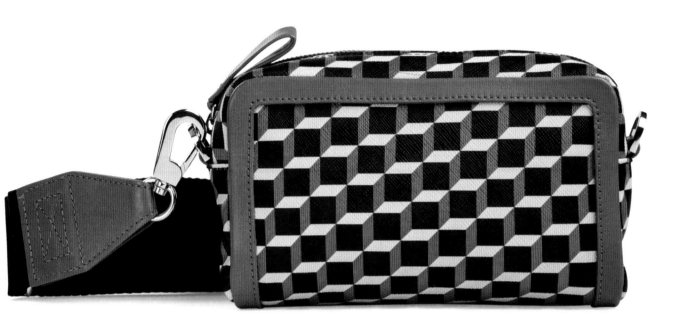

The Cube Perspective coated canvas has been the brand's signature mono-gram since its creation in 2010. The pattern is especially noticeable on this unisex bag that can be worn at the waist or as a crossbody. The canvas is woven and printed in Italy by expert artisans. Each season, the Cube Box changes colors to match on-trend themes.

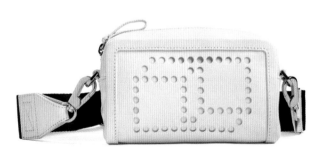

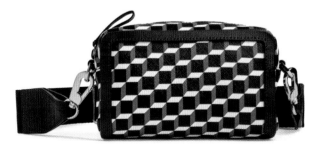

BULLES

2015

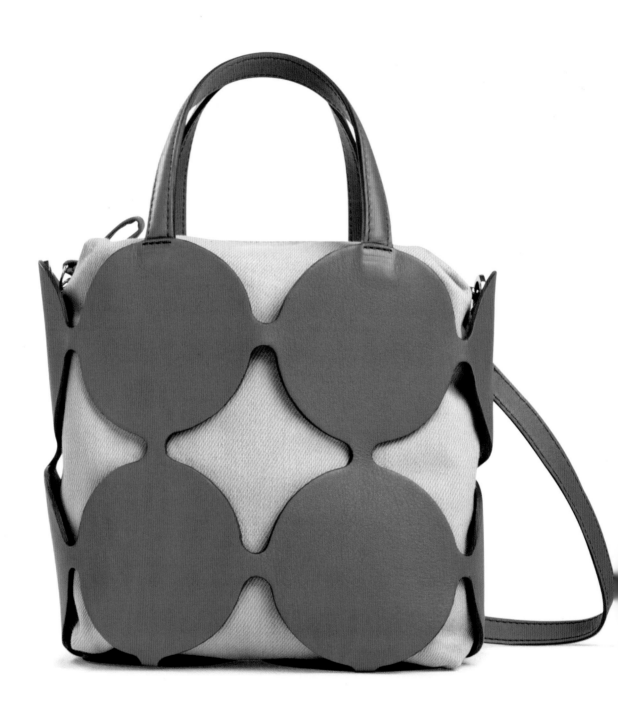

This bag could rival the works of artist Victor Vasarely. But this disc-adorned, openwork style is rather restrained, associating bright colors with beige, or presented as tone-on-tone. The look remains very graphic in any style. It is available in bucket and tote bag versions. Its inner pocket is made of cotton twill.

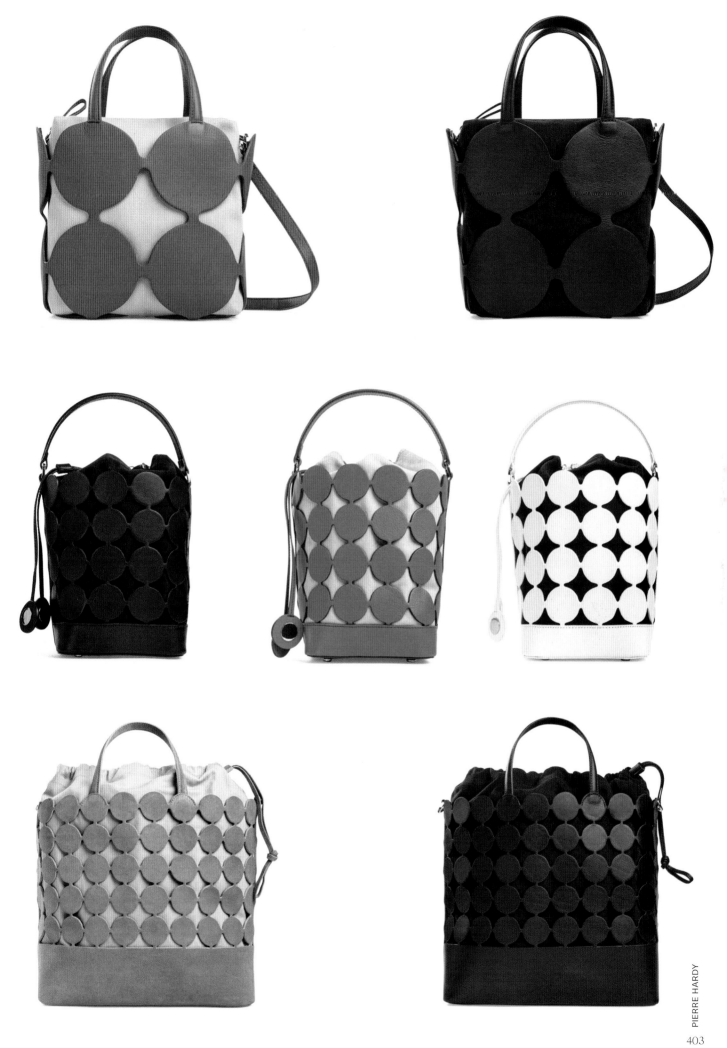

PRADA
INTELLIGENT SIMPLICITY

"For me, it's important to anticipate where fashion is headed." **Miuccia Prada**

Prada may be the world's most philosophical fashion brand. Through her creations, Miuccia Prada speaks of the emancipation of women and their role in society, and she understands how to interpret in fashion the complex relationship between the ideas of femininity and feminism. Self-confidence and freedom of expression are two values that are an integral part of her sources of inspiration. When we think of Prada's style, we imagine restraint depicted in straight and pure lines, but in the collections, silhouettes with unusual prints and kitsch mixed with a vintage look are always present. Miuccia likes to make the styles of the 1950s and 1960s coexist with the future, which gives her creations an avant-garde and visionary side. All pieces seem well thought out, with enough intellectual air about them to attract fashionistas searching for meaning. To perfect her intelligent vision of fashion, Miuccia draws much of her inspiration from contemporary art, literature, and film. She is also constantly looking for innovative fabrics, such as Re-Nylon, made from regenerated nylon from recycled plastic collected from the world's oceans. Prada is indeed a brand in tune with the times.

7 KEY DATES

1913
Mario and Martino Prada open the Fratelli Prada boutique in the Galleria Vittorio Emanuele II in Milan. They sell luxury leather bags and accessories for travel, including trunks. Succeeding them is Luisa, Mario's daughter, who ran the company for almost twenty years.

1977
Mario's granddaughter, Miuccia, takes over creative direction, assisted by Patrizio Bertelli, a businessman who would become her husband.

1979
Miuccia launches the first bags made of durable water-resistant nylon. She uses Pocono, a nylon reworked to be like silk. In 1984, the iconic backpack was launched, and in 1985, the tote makes its appearance.

1988
The first women's ready-to-wear collection is launched.

2001
Prada opens its first Epicenter, designed by architect Rem Koolhaas, in New York City.

2015
Permanent installation of the Fondazione Prada in Milan, which organizes many artistic and cultural events.

2020
Belgian designer Raf Simons joins Miuccia as co-creative director of Prada's collections.

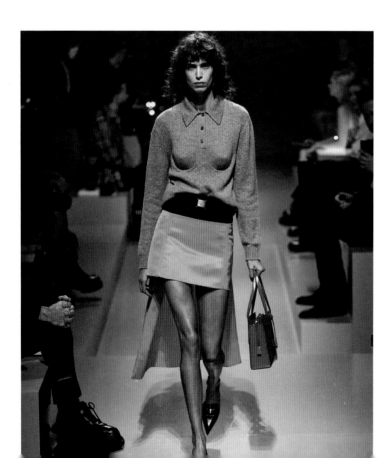

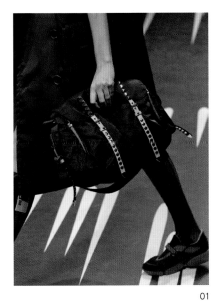

01

02

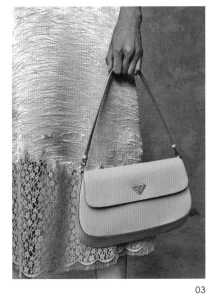

03

04

THE 5 HOUSE CODES OF PRADA

01.
Nylon

02.
The soft green color

03.
The triangle logo
It was first used by Mario Prada, in 1913, as a mark of quality and craftsmanship.

04.
Paradoxes in clothing design
For example, the masculine "banker's" coat in a very feminine floral print.

05.
Galleria Vittorio Emanuele II in Milan

FASHION HOUSE FACT
Miuccia Prada holds a degree in Political Science from the University of Milan.

MORE TO KNOW
Pocono, the nylon used by Miuccia Prada in her early bag collections, is a high-tech fabric used during the war years to make parachutes and military tents.

05

PRADA MOON

2002

Composed of ninety-two pieces, this bag takes about a day to make. Its so-called "hobo" shape is reminiscent of a satchel, but its two handles give it the classic look of a handbag. It has the brand's very recognizable metal parts: a wide buckle in the center and eyelets, inspired by the world of sailing. The Prada Moon bag was redesigned in 2023 in different colors, but it still retains its distinctive metallic touches. In this new version, the leather has been given a special treatment that gives it a slightly padded look, making it even lighter. Its removable leather key clochette matches the color of the bag.

PRADA GALLERIA

2007

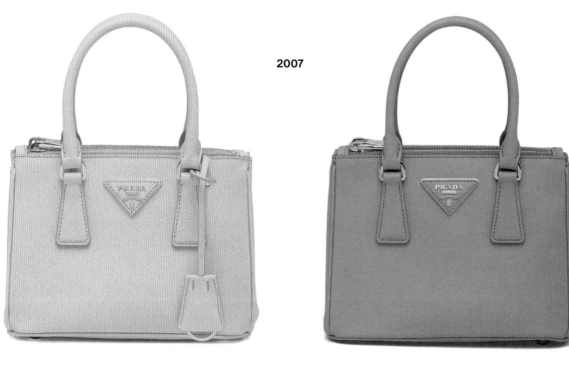

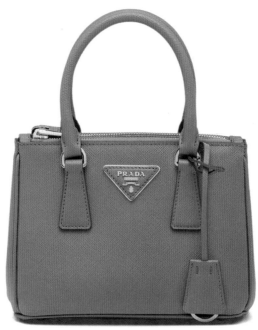

The iconic bag par excellence stands the test of time and is reinvented each season. In 2007, it was launched in Saffiano leather, a material patented by Mario Prada that is highly resistant to sun, water, and scratches. The leather is also very easy to clean.

The lines of this bag are simple and pure. The Prada Galleria refers to the classic styles of the past with its rectilinear shape and curved handles. It has three parallel compartments, two of which are zipped. Its silhouette remains the same, only the face is tirelessly reimagined: in different colors and leathers, embroidery, topstitched bands, a mix of colors—all original and even eccentric options are considered. It comes in four sizes and can be worn in two ways thanks to its detachable shoulder strap.

PRADA CAHIER

2016

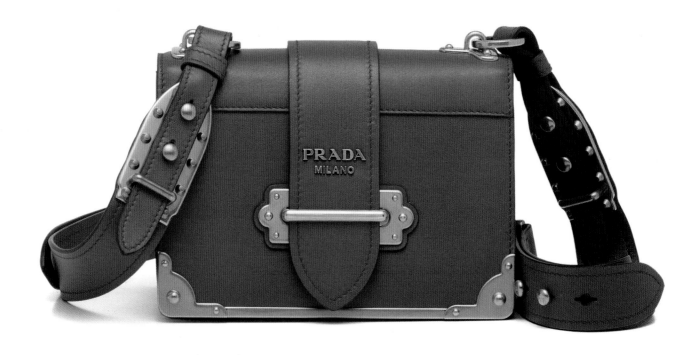

This bag gives the feeling of walking around with an old book. Its bronze-colored metal edges are a nod to the protective corners found on antique books. It is made of Saffiano leather, which evokes a book's hard cover. Less pared down than other Prada bags, the Prada Cahier has a prominent metal clasp and an adjustable shoulder strap with decorative metal pieces that allow it to be adjusted. Instead of the famous triangle logo, Prada's name is inscribed on the front of the bag.

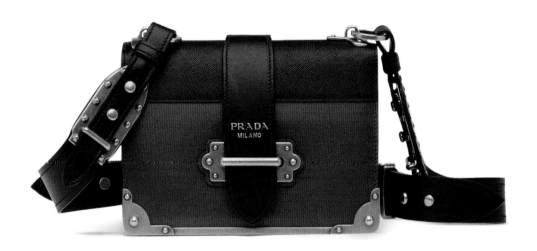

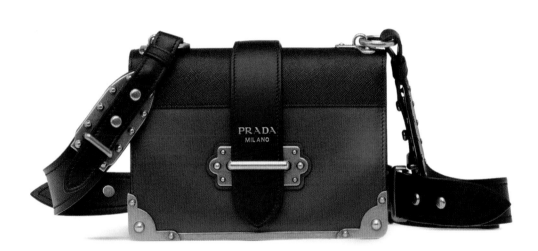

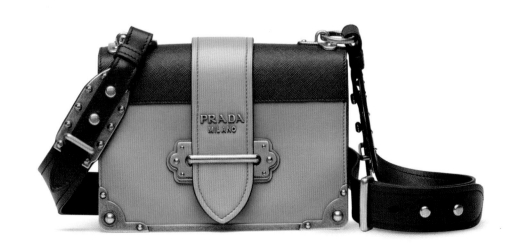

PRADA RE-NYLON

2019

This was to be expected. Prada was not content with a typical nylon material since the brand always looks for innovation, coupled with a desire to stay current. The small revolution for the brand was the Prada Re-Nylon collection, which heralds a change of material to integrate sustainable development. Re-Nylon is a textile that can be infinitely regenerated and without a loss in quality. It is made entirely from nylon from recycled plastic collected from the world's oceans, including fishing nets and textile fiber waste. This makes it completely sustainable and environmentally friendly. As proof, the use of ECONYL thread for the Prada Re-Nylon collection contributes to reducing global warming up to 90 percent more compared to the use of virgin nylon thread.

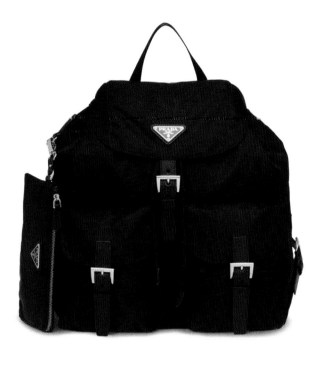
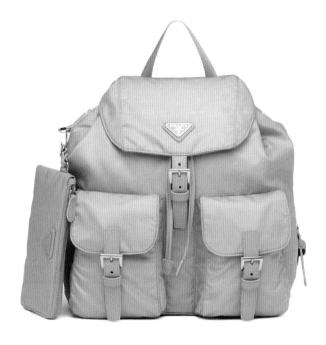

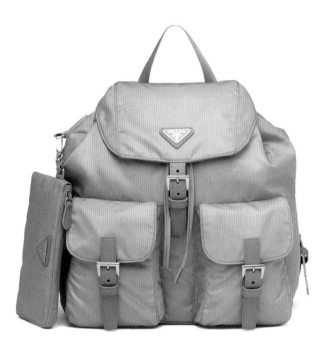
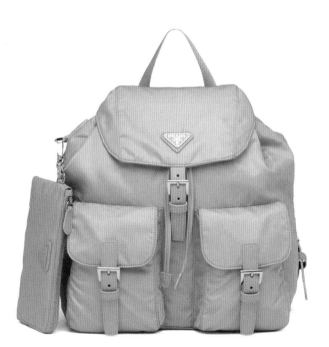

It all started in 2019 with a capsule collection of six of the brand's iconic bags. In 2020, the range expanded, and Prada's two iconic nylon fabrics were offered in sustainable Re-Nylon fabric: gabardine nylon, thin but strong and lustrous, and woven on looms usually dedicated for silk; and Piuma nylon, which is incredibly thin and light and evokes the feel and texture of silk. Both are now Re-Nylon certified. Little by little, from backpacks to crossbodies to handbags, all of Prada's iconic styles have been impacted by this revolutionary material.

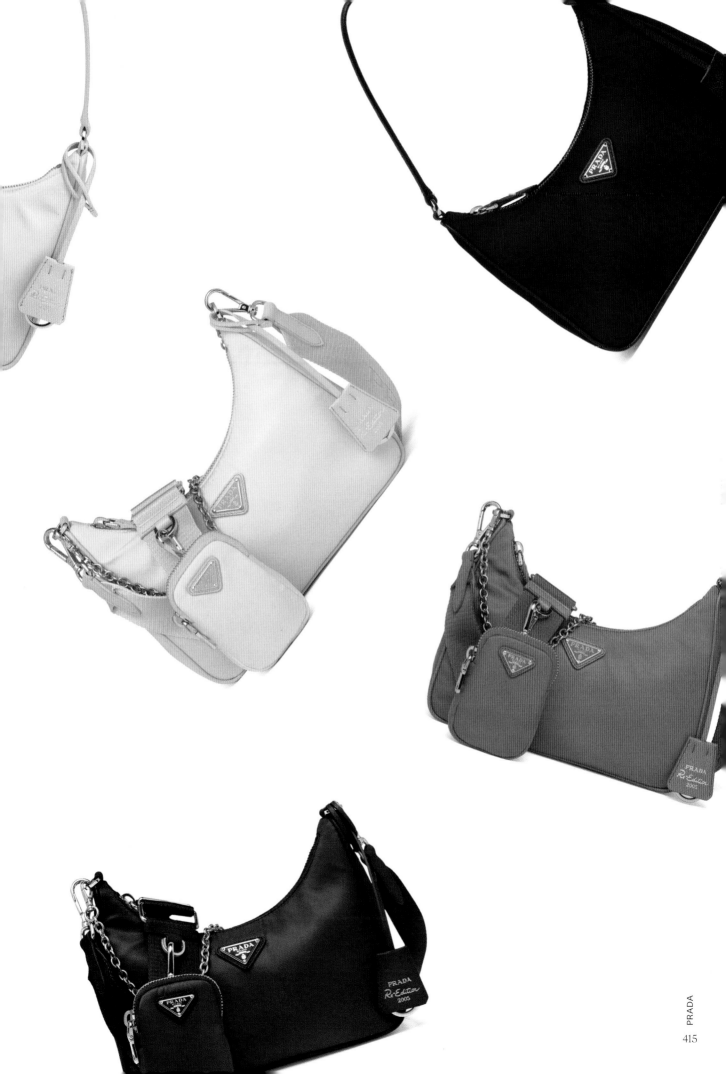

PRADA CLEO

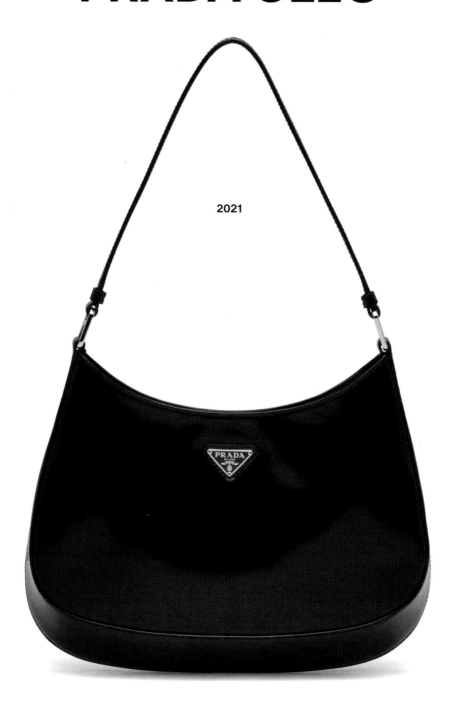

2021

Inspired by the style of Prada bags from the 1990s, the Prada Cleo uses traditional techniques but at the same time is fiercely modern. Its curved base and slightly angled sides are designed to hug the body. The bag comes in patent calfskin, brushed calfskin, and crystal-studded satin. It displays the triangular logo on the front. Two versions are available: flap or top opening. In terms of colors, the timeless black and white are dependably present, but also soft colors such as blush orchid, pale pink, and aqua, Prada's signature shades.

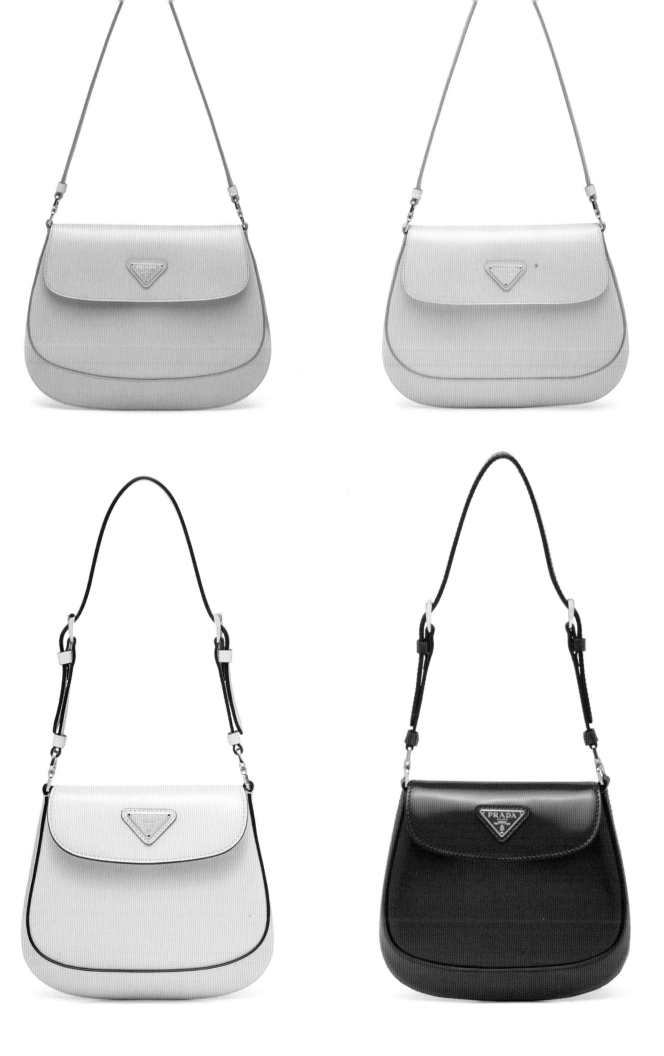

PRADA
RE-EDITION 1995

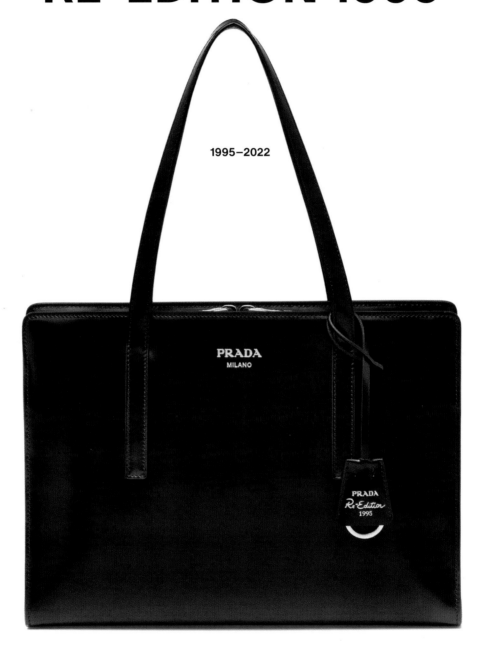

1995–2022

There have been so many iconic bags by Prada that it's only natural that Miuccia would want to bring out styles created decades ago that still have a very current look—like this one. Called Prada Re-Edition 1995, it was introduced during the Fall/Winter 1995 collection. Here again, modernity and purity are the order of the day and are two key concepts at Prada that contribute to the brand's aura of timeless luxury. This very straight bag has raw, geometric edges. Reimagined for the Spring/Summer 2022 season, it is offered in the finest brushed leather. The small key chain attached to the handle displays the Prada Re-Edition 1995 logo.

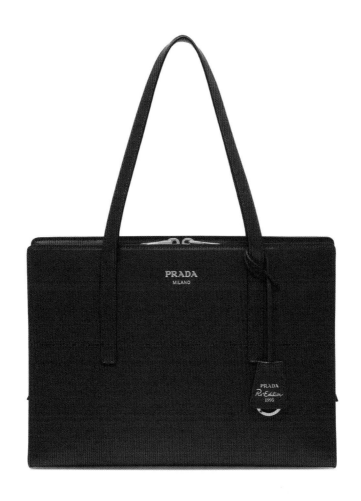

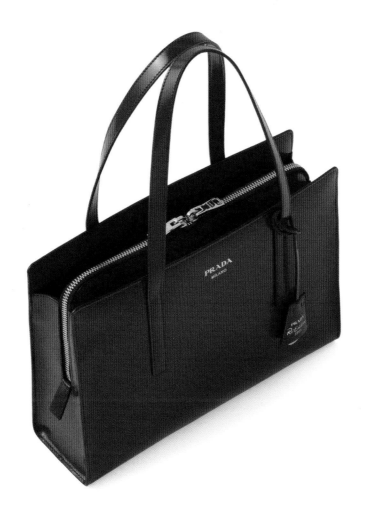

PRADA SYMBOLE

2022

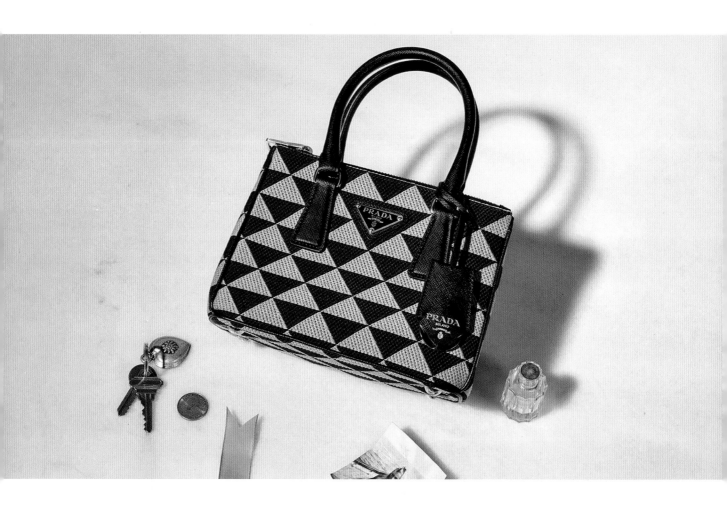

Here, the triangle logo of the fashion house becomes a jacquard print. Embroidered into the fabric of the handbag itself, this geometric pattern makes it possible to spotlight the logo, created in 1913, in a more prevalent yet still subtle way. The bag Symbole is available in several models and colors. It's a beautiful play on the logo as a look within a look!

PRADA TOTE
IN ANTIQUED NAPPA

2023

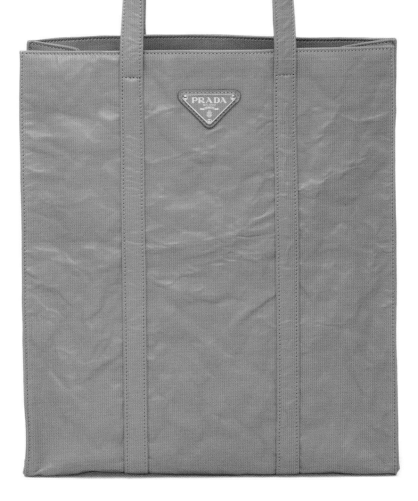

This tote, with an inner zipped pocket, was inspired by a version released in 2001. The Spring/Summer 2023 version is made of antiqued nappa leather, one of the brand's traditional leathers, achieved through a special process. The wavy texture of the bag is the result of combining nappa leather with a fabric that has metallic elements in the weft. The leather is then "crumpled up" by hand and then stretched again. This leather was used in the brand's products starting in 2009.

RABANNE ETERNALLY MODERN

"The only way to go further in fashion is to look for new materials." **Paco Rabanne**

Founded: around 1960

The story: Paco Rabanne was of Spanish origin. He studied architecture at the École des Beaux-Arts in Paris. In the 1960s, he launched his eponymous brand and made a name for himself using unconventional materials in fashion, including metal, plastic, and even paper. In 1966, he presented his first collection, "12 Unwearable Dresses in Contemporary Materials." With its mix of sequins, metal rings, and rhodoid, it was a visionary approach. Rabanne continued to innovate with unusual materials. In 2000, he retired from couture but continued to make ready-to-wear until 2009. A succession of artistic directors (Rosemary Rodriguez, Patrick Robinson) followed before Julien Dossena arrived in 2013 to lead the label toward ever more modernity. Paco Rabanne died in February 2023. In the same year, the brand changed its name to simply Rabanne.

The style: Visionary materials, sexy, close-fitting silhouettes in mesh or jersey. The metallic details are still very present.

Heard on the street: *"A bright woman must wear Rabanne."*

FASHION HOUSE FACT
Because he used a lot of metal, Paco Rabanne was nicknamed "the metallurgist of fashion."

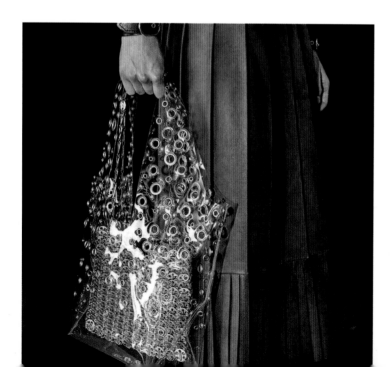

WHO WEARS RABANNE?
In Paco's time: Brigitte Bardot, Françoise Hardy, Audrey Hepburn, and Jane Fonda. Today, Beyoncé, Amal Clooney, Elle Fanning, Katy Perry, and Emily Ratajkowski are among the followers of this metallic style.

1969

1969

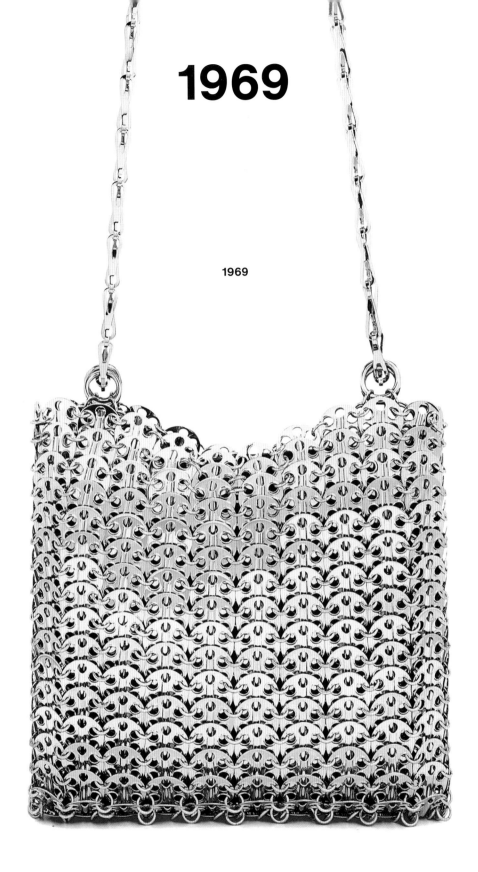

This is the brand's most representative item! This chain mail bag, created in 1969, was inspired by the aprons worn by butchers in France. Paco Rabanne transformed what was metal-clad workwear into an armored bag simply by using a pair of pliers. The accessory has become emblematic of the brand's experimental work. Slightly modified, the shoulder strap evokes the pull chains of public toilets of the time.

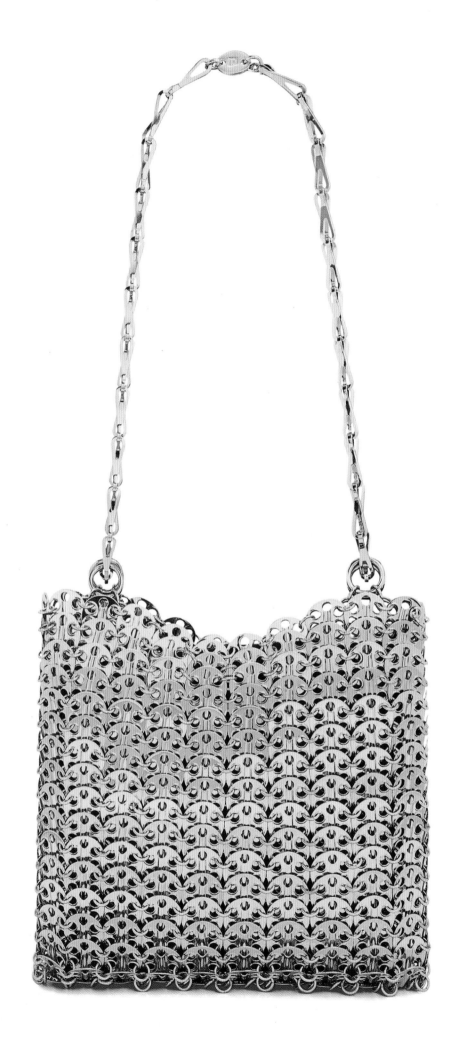

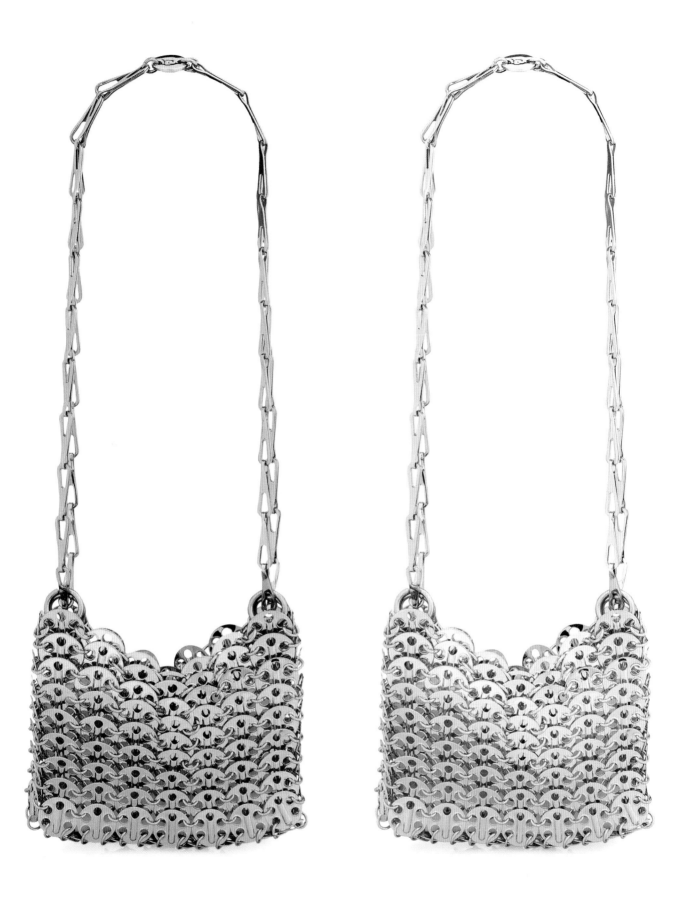

The iconic 1969 bag has become lighter with this reissue. Heavy steel has been replaced by lighter aluminum with new glossy finishes in silver and gold. It consists of 367 discs for the original format and 120 for the mini version. It is assembled entirely by hand. Today, there are multiple variations (micro, nano, moon, bucket, star-shaped rhinestones, spherical, etc.). The great stylistic power of the bag is that it doesn't need a logo to be recognized.

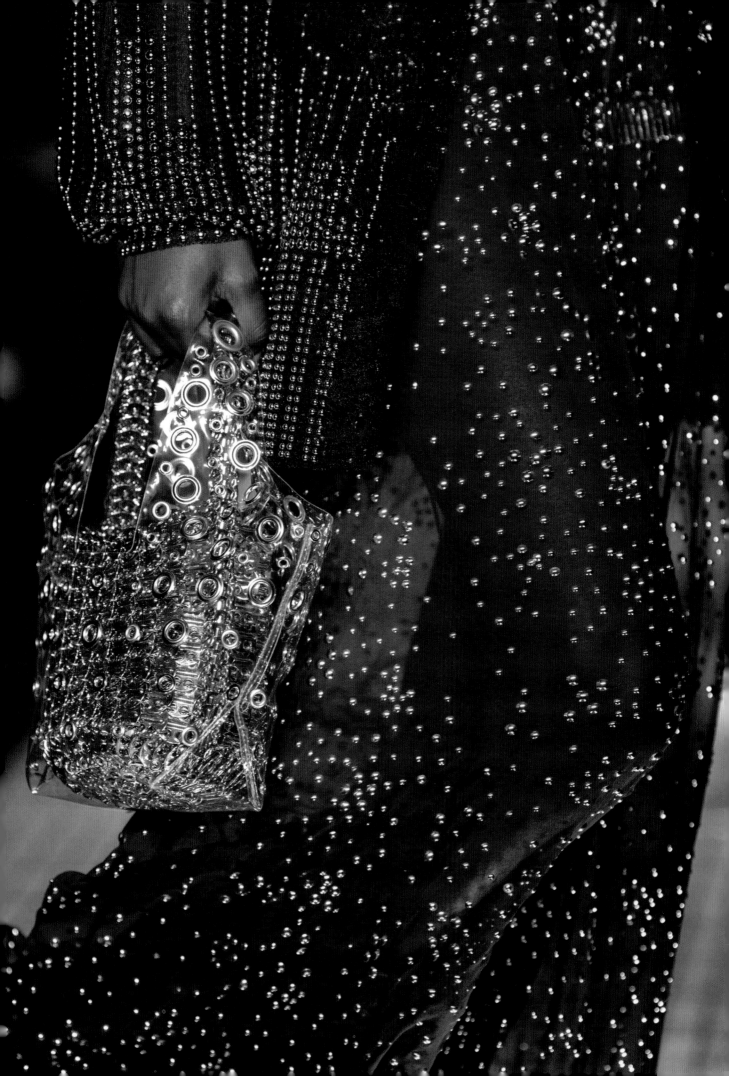

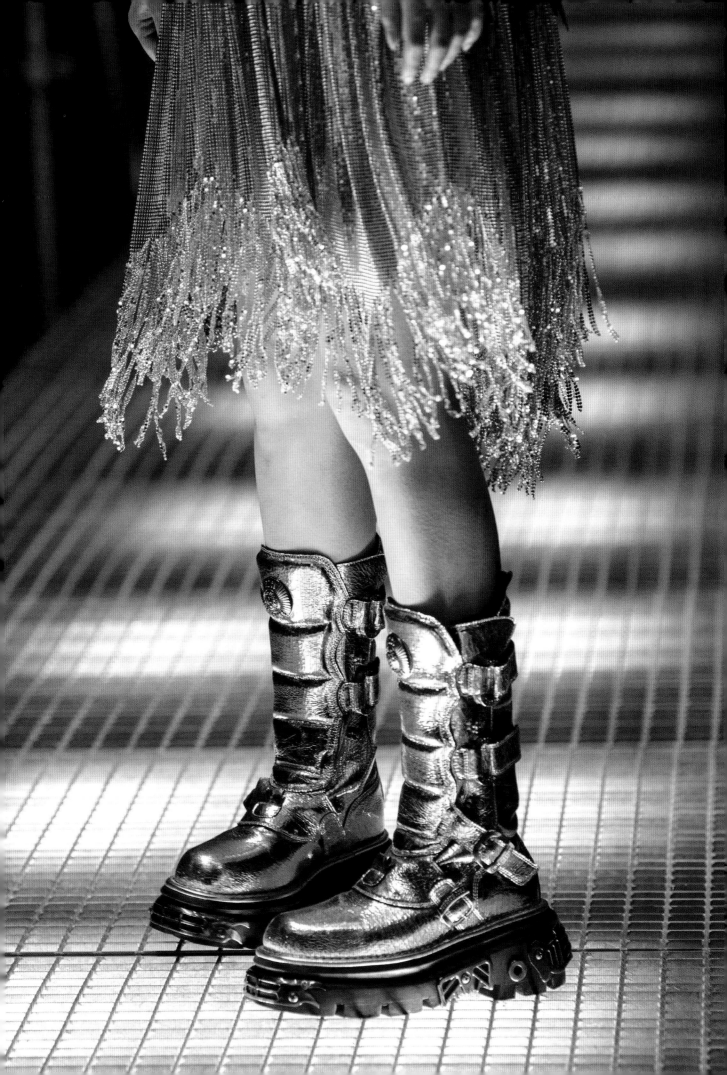

ROGER VIVIER
THE COUTURE SPIRIT

"I think it's important to convey an idea of joy and spontaneity that is not only dear to me but was also dear to Roger Vivier."

Gherardo Felloni, creative director of Roger Vivier

Founded: 1937

The story: Roger Vivier was a true artist who breathed dreams into the world of shoes. In 1937, he opened his first studio on rue Royale in Paris. He is credited with giving women height by inventing the stiletto heel in 1954. The wide buckle with which he adorned his creations is his signature. Roger Vivier died in 1998. The house was relaunched in 2003, with Bruno Frisoni as creative director and Ines de la Fressange as a multifunctional muse. Bags made their appearance at this time. In 2007, Roger Vivier was the first accessories house to present an haute couture collection. In 2018, Bruno Frisoni left as creative director, succeeded by Gherardo Felloni.

The style: Chic, chic, and very chic. The Roger Vivier woman is sophisticated, but with a little eccentric touch.

Heard on the street: *"My Roger Vivier bag? It's the same one Julia Roberts carries!"*

WHO WEARS ROGER VIVIER?
Josephine Baker, Marlene Dietrich, and Catherine Deneuve during Roger Vivier's era. Since the relaunch of the fashion house, Jessica Chastain, Penélope Cruz, Nicole Kidman, Lucy Liu, Rihanna, Julia Roberts, Sharon Stone, Kate Winslet, Dong Jie, Ma Su, Chen Yuqi … and still Catherine Deneuve.

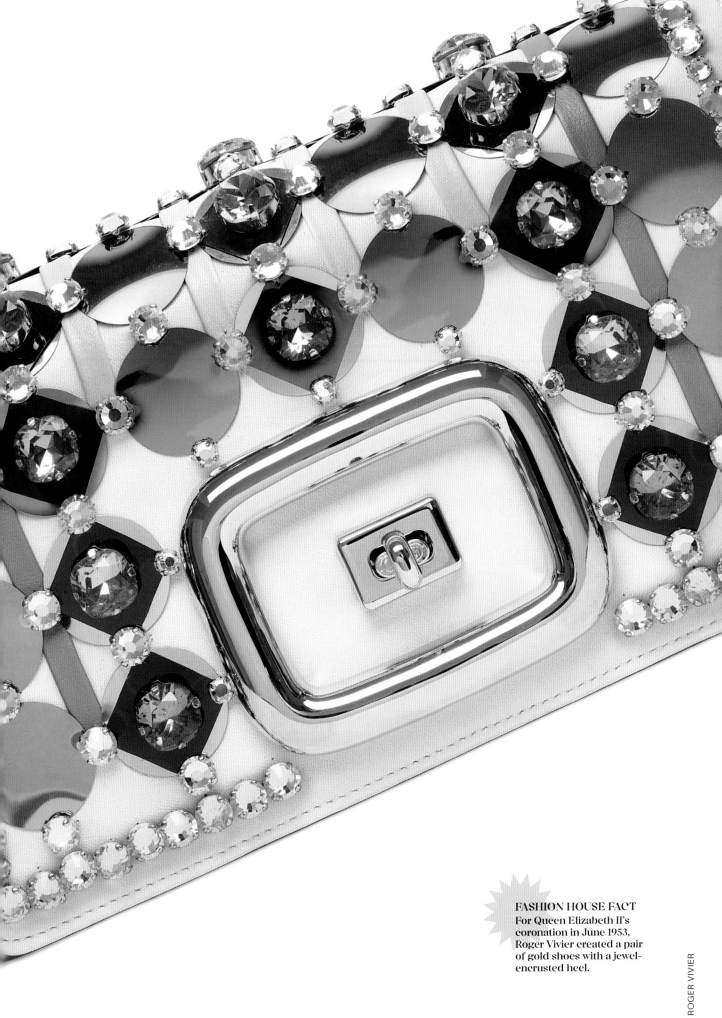

ROGER VIVIER

VIV' CHOC

With its signature rounded buckle framing the clasp, the Viv' Choc has quickly become the brand's new iconic bag. It is the perfect leather bag for everyday, but it can depart from its simpler style and show up in more uncommon materials, such as taffeta, braided fabric, and raffia. It has a flat pocket on the back embossed with the brand name. It comes in several sizes and, of course, in a variety of colors. By simply removing the shoulder strap, it becomes a clutch.

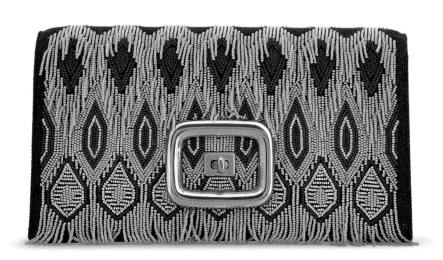

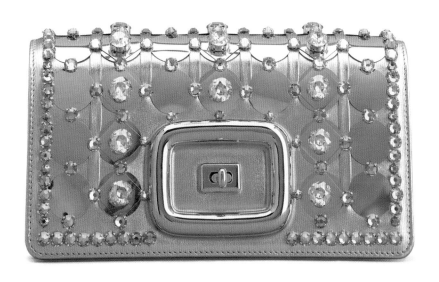

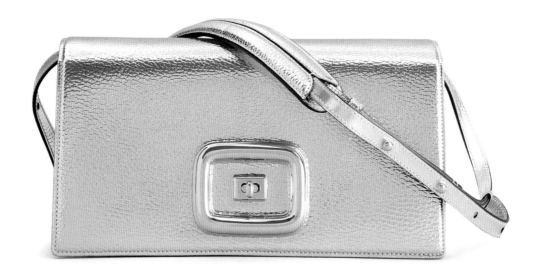

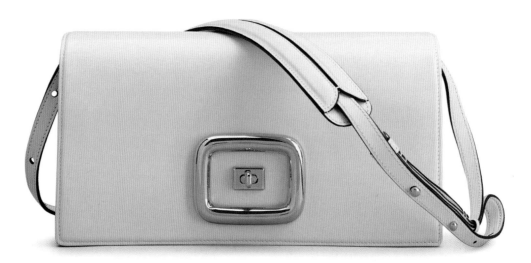

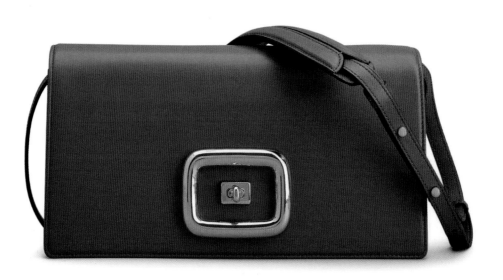

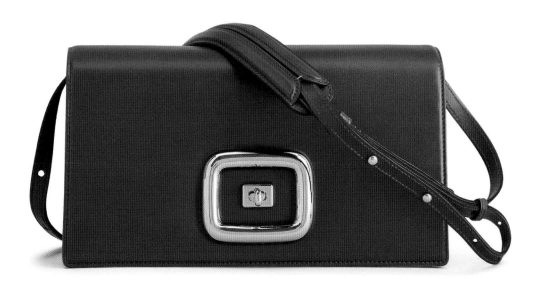

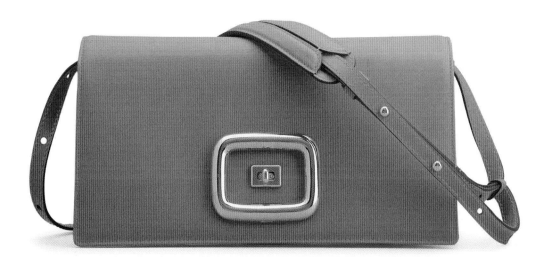

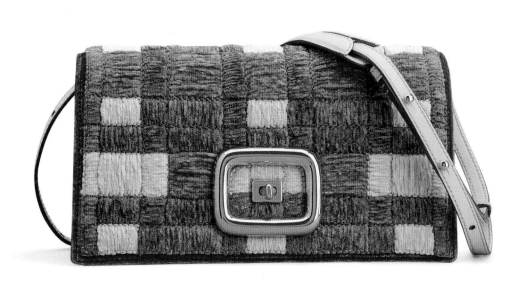

VIV' CHOC
PIÈCE UNIQUE

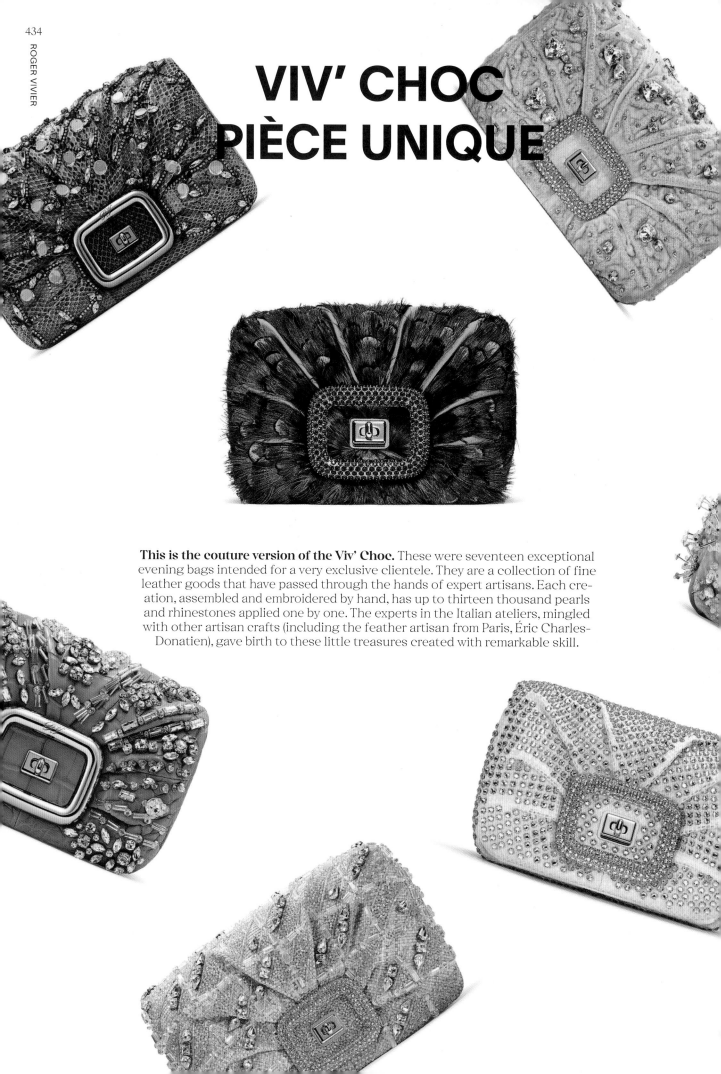

This is the couture version of the Viv' Choc. These were seventeen exceptional evening bags intended for a very exclusive clientele. They are a collection of fine leather goods that have passed through the hands of expert artisans. Each creation, assembled and embroidered by hand, has up to thirteen thousand pearls and rhinestones applied one by one. The experts in the Italian ateliers, mingled with other artisan crafts (including the feather artisan from Paris, Éric Charles-Donatien), gave birth to these little treasures created with remarkable skill.

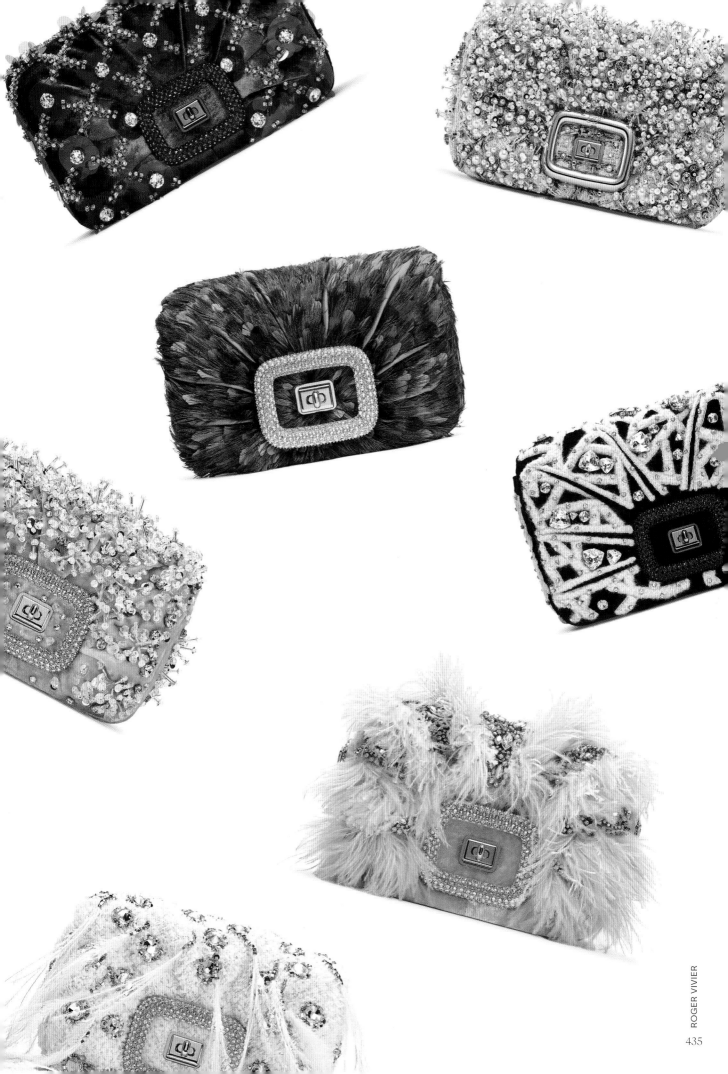

VIV' CABAS

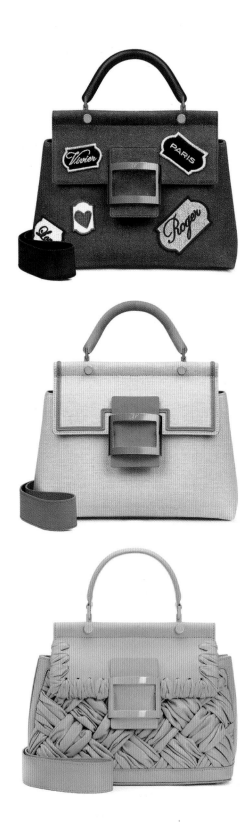

The ultimate unadorned, yet elegant, bag. Beautiful in its simplicity, this bag is adorned only with a flap and the iconic buckle. It can be carried by hand or as a crossbody (with a removable strap). It is available in leather in essential colors, including black, beige, or caramel, but all materials are possible. It can also be adorned with glistening accents, as in its Flower Strass buckle, embellished with crystal flowers.

RV BOUQUET STRASS DRAPÉ CLUTCH

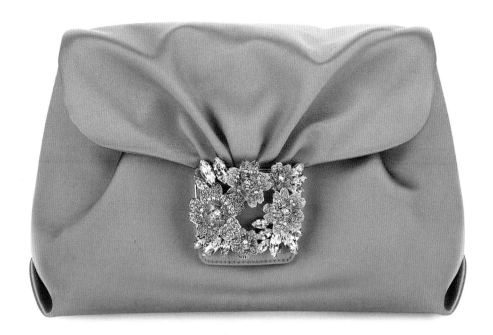

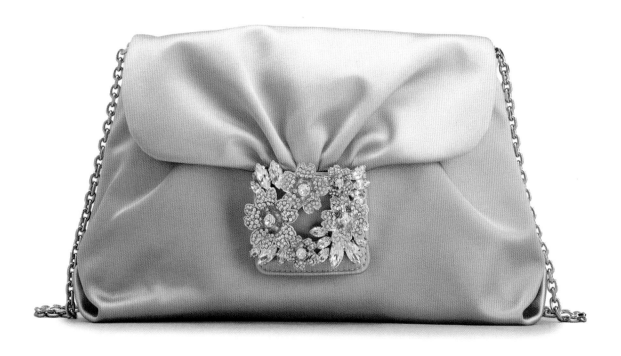

The house's new iconic buckle is the Bouquet Strass, inspired by antique jewelry creations. It is the central element of this bag, called the RV Bouquet Strass Drapé Clutch. Crafted from satin with a refined drape, the bag features a chain strap.

RSVP PARIS
AN EYE FOR ARTISTRY

"Craftsmanship is our language we use to express the essence of our creations." **RSVP Paris Group**

Founded: 2015

The story: RSVP is a Parisian design studio that calls itself a community of artisans. This cool leather goods brand was created thanks to the efforts of Jonathan Andrès and Thomas Cerkevic, who wanted to offer superior-quality products at affordable prices. Cutting out the middleman was their aim for cutting costs. Before launching, they opted for the preorder system, which continues today when they release a new style. The Golden Eyes small bag very quickly became a bestseller. Artistic director Cléo Charuet is part of this very trendy collective that sources all its leather from France.

The style: Minimal, but with details that make it a complete look, with a very designer shape that gives it a particular style of modern luxury.

Heard on the street: *"I preordered my bag; that's the future. It's also like haute couture . . ."*

WHO WEARS RSVP?
Those looking for bags with striking details. Ines de la Fressange is a fan.

FASHION HOUSE FACT
RSVP Paris offers a second life to its creations by offering to buy, repair, or resell them.

GOLDEN EYES

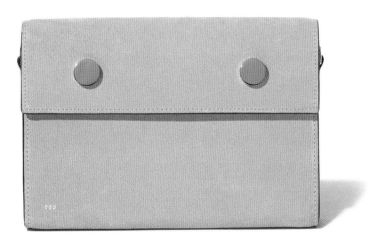

Its two small gold-plated brass hardware pieces on the front are the source of its name. The Golden Eyes bag is made of leather, in limited edition. It is an extremely simple design, with a detachable shoulder strap that allows it to be carried as a clutch. The edition number is on the front.

MILKMAN

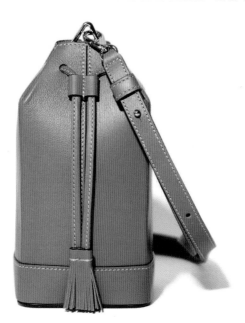 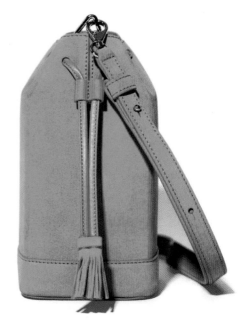

No one before had thought to use a milk carton as inspiration for a handbag. But proof it could be done is represented in this small bucket bag with a square base. Its vertical shape is the result of delicate craftsmanship. It is available in grained calfskin, smooth calfskin, and embossed crocodile leather. It has a small handle to carry it by hand and a detachable shoulder strap to carry it as a shoulder bag or crossbody. Multiple colors are available but, knowing that these bags are limited edition, it is difficult to predict which colors will remain available. There is no logo on the bag to catch the eye, but the number gives its order within the series.

LOW FIVE

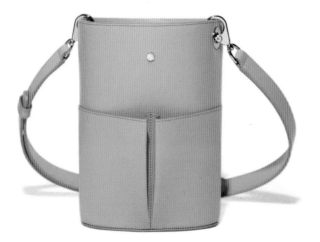

Don't think this is a basic bucket bag! This is inspired by the design of the "Veckla" vase collection designed by Swedish artist Stig Lindberg for the ceramics company Gustavsberg in the 1940s. Oval shaped, the Low Five has four flared side pockets. Its small gold button acts as a logo, although the brand's letters are embossed on the underside. It is made of French calfskin and lined with a microfiber fabric with a suede look.

MUNCHKIN

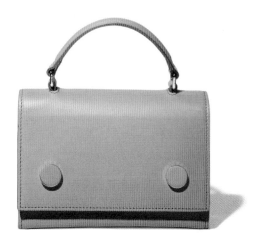
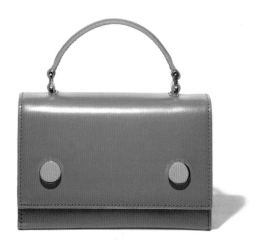
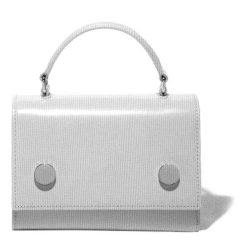

This is the smallest size in the Golden Eyes range, whose two gold buttons seem to be looking at you. Unlike its sister, it has a handle. It is available in smooth calfskin, grained calfskin, suede calfskin, and crocodile style. A shoulder strap permits wearing it on the shoulder or as a crossbody. The brand name is embossed on the underside of the bag.

SAINT LAURENT

SOLFERINO

What truly makes a Saint Laurent bag? The three letters of the logo created by the graphic designer Cassandre: *"Cassandre was the greatest, the best graphic designer of his time,"* said Yves Saint Laurent. *"The first thing we did, even before we raised the funds or found collaborators, was to meet with him. That was in 1961."* He presented only one idea: interlocking initials. The rest is history. Even after Hedi Slimane, then artistic director of the brand, renamed the brand Saint Laurent Paris in 2012, the three letters remained on the bags. Today, most accessories are branded with the *YSL* logo, like the Solferino bag created by Anthony Vaccarello in 2020 and already a classic.

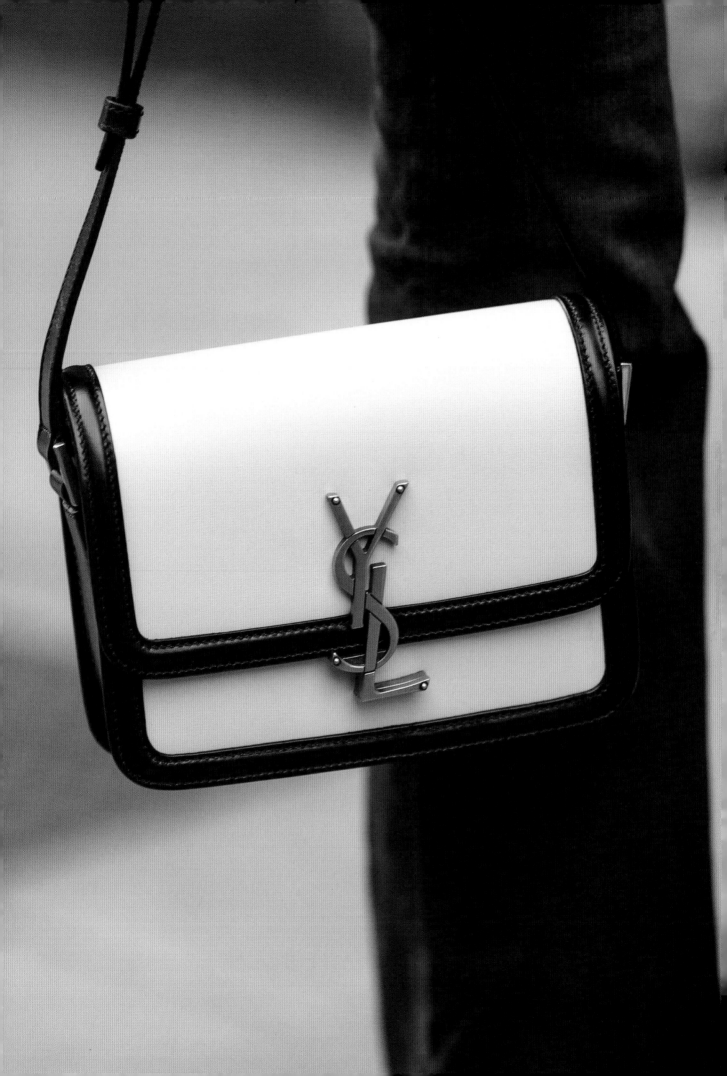

SCHIAPARELLI
THE BOLDNESS OF SURREALISM

"Designing dresses is not a profession for me, but an art." **Elsa Schiaparelli**

Founded: 1927

The story: Born in Rome, Elsa Schiaparelli was one of the first designers to truly have fun with fashion. Without the restraints of formal training as a seamstress, she was free to create what she wanted and how she wanted. She worked with many artists, such as Jean Cocteau, Man Ray, and Salvador Dalí; the spirit of surrealism intertwines her creations. She innovated in everything, from fabrics (she used elastic wool) to sales (she was one of the first to sign licenses for her lingerie and eyewear). Just before the Second World War, she introduced camouflage print into haute couture. Oversized jewelry and shocking pink were her signatures. In 1954, Elsa closed her fashion house and devoted herself to her autobiography, *Shocking Life*. She died in 1973. Schiaparelli was bought in 2006 by Diego Della Valle, owner of Tod's. After several artistic directors, Daniel Roseberry, a native of Texas, is now in charge. Like Elsa, he likes to experiment with fabrics and materials—and doesn't lack a sense of humor.

The style: Surrealism, which makes you stop and contemplate. Elsa conceived of fashion as an art. Daniel Roseberry follows in her footsteps.

Heard on the street: *"When you have a nose for fashion, you carry a Schiaparelli bag!"*

WHO WEARS SCHIAPARELLI?
Adele, Beyoncé, Bella Hadid, Maya Hawke, Kylie Jenner, Anya Taylor-Joy, Kim Kardashian, Lady Gaga, and Margot Robbie.

FASHION HOUSE FACT
The fashion house opened in Hôtel de Fontpertuis at 21 place Vendôme in Paris in 1935. It reopened in the hotel in 2012.

SECRET

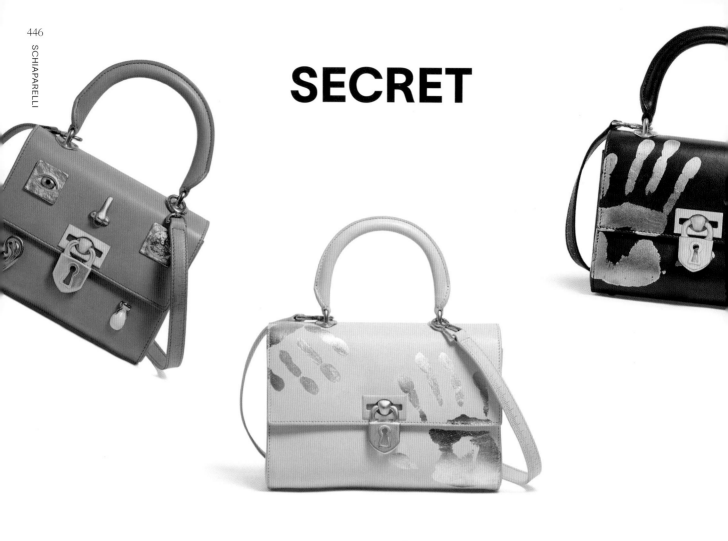

When this brand created its first bag, the padlock was a no-brainer. The lock has been one of Schiaparelli's key emblems since the brand's beginnings. It has appeared in the form of buttons, jewelry, and pockets. Here, it is used as a clasp (in gilded brass), to emphasize that the wearer is walking around with precious objects—or perhaps has things to hide. This one is an evolution of the first Schiaparelli bag, released in 2019, whose padlock was not centered on the bag. It is available in several versions: Secret Empreintes, Secret Bijoux, Secret Duchesse, and Secret Croquis. It is made of leather or denim and comes in several sizes. It can be carried by hand or by its detachable shoulder strap. Its lining is made of shocking pink leather. The padlock can also be found on the 24H travel bag.

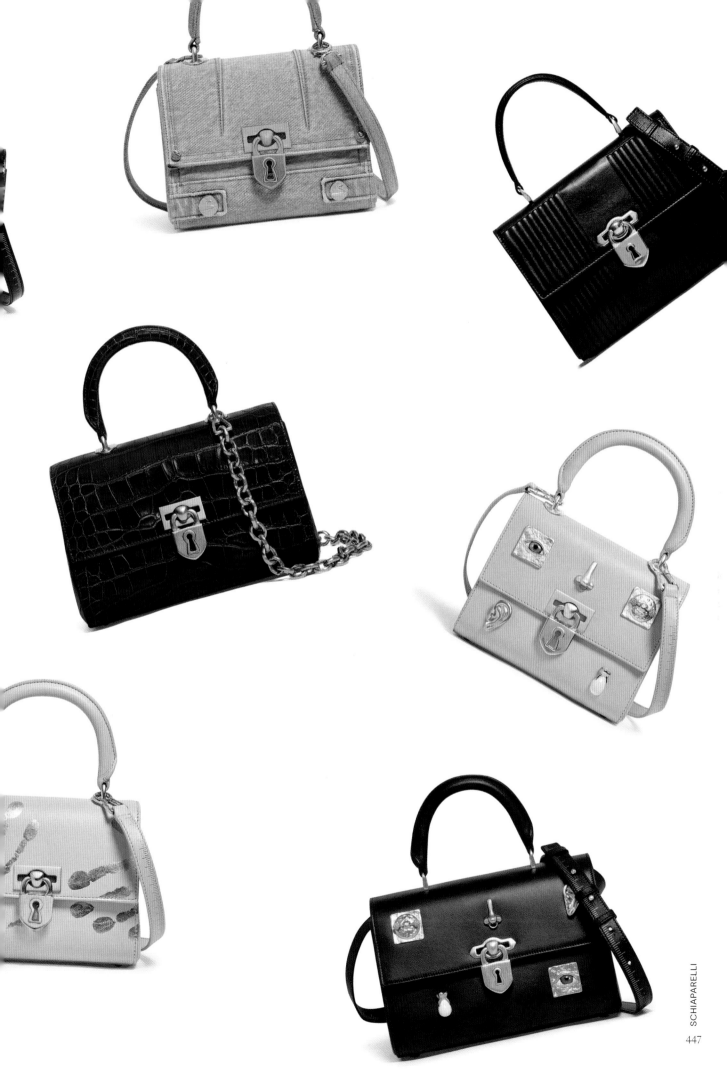

ANATOMY

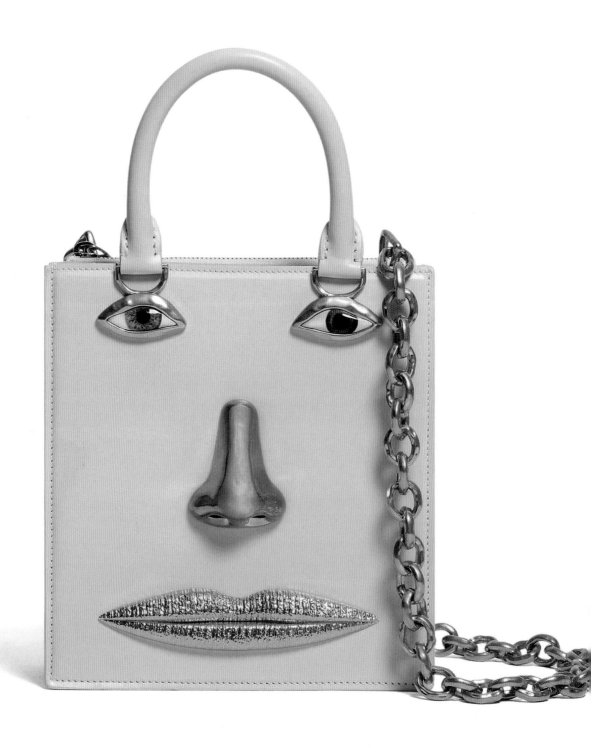

A bag that never lets you feel lonely! It has a face with eyes—on the front and back—and a nose and a mouth. It reminds us that Elsa Schiaparelli was a fan of surrealism. Made of leather, but also available in denim, the Anatomy bag can be carried by hand or with its chain strap. Anatomie Empreintes is a variation, with gold-leaf hand motifs. It is lined in shocking pink leather.

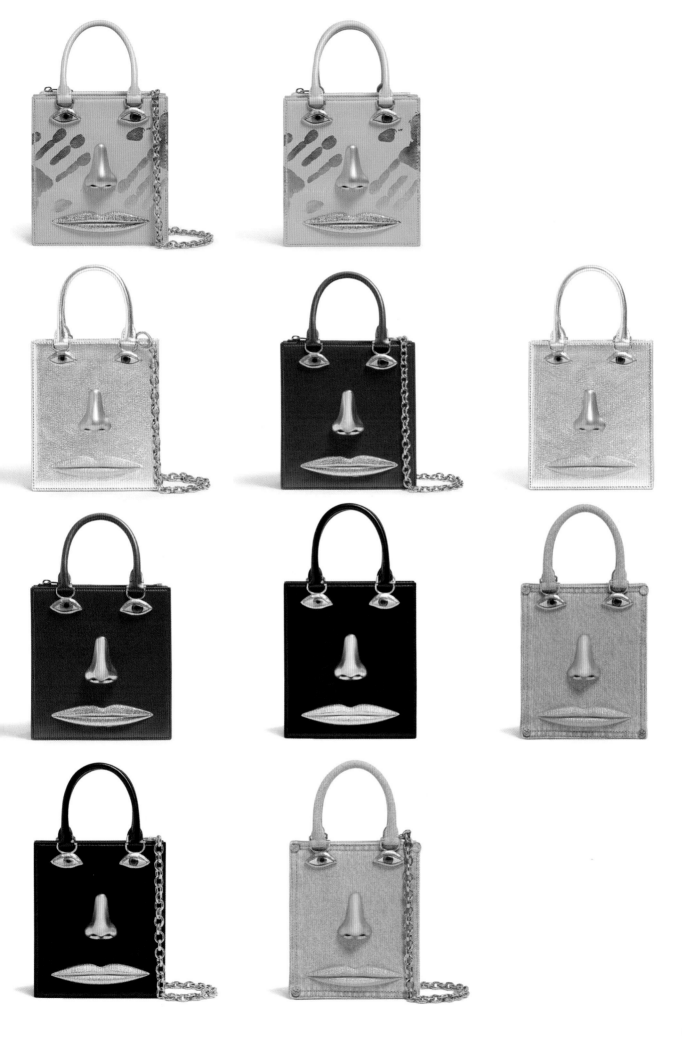

NOSE

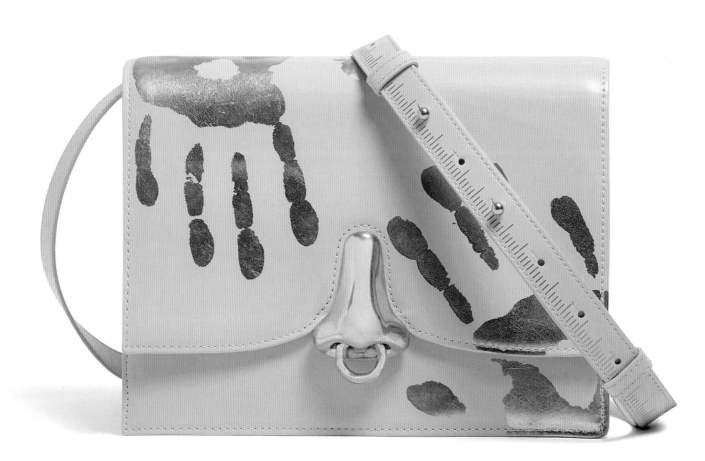

Continuing the theme of surrealism, the nose on this bag is set with a piercing that serves as the clasp (it is magnetized). Made of leather or denim, it can be carried as a clutch or worn on the shoulder with the detachable gold chain. Three sizes are available, including the Trotteur format with a leather shoulder strap.

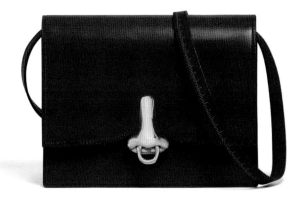
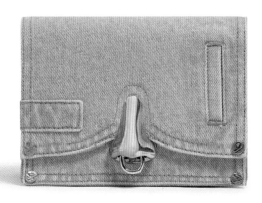
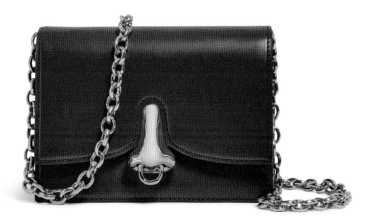
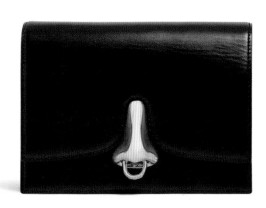
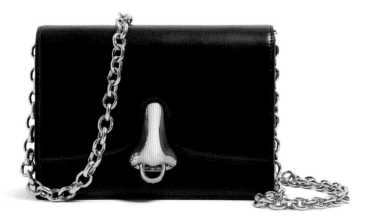
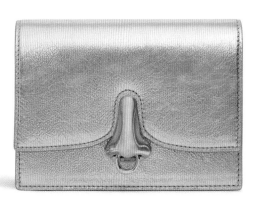

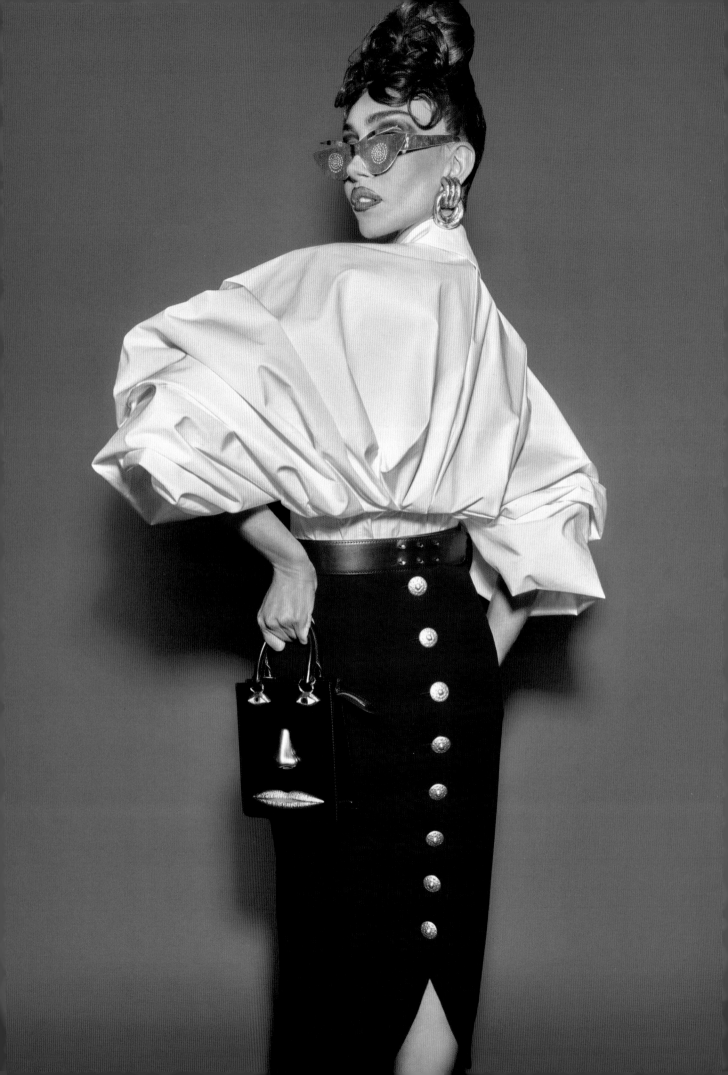

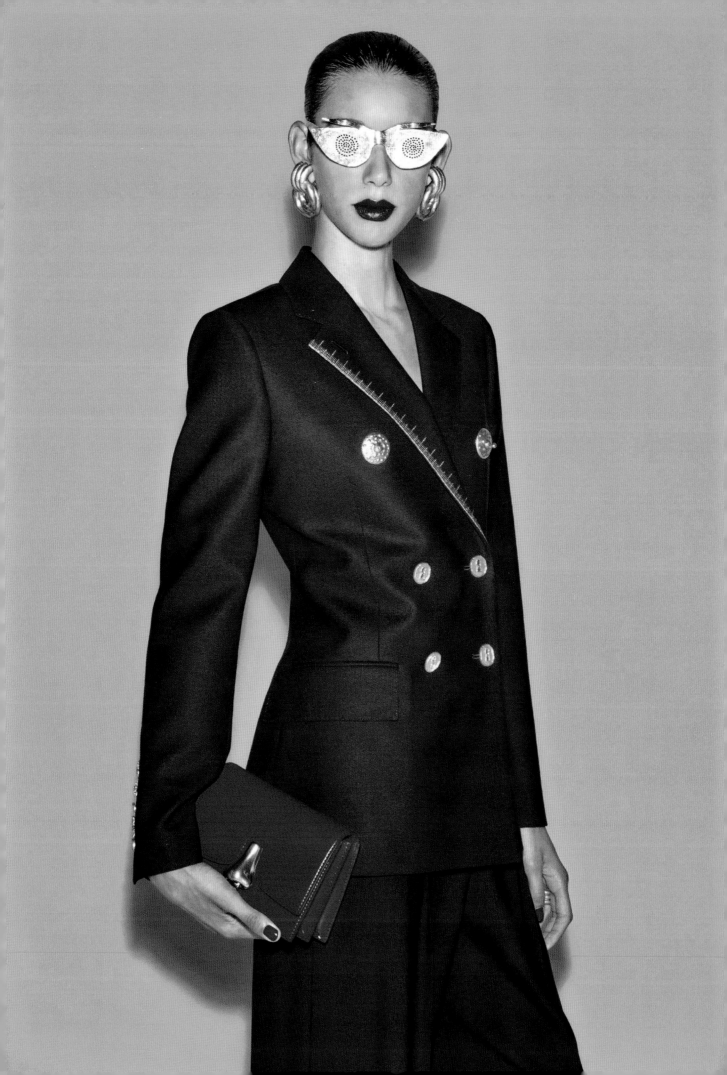

SOEUR
SIMPLICITY IN SUBTILTY

"I want everyone who dresses in our brand to feel understood and valued." **Domitille Brion, creative director of Soeur**

Founded: 2008

The story: This brand began with two sisters (*soeur* means sister in French), Domitille and Angélique Brion, who joined forces to launch this ready-to-wear line. They started by making dresses for very young girls, but the mothers who brought their daughters into the shop would also often request dresses for their older daughters, so Domitille and Angélique quickly expanded their range of sizes. Today, Soeur dresses women of all sizes and generations. As for accessories, the two sisters have created bags combining beautiful materials and varied volumes to make them everyday objects.

The style: Simplicity, enlivened by original proportions and striking details. *"I don't have a specific woman in mind,"* Domitille explains. *"I just know she's simple, active, free, graceful, and sexy. Considering what's masculine, feminine, authentic, and colorful … I love putting opposites together!"*

Heard on the street: *"I was already dressing in Soeur when the label made clothes only for young girls."*

WHO WEARS SOEUR?
Ines de la Fressange, Sandrine Kiberlain, Suzanne Lindon, Violette and Nine d'Urso—this is the unofficial brand of true Parisiennes.

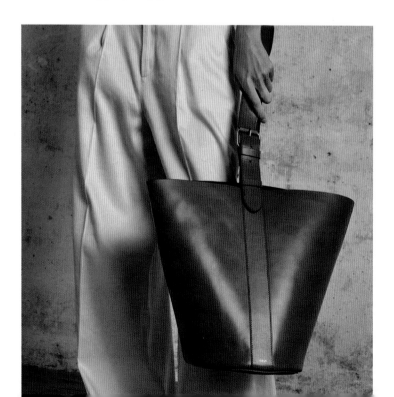

FASHION HOUSE FACT
Creative director Domitille Brion was formerly trained at a prestigious school. She worked at Bonpoint (for twelve years), Bonton, Lacoste, and Petit Bateau before cocreating Soeur with her sister.

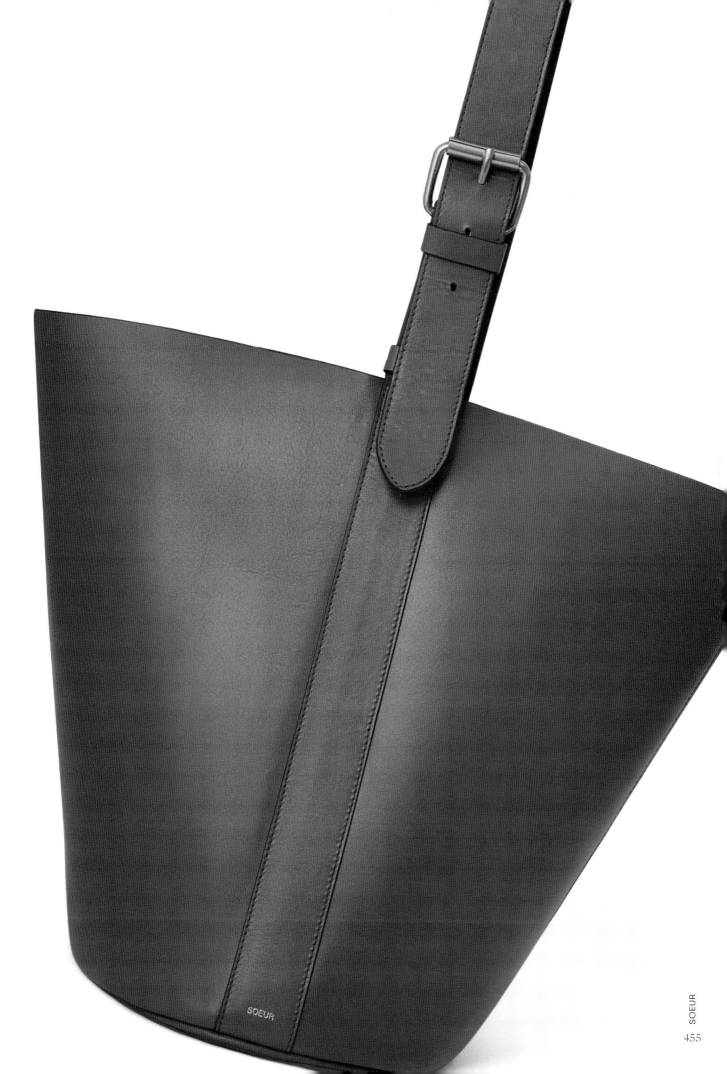

SAUL

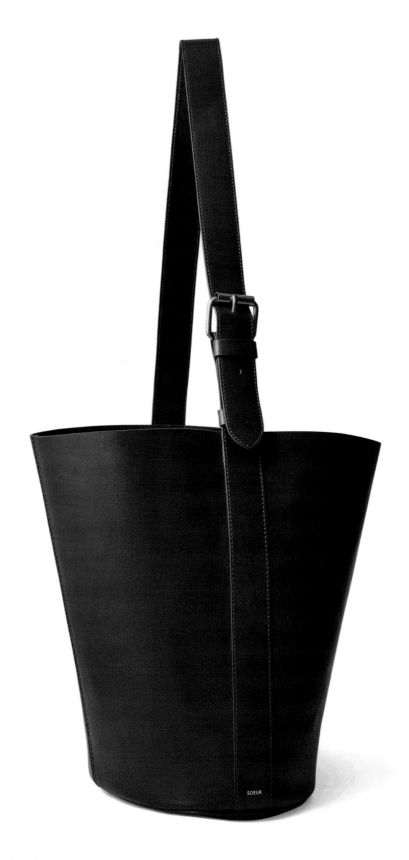

The bucket bag in its purest form. This bag has atypical proportions, which
makes it unique, an approach typical of Soeur. It is made of soft leather,
in colors black or brown, and is also available in a mini format.

SUZON

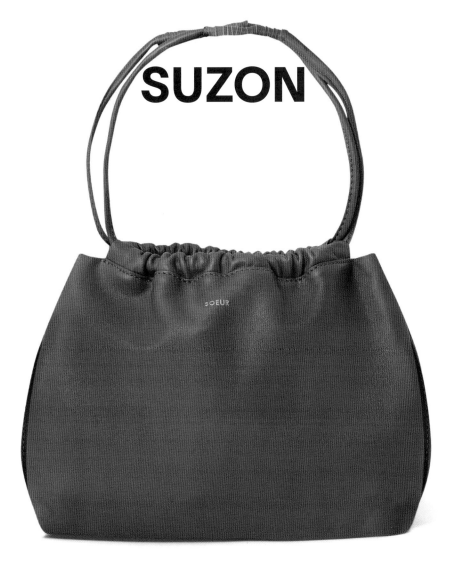

This small pouch-style bag in soft lambskin is worn on the shoulder. It comes in orange, green, and brown, and soon in yellow. Parisians love it, so obtaining one usually requires being on a wait list.

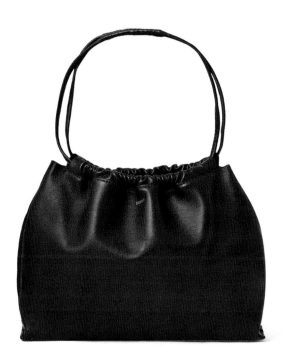

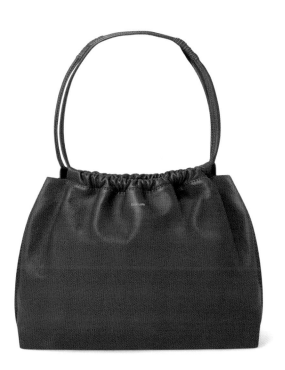

STELLA
MCCARTNEY

ICONIC HIT–ICONIC HIT–ICONIC HIT–ICONIC

FALABELLA

The most promising alternative to bags made from animal leathers. Since the beginning, Stella McCartney has been working to make bags in vegan leather, or at least in the most ecological materials possible. In 2009, she created the Falabella, which has become the iconic bag of the brand. Since 2023, she has been using Mirum, a plant-based, plastic-free material that can be worked to look like leather. It is also the first of its kind to be both 100 percent recyclable and compostable. It's a true innovation that can revolutionize fashion.

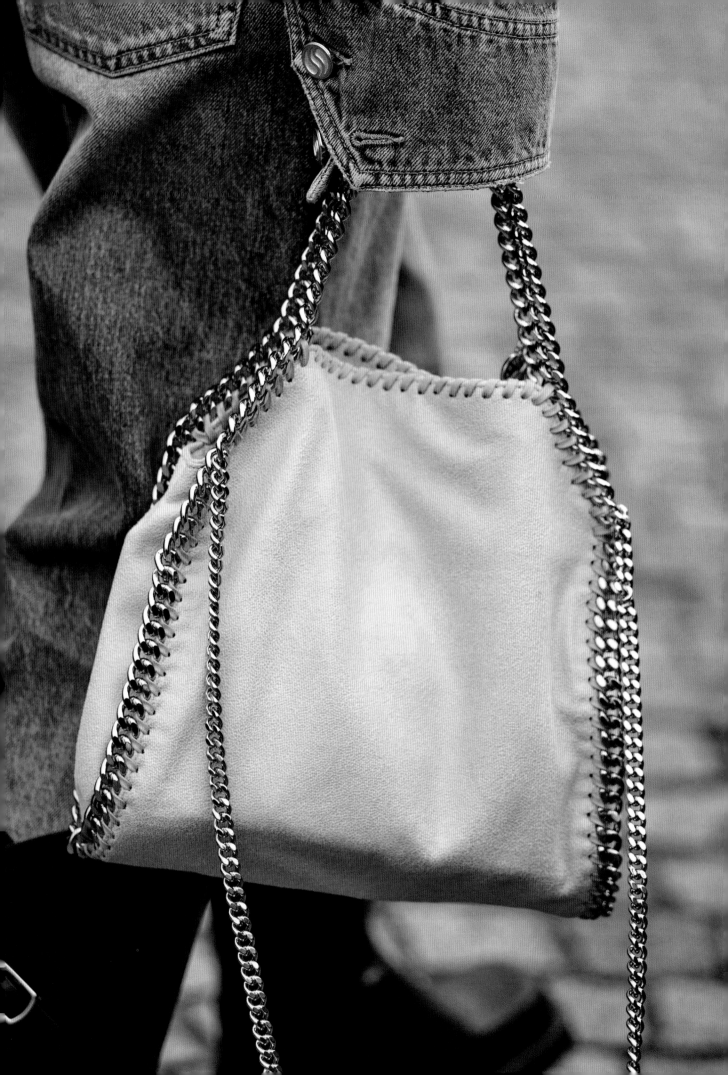

TOD'S
ITALIAN
LUXURY

"Behind every Tod's bag—attractive, useful, and comfortable to wear—is the Italian spirit, the Italian dream."

Diego Della Valle, CEO of Tod's

Founded: 1978

The story: Filippo Della Valle opened a small shoemaking workshop at the beginning of the twentieth century. This passionate man developed his business and passed down his know-how to his children. His authentic codes of style and quality still define the brand's culture today. In the 1970s, the founder's grandson, Diego, expanded the label globally and expanded production, though keeping the manufacture of the pieces artisanal. In 1978, he created the famous 133-spike driving shoe, the Gommino, which experienced phenomenal success, thus officially launching the Tod's brand. Since 1997, the company has also been producing leather bags. When ready-to-wear arrived at the fashion house in 2006, different creative directors created the collections, including Derek Lam, Alessandra Facchinetti, and Walter Chiapponi (until 2023). Matteo Tamburini is now the creative director.

The style: Tod's is steeped in a tradition of refinement and good taste, but with a casual "je ne sais quoi" chic.

Heard on the street: *"You can't make a mistake in displaying your taste when carrying a Tod's bag, as they all have a timeless quality."*

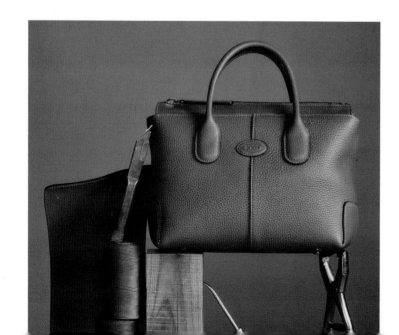

FASHION HOUSE FACT

Fashion can also be used to preserve history. The Tod's group, which also owns Roger Vivier, Hogan, Fay, and Schiaparelli, financed the renovation of the Colosseum in Rome.

TOD'S DI BAG

1997

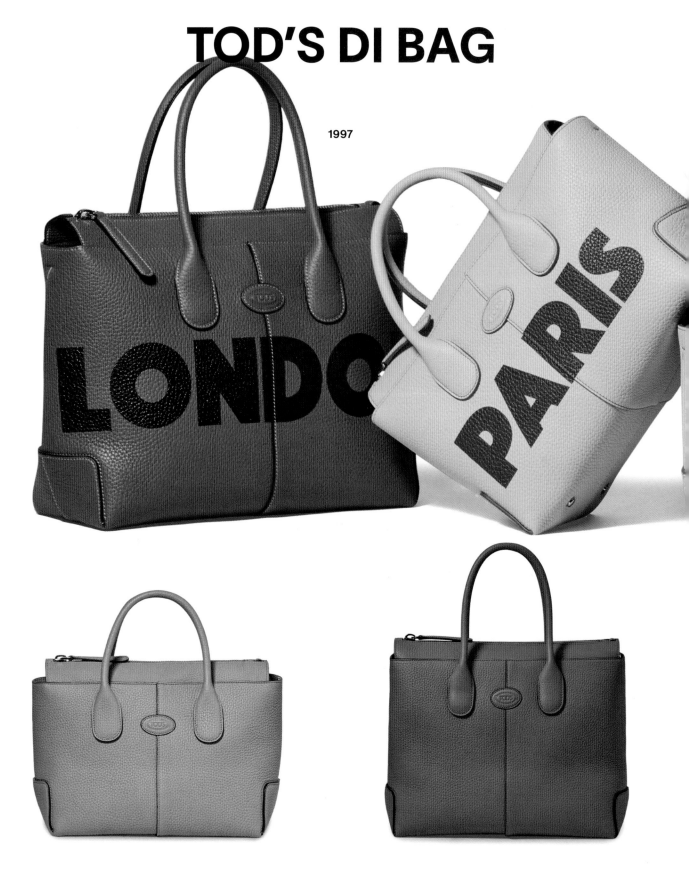

This is without a doubt the brand's most emblematic bag. It owes its name to Princess Diana, who carried it often. Its timeless style and ultrarefined details were quickly a hit with chic women who were looking for a bag with discreet luxury. Its distinguishing features are the center seam, rolled handles, almond-shaped end, and hand-painted rawhide trimming. The bag closes with a zipper using a large leather tab.

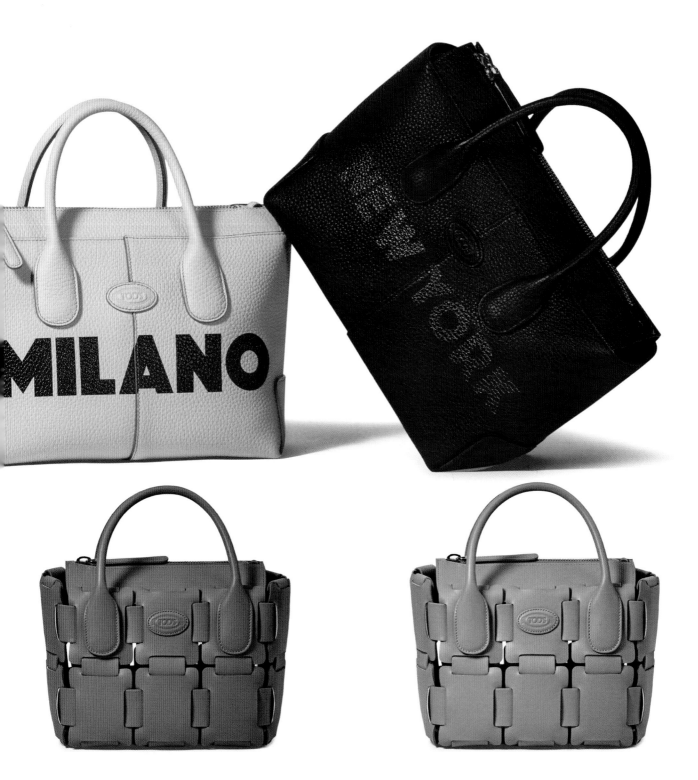

The artisanal techniques used to create the Di Bag are the same as those used by traditional saddlemakers. The cutting of the leather and the stitching and finishing of each model are the result of very meticulous work in which every detail counts.

The Di Bag comes in different sizes. Its shoulder strap is adjustable, and it comes in all colors, depending on the season.

VALEXTRA
ITALIAN CRAFTSMANSHIP

Valextra is engineered beauty.

Founded: 1937

The story: It began in Milan with its founder, Giovanni Fontana, a man who was good at turning a vision into a creative idea. He aimed to design objects of desire with everyday uses and impeccable quality. He integrated floor-to-ceiling windows into the architecture of the brand's historic atelier to observe the daily life of the Milanese and anticipate pieces that would merge utility with aesthetics. From the iconic Tric Trac wrist bag, designed in 1968, to the Iside handbag, the tradition of craftsmanship and innovation always go hand in hand within this fashion house.

The style: Urban, elegant, and refined. Valextra still has a very discreet signature look, linear shapes, and leather that is recognizable at first glance. It is a very popular label for luxury lovers who are looking for beauty and quality.

Heard on the street: *"Less is more, but (Val)extra is better."*

FASHION HOUSE FACT
Millepunti grained leather is one of the characteristic elements of a Valextra creation. This technique, which means "thousand points," describes the finely grained surface of the bag. Thanks to a unique treatment, the leather forms small dots that lend chicness, but above all, durability. It's the perfect leather for everyday wear.

WHO WEARS VALEXTRA?
From the 1940s to the 1970s, Valextra handbags and luggage were worn and carried by VIPs such as Grace Kelly, Aristotle and Jacqueline Onassis, and Maria Callas. Today, Jennifer Aniston, Charlotte Casiraghi (Grace Kelly's granddaughter), Elle Fanning, Olivia Palermo, Emmy Rossum, and Reese Witherspoon are fans of this luxury product without any bling.

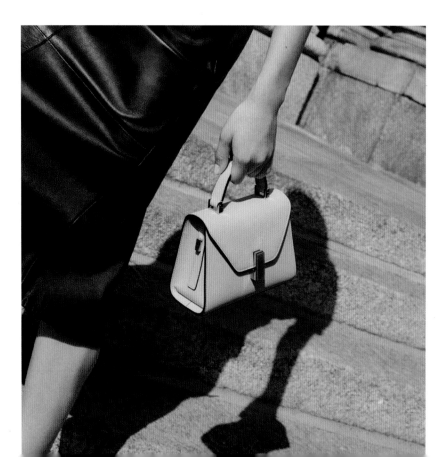

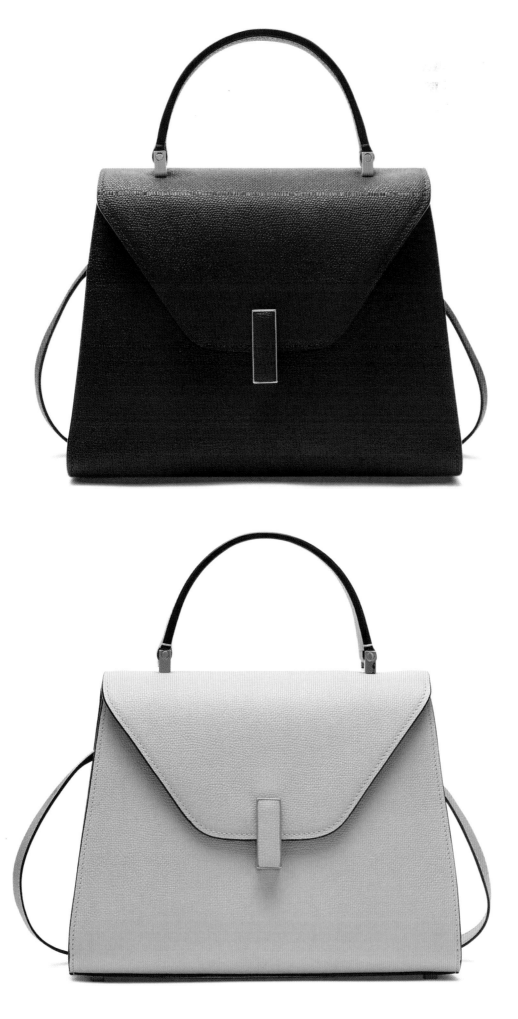

ISIDE

2011

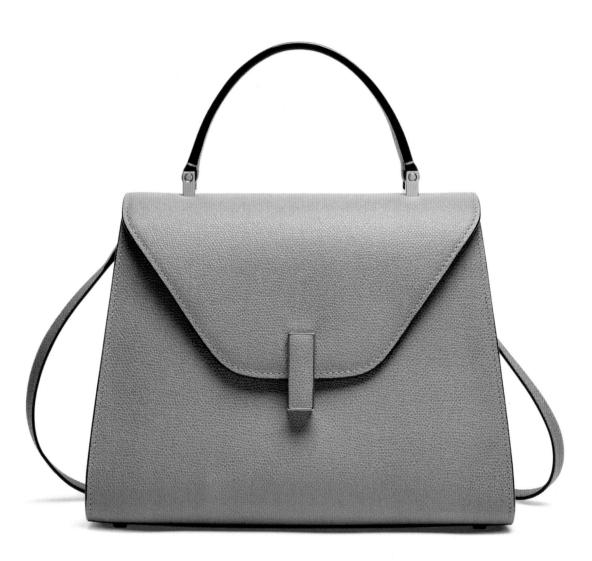

The brand's signature bag. It manages the feat of being both simple and sophisticated. Whether you're in jeans or a dress, shorts or a suit and pants, the Iside is an instant way to add a luxury label to your look. Its lines are pure, almost architectural. It has a handle and a detachable shoulder strap for dual wear. The colors offered are numerous, unique to Valextra (they are created for the brand), and always very subtle. Some bags are multicolored and play with color blocking while others are embroidered. The Iside comes in five sizes: medium for the day (it will hold many things); the mini for the *aperitivo*, as they say in Italy, in which you slip your phone and a wallet; the micro, perfect for a night out dancing; the clutch, with its gold chain, for a glamorous night out; and the belt bag, for all those moments when you want to be totally free. The gold clasp sometimes plays chameleon by taking on the color of the bag or is adorned with another color for a graphic look. The hand-lacquered edges of the bag bear witness to Valextra's understated luxury. Each bag has its own code number that links it to the craftsperson who made it. This is a bag with soul.

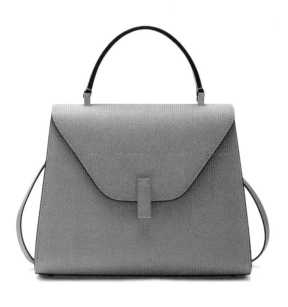
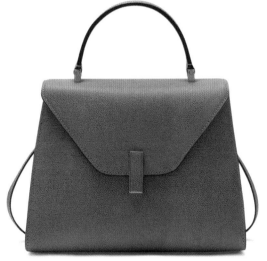
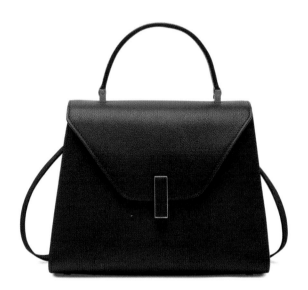
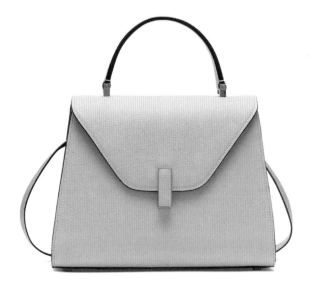
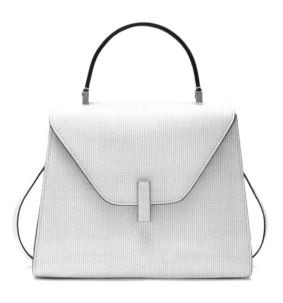

VANESSA BRUNO
BOHEMIAN CHARM

"Enhancing everyday life takes work." **Vanessa Bruno**

Founded: 1996

The story: Born to a Danish mother and a Franco-Italian father, Vanessa Bruno launched her label in 1996, mixing Franco-Italian chic with the Danish bohemian spirit. She quickly made a name for herself with her romantic Parisian style. In 1998, she released a seemingly mundane tote bag, but its sequined handles immediately made it an accessory that the world would covet.

Vanessa's fashion is anchored in everyday life. Each of her creations is well thought out and always with that little extra soul that puts a little sparkle in life.

The style: Bohemian and romantic, with a zest of nonchalance that gives it real soul. *"The Vanessa Bruno woman is a free, independent woman who loves to travel and meet new people,"* says the designer.

Heard on the street: *"Vanessa Bruno has a superpower. Her tote bag is twenty-five years old and hasn't aged a bit. Her creations have the same style and stay current and, what's more, feel like Vanessa is still thirty years old!"*

WHO WEARS VANESSA BRUNO?
Jessica Alba, Kate Bosworth, Charlotte Gainsbourg, Vanessa Paradis, Charlotte Rampling, and Reese Witherspoon.

FASHION HOUSE FACT
Working in raffia, a natural fiber, is an annual event for the brand. The fabric can be found on iconic models, such as the Cabas Tote and the Moon. The bags are handmade in Madagascar according to traditional know-how and with respect for the planet. Vanessa Bruno is keen to contribute to improving the standard of living of local artisans, especially women.

CABAS TOTE

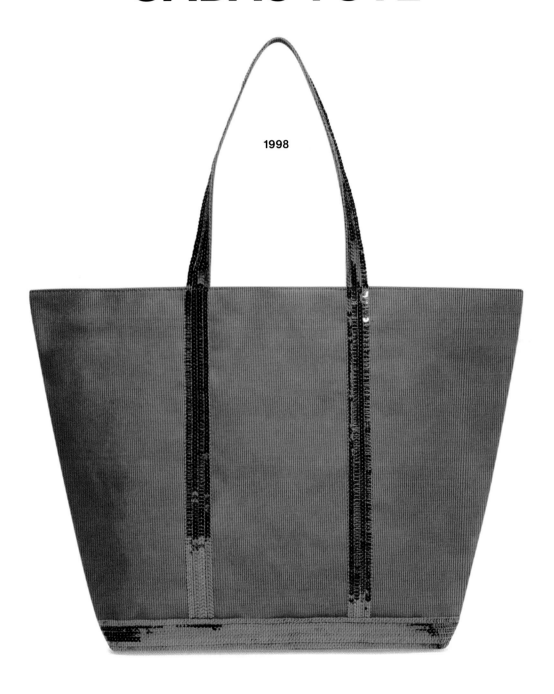

1998

More than an It bag, the Cabas Tote is a basic tote bag that never goes out of style. According to Vanessa, the bag is "*the perfect companion for a young mother but also for a business owner.*" Its sequins cross generational lines, adored as much by teenage girls as by career women. A worldwide bestseller, the Cabas Tote was born out of Vanessa's personal story. As a young mother and entrepreneur, the designer was looking for a bag to accompany her everywhere, whether on a bike, at the office, or at a party. She combined these different moments of the day into a unique bag and decided to combine cotton canvas with sequins. It was this mix of opposites that created its inimitable chic. Available in different sizes, materials (linen, cowhide leather, raffia), and colors, the Cabas Tote has been reinvented every season since its beginning. It has become a true iconic bag, and even made its debut at the Musée des Arts Décoratifs in Paris in 2004, as part of an exhibition on handbags.

MOON

2017

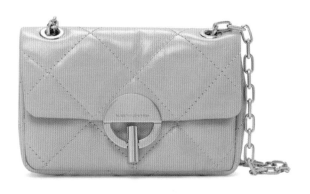

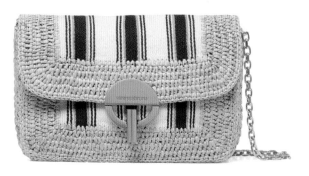

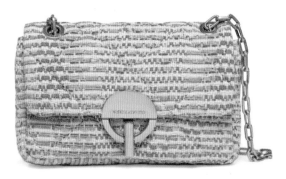

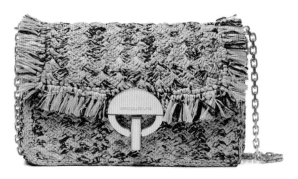

The Moon is a tribute to Vanessa Bruno's daughter Lune. Originally, this rectangular bag was made of quilted leather. It was designed as a "jewel" bag, with its round half-moon clasp and golden chain. The Moon comes in linen, raffia, nubuck, cotton, and even faux fur. It is also available in medium and nano formats.

OTHILIA

2021

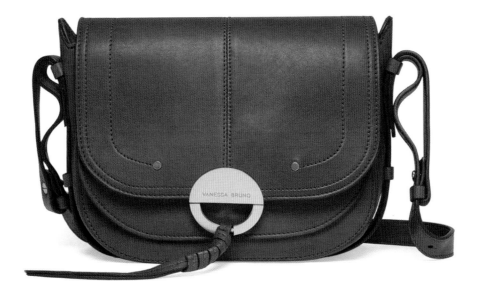

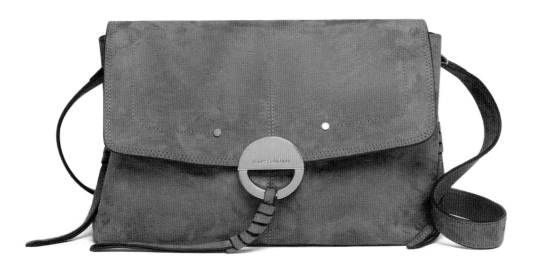

A softer, rounded shape marked by topstitching that fits very well with the brand's bohemian vibe. Othilia has two compartments and a double flap. It closes with a snap button hidden behind a round, open gold piece engraved with the brand's name. A leather tie is attached to it. The shoulder strap is adjustable for shoulder or crossbody wear. It is available in leather or nubuck and in natural colors.

ZADIG & VOLTAIRE
CASUALLY CHIC

"Zadig & Voltaire advocates effortless luxury, between irreverence and elegance."

Cecilia Bönström, artistic director of Zadig & Voltaire

Founded: 1997

The story: After a few experiences in fashion, Thierry Gillier launched Zadig & Voltaire, a ready-to-wear brand that mixes high-end materials with rock-inspired clothing adorned with inscriptions inspired by musical artists such as Elvis Presley and Mick Jagger, and with recurring motifs such as skulls and angels. Cecilia Bönström has been artistic director since 2006. While preserving the style codes of the brand, she infuses it with her personal style, between feminine and masculine, between chic and casual. This style has crossed borders, and Zadig & Voltaire's success is now global with stores located worldwide. Just like its iconic bag, Rock, it's now recognizable at a glance.

The style: Rock, chic, timeless. A touch of casual. Looking cool wearing Zadig & Voltaire is the rule.

Heard on the street: *"I chose the Rock Clutch with the gold chain. It looks less rock for going to the opera."*

FASHION HOUSE FACT
The Kate bag, which is still present in the collections, was created in 2019 by supermodel Kate Moss in collaboration with Cecilia Bönström.

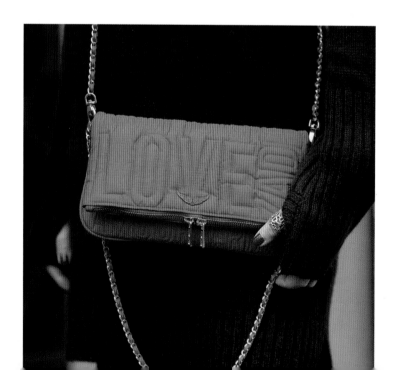

WHO WEARS ZADIG & VOLTAIRE?
Priyanka Chopra, Gigi Hadid, Katie Holmes, Jessica Jung, Heidi Klum, Kate Moss, Sarah Jessica Parker, Freida Pinto, Florence Pugh, Taeyeon, and Taylor Swift.

ROCK CLUTCH

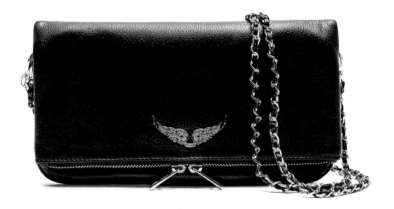

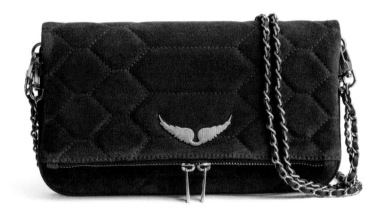

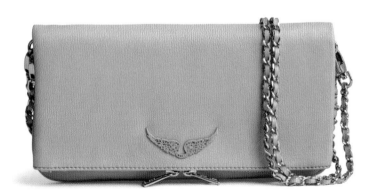

This iconic clutch illustrates the rock spirit that is often attributed to the label. It has two removable metal chains, and its zip flap along the edge closes with a magnet. It has a small back pocket that is also zipped and an inside patch pocket. The wings emblem on the front varies depending on the material or color of the bag and acts as a logo. Available in different materials (quilted or grained leather, python print, studded, quilted suede, beaded, and velvet), the Rock Clutch can be carried by hand, on the shoulder, or as a crossbody. The color palette is broad, even if purists feel a Zadig & Voltaire clutch should be black.

ACKNOWLEDGMENTS

MANY THANKS TO . . .

Catherine Roig, author and one of my first awesome editors at *Elle* magazine. Éditions E/P/A was looking for someone to write a book about handbags. She remembered my addiction to them and told them about me, so thanks also to Catherine Saunier-Talec, managing director of the Hachette Livre division, for listening to her.

Boris Guilbert, the editor of this book, for his very British stiff upper lip, which is essential to a book of this kind. (I recommend you read a book whose publishing he supervised: *Elizabeth II, Les chapeaux de la Couronne*, by Thomas Pernette, illustrated by Jason Raish.)

Laurence Lehoux, who proved that the union of two editors on a 480-page book is power.

Marie Laure Miranda. Her good humor, professionalism, "Swiss-army-knife" side that can do everything, and her little melodic accent were all essential for making this book a reality.

Françoise Mathay, the iconographer who leaves nothing to chance and knows how to organize her emails. She has a very Luxembourgish seriousness that is well adapted to my Swiss origins.

Zerozoro, the team of art directors who pushed forward while masked, emerging out of the darkness and galloping—and brilliantly so—into this adventure.

Ines de la Fressange, for her wonderful foreword written mid-summer (with a Soeur bag as a beach bag). And for inspiring me more and more each day.

Aramis and Vadim, my wonderful sons and witnesses of my twenty-four-hour devotion to this book, who ended up taking part in the historical research on the brands so that we could spend time together.

Sienna, my wonderful daughter, who is a "bagaholic" like me and alerted me to the brands I must not forget.

Stan, my wonderful and amazing baby, who was very patient, understanding, and encouraging. And who took advantage of my immersion to spend time immersed himself twenty thousand leagues under the sea.

Pascale and Bertrand, who saved their grandson's month of July. Because of the writing of this book, he was destined to spend his time in the virtual world of *Animal Crossing* twenty-four hours a day (thanks to Nintendo Switch). Thanks to them, he saw the real sun, the real sea, and his real cousins.

My mom for giving me the "bag bug," this addiction to handbags that is ultimately fascinating.

Nathalie Pavlovsky for her talent for connecting people.

Emmanuelle Walle for her extraordinary efficiency.

Nora Bordjah, who always gives the right advice—and creates sublime jewelry.

Virginie Mouzat for opening me up to awareness and so many other things . . .

Marie-Pierre Dupont, grande dame of the press, who entrusted me with the column "Accessoires et Importants" in the magazine *Femina* in Switzerland when I was a student.

And to all the teams of the brands featured in this book who sometimes took time away from the beach to answer our persistent emails. Their collaboration in all stages of this book has been invaluable.

BIBLIOGRAPHY

Many thanks also to all my sources, mainly online:
www.lefigaro.fr / www.lemonde.fr
www.admagazine.fr / www.marieclaire.fr
www.elle.fr / www.fashionnetwork.com
www.thesocialitefamily.com / www.vogue.fr
www.harpersbazaar.com / www.vogue.com
www.wwd.com / www.businessoffashion.com
www.youtube.com

And publications, too:
Un siècle de mode,
Catherine Örmen, Larousse, 2018.
The Fashion Design Directory,
Marnie Fogg, Thames & Hudson, 2011.
Tout sur la mode. Panorama des mouvements et des chefs-d'oeuvre,
edited by Marnie Fogg, Flammarion, 2013.
Luxe et mode: Grandes et petites histoires,
Gérard Nicaud, Michel de Maule, 2023.
Les plus grands créateurs de mode. De Coco Chanel à Jean Paul Gaultier, Noël Palomo-Lovinsky, Eyrolles, 2015.
Fashion Game Book: Histoire de la mode du 20e siècle,
Florence Müller, Assouline, 2008.
Fashion Quotes: Stylish Wit & Catwalk Wisdom,
Patrick Mauriès and Jean-Christophe Napias, Thames & Hudson, 2016.

All the brands' websites have obviously been sources of information:
www.acnestudios.com
www.maison-alaia.com
www.alexandermcqueen.com
www.amiparis.com
www.anyahindmarch.com
www.apcstore.com
www.balenciaga.com
www.balmain.com
www.bottegaveneta.com
www.bulgari.com
www.carel.fr
www.celine.com
www.chanel.com
www.chloe.com
www.christianlouboutin.com
www.coach.com
www.coperniparis.com
www.us.delvaux.com
www.destree.com

www.dior.com
www.dolcegabbana.com
www.fendi.com
www.ferragamo.com
www.us.fleuron.paris
www.grafparis.com
www.gerarddarel.com
www.armani.com
www.givenchy.com
www.gucci.com
www.hermes.com
www.hervechapelier.com
www.inesdelafressange.fr
www.isabelmarant.com
www.isseymiyake.com
www.jacquemus.com
www.jerome-dreyfuss.com
www.jimmychoo.com
www.judithleiber.com
www.jwanderson.com
www.lancel.com
www.loewe.com
www.longchamp.com
www.loropiana.com
www.louisvuitton.com
www.luniform.com
www.michel-paris.com
www.marcjacobs.com
www.michaelkors.com
www.miumiu.com
www.moynat.com
www.off---white.com
www.olympialetan.com
www.patou.com
www.pierrehardy.com
www.prada.com
www.pacorabanne.com
www.rogervivier.com
www.rsvp-paris.com
www.ysl.com
www.schiaparelli.com
www.soeur.fr
www.stellamccartney.com
www.tods.com
www.valextra.com
www.vanessabruno.com
www.zadig-et-voltaire.com

PHOTO CREDITS

The publisher would like to thank all the fashion houses, photographers, and their representatives for their invaluable help in the production of this book. We have made every effort to correctly assign the copyright of the photographs to their correct sources. However, if despite our best attention, an error or omission has occurred, we would like to apologize for it now and will happily make the necessary correction(s) in a future reprint.

PP. 6, 8: © Christian Vierig / Getty Images Entertainment via Getty Images.
ACNE STUDIOS (pp. 10–15): © Acne Studios.
ALAÏA (pp. 16–19): © Alaïa, 2023, except p. 16: © Andrew Lamb / Catwalking via Getty Images.
ALEXANDER MCQUEEN (pp. 20–25): © Alexander McQueen, 2023.
AMI PARIS (pp. 26–29): © AMI, except p. 26: © AMI, Courtesy of Michael Bailey-Gates.
ANYA HINDMARCH (p. 30–35): © Anya Hindmarch, 2023.
A.P.C. (pp. 36–43): © A.P.C. 2023, except p. 36: © Estrop / Getty Images Entertainment via Getty Images.
BALENCIAGA (pp. 44–51): © Balenciaga, 2023.
BALMAIN (pp. 52–69): pp. 52, 53 code 03 and 05: © Stephane Cardinale / Corbis Entertainment via Getty Images; code 01: © Peter White / Getty Images Entertainment via Getty images; code 02: © Dominique Charriau / WireImage via Getty Images; code 04: "Le Mans" ensemble and monogrammed luggage, Pierre Balmain Haute Couture, Spring/Summer 1971 © Patrimoine Balmain, All Rights Reserved.
BOTTEGA VENETA (pp. 70–71): © Pietro D'Aprano / Getty Images Entertainment via Getty Images.
BULGARI (pp. 72–77): © Bulgari, 2023.
CAREL (pp. 78–83): © Carel Paris.
CELINE (pp. 84–85): © Streetstyleshooters / German Select via Getty Images.
CHANEL (pp. 86–107): © CHANEL, except p. 86: photo Mike de Dulmen © All Rights Reserved; p. 87 code 02: © Alix Marnat for CHANEL.
CHLOÉ (pp. 108–119): © Chloé, except pp. 118–119: © Victor Virgile / Gamma-Rapho via Getty Images.
CHRISTIAN LOUBOUTIN (pp. 120–123): © Christian Louboutin, 2023.
COACH (pp. 124–125): © Gilbert Carrasquillo / GC Images via Getty Images.
COPERNI (pp. 126–131): © Coperni, 2023.
DELVAUX (pp. 132–139): © Delvaux, 2023.
DESTREE (pp. 140–143): © Destree, 2023.
DIOR (pp. 144–167): p. 144: All Rights Reserved; p. 145: © Granville, Musée Christian-Dior/All Rights Reserved (01) and (02); © Association Willy Maywald/ADAGP, Paris, 2023 (03) and (04); © Granville, Musée Christian-Dior/Benoit Croisy (05); p. 146: All Rights Reserved; © Dior Focus/Ivan Vandel; p. 147: © Dior Focus/Ivan Vandel; All Rights Reserved; p. 148: © Pol Baril; p. 149: © Keystone-France/Gamma-Rapho; © Paris, Dior Héritage; © Laura Sciacovelli (model: Patrycja Piekarska); p. 150: © Dior; p. 151: © Dior; © Guy Marineau; p. 152: © New York Daily News/Getty Images; © Tim Graham Picture Library/Getty Images; p. 153: © Tim Graham Picture Library/Getty Images; pp. 154–155 © Pol Baril; p. 156 (from left to right, and from top to bottom): © Anastasia Prahova / photo © Gleb Vinogradov; © Olympia Scarry / photo © Ivan Vandel; © Zhang Ruyi / photo © Likai; © Wen Fang / photo © Ivan Vandel; p. 157 (from left to right, and from top to bottom): © Limited Edition in collaboration with Hilary Pecis; © Limited Edition in collaboration with Mariko Mori; © Limited Edition in collaboration with Judy Chicago; © Limited Edition in collaboration with Michaela Yearwood-Dan; © Limited Edition in collaboration with Gilbert & George; © Limited Edition in collaboration with Brian Calvin; © Limited Edition in collaboration with Minjung Kim; © Limited Edition in collaboration with Françoise Pétrovitch; p. 158: © Dior; p. 159: © Dior; © Guy Marineau; pp. 160–162: © Dior; p. 163: © Dior (model: Hedvig Palm); p. 164: © Dior; p. 165: © Dior; © Ricardo Ramos (model: Marsella Rea); p. 166: © Dior; p. 167: © Dior; © Morgan O'Donovan (models, from left to right: Aleksandra Racic, Hiandra Martinez, Marie Zuelsdorf).
DOLCE & GABBANA (pp. 168–169): © Pietro D'Aprano / Getty Images Entertainment via Getty Images.
FENDI (pp. 170–189): © Fendi, 2023, except p. 170 and p. 171 code 02: © Daniele Venturelli / WireImage via Getty Images; p. 171 code 01: © Victor Boyko / Getty Images Entertainment via Getty Images; code 04: © Christian Vierig / Getty Images Entertainment via Getty Images; p. 177 top: © MEGA / GC Images via Getty Images; bottom: © Taylor Hill / Getty Images Entertainment via Getty Images.
FERRAGAMO (pp. 190–191): © Streetstyleshooters / German Select via Getty Images.
FLEURON PARIS (pp. 192–195): © Fleuron Paris, 2023.
FRANÇOIS-JOSEPH GRAF (pp. 196–201): © Julio Piatti for François-Joseph Graf Paris, except pp. 196, 200, and 201 © Chloé Gassian for François-Joseph Graf Paris.
GERARD DAREL (pp. 202–207): © Gerard Darel, 2023.
GIORGIO ARMANI (pp. 208–213): © Courtesy of Giorgio Armani, except p. 208: © ADV Giorgio Armani Wear AW19 – Dominique Issermann; pp. 212–213: © Courtesy of Giorgio Armani, Federica Bottoli, and Caos18.
GIVENCHY (pp. 214–221): © Givenchy, except p. 214: © Stephane Cardinale / Corbis Entertainment via Getty Images.
GUCCI (pp. 222–231): © Gucci, except p. 230 top for Jackie Kennedy-Onassis: © Fairchild Archive via Getty Images; p. 231 for Samuel Beckett in 1972 © Farabola / Bridgeman.

HERMÈS (pp. 232–253): p. 232: © Victor Virgile / Gamma-Rapho via Getty Images; p. 233: code 01 © Nacho Alegre; code 02 Gaspar J. Ruiz Lindberg © Hermès 2023; code 03 and code 05 © Studio des Fleurs © Hermès 2023; code 04 © Quentin Bertoux; bottom, Guy Lucas de Peslouan © Hermès 2023; pp. 234–236: Studio des Fleurs © Hermès 2023; p. 237 top: Studio des Fleurs © Hermès 2023; middle and bottom: © Edward Berthelot / Getty Images Entertainment via Getty Images; p. 238: © Edward Berthelot / Getty Images Entertainment via Getty Images except middle left: © Jeremy Moeller / Getty Images Entertainment via Getty Images; p. 239 top: © Edward Berthelot / Getty Images Entertainment via Getty Images; bottom: © Victor Virgile / Gamma-Rapho via Getty Images; p. 240: © Bettmann via Getty Images; bottom: Grace Kelly in California in 1956 © Allan Grant/The LIFE Picture Collection/Shutterstock; p. 241 top: © Evening Standard / Hulton Royals Collection via Getty Images; bottom: © Popperfoto via Getty Images; pp. 242–245: Studio des Fleurs © Hermès 2023; p. 246 top: © Edward Berthelot / Getty Images Entertainment via Getty Images; middle: © Edward Berthelot / Getty Images Entertainment via Getty Images; bottom: © Gaspar J. Ruiz Lindberg; p. 247 top: © Streetstyleshooters / German Select via Getty Images; middle: © Jeremy Moeller / Getty Images Entertainment via Getty Images; bottom: © Victor Virgile / Gamma-Rapho via Getty Images; pp. 248–251: Studio des Fleurs © Hermès 2023; pp. 252–253: © Maxime Verret.
HERVÉ CHAPELIER (pp. 254–257): © Hervé Chapelier, 2023, except p. 254: © Mika Inoue, 2023.
INES DE LA FRESSANGE (pp. 258–259): © Romain Boé for Ines de la Fressange.
ISABEL MARANT (pp. 260–269): © Isabel Marant, 2023.
ISSEY MIYAKE (pp. 270–271): © Streetstyleshooters / German Select via Getty Images.
JACQUEMUS (pp. 272–277): © Jacquemus, 2023, except pp. 276–277: © Arnold Jerocki / French Select via Getty Images.
JÉRÔME DREYFUSS (pp. 278–287): © Jérôme Dreyfuss, except p. 278: Art Direction & Photo: Germain Chauveau.
JIMMY CHOO (pp. 288–295): © Courtesy of Jimmy Choo, except p. 288: © Karwai Tang / Getty Images Entertainment via Getty Images.
JUDITH LEIBER (pp. 296–297): © Jon Kopaloff / FilmMagic via Getty Images.
JW ANDERSON (pp. 298–305): © JW Anderson, 2023.
LANCEL (pp. 306–309): © Lancel, 2023, except p. 306: © Keystone-France / Gamma-Keystone via Getty Images.
LOEWE (pp. 310–319): © Loewe, 2023, except p. 310: © Victor Virgile / Gamma-Rapho via Getty Images.
LONGCHAMP (pp. 320–325): p. 320: © Jeremy Moeller / Getty Images Entertainment via Getty Images; pp. 321–323: © Longchamp; pp. 324–325: © Gary Schermann for Longchamp.
LORO PIANA (pp. 326–331): © Loro Piana.
LOUIS VUITTON (pp. 332–351): © Louis Vuitton Malletier, except p. 332: © PVDE / Bridgeman Images; p. 333 code 01: © Peter White / Getty Images Entertainment via Getty Images; code 03: © Marc Piasecki / WireImage via Getty Images; code 04: photo © Christie's Images / Bridgeman Images; p. 334 © Pierre Vauthey / Sygma via Getty Images; pp. 334–335: © Rob Loud / Getty Images Entertainment via Getty Images; p. 335 multicolor monogram is a creation of Takashi Murakami for Louis Vuitton; p. 336: © Lorenzo Santini / WireImage via Getty Images; p. 337: © Stephane Cardinale / Corbis Entertainment via Getty Images; p. 341 top: © Rindoff/Dufour / French Select via Getty Images; bottom: © Bridgeman Images; p. 348 left: © Edward Berthelot / Getty Images Entertainment via Getty Images; right: © Christian Vierig / Getty Images Entertainment via Getty Images; bottom: © Raimonda Kulikauskiene / Getty Images Entertainment via Getty Images; p. 349: © Christian Vierig / Getty Images Entertainment via Getty Images.
L/UNIFORM (pp. 352–359): © L/UNIFORM, 2023.
MAISON MICHEL (pp. 360–363): © Lucile Perron, except p. 360: © June Tamò-Collin.
MARC JACOBS (pp. 364–365): © Jeremy Moeller / Getty Images Entertainment via Getty Images.
MICHAEL KORS (pp. 366–371): © Michael Kors, 2023.
MIU MIU (pp. 372–375): © Miu Miu, 2023.
MOYNAT (pp. 376–383): © Archives Moynat.
OFF-WHITE (pp. 384–387): © Off-White, 2023, except p. 384: © Victor Boyko / Getty Images Entertainment via Getty Images.
OLYMPIA LE-TAN (pp. 388–389): © Olympia Le-Tan, except p. 388: © Maud Chalard © Olympia Le-Tan; p. 389 bottom left: © Jenny Zemanek / Licensed by Jehane Ltd © Olympia Le-Tan; bottom right: © Succession Picasso 2023 © Olympia Le-Tan.
PATOU (pp. 390–395): © Patou, Guillaume Henry, 2023.
PIERRE HARDY (pp. 396–403): © Pierre Hardy, 2023.
PRADA (pp. 404–421): © Courtesy of Prada, except p. 405 code 02: © Patrick McMullan via Getty Images; code 05: © Ullstein Bild Dtl. via Getty Images.
RABANNE (pp. 422–427): © Paco Rabanne, 2023, except p. 422: © Paco Rabanne, 2023, Louise Chevallet.
ROGER VIVIER (pp. 428–437): © Roger Vivier, except p. 428: © Viv' Choc Pièce Unique.
RSVP PARIS (pp. 438–441): © RSVP, 2023, except p. 438: photo All Rights Reserved.
SAINT LAURENT (pp. 442–443): © Edward Berthelot / Getty Images Entertainment via Getty Images.
SCHIAPARELLI (pp. 444–453): © Schiaparelli, 2023.
SOEUR (pp. 454–457): © Soeur, 2023.
STELLA MCCARTNEY (pp. 458–459): © Edward Berthelot / Getty Images Entertainment via Getty Images.
TOD'S (pp. 460–463): © Courtesy of Tod's.
VALEXTRA (pp. 464–467): © Valextra, 2023.
VANESSA BRUNO (pp. 468–471): © Vanessa Bruno.
ZADIG & VOLTAIRE (pp. 472–475): © Zadig & Voltaire, 2023, except p. 472: © Streetstyleshooters / German Select via Getty Images.
P. 476: © Sylvain Lefevre / Getty Images Entertainment via Getty Images

General management: **Catherine Saunier-Talec**
Direction: **Ariane Lainé-Forrest**

Editorial management: **Boris Guilbert** and **Laurence Lehoux**
Editorial coordination: **Marie Laure Miranda**
Graphic design and layout: **Studio Zerozoro**
Iconographic research: **Françoise Mathay**
Proofreading: **Valérie Nigdélian**
Production: **Amélie Moncarré**
Photoengraving: **Hyphen-Media for Hyphen-France**

ISBN: 978-1-4197-7819-3

Copyright © 2023 Éditions E/P/A – Hachette Livre

For photo credits, see page 479

Cover © 2024 Abrams

First published in France in 2023 by E/P/A
58 rue Jean Bleuzen
92178 Vanves Cedex

Printed and bound in China
10 9 8 7 6 5 4 3 2 1

Abrams books are available at special discounts when purchased in quantity for premiums and promotions as well as fundraising or educational use. Special editions can also be created to specification. For details, contact specialsales@abramsbooks.com or the address below.

ABRAMS The Art of Books
195 Broadway, New York, NY 10007
abramsbooks.com